# August Sander

## PHOTOGRAPHER EXTRAORDINARY

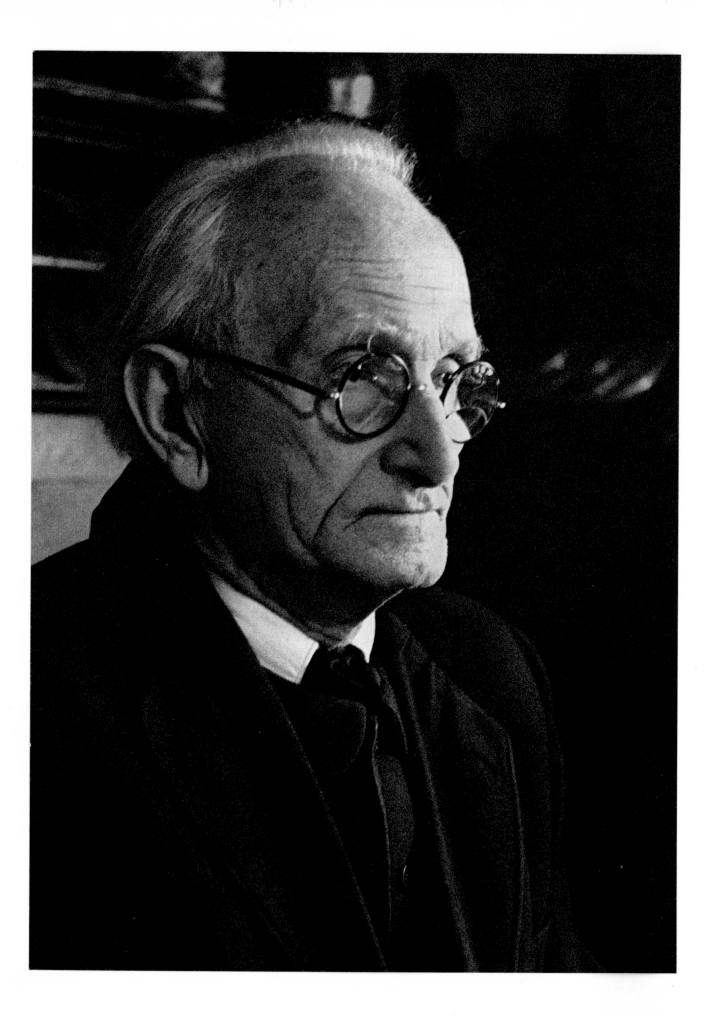

# MEN WITHOUT MASKS

## FACES OF GERMANY
### 1910—1938

## August Sander

with an introduction by
Gunther Sander

and foreword by
Golo Mann

New York Graphic Society Ltd.
Greenwich, Connecticut

Translated from the German by Maureen Oberli-Turner

Original edition published under the title
MENSCHEN OHNE MASKE by Verlag C. J. Bucher, Lucerne and
Frankfurt/M, 1971.
Design Hans Peter Renner

Published in Great Britain under the title
AUGUST SANDER: PHOTOGRAPHER EXTRAORDINARY
by Thames and Hudson Ltd., London, 1973.

Published in the United States of America and Canada by New York
Graphic Society Ltd., Greenwich, Connecticut 06830, 1973.

International Standard Book Number 0-8212-0533-1

Library of Congress Catalog Card Number 73-77664

Printed in Switzerland by C. J. Bucher AG, Lucerne.

# Contents

# Foreword

Like the storyteller, the photographer captures individual qualities best in movement. When someone is trying to be natural, or, better, when he does not even know he is being photographed, then he reveals character. But if he approaches the camera with a certain solemnity, with the intention of showing himself off, then he has become something more than himself: he is revealing a secret self-image. Then there is no movement, no laughter, only deadly seriousness and the desire to be taken seriously by others. Then the type is created; and it is types that the creator of these portraits set out to record. Of course he did not tell his subjects this, otherwise they would not have co-operated; to attain his end he had to flatter personal vanities. And so they showed themselves to him in all their finery, in Sunday best, in full-dress uniform. The gentlemen of the upper classes, who knew no distinction between Sunday and weekday, nevertheless put themselves out to conform to an unaccustomed, elevated, stylized attitude; and the man in overalls stylized himself as well, without knowing it. They are all types. Not the types of a single generation, biologically speaking; they include old and young. But types of a generation of generations, historically speaking; types of an age, the age which as far as Germany is concerned bears the name of 'the Weimar Republic'.

It is a historical period. How much so, can be seen by leafing through this collection of pictures. The fact that many of the people depicted may still be with us – the young teacher preparing for his retirement, those who were children now in their prime – is no refutation of this. A historical period is not necessarily long. The restored Bourbons reigned only fifteen years, the 'bourgeois King' eighteen; and yet 'Restoration' and 'Louis-Philippe' are chapters in history, with perspectives, and forms of expression, entirely their own. Just so Weimar. Even without being very far back in time, a period can be self-contained, definable, utterly alien to the present-day world. All this depends simply on what lies between it and ourselves.

'History', the realization of having experienced whole historical eras, is one of the most surprising aspects of growing older. The present writer has seen officers just like the captain pictured in these pages proudly showing oft his uniform and decorations in the winter woods, a soldier of the 'Great War'. At the time he seemed modern enough; now he is part of history. His whole attitude and image are closer to the officers of 1870 than to the Americanized officers of the West

German Army. And there can be no doubt that he felt strange and ill at ease in the Weimar Republic.

It was an era in which men and women preserved fine, intact traditions in their hearts, but these traditions found no fulfilment in public life. Widely diverging ideas of right and wrong existed side by side. There were still classes, ranks and types. The devout wholesaler with the Kaiser Friedrich beard; the notary peering through his pince-nez at a world which he felt should be governed – as it still was to a certain extent – by the legal profession; the farmer and his wife; they all had their established ideas and were content with their lot. But there no longer existed an established hierarchy to buttress their aspirations. Public life abounded in strife, contradictions, menace, noise and emptiness; the stubborn retention of the old way of life co-existed with feverish experimentation. The past and the future battled over the present.

Who is the industrial magnate, sitting in his Empire chair with such dignity and composure? I do not know, and I do not wish to know, but judging from the prototype he represents, he could be Dr Cuno, the Director of HAPAG and former Chancellor of Germany, of whom Walter Rathenau once remarked: 'This cigar will have to be smoked one day for the elegance of its outer leaf.' There is nothing outdated about this gentleman. He is no class-warrior, no diehard autocrat, but a man prepared to negotiate reasonably with trade-union leaders through his representatives; nor is he a blinkered nationalist; he feels at home in England and knows the United States tolerably well. He has an air of authority, and is conscious that he owes it to himself to maintain a certain dignity. Is he even, perhaps, a collector of modern art? Does his wife preside over a salon? He saw right through the Kaiser, and the pitiful rulers of the Republic do not impress him; he is on tolerably good terms with them all the same, and probably plays a part in the power game behind the scenes. He is a well-adjusted, influential personality – all the more influential now that the monarchy has disappeared.

The Grand Duke pictured here reigns no longer. Were he still in power, he would be obliged to inspect military parades on horseback, open parliament with a speech from the throne, and go to the railway station in a star-spangled uniform to meet crowned cousins, and he would not be able to indulge in the luxury of looking as middle-class, and as morosely smug, as he does here. The new way of life has brought its advantages for His Royal Highness. Without doubt, he is still the most respected citizen of his small capital, and he patronizes the arts and sciences as best he can within the somewhat modest limits laid down by his financial advisers. Now and then he travels to Berlin, Munich or Paris to amuse himself unrecognized. He yields to democracy without believing in it. He has had opportunity enough to observe his fellow men, and he has no illusions left; nor does he believe in the future of his class. His features reflect experience, scepticism, satiation, and an inborn assurance which has never needed to assert or prove itself. Is not the industrial magnate incomparably more elegant in appearance? And is not the notary, standing on the steps of his villa with his dog and walking-stick, incomparably more imposing?

There is a short story by Thomas Mann which begins with the sentence: 'Emmi Blasius could not marry her only beloved, because Assessor Lieban did not have enough.' Emmi's family could easily have been the wine-merchant's family posed beneath the opulently framed oil-painting.

The wine-merchant and his wife evidently still see their ideal in the persons of the Kaiser and his consort, and take pains to emulate them – as far as the corpulence of the wine-merchant permits. Emmi herself is dutiful, domesticated, gentle and romantic, a bit downtrodden. If she had a brother, he might well be the Korps student we see here, his face marked by duelling scars. Or he might be the other student, dressed in the uniform of the new Nazi Party. There's nothing downtrodden about him. Since he committed himself to politics, his studies have been no more than a pretext; his official responsibilities take up all his time; he must lead, recruit new members, plot and scheme, stir up the people, and pester the university authorities who dare not take a firm stand against him. He is earnest, handsome and capable; he has taken trouble with the arrangement of his ash-blond locks, and the party medals and sword-belt produce the desired effect. With his hands he imitates the attitude of his Führer. This good-looking, fervent boy can be certain of success when the Party has achieved its victory – even without exams – and there is no fear that he will be bound by outdated scruples. His father is too bourgeois for his liking; there is no looking back. In order to climb and to remain on top, money and education are no longer enough; one must swim with the tide.

By way of contrast, let us turn to the politician, the member of parliament. He is the incarnation of the Weimar Republic. In the Empire he was described as 'progressive' and 'enlightened'; now he is a member of the Democratic Party (in steady decline since 1919). His father passed on memories of 1848 to his son, he himself started out in the 1890s, and it is from this period that his ideals – not to mention his collar and tie, umbrella and overcoat – originate. In the meantime, he feels, we have achieved what our fathers strove for. So why are people still so restless? Recently, at one of his election meetings, the youth with the ash-blond hair insulted and derided him. His reply was good enough in its way, but totally ineffective. The meeting ended in a free fight from which the politician and his followers, mostly older people, ingloriously fled. At the next election he is sure to lose the seat he has held since 1907.

It could be said there is nothing new in this situation, but in fact the proportions and the perspectives have changed. In the 1970s, for example, nobody in Germany is interested in the past. No one sets out to state his point of view with dignity. Generals deport themselves like American-style businessmen – which is what they are all too likely to become when they retire. The proletarian has become a factory employee, the prosperous peasant a mere farmer; in a meeting between industrialists and trade-union leaders, it is hard to distinguish between the two groups. Even the most conservative of politicians endeavours at least to appear contemporary, and may even go so far as to make discreet concessions to the future by sporting a fashionable haircut, sidewhiskers and a polo-neck sweater. The future, in the person of its self-appointed representatives, is in conflict with the present, which is more inclined to give in than to resist. And the day before yesterday has already vanished.

A famous professor in the Weimar period described the age as 'a stagnant swamp filled with the croaking of radical frogs'. There was some truth in this. People lived in a fool's paradise such as was never known before or since (and a mighty fool it was who finally conquered the whole). Fantastic ideas about the future were in the air; the past was regarded variously as glorious or

inglorious, the present merely as provisional. And each individual's ideal, and his image of the future, corresponded to his image of himself. Sander's three revolutionary conspirators, sitting on a doorstep, could not be more perfectly expressive of what they are if they had been directed by a theatrical genius. These are no nineteenth-century revolutionaries; they had stronger faces. Nor are they from 1959; there are no revolutions any more, only military coups. No: they are the supporters of the dream revolution, that European revolution of 1919 which lost out everywhere (except in Russia, where things were very different). And when we look at its adherents, we can understand why they achieved nothing. These men might well have played at founding a 'Soviet Republic' in Munich in 1919, and come to grief then; or perhaps fate caught up with them in Germany fourteen years later, or in Russia later still. We are tempted to say to them: keep out of all this. How can you believe that you can tear apart the densely woven fabric of a modern society, create a revolution, exert power? They would take no notice; for they all know better. No one can escape his destiny, the destiny which will put an end to the Weimar Republic and much more besides, and which does not distinguish between solid citizens and ne'er-do-wells, between good and bad, or between old and young.

Those who live 'where the heavy oars of the boats sweep the waters', craftsmen, farmers, workmen, must not be left out. Strange: they too were prepared to reveal that which was expected of them: the individual and the type. The unemployed man is a Bert Brecht figure from 1931, and peasant families like these are no longer to be found in Westerwald. They too are part of history. They too, who know nothing of 'epochs' and 'eras', are part of their own era in their inmost being: the twilight era between war and war, full of substance and tension, now scattered by the winds.

This era produced no Balzac and no Stendhal; for this it was not delicately enough organized. Its finest novels were set outside their time: *Andreas*, for example, or Hesse's *Narziss und Goldmund*, Thomas Mann's *Der Zauberberg*, or the *Geschichte Jakobs*. Alfred Döblin's *Berlin Alexanderplatz* is the one great exception. Weimar society's only major reflection in art lies in photography; and we can only shake our heads in astonished recognition.

GOLO MANN

*People of the Twentieth Century*

# Archetypes

To show the people of the twentieth century – this was a boyhood vision, when the profession of photographer was still no more than a far-off dream.

August Sander grew up in a country village, and it was natural enough that he should be on intimate terms with the local peasants. He was well acquainted with their way of life and was fully aware of their intense relationship with Nature. The practical concept – the so-called *Stamm-Mappe* or home album – resulted from a selection of portraits which formed the basis of what was to follow. These pictures are of persons whom August Sander knew intimately, and he arranged the collection 'according to their essential archetype, with all the characteristics of mankind in general' (August Sander, *Chronik der Stamm-Mappe,* Kuchhausen, June 1954).

The first pictures, taken in the 1890s, were destroyed due to the carelessness and ignorance of strangers. In 1911, in Cologne, August Sander made a new start on the project 'People of the Twentieth Century'. He found his models in Westerwald, and in 1927 sixty of his 'archetype' pictures were exhibited to the public for the first time in Cologne. He planned to include six hundred pictures in the completed work.

Sander's intention is documented by an extract from his own commentary to his portfolio *Fahrendes Volk:* 'It is not my intention either to criticize or to describe these people, but to create a piece of history with my pictures.'                                      *G. S.*

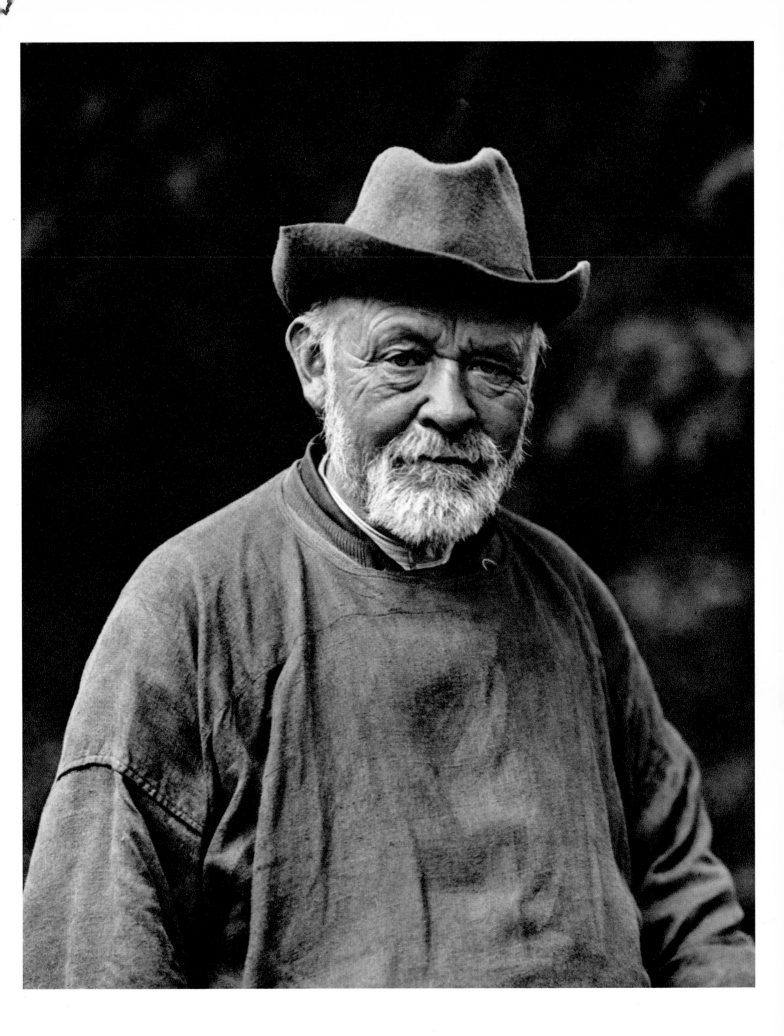

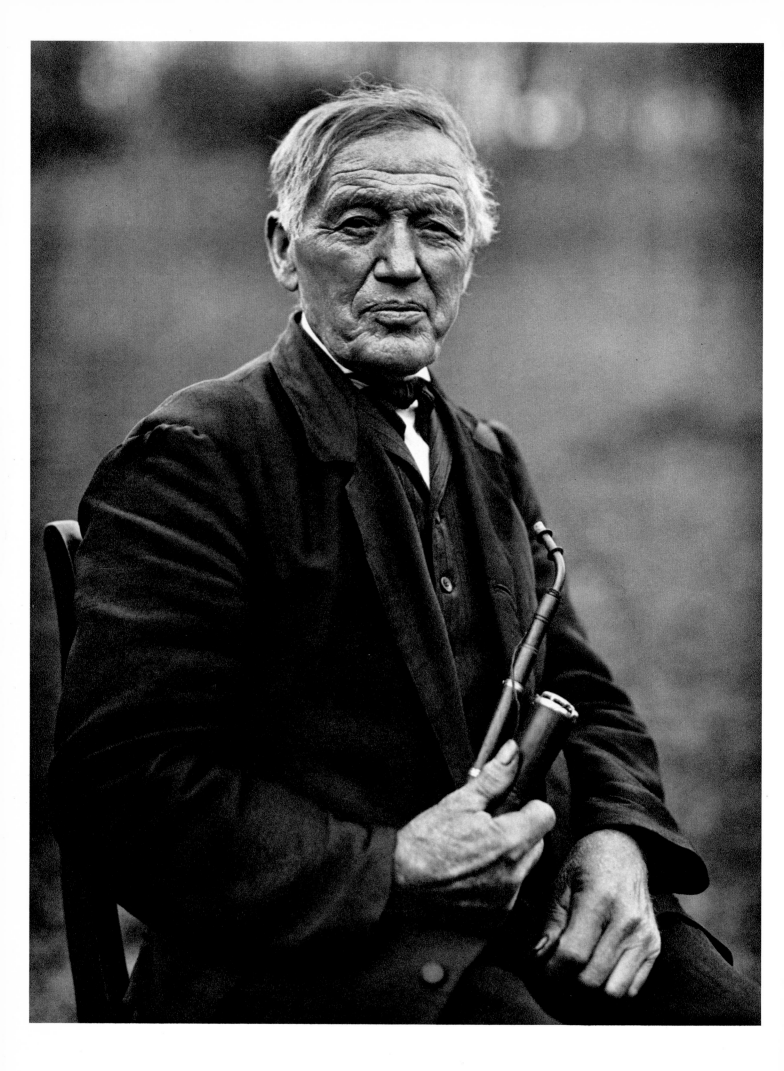

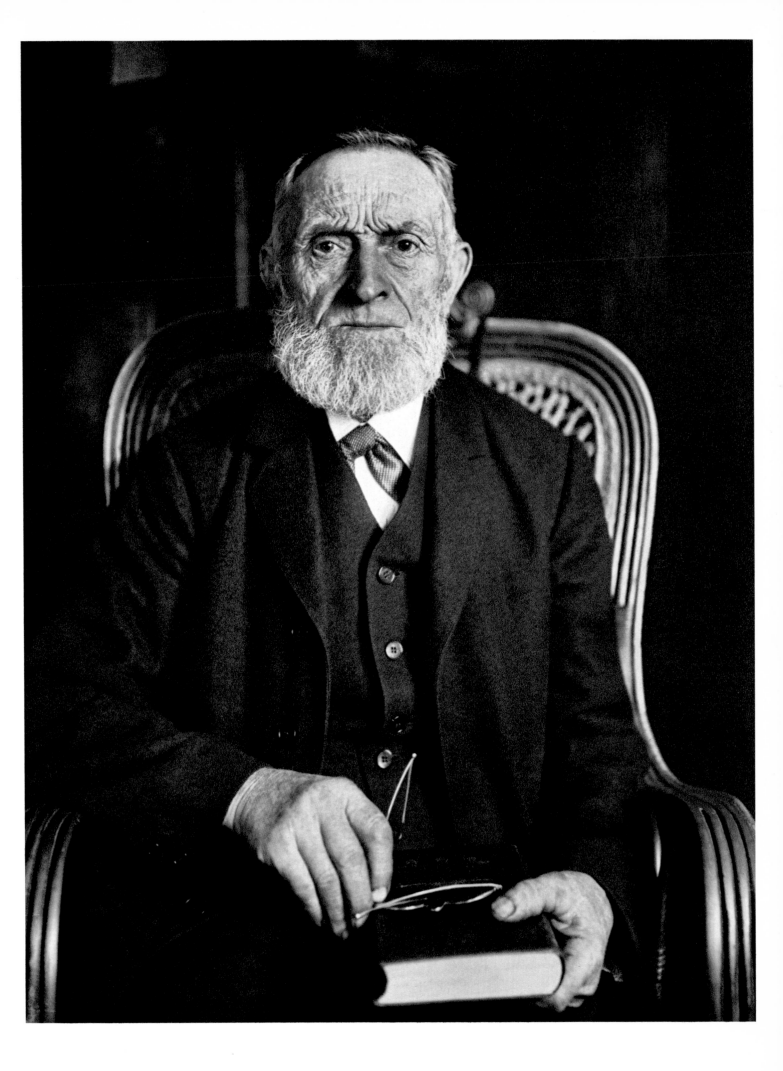

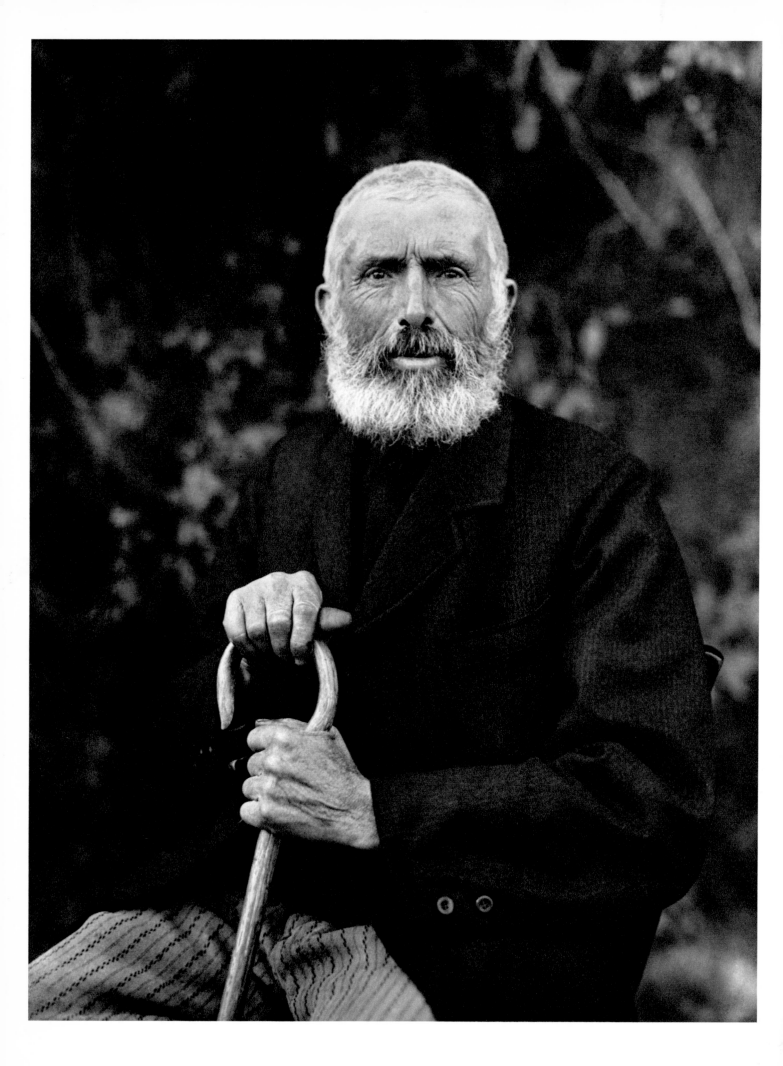

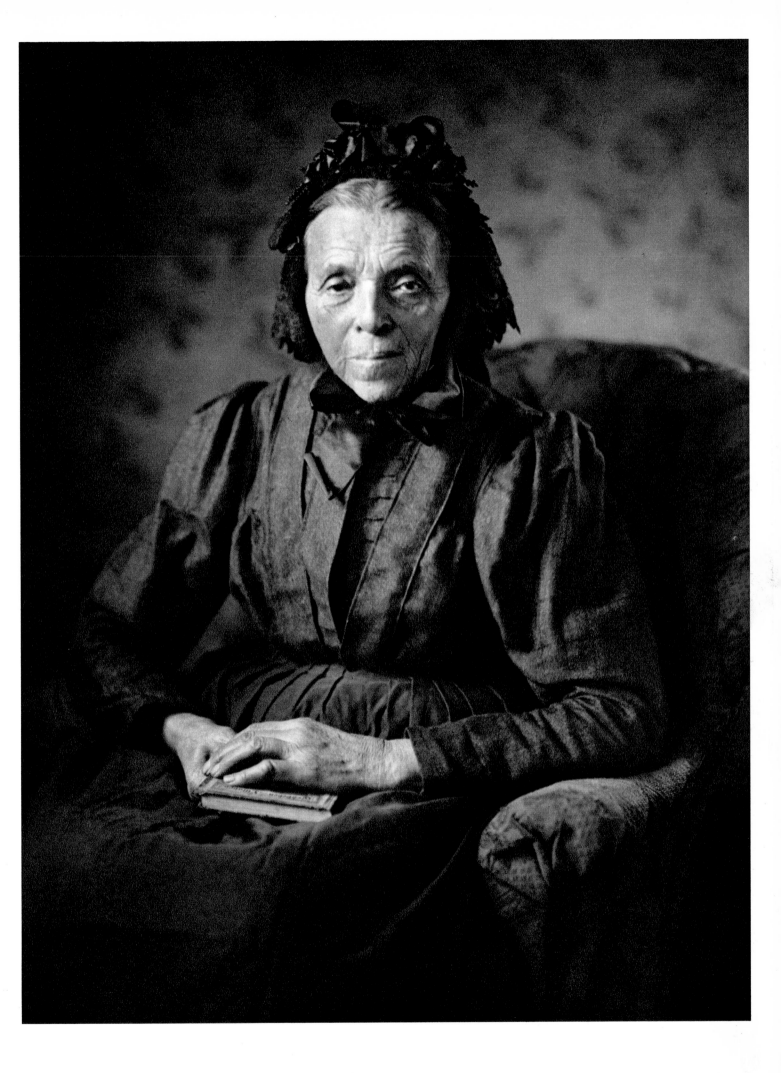

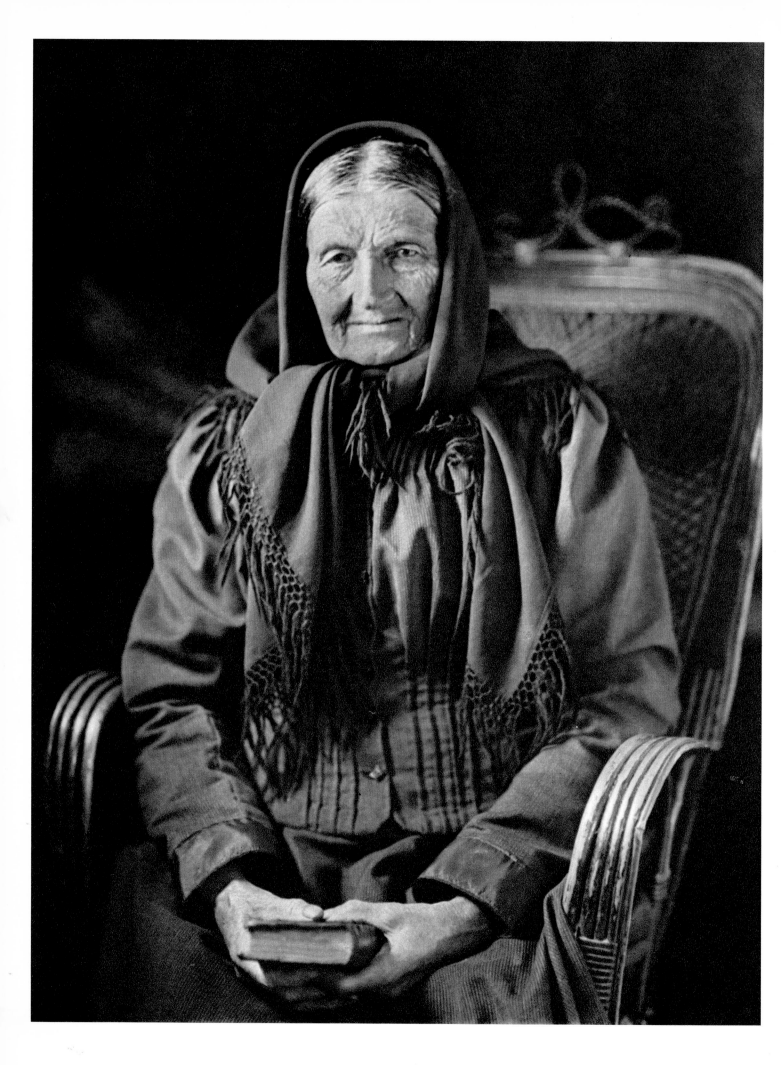

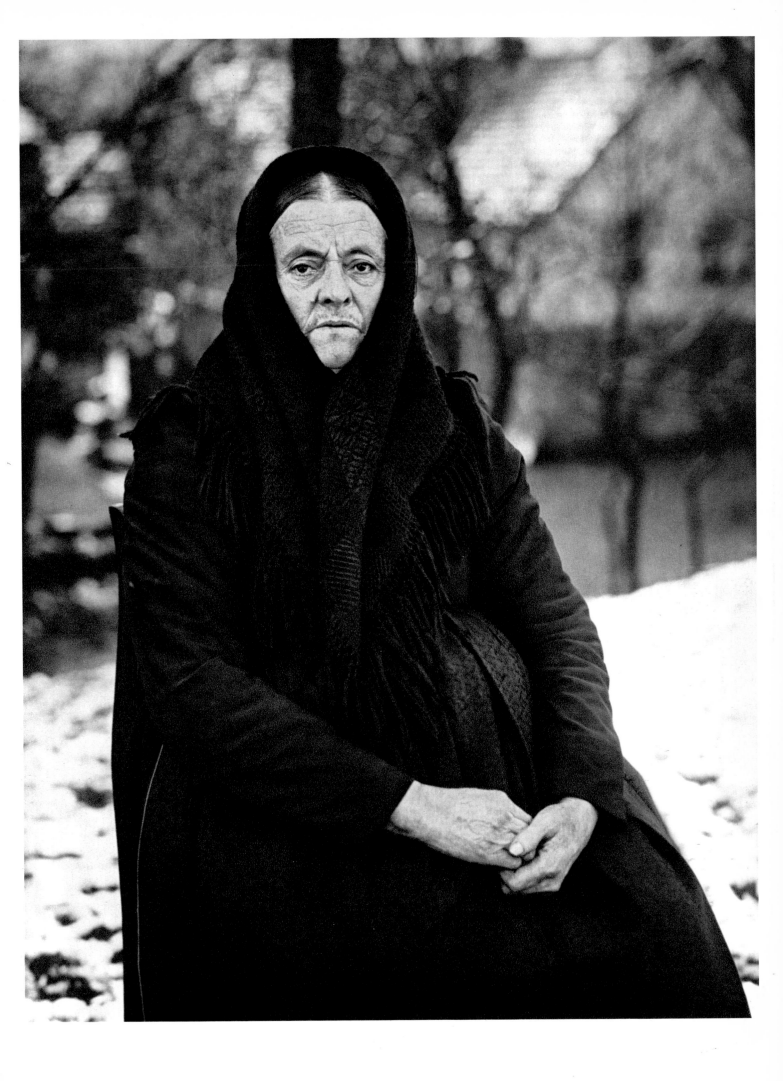

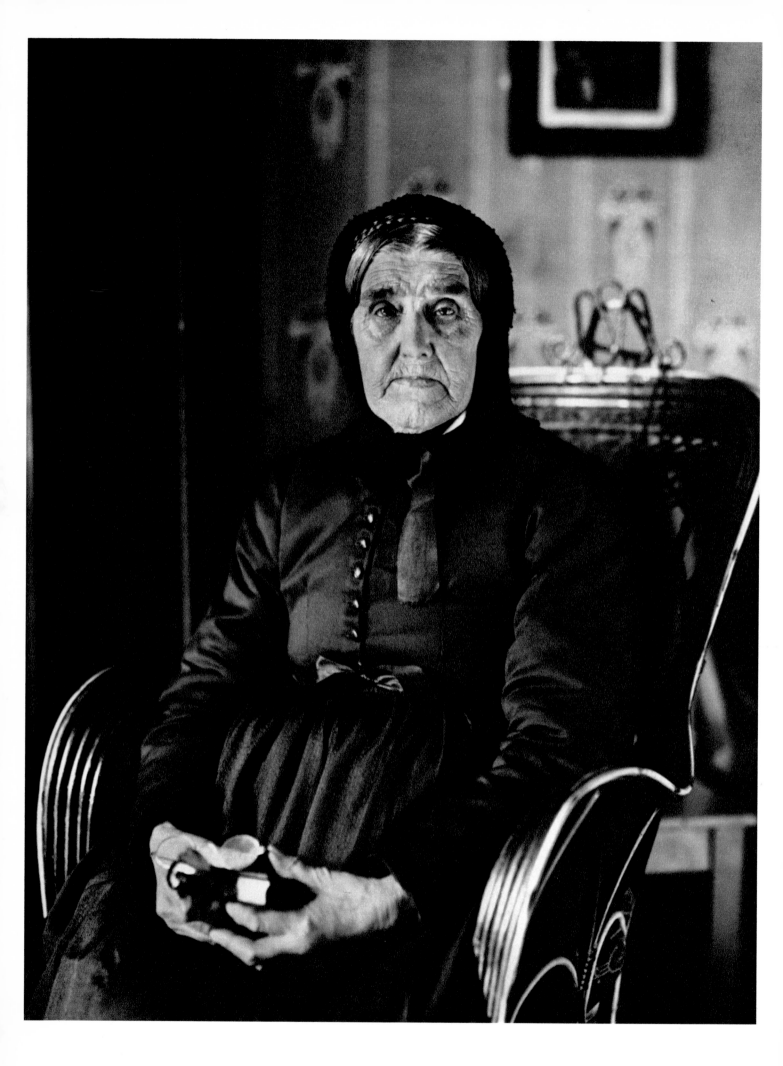

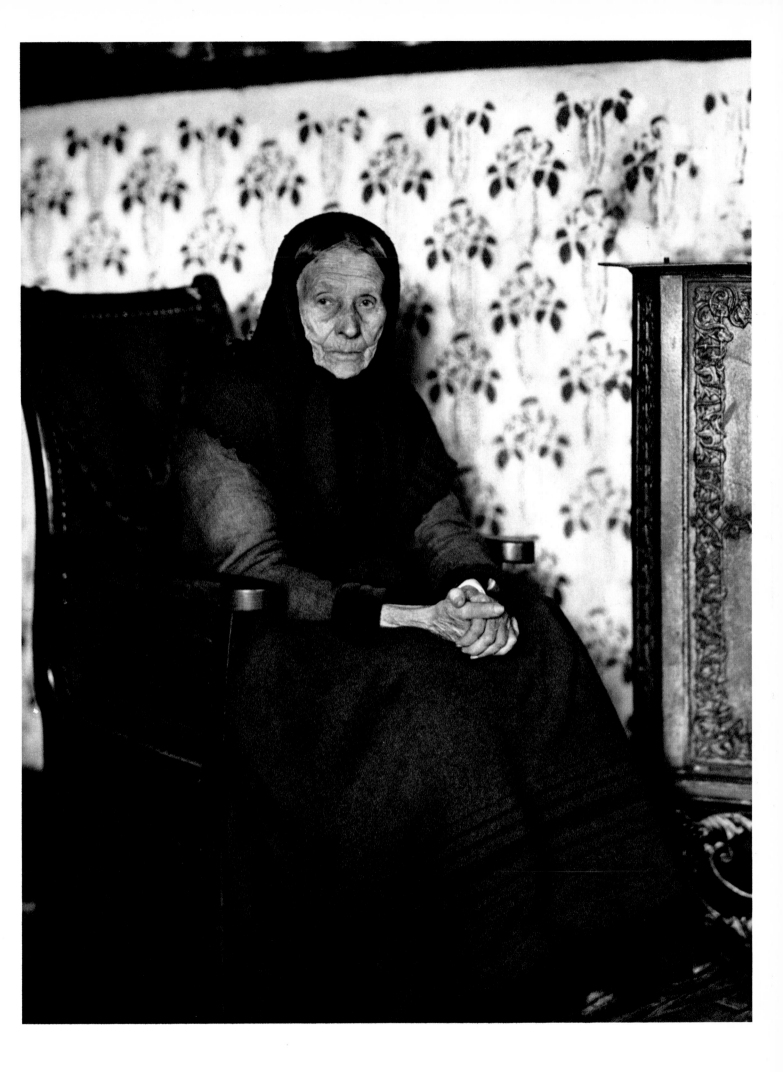

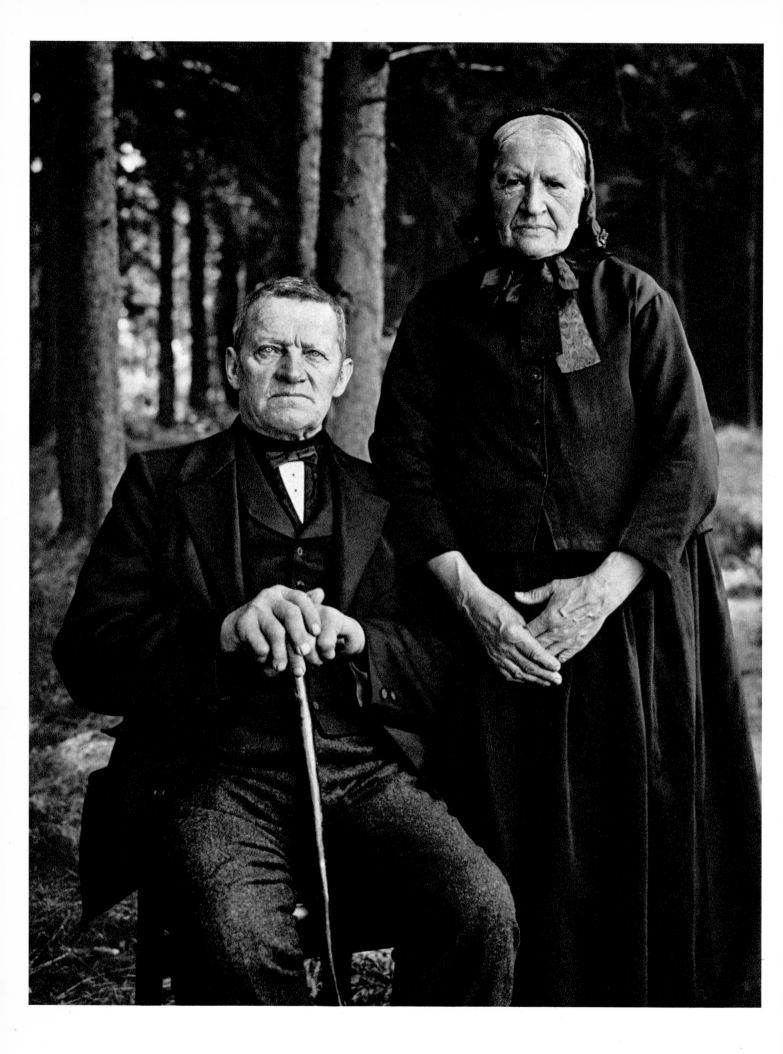

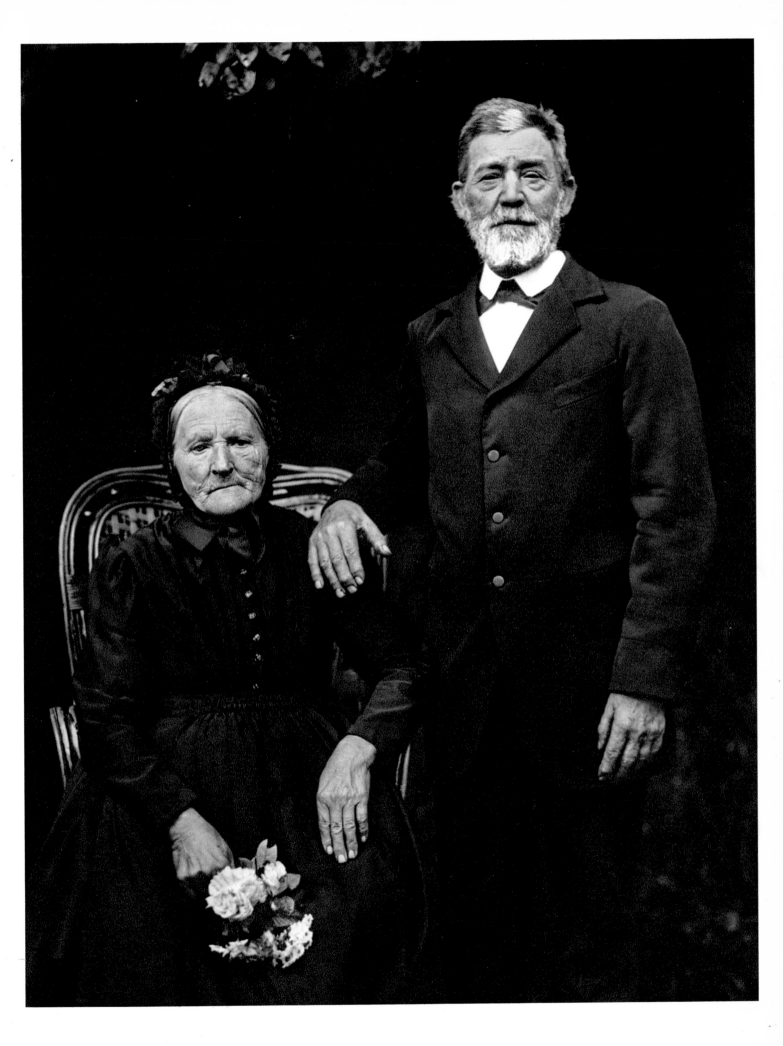

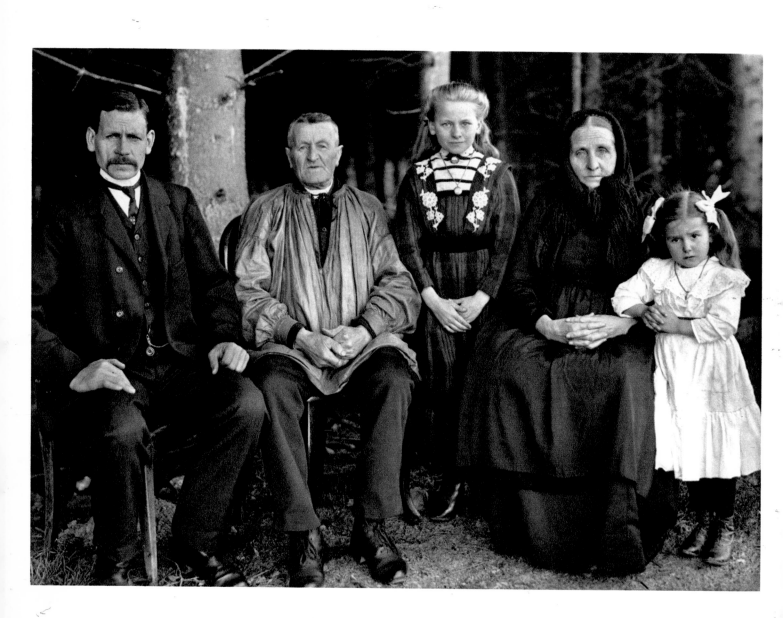

# Country Folk

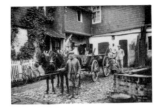

Before the harvest
(Westerwald, 1930)

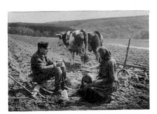

Afternoon break
(Westerwald, 1930)

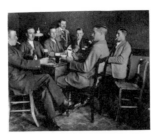

Peasants playing skat
(Westerwald, 1912)

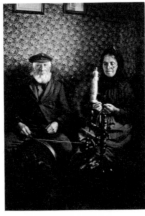

At the spinning wheel
(Westerwald, 1931)

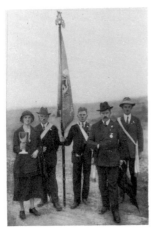

Prize-winning choral club
(Westerwald, 1927)

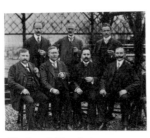

Circle of friends in a
small town (Herdorf, 1911)

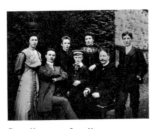

Small town family
(Herdorf, 1911)

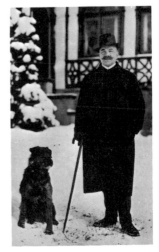

The manufacturer
Weinbrenner
(Herdorf, 1911)

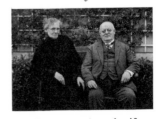

Small town man and wife
(the parents of the writer
Ludwig Mathar;
Monschau, 1928)

Gossip over coffee
(Herdorf, 1913)

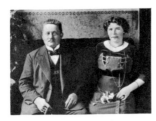

Small town landlord
(Herdorf, 1913)

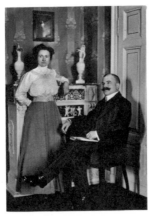

Small town man and wife
(Herdorf, 1913)

Young peasants

Peasant men and women

Peasant children

Peasant families

Everyday life

Peasant festivities

Life in a small town

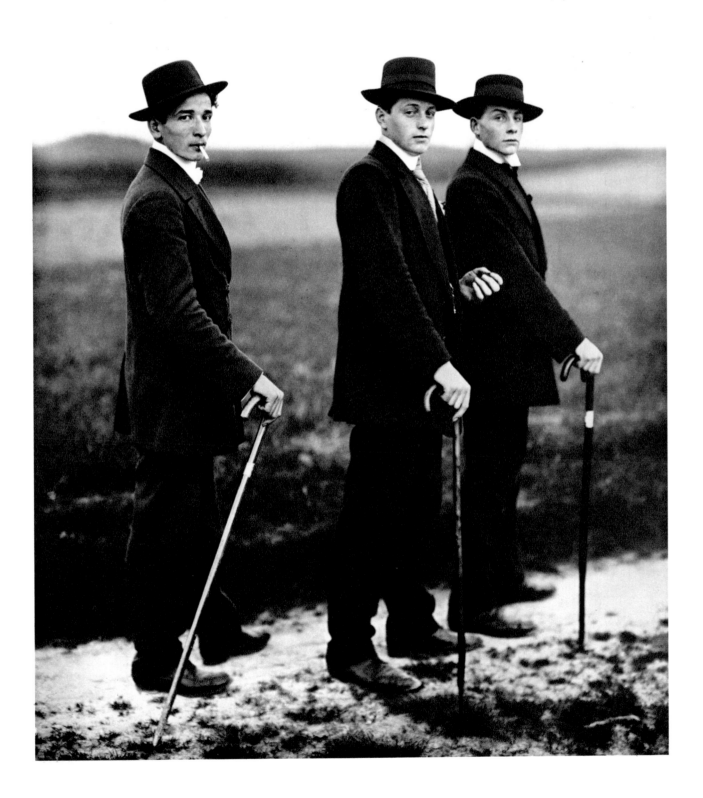

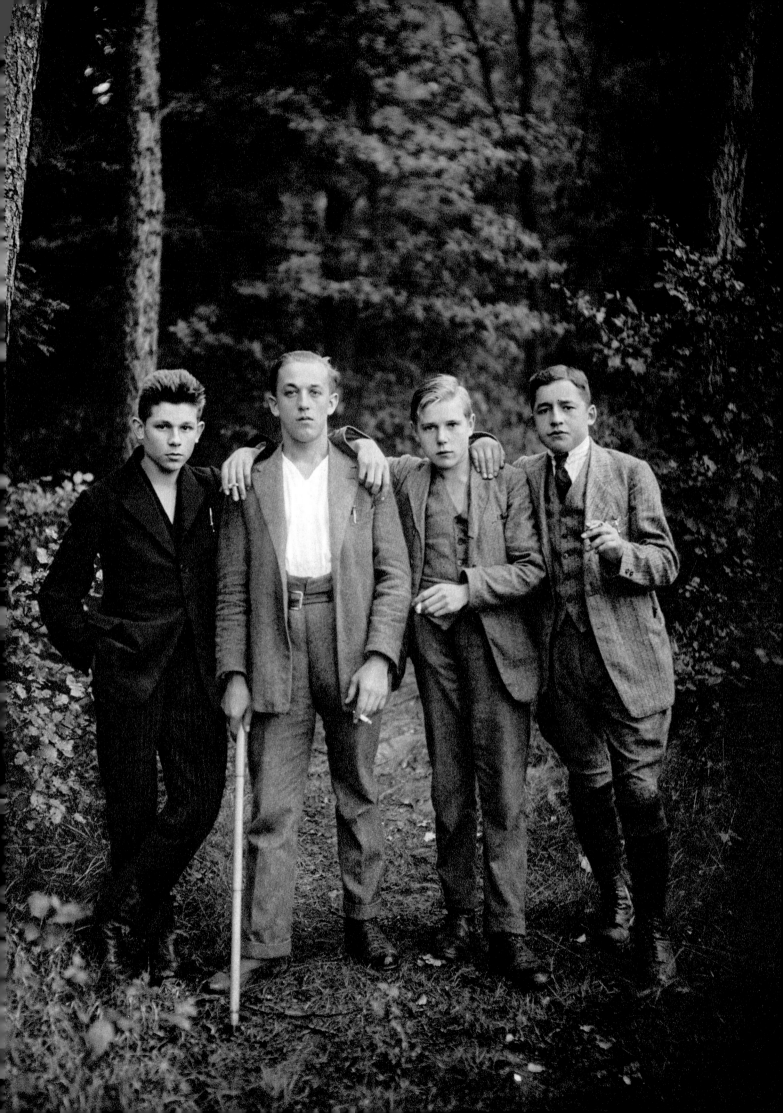

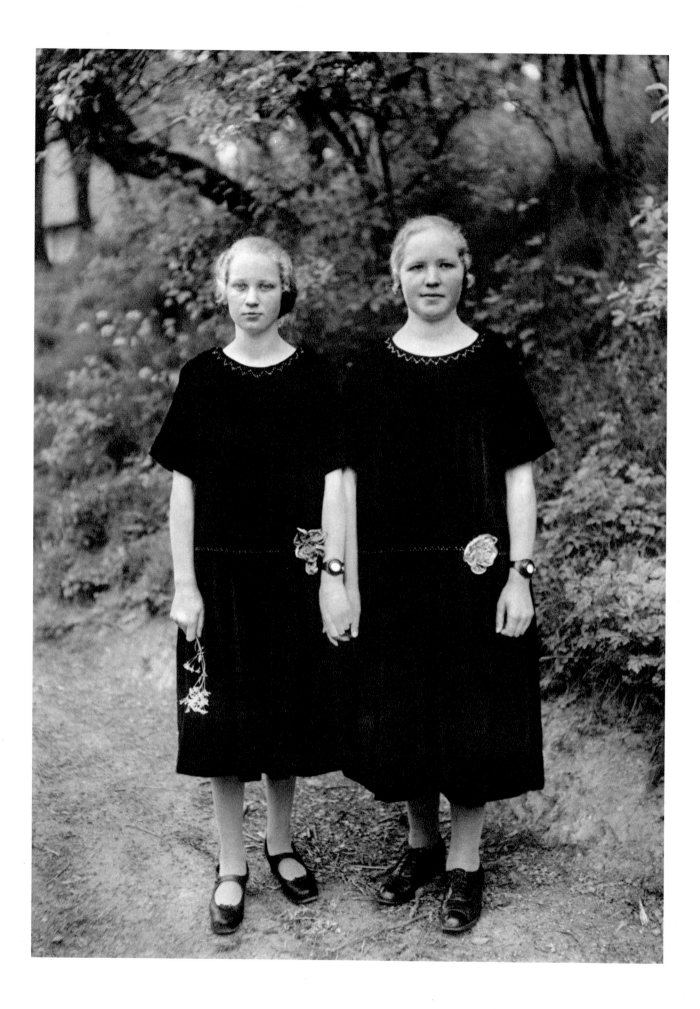

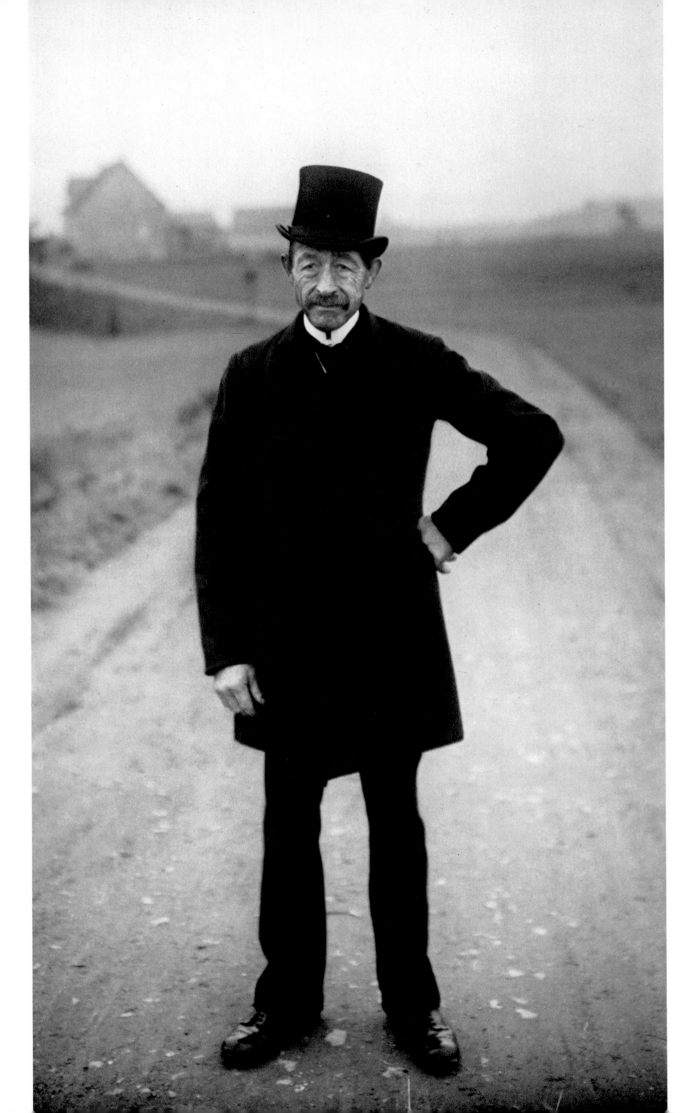

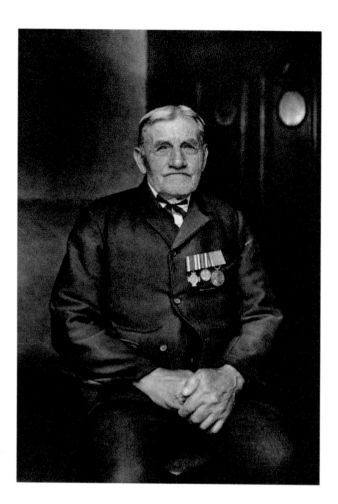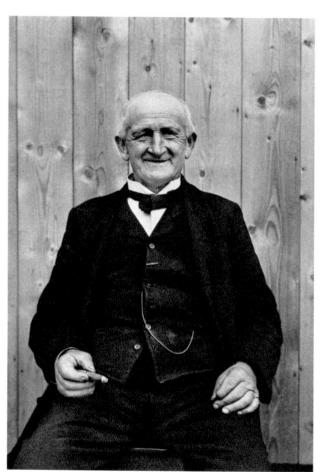

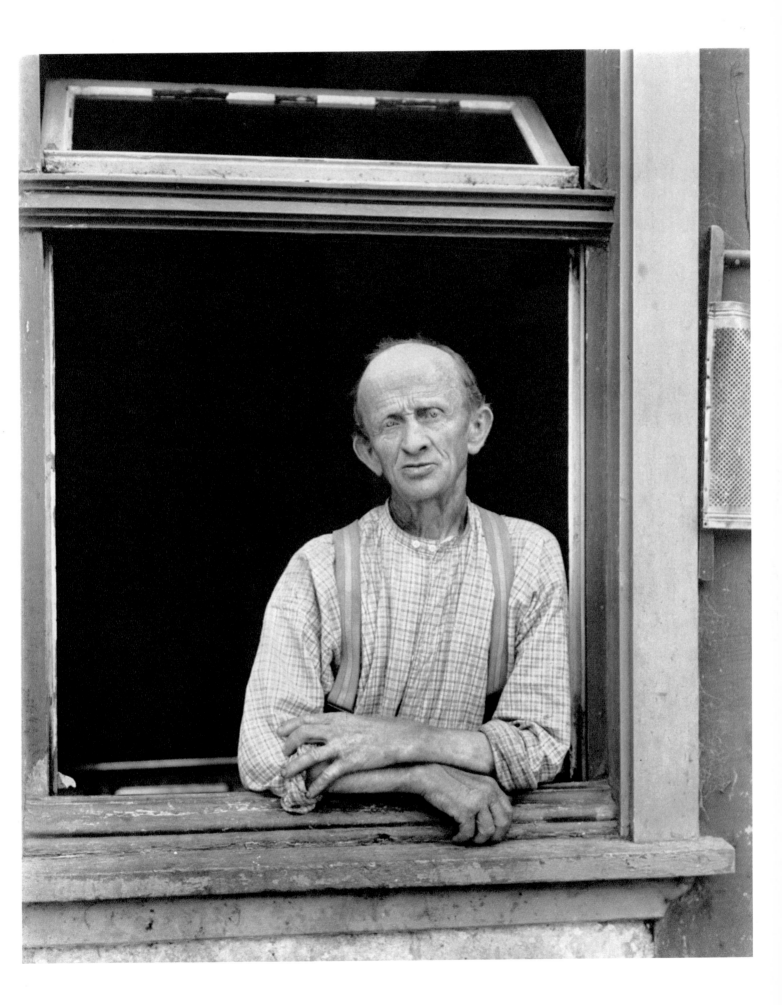

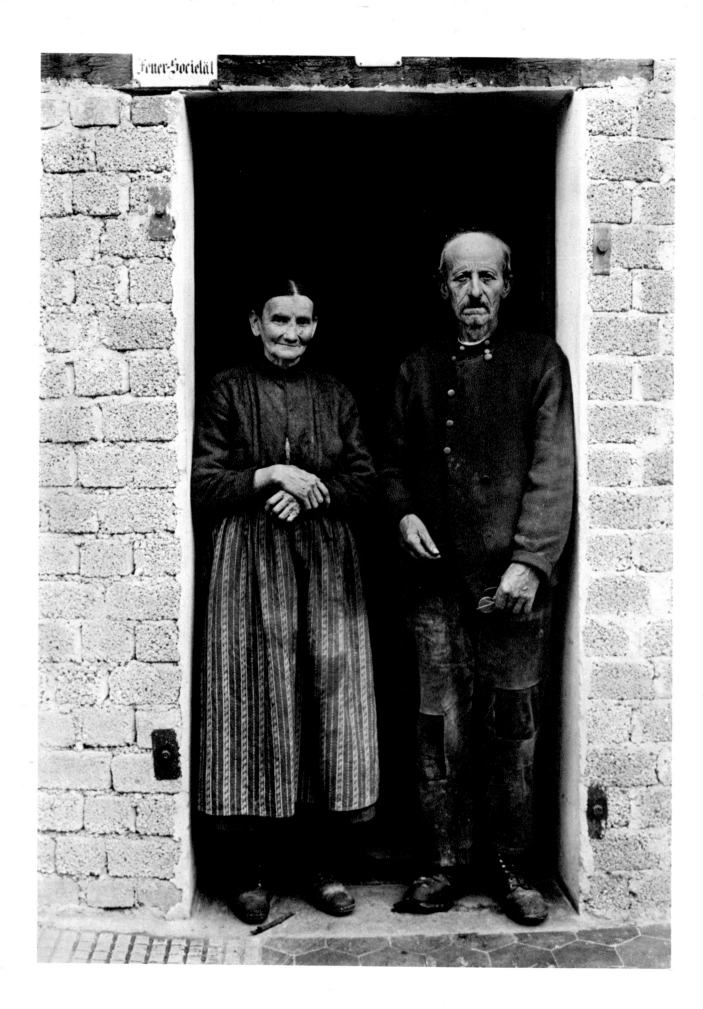

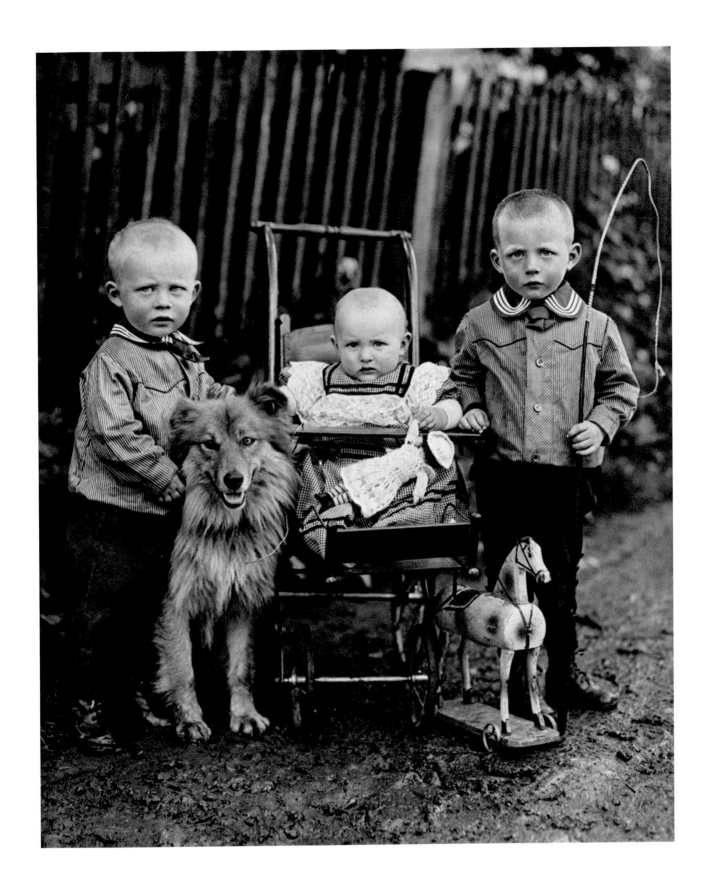

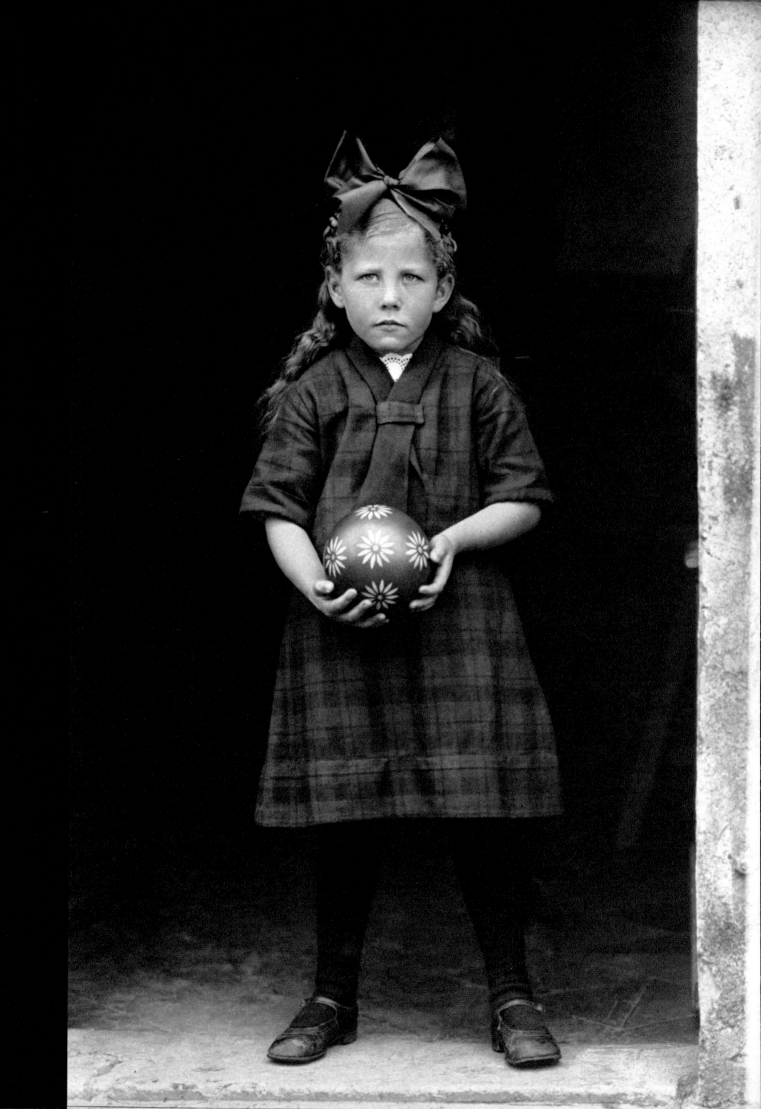

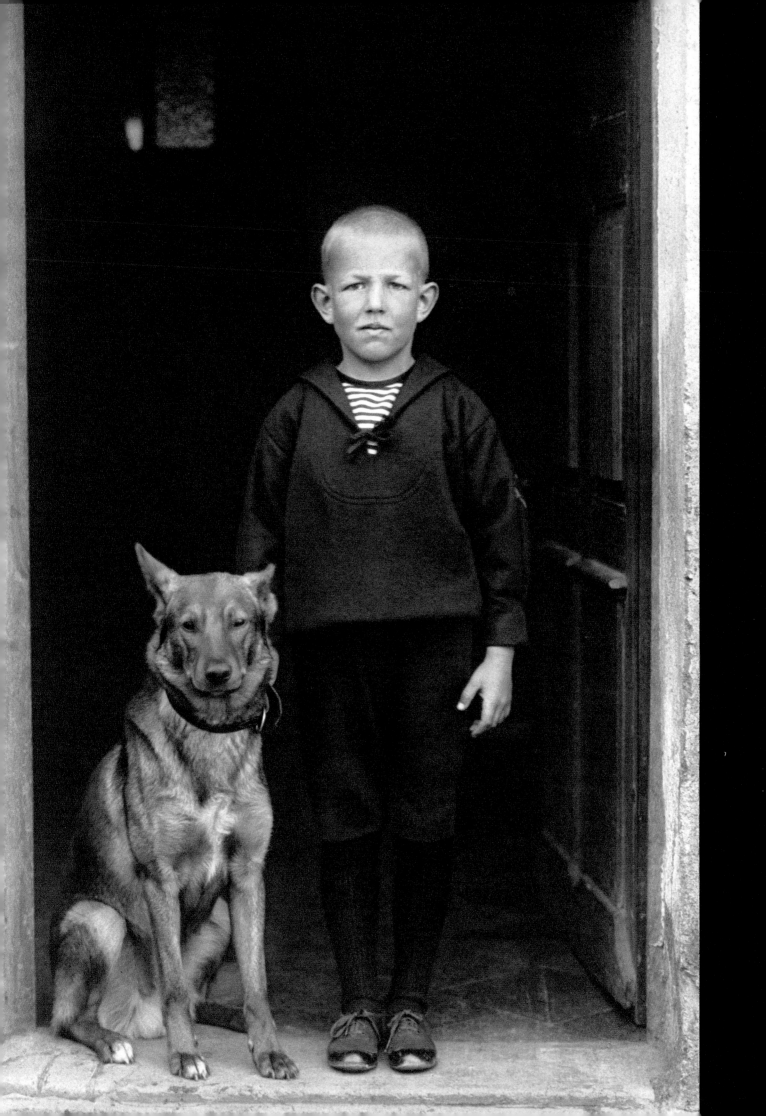

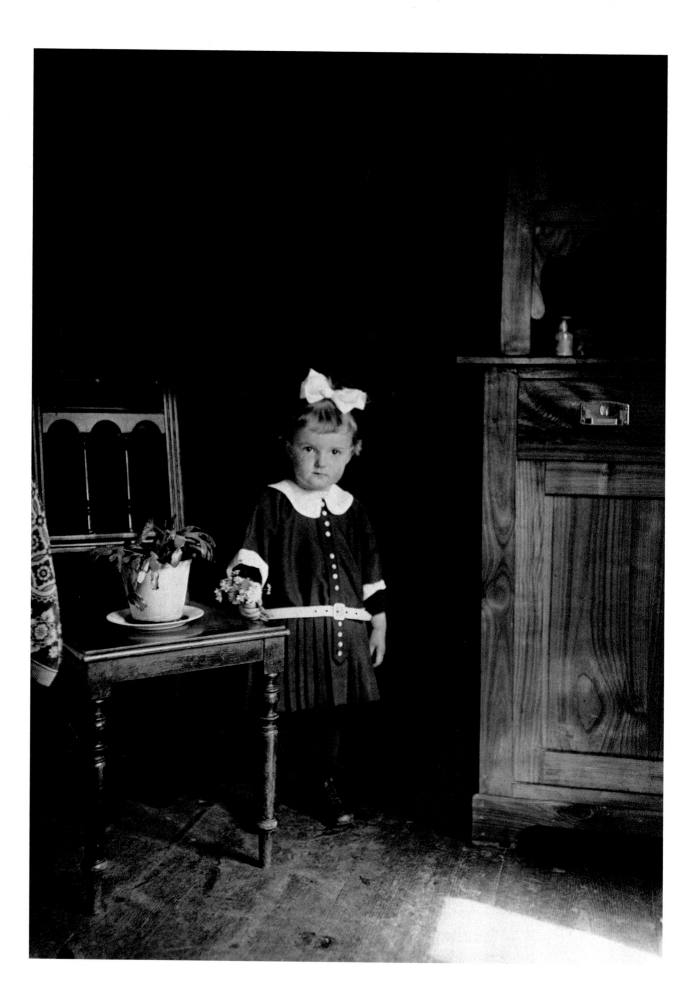

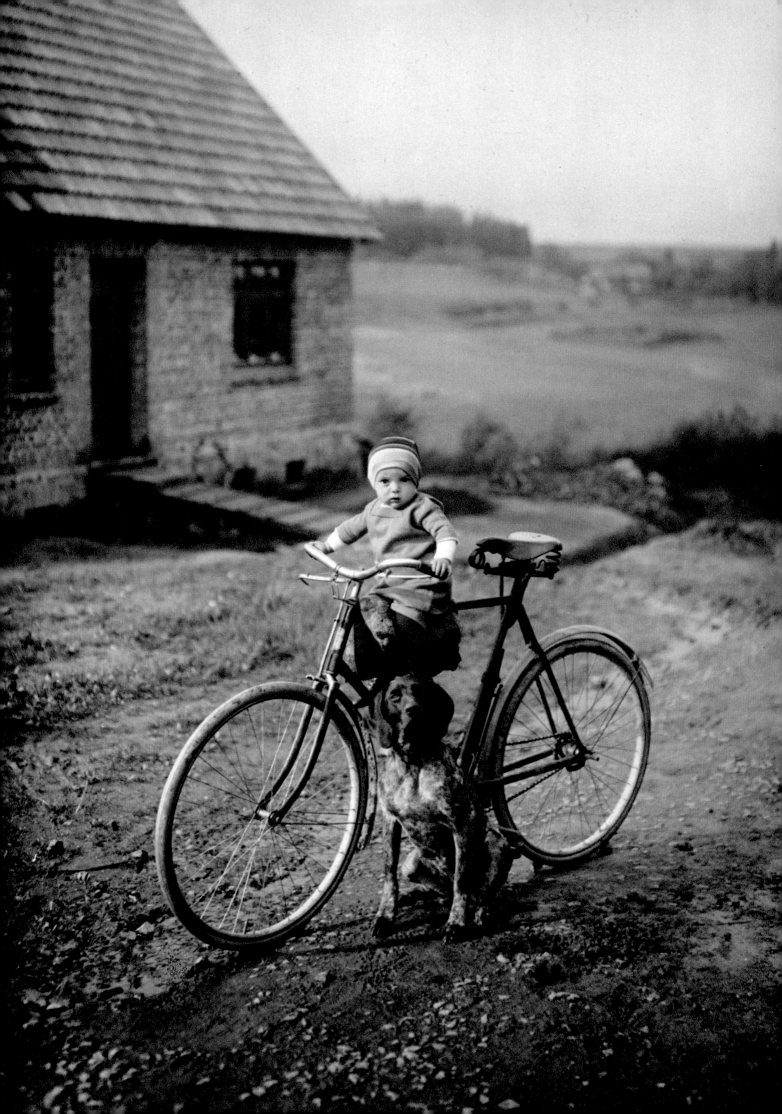

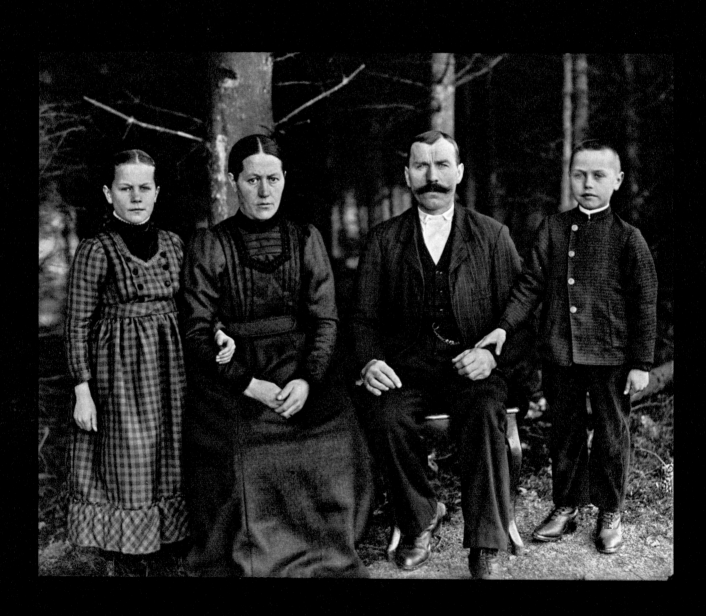

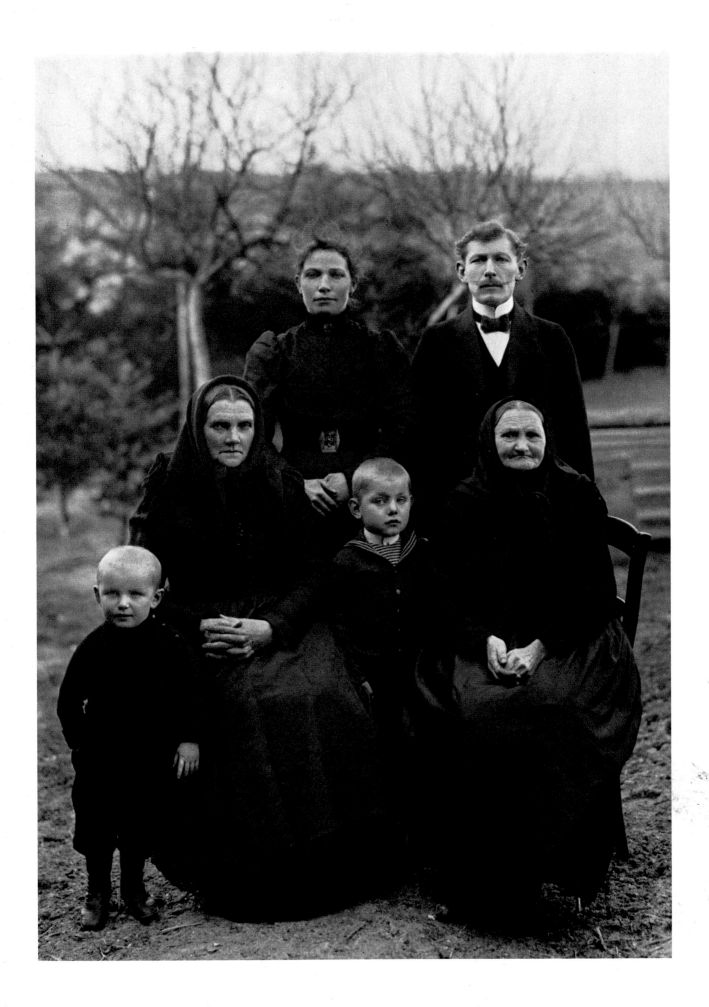

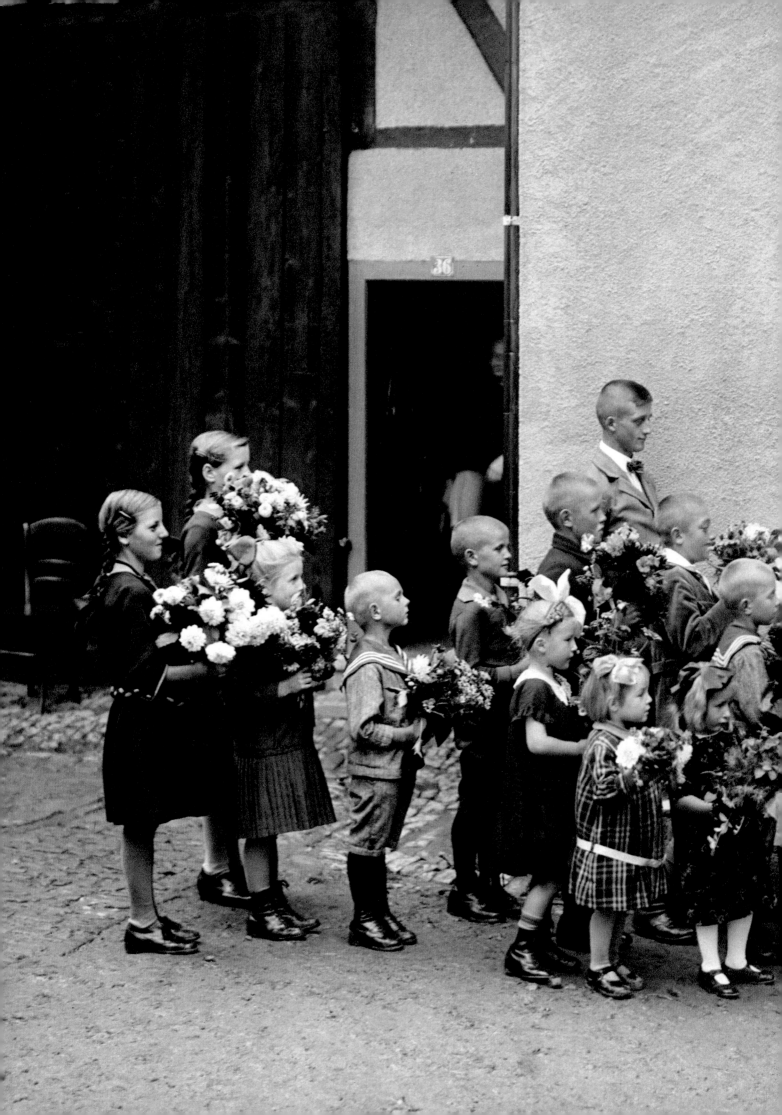

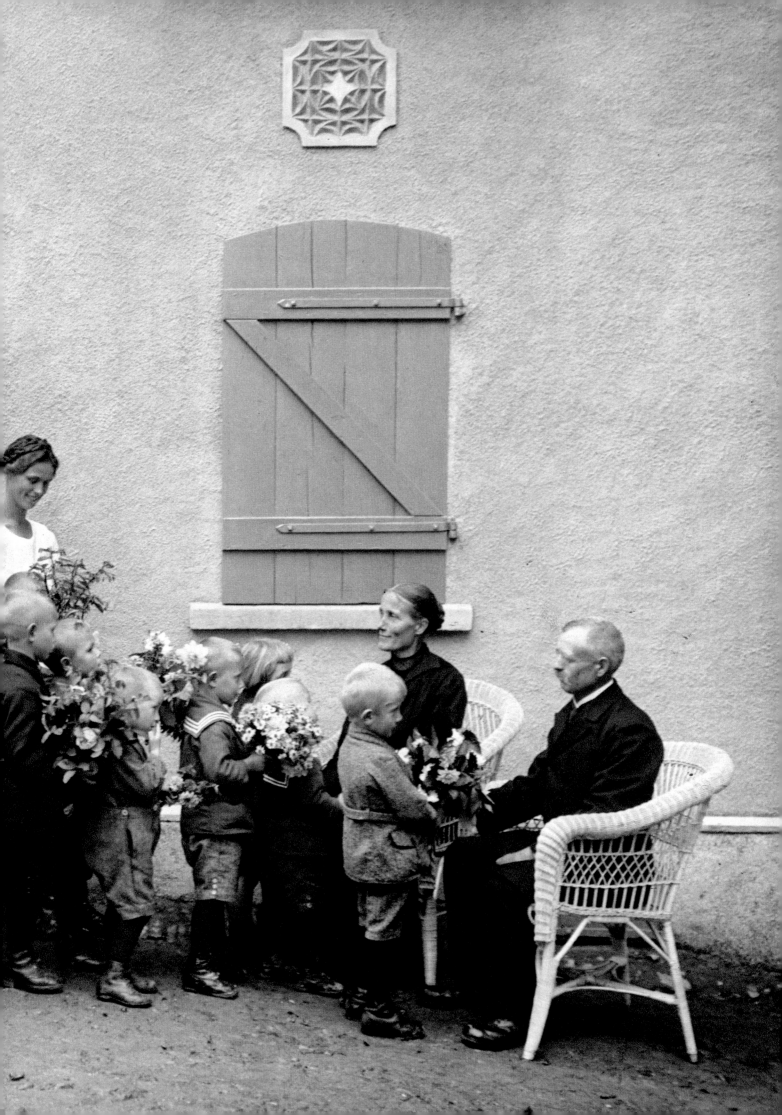

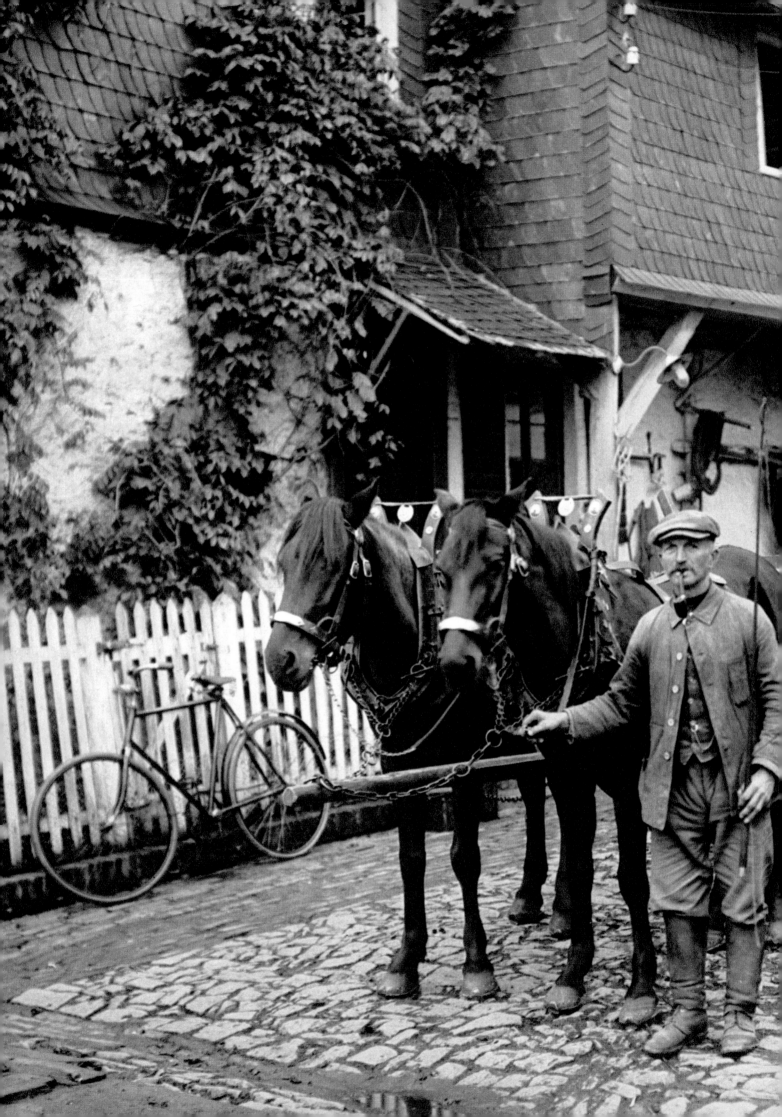

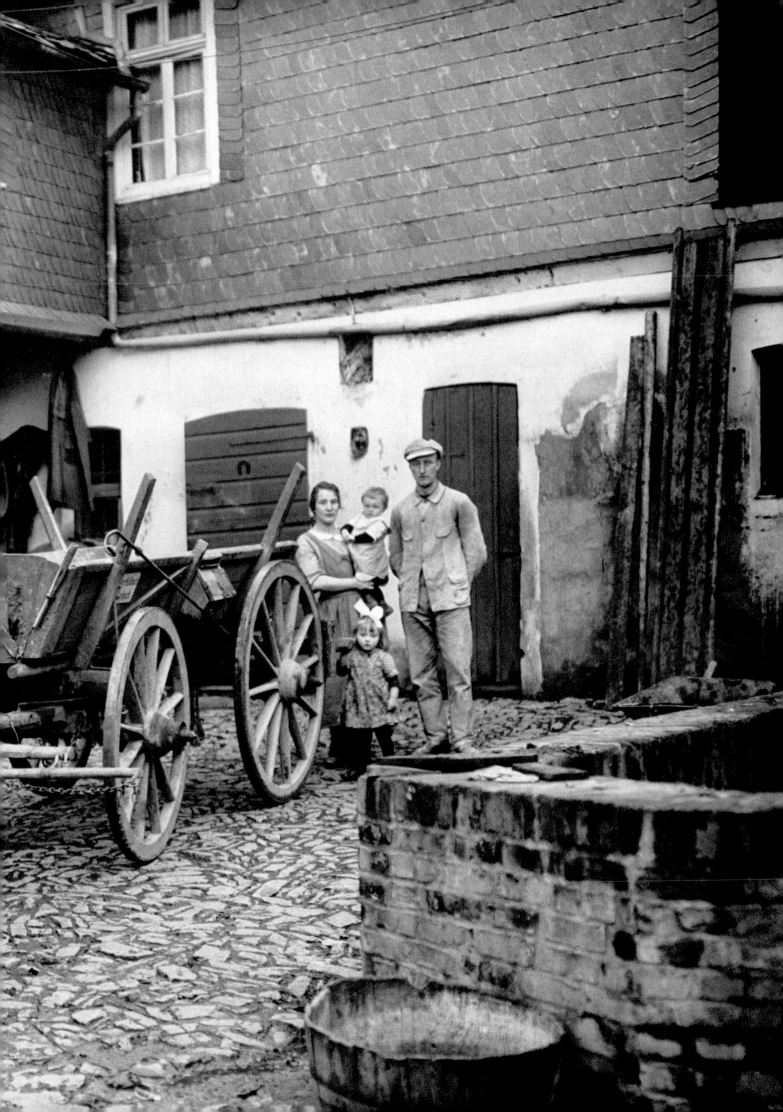

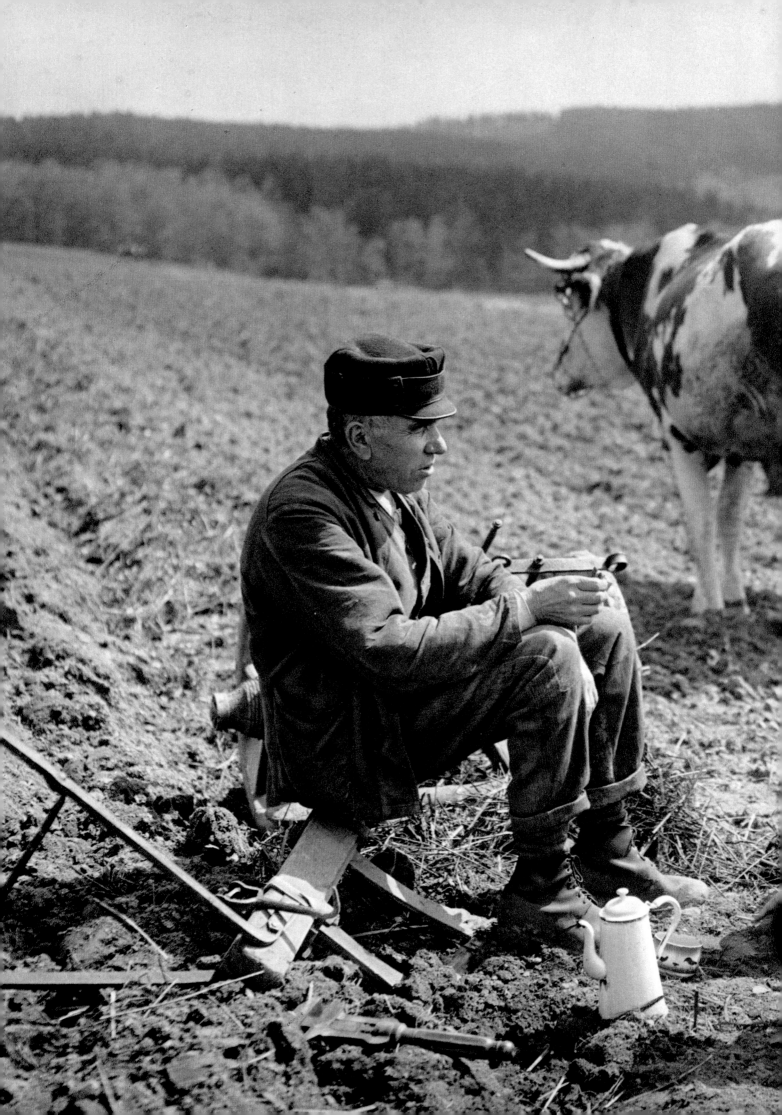

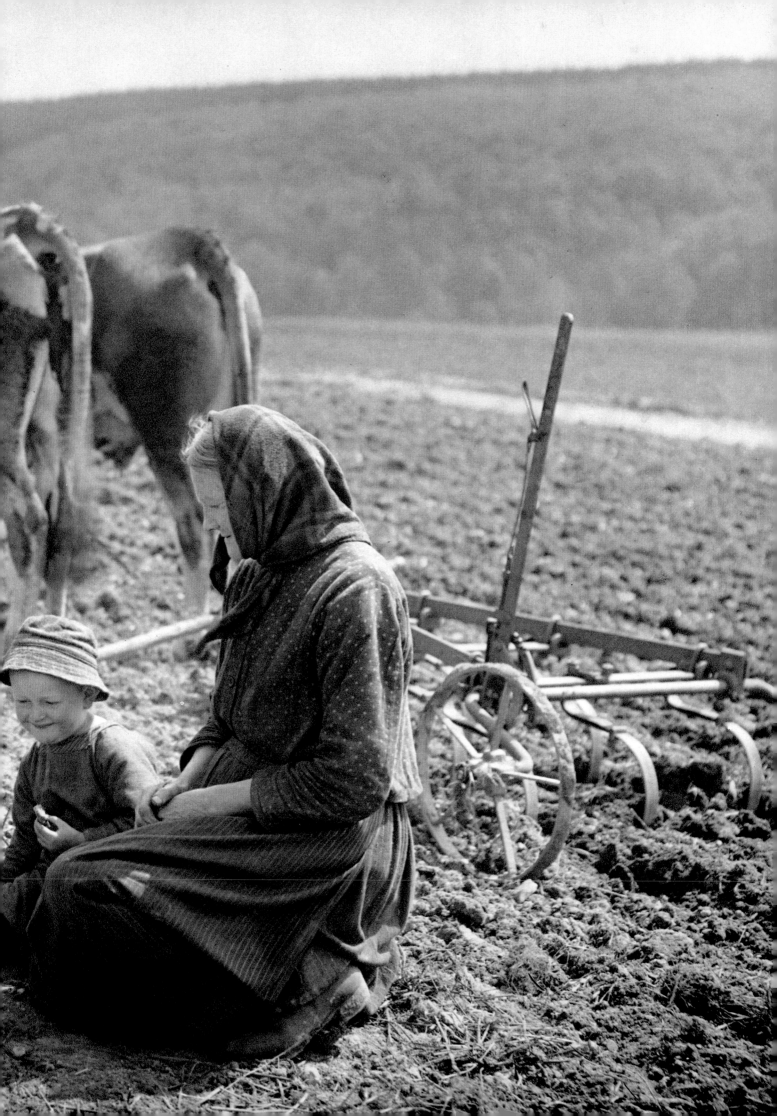

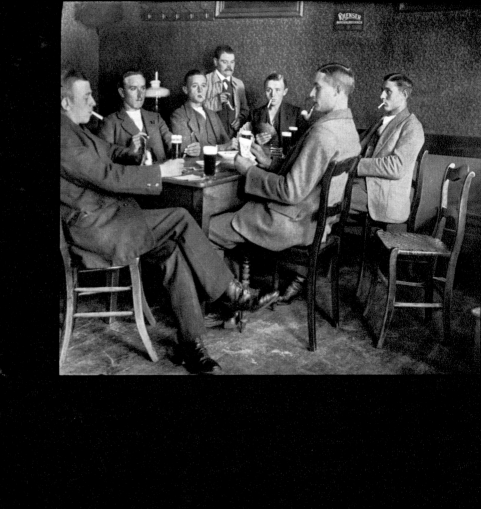

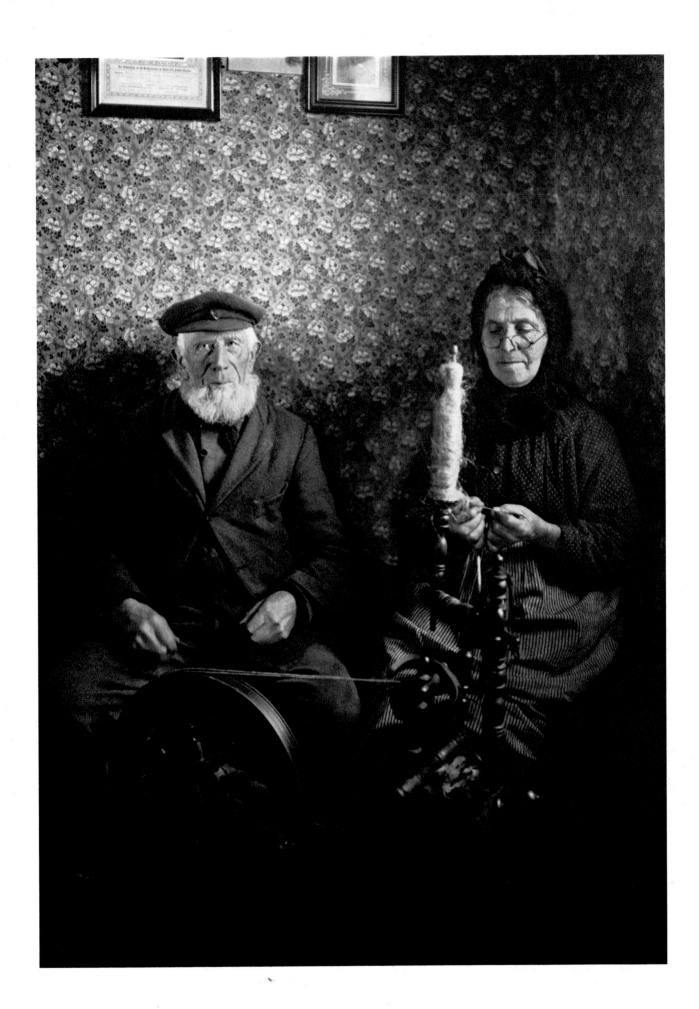

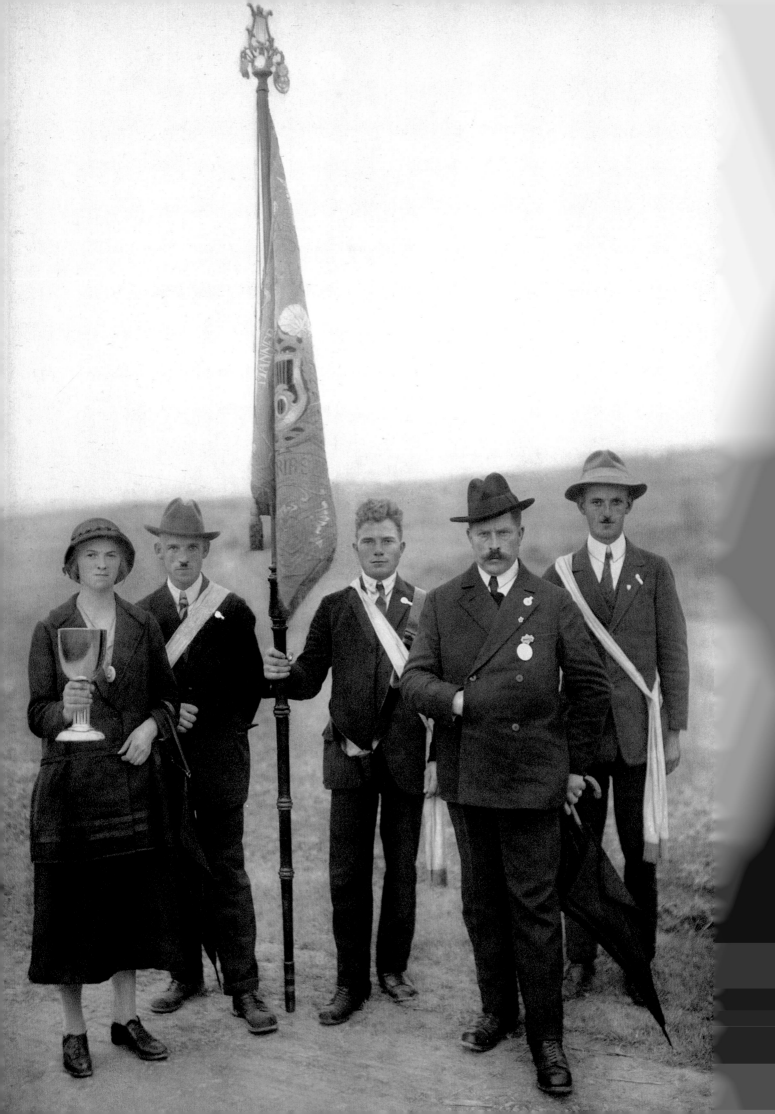

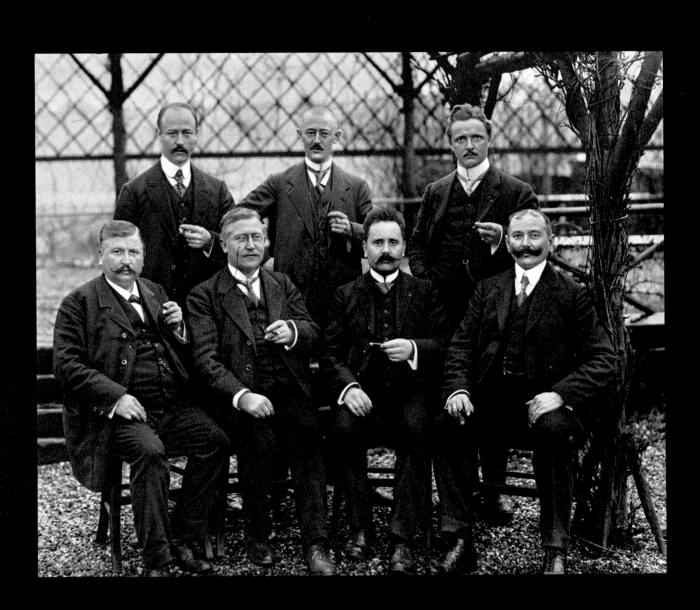

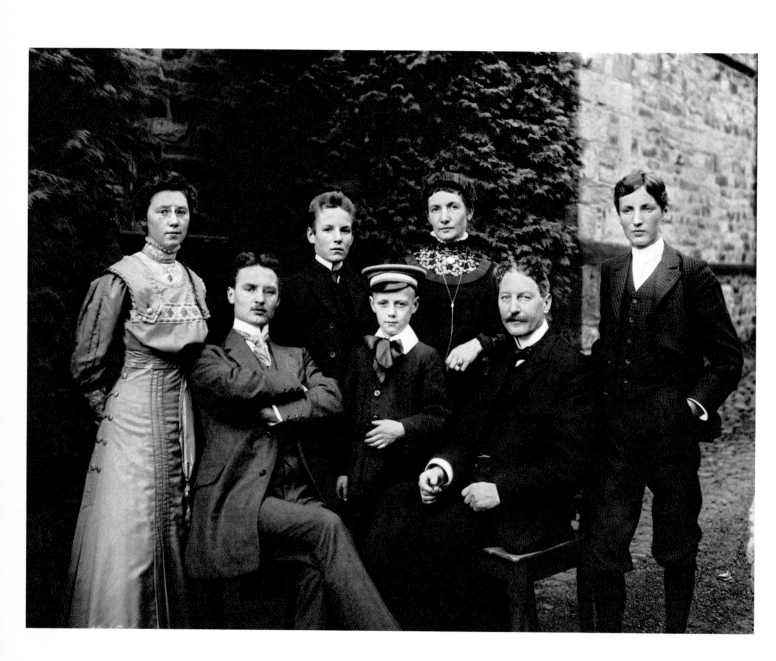

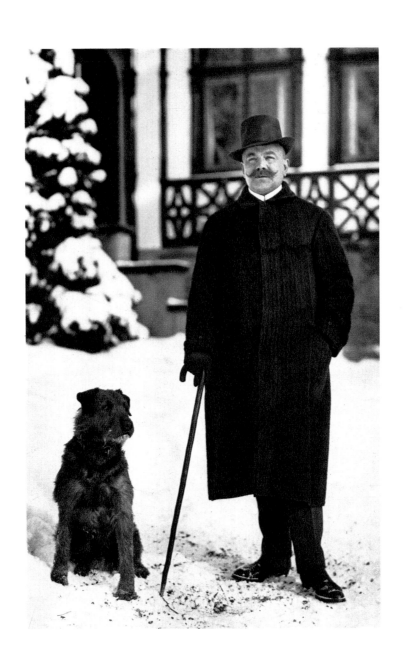

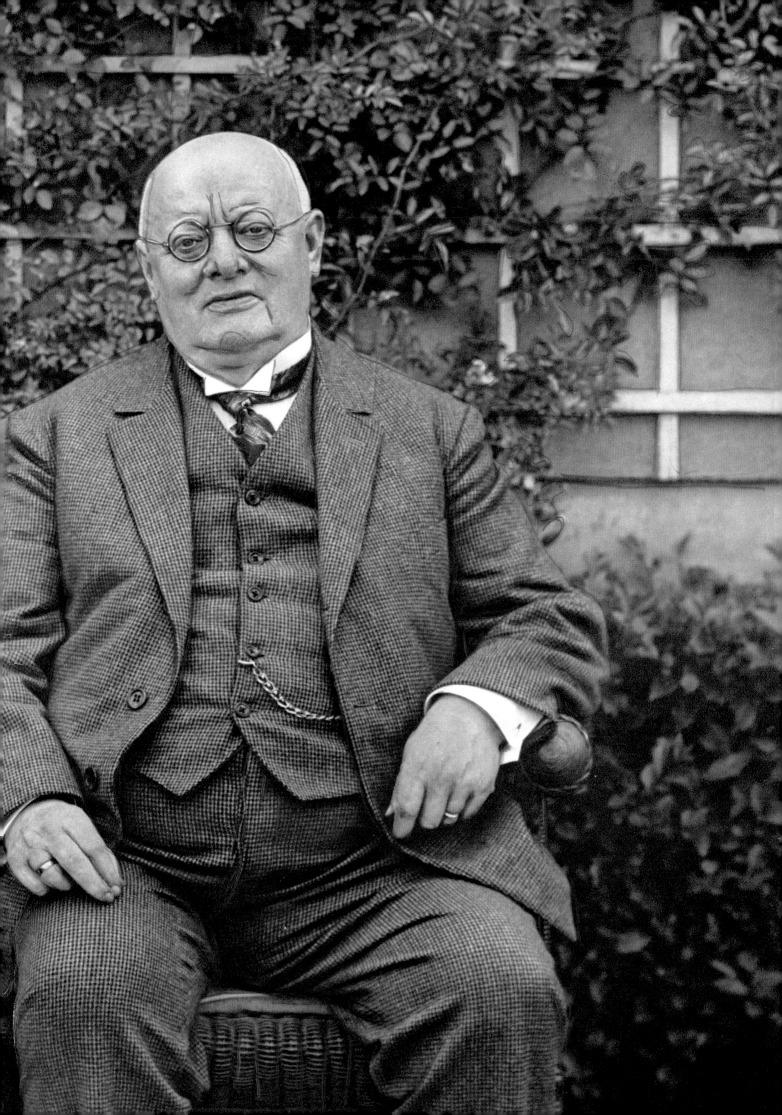

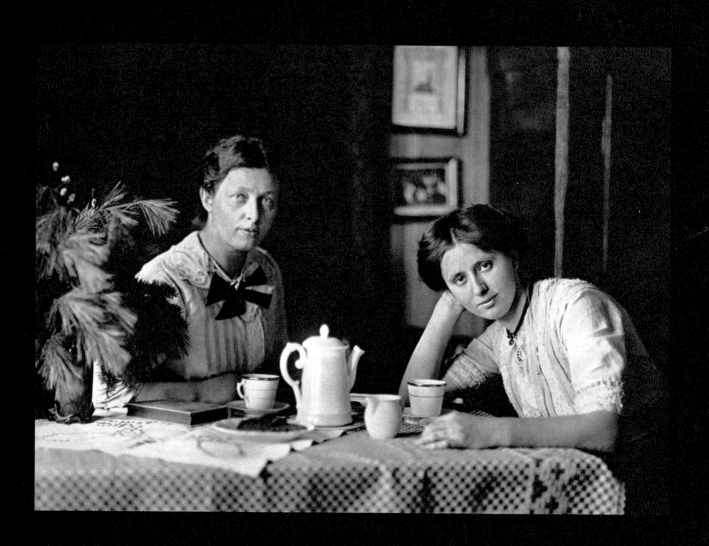

# Trades, Classes and Professions 1

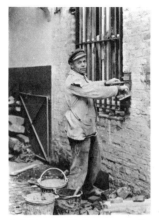

Bricklayer (Cologne, 1929)

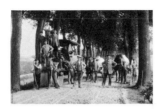

Road construction workers
(Westerwald, 1931)

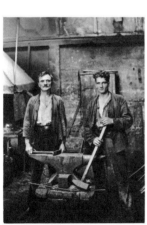

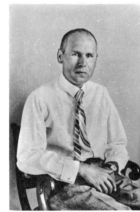

Iron foundry worker
(Cologne, 1934)

Industrial engineer
(Cologne, 1933)

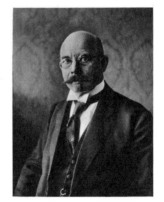

Industrialist
(Paul Morszek; Weiden,
near Cologne, 1925)

Industrialist
(Max Spindler;
Wuppertal, 1928)

Industrialist
(Hein Moeller,
Kloeckner-Moeller KG;
Bonn, 1933)

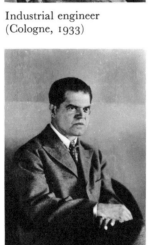

Industrialist
(Arnold von Guilliaume;
Cologne, 1928)

Inventor (the Dadaist
Raoul Hausmann;
Berlin, 1928)

Blacksmiths
(Wuppertal, 1929)

Craftsmen

Labourers

Technicians

Industrialists

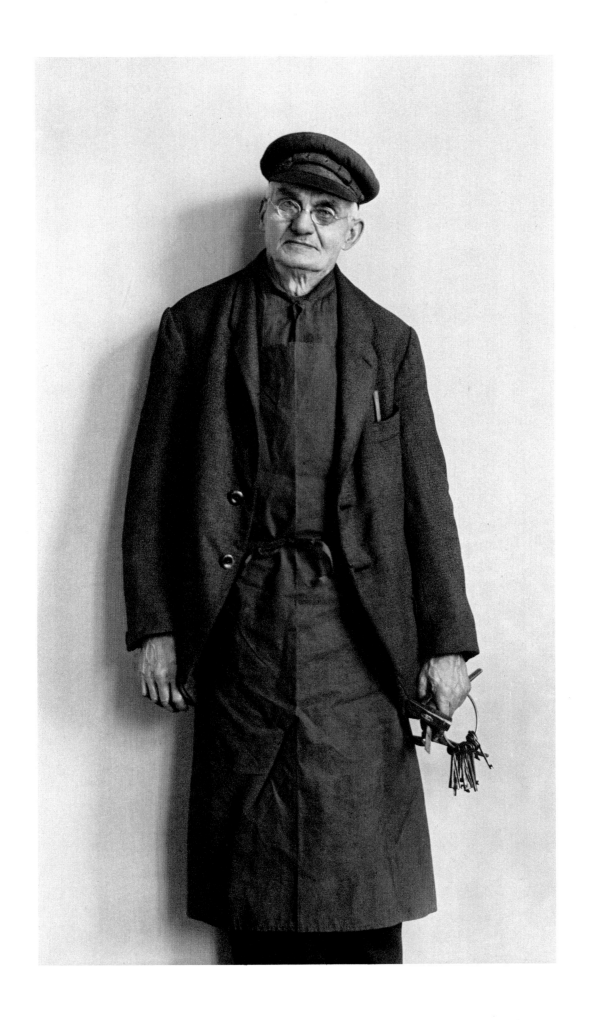

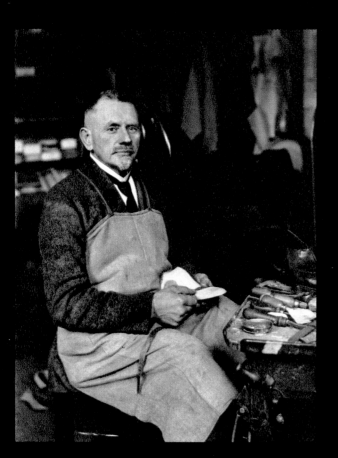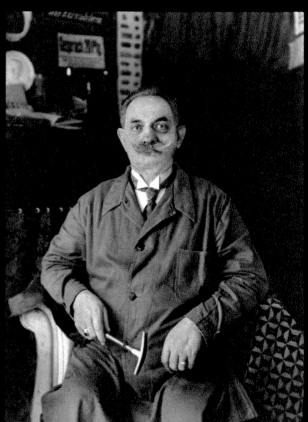

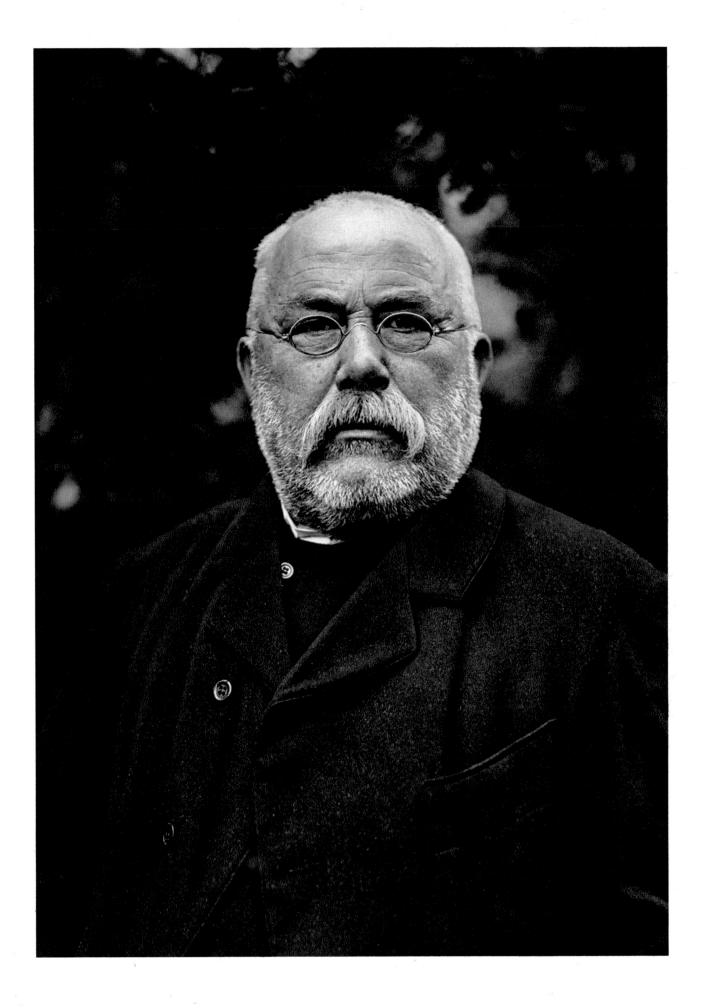

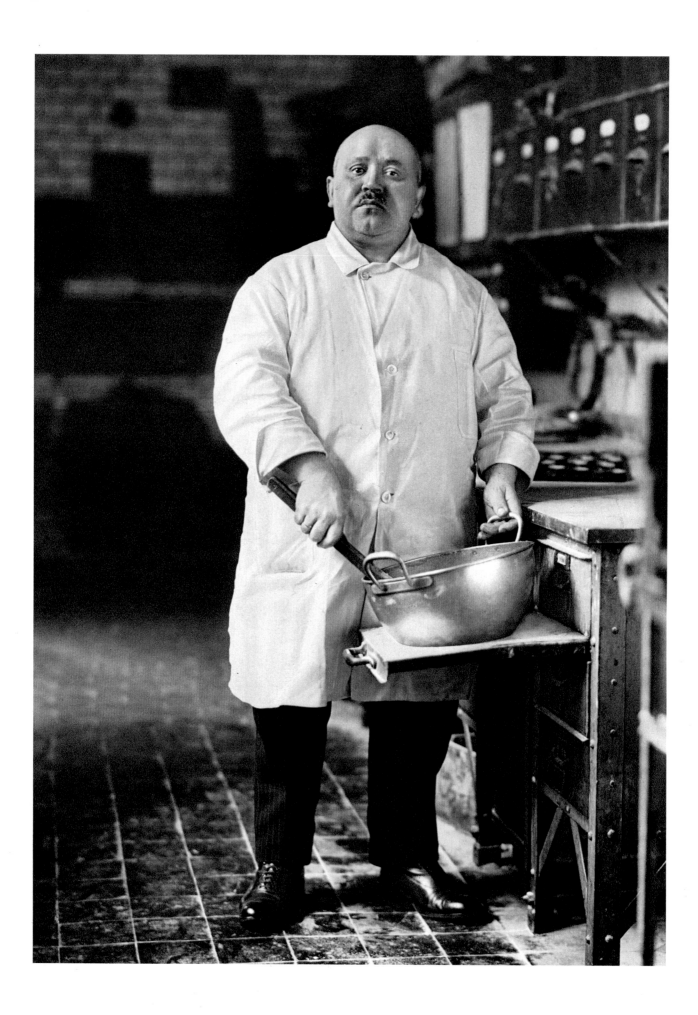

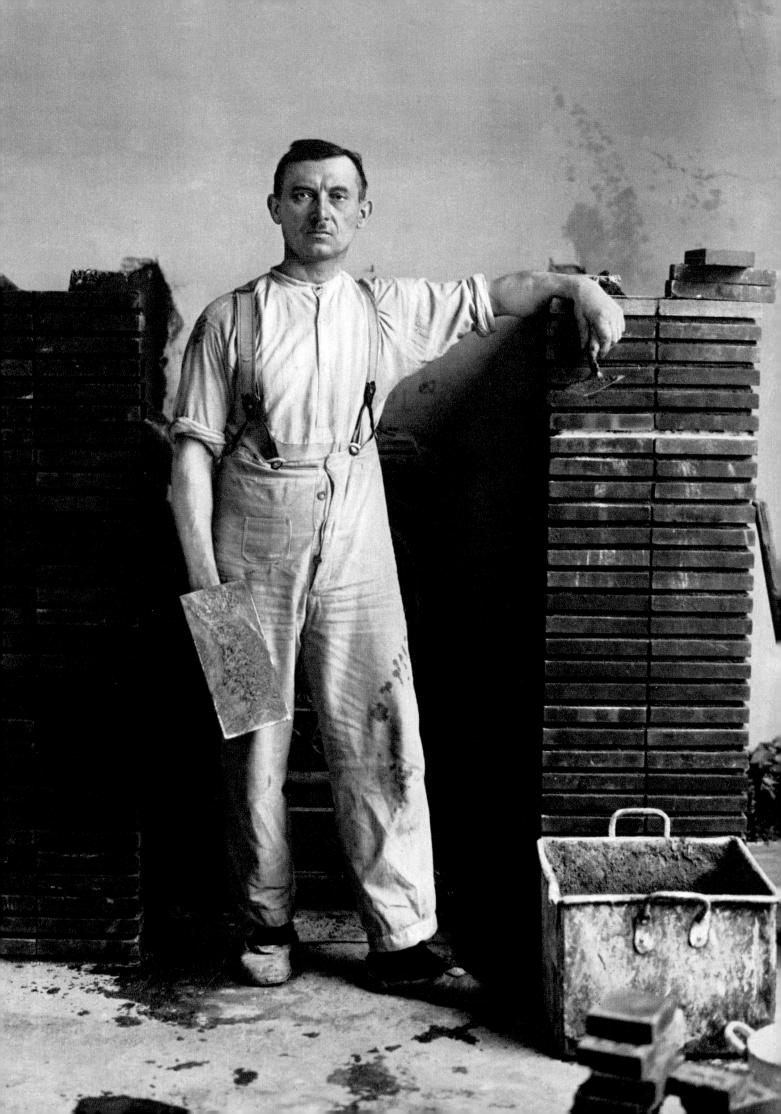

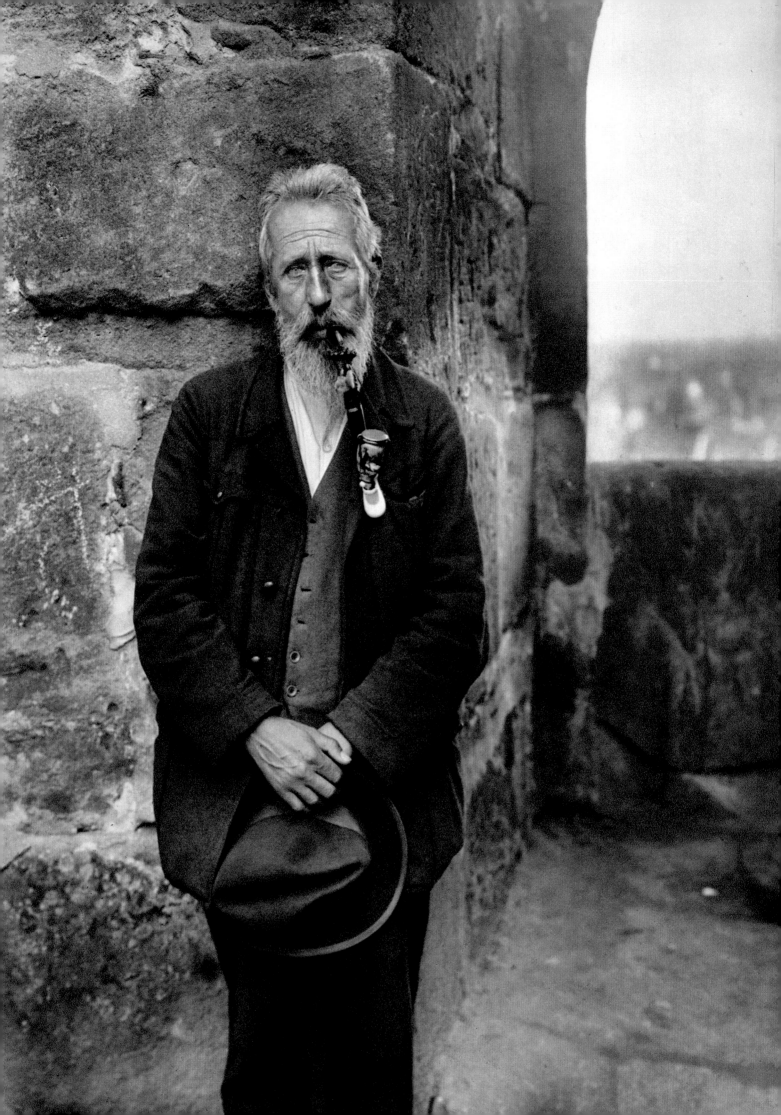

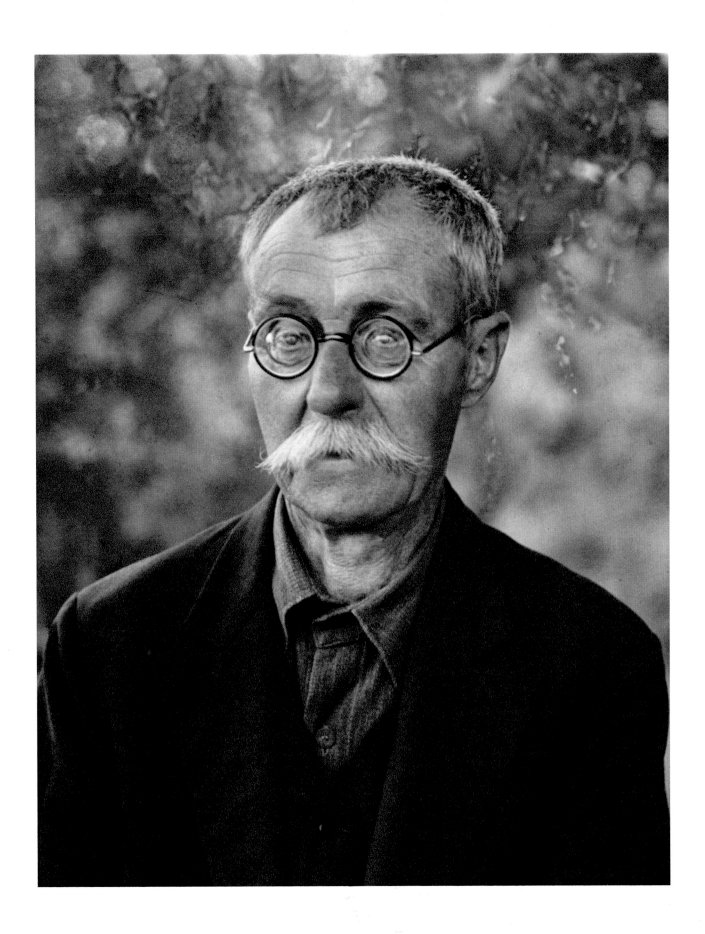

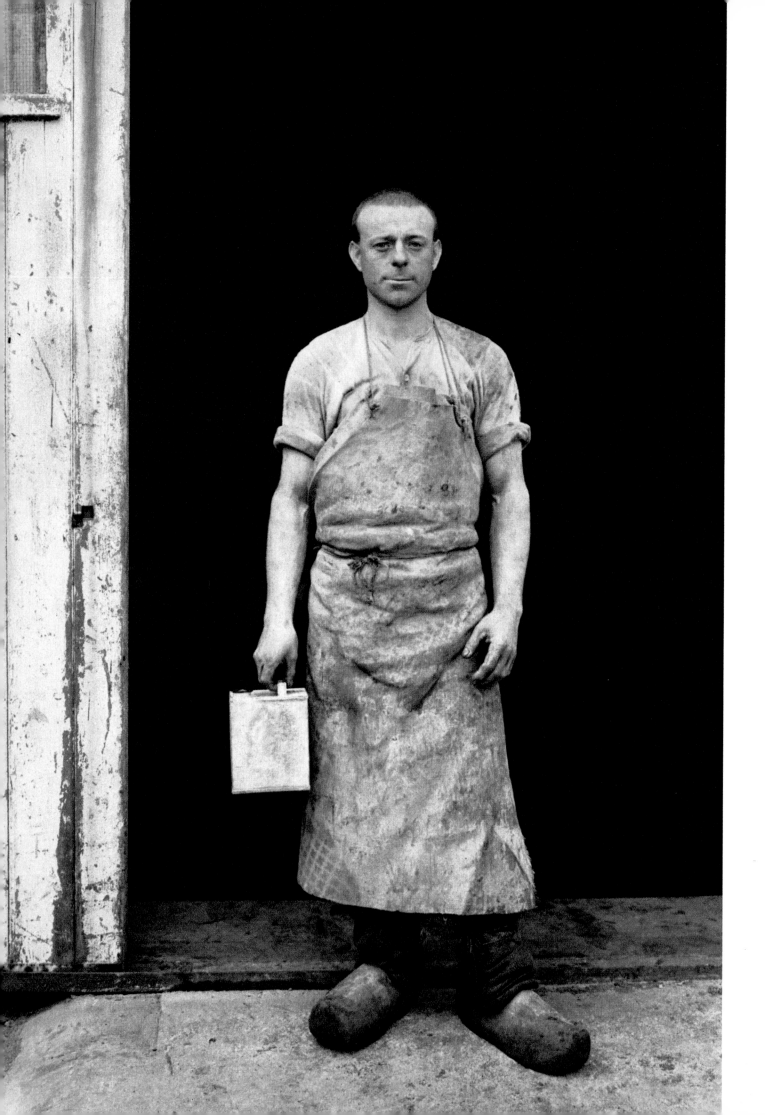

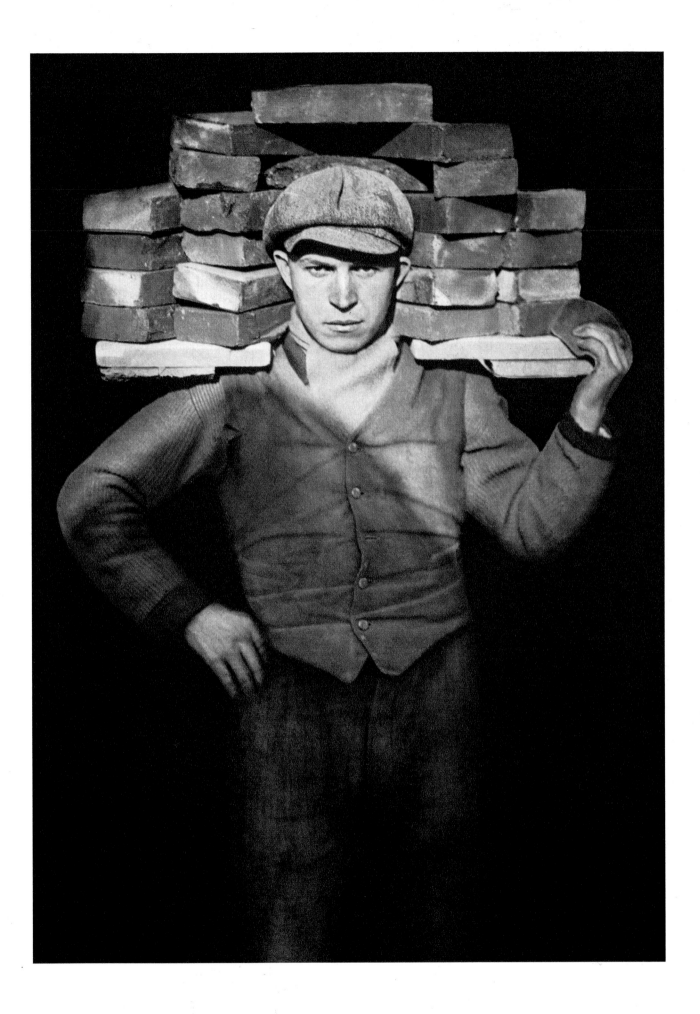

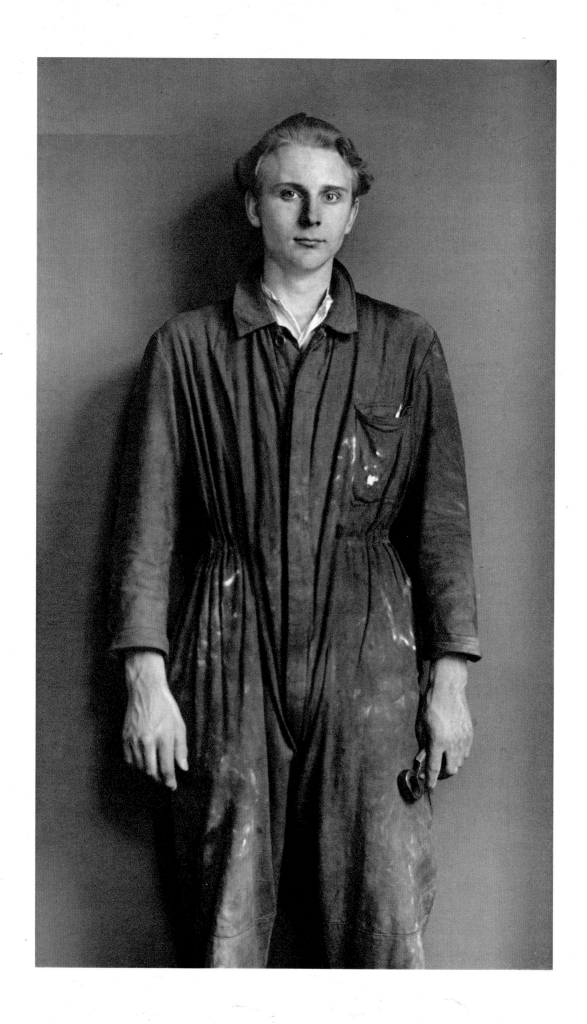

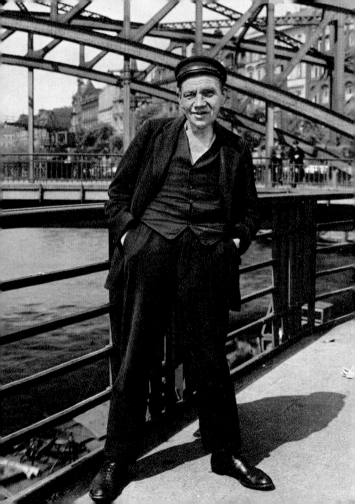

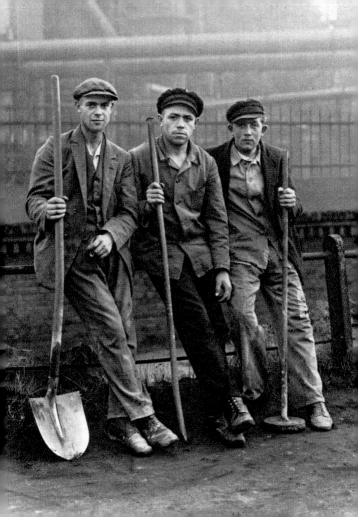

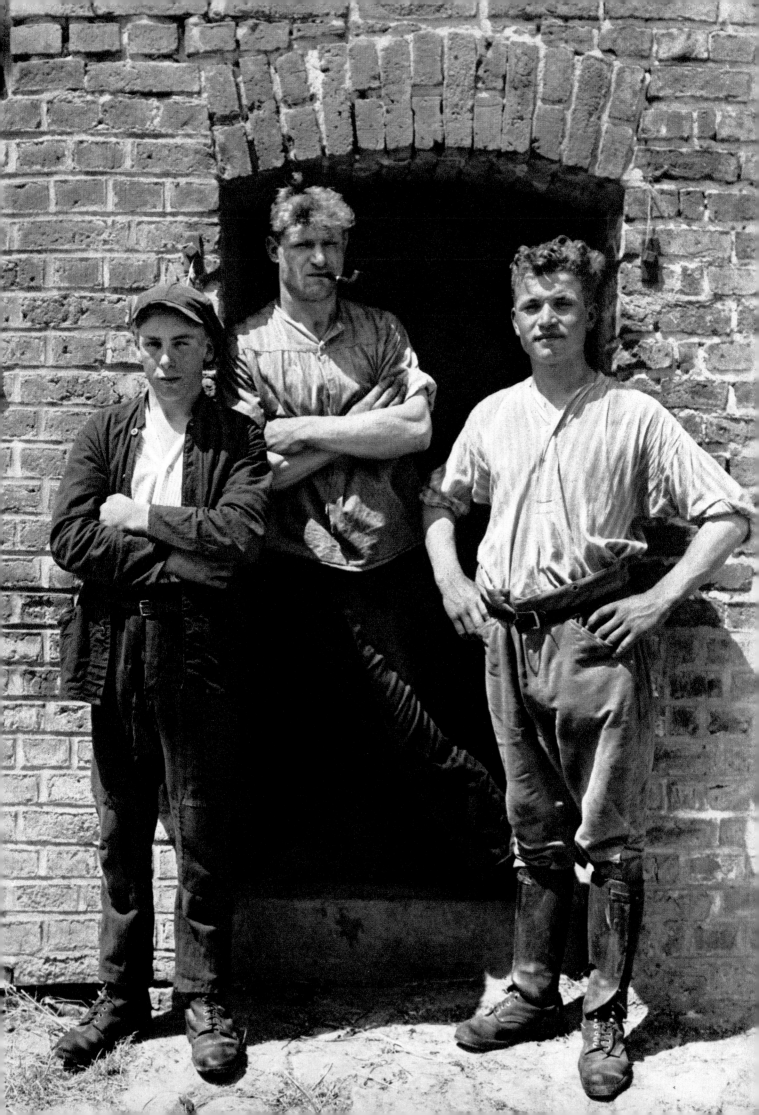

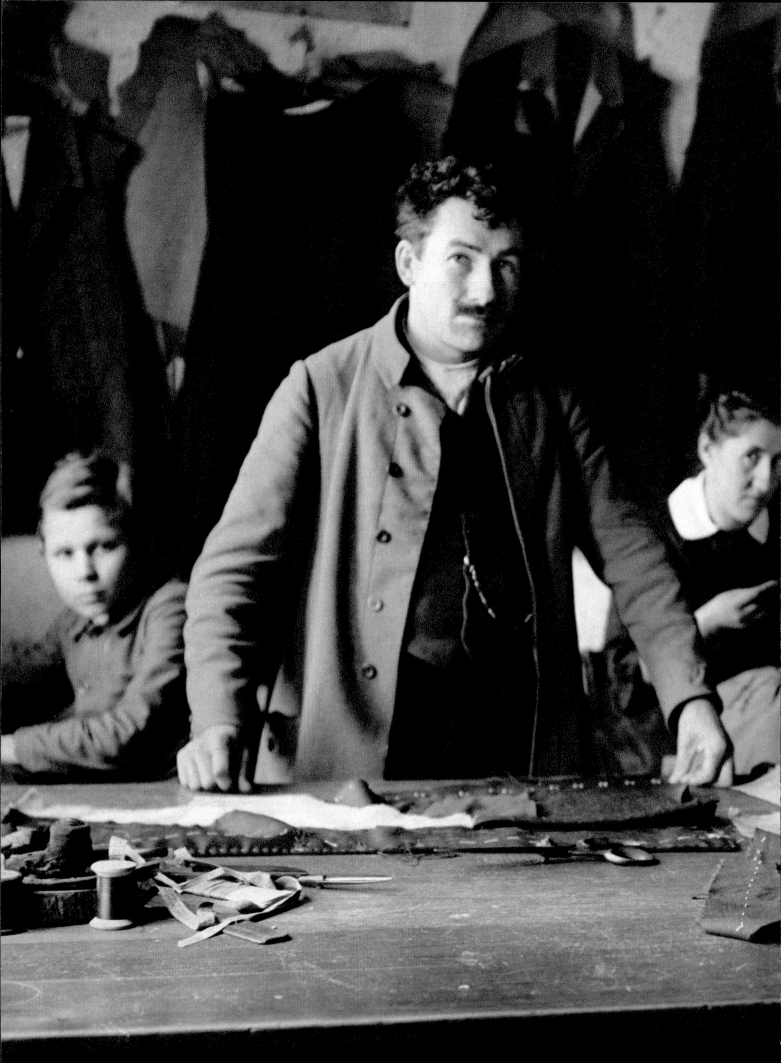

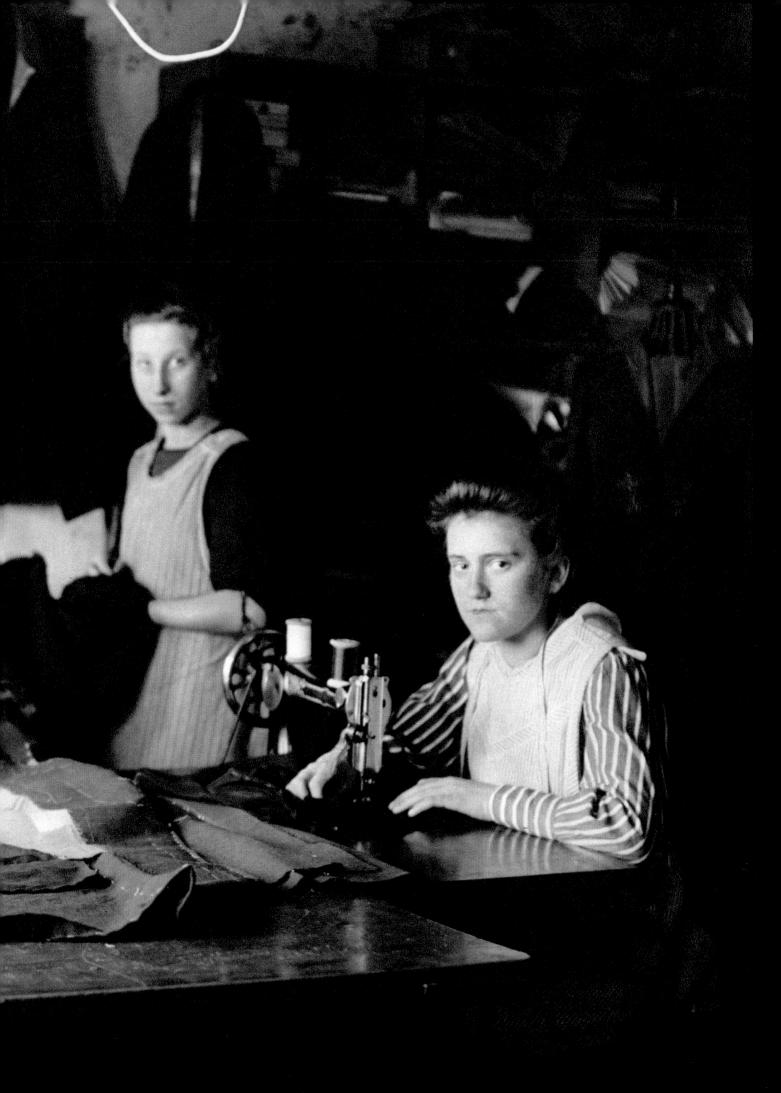

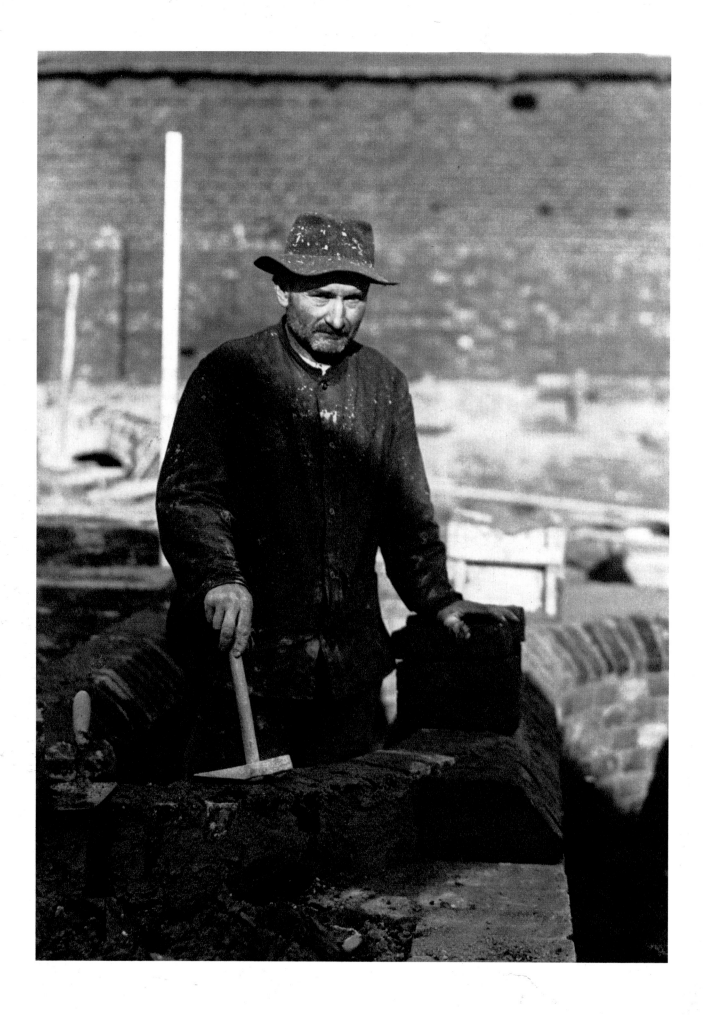

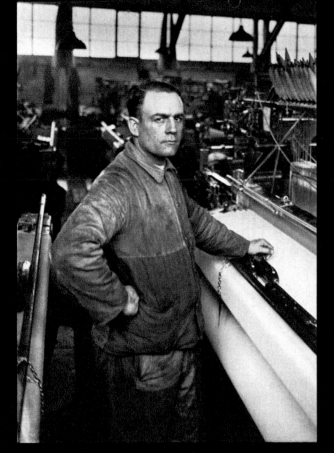
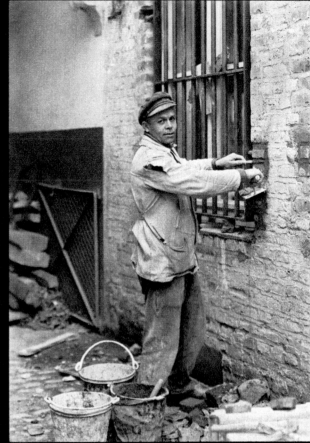
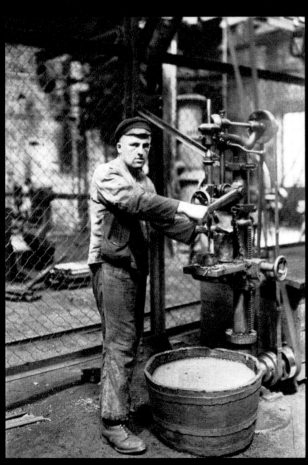
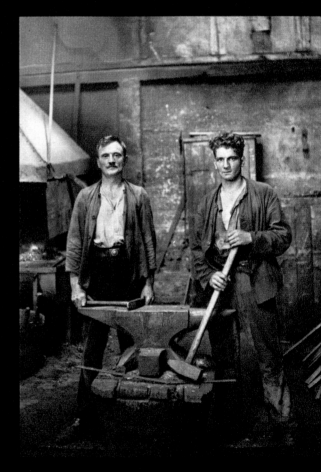

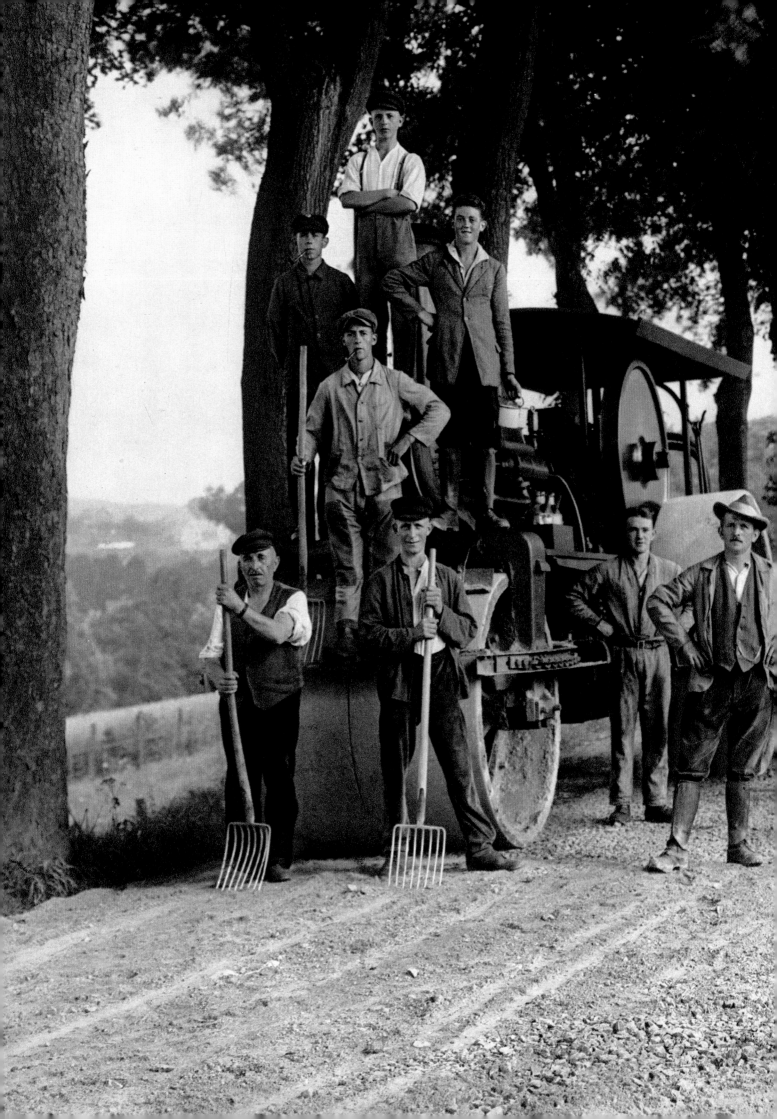

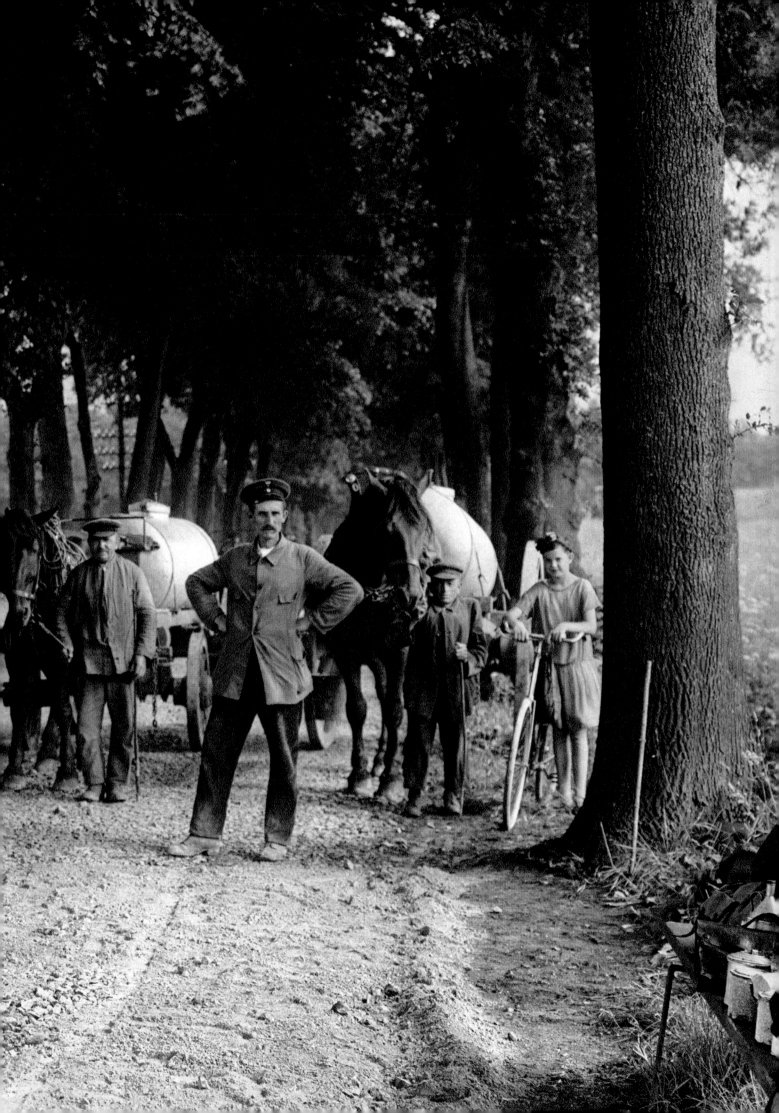

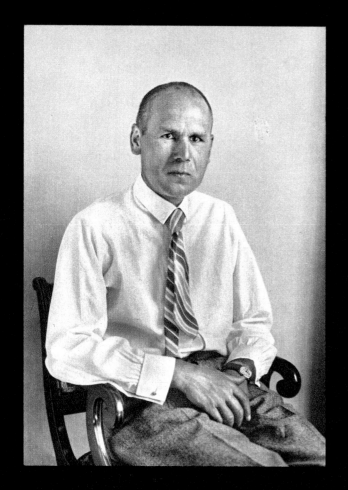

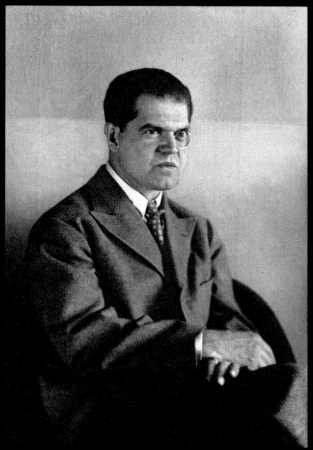

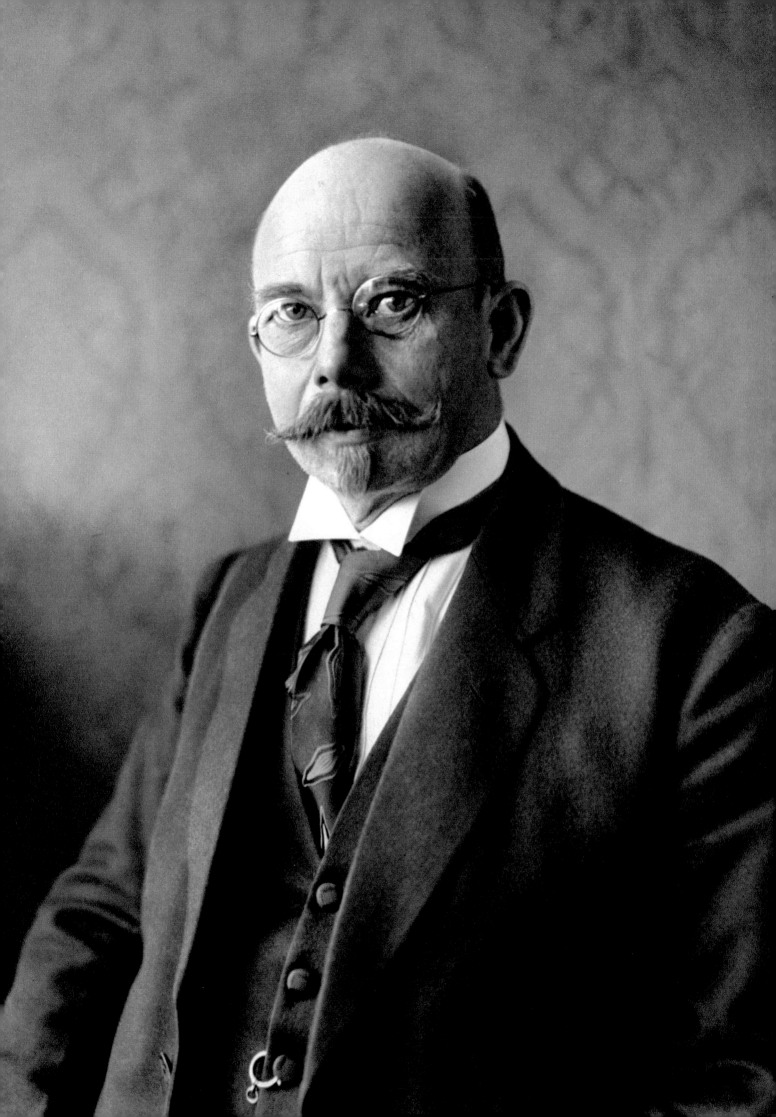

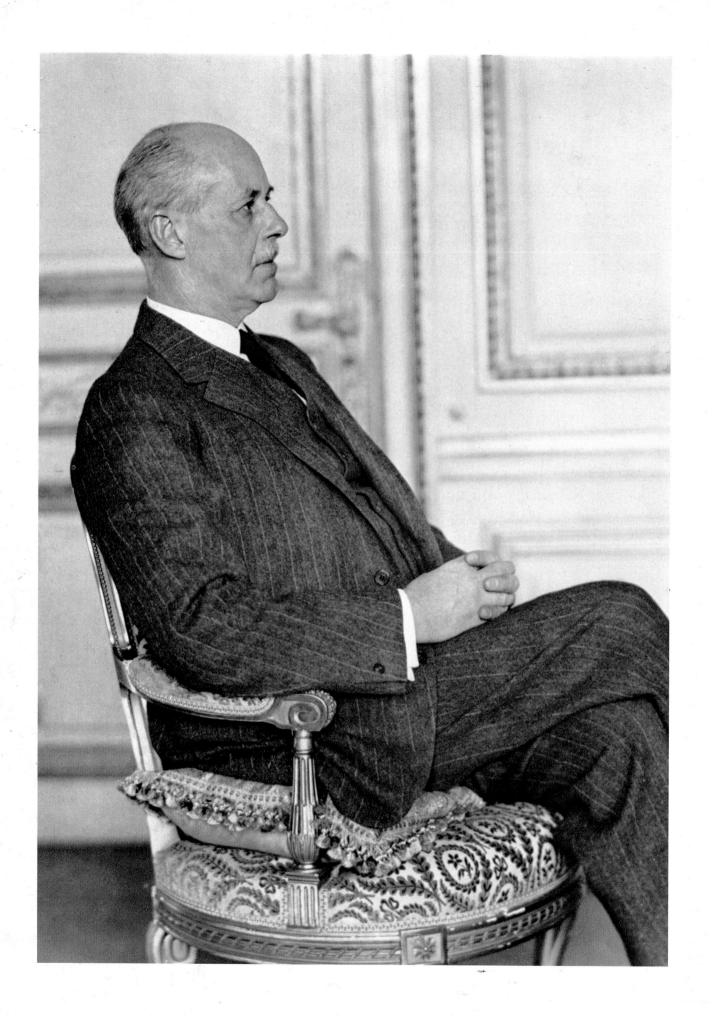

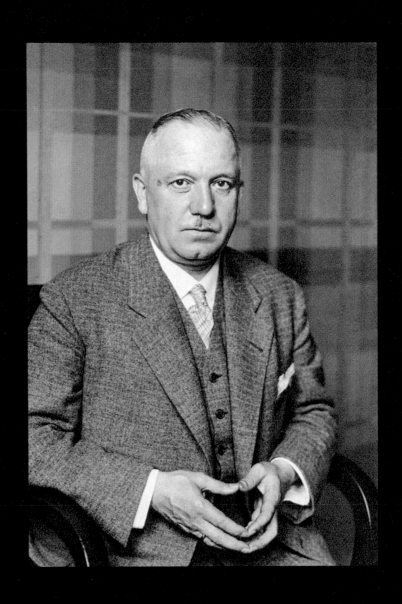

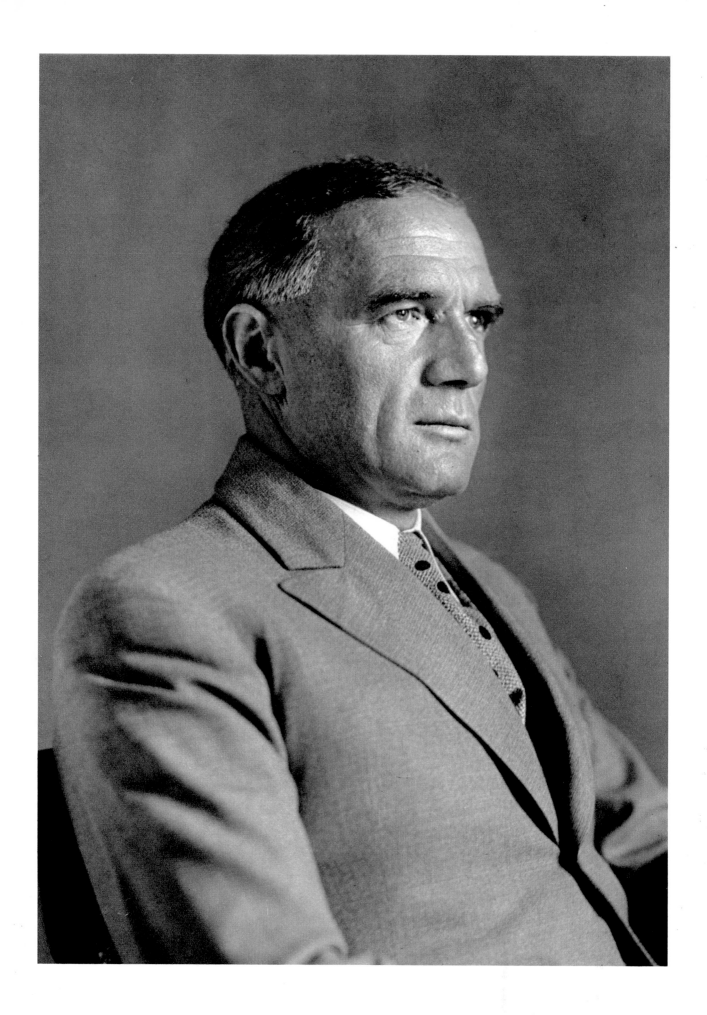

# Trades, Classes and Professions 2

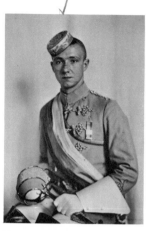

Korps student from
Nuremberg (Cologne, 1928)

Communist working students
(Cologne, 1926)

Communist working student
(Oberhausen, 1926)

Primary schoolteacher
(Herdorf, 1906)

Village schoolteacher
(Westerwald, 1921)

Student teacher
(Westerwald, 1928)

Senior high-school master
(Cologne, 1932)

High-school master
(Cologne, 1932)

Dr Karl With, Director of
the Kunstgewerbemuseum
(Cologne, 1932)

The art historian
Prof. Dr Wilhelm Schäfer
(Cologne, 1928)

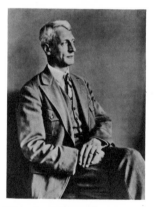

The physician and
theologian
Professor Dr Karl Barth
(Cologne, 1929)

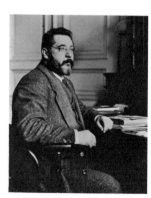

The librarian and Iceland
explorer Heinrich Erkes
(Cologne, 1919)

Professor Dr Otto Mente
(Berlin, 1929)

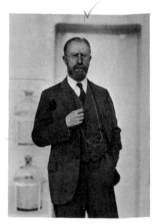

Professor Dr Schleyer,
medical superintendent
at the Augusta Hospital
(Berlin)

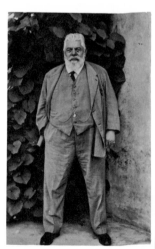

Chemist
(Sepp Melichar; Linz 1931)

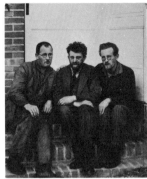

Revolutionaries (in the centre Erich Mühsam; Berlin, 1928)

Rosy Wolfstein, politician and wife of Paul Fröhlich (Frankfurt, 1928)

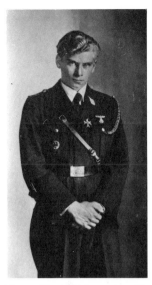

Baron von Maltitz (Darmstadt, 1928)

'Dr Braun', founder of a breakaway party, the League of Spiritual Renewal (Cologne, 1931)

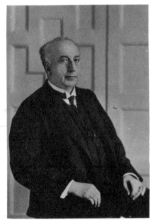

Count Hardenberg, treasurer to the Grand Duke of Hesse-Nassau (1928)

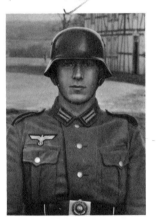

Young soldier (Westerwald, 1945)

Young Nazi (Cologne, 1936)

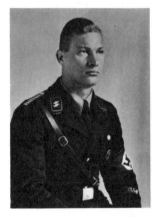

Member of Adolf Hitler's SS Guard (Cologne, 1938)

The businessman and Democratic Party parliamentarian Johannes Scheerer (Cologne, 1928)

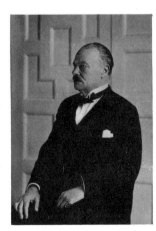

The Grand Duke of Hesse-Nassau (Darmstadt, 1928)

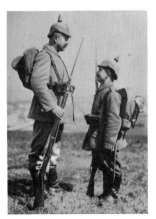

Military contrast (France, 1915)

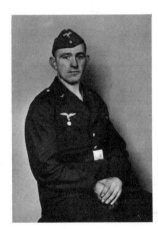

Airman (Cologne, 1941)

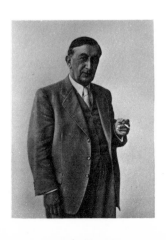

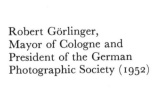

Robert Görlinger, Mayor of Cologne and President of the German Photographic Society (1952)

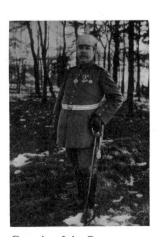

Captain of the Reserve (Alsace-Lorraine, 1916)

Students

Teachers

Scientists

Doctors

Chemists

Lawyers

Clerics

Officials

Businessmen

Politicians

Aristocrats

Soldiers

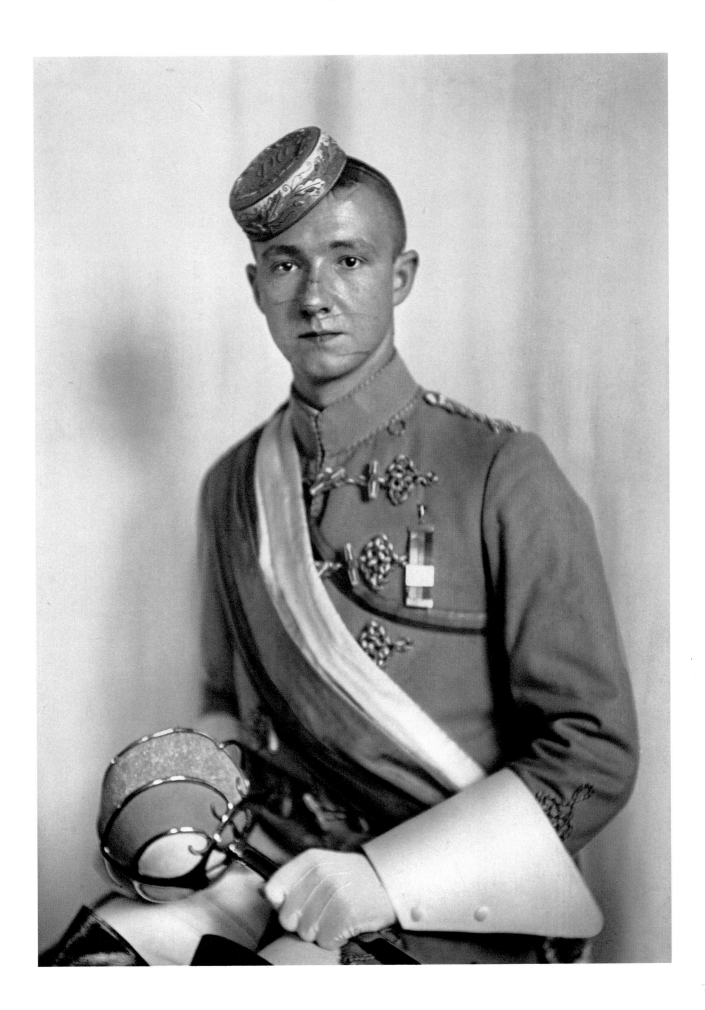

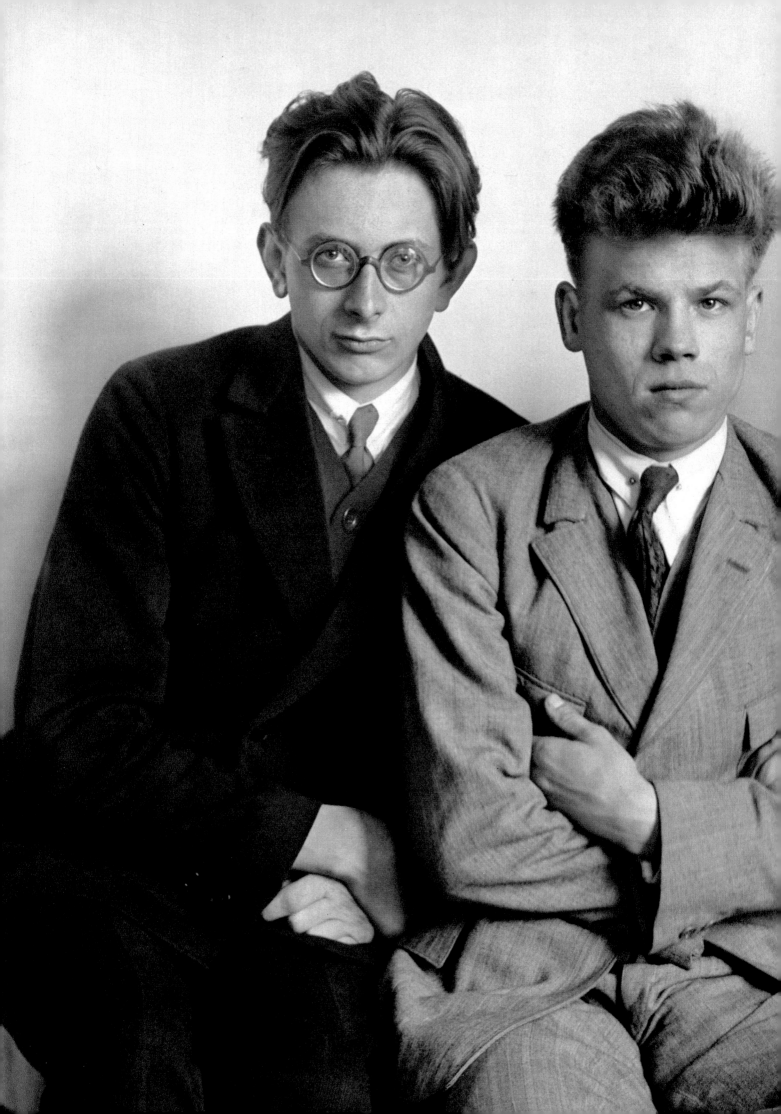

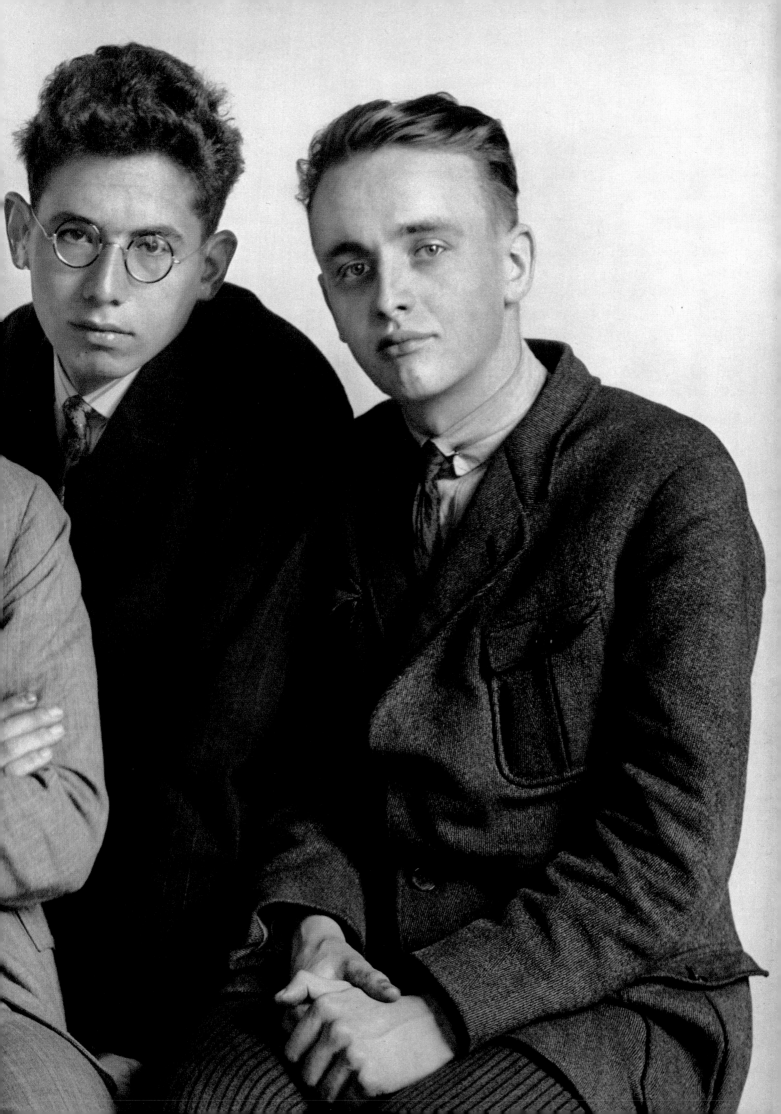

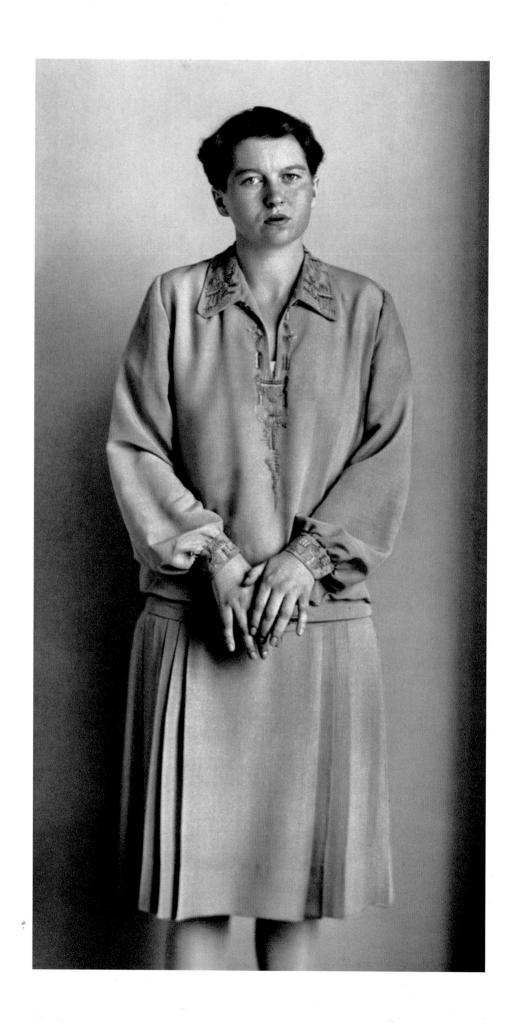

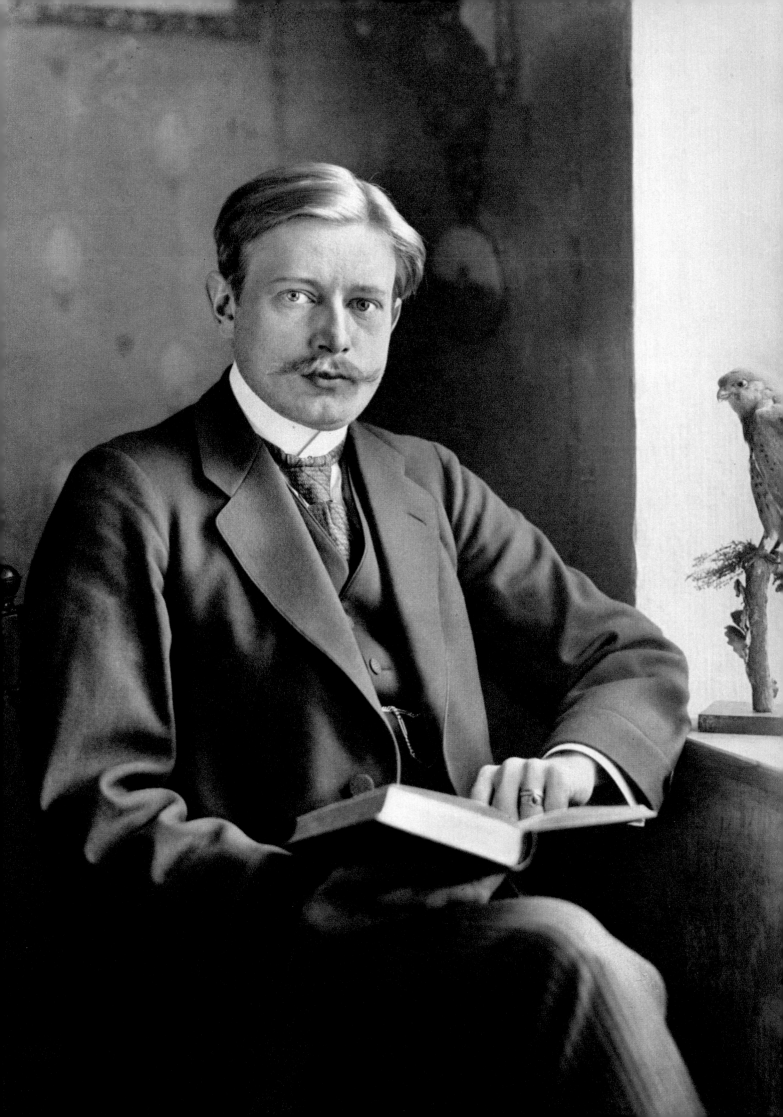

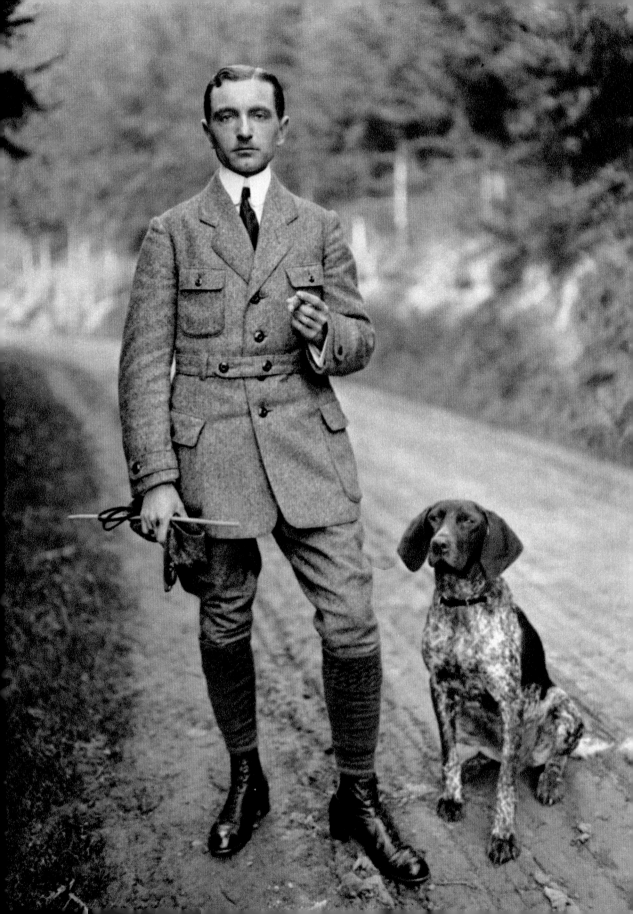

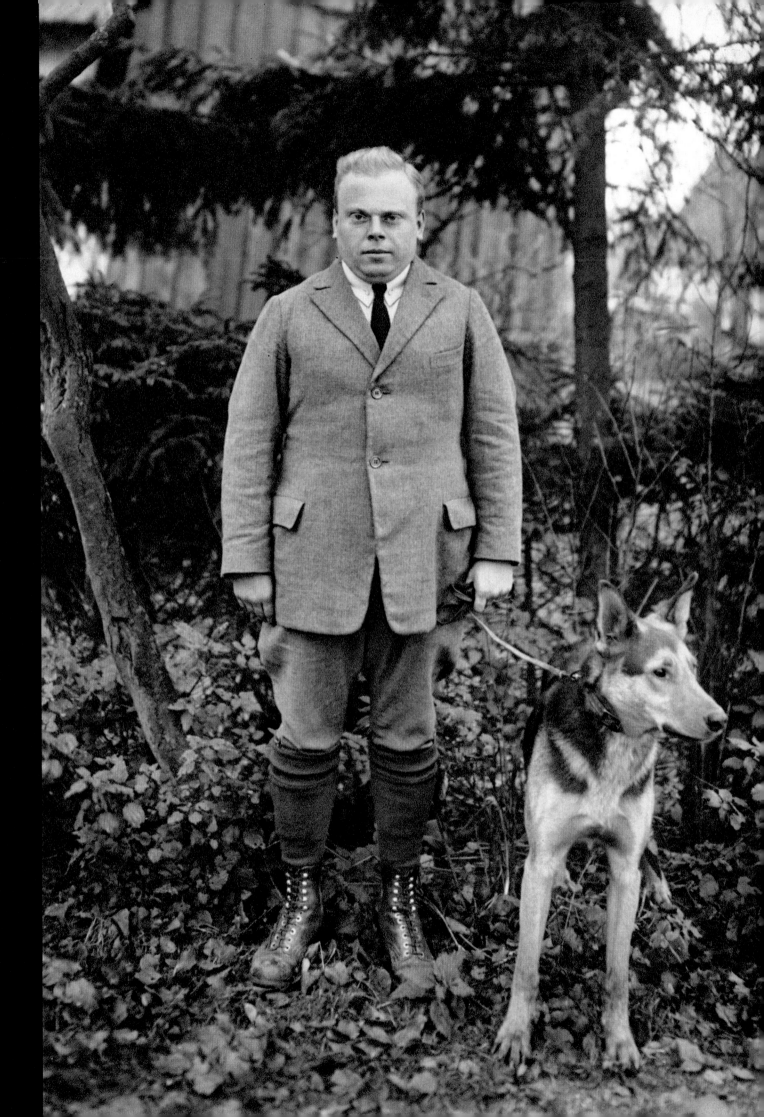

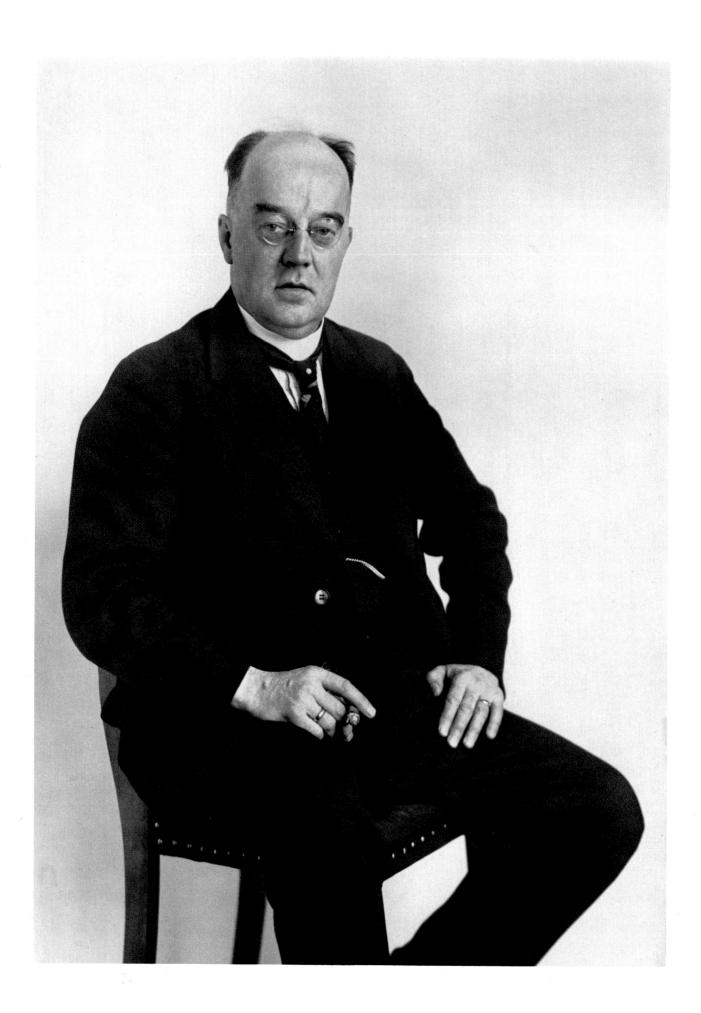

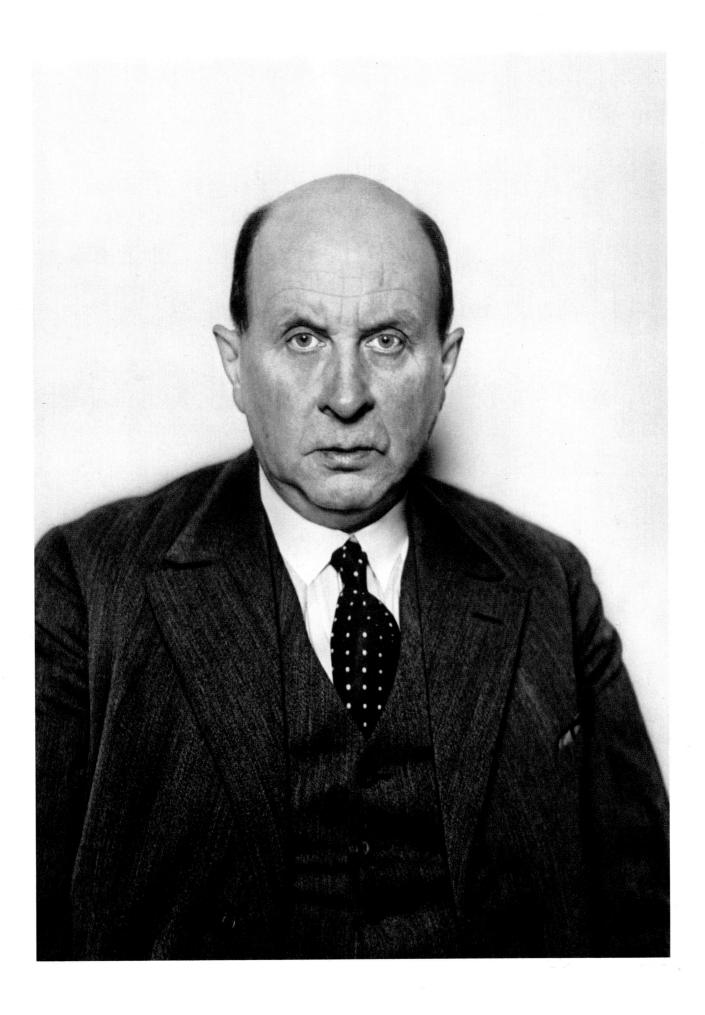

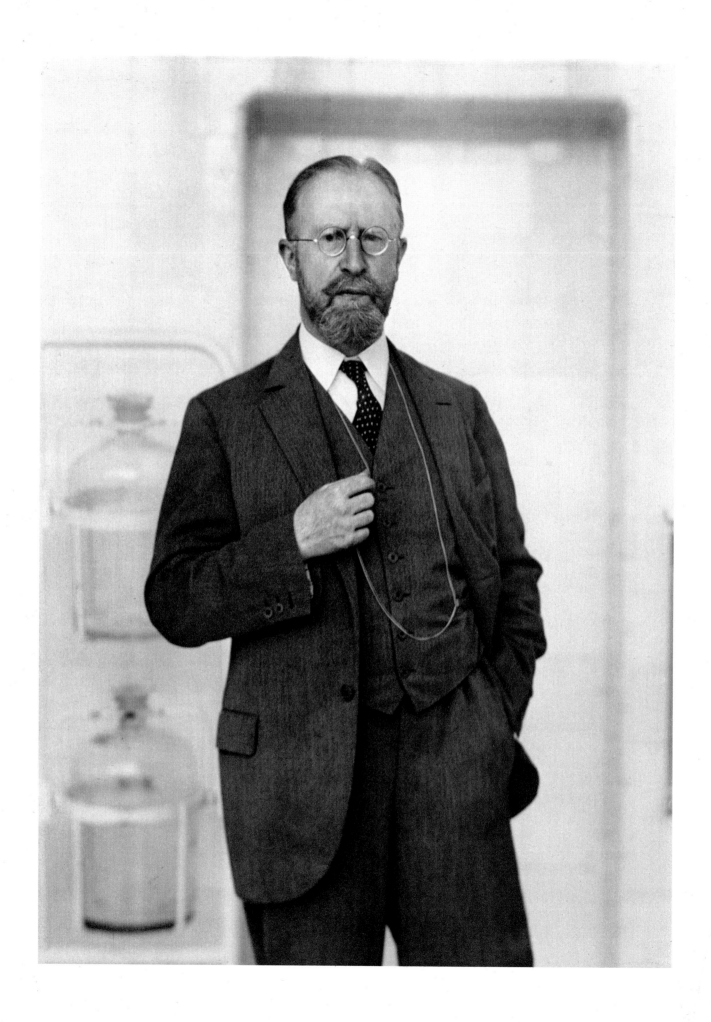

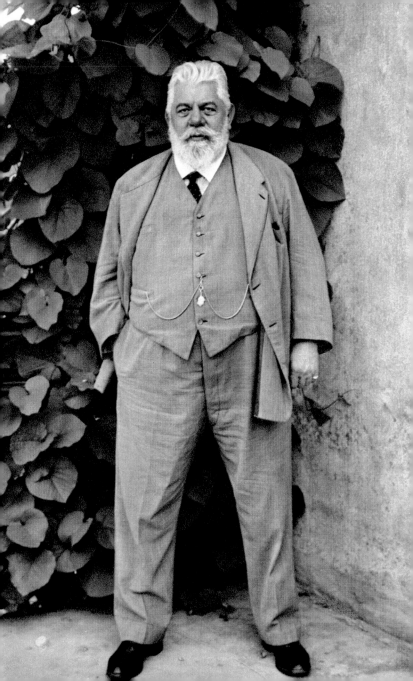

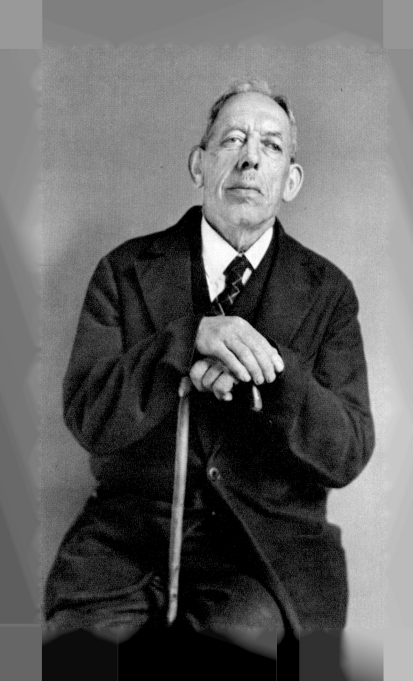

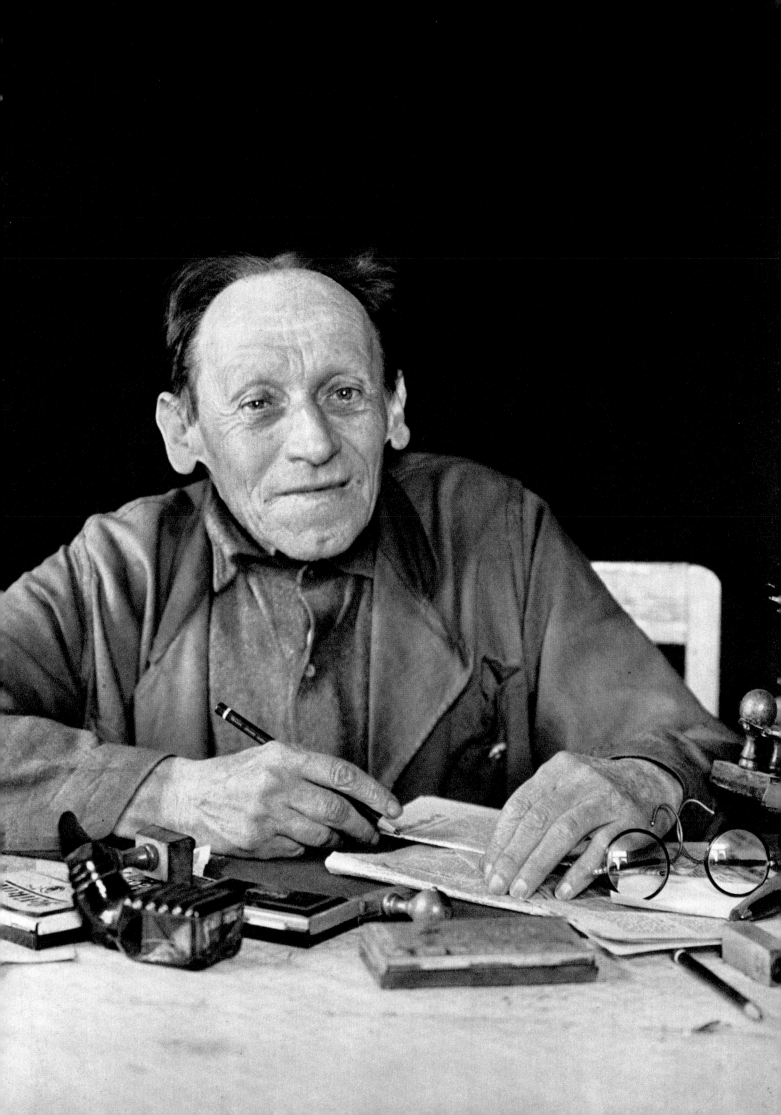

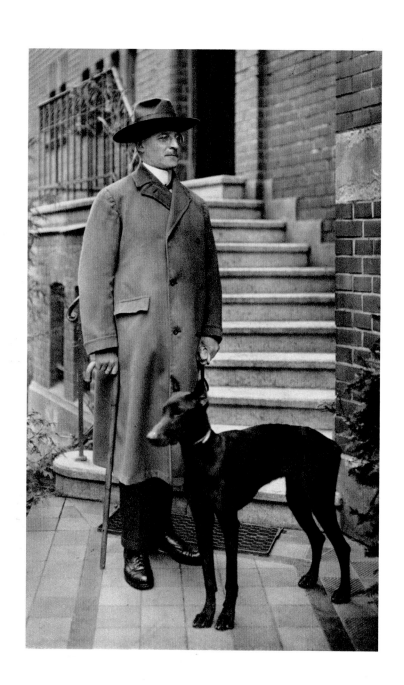

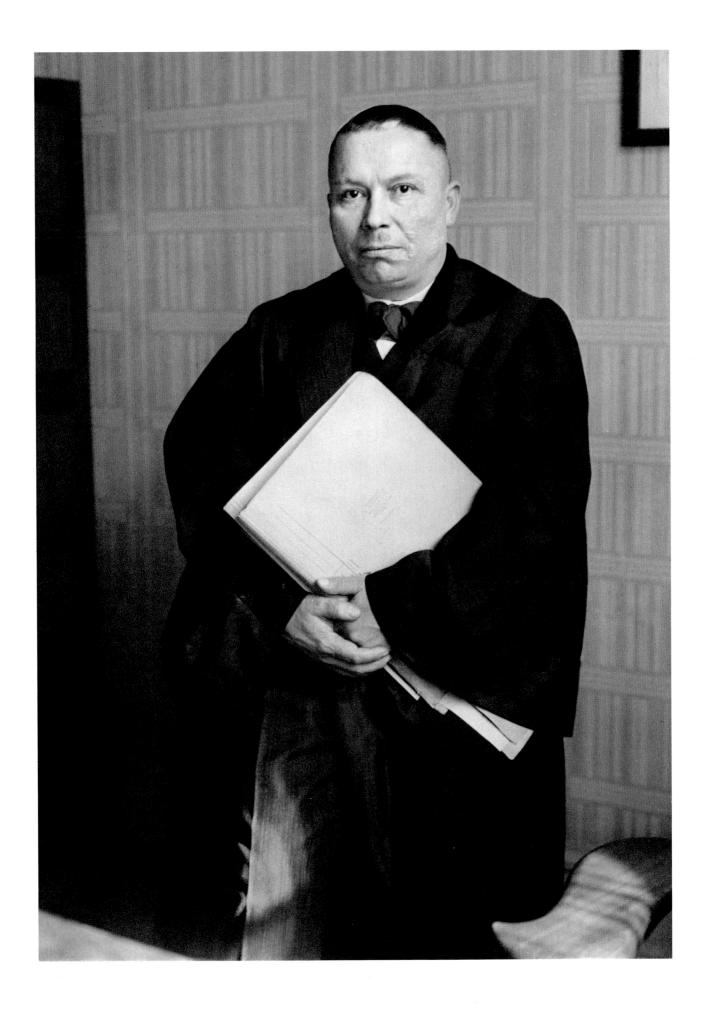

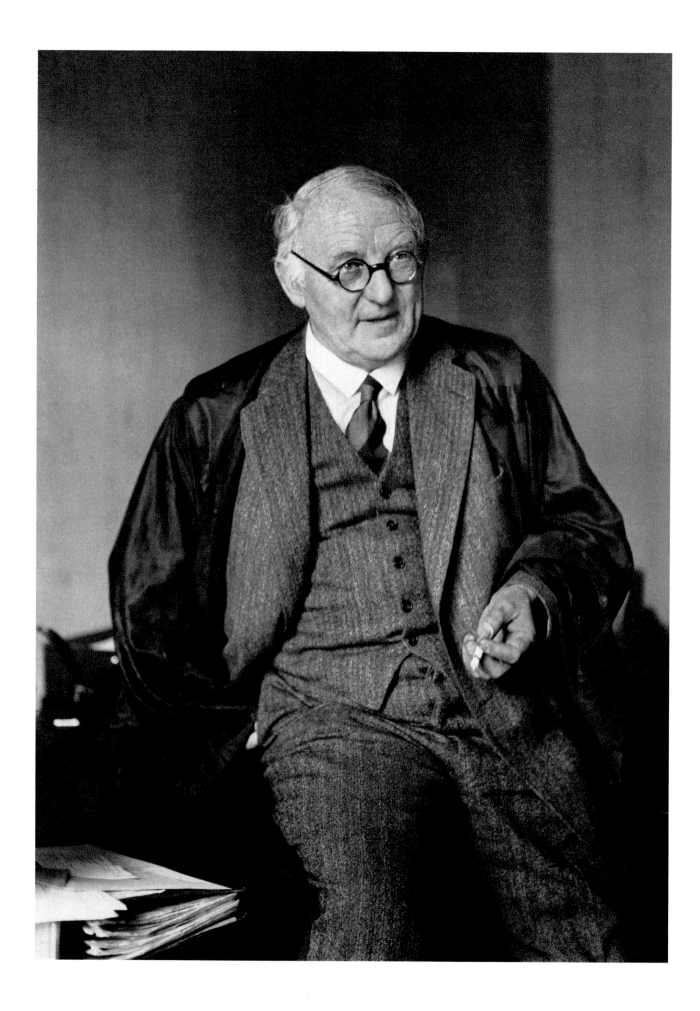

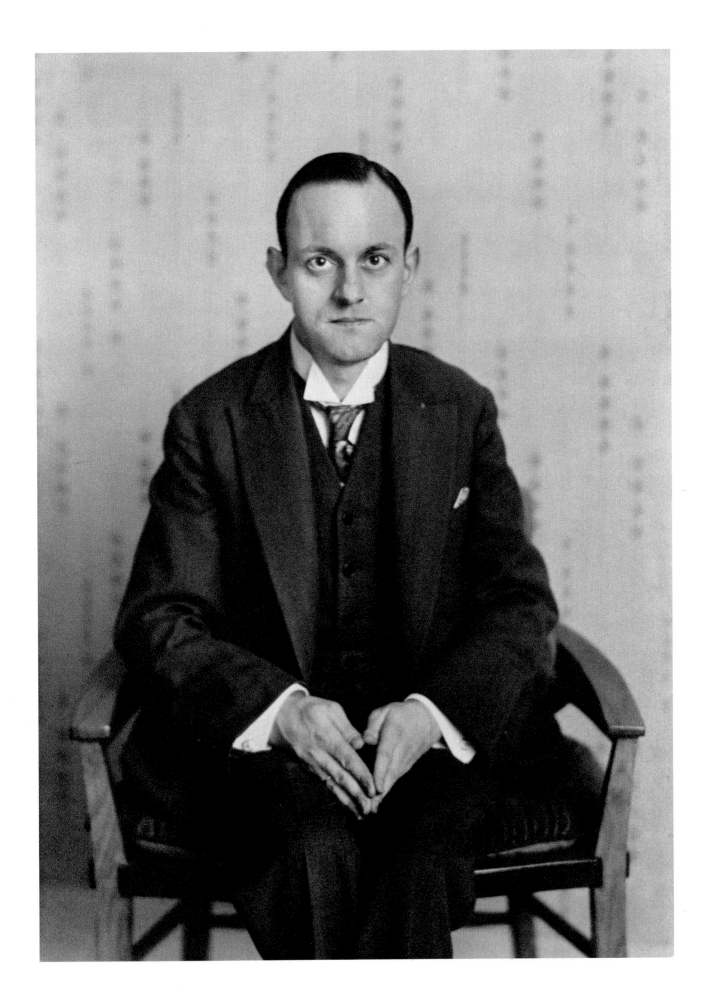

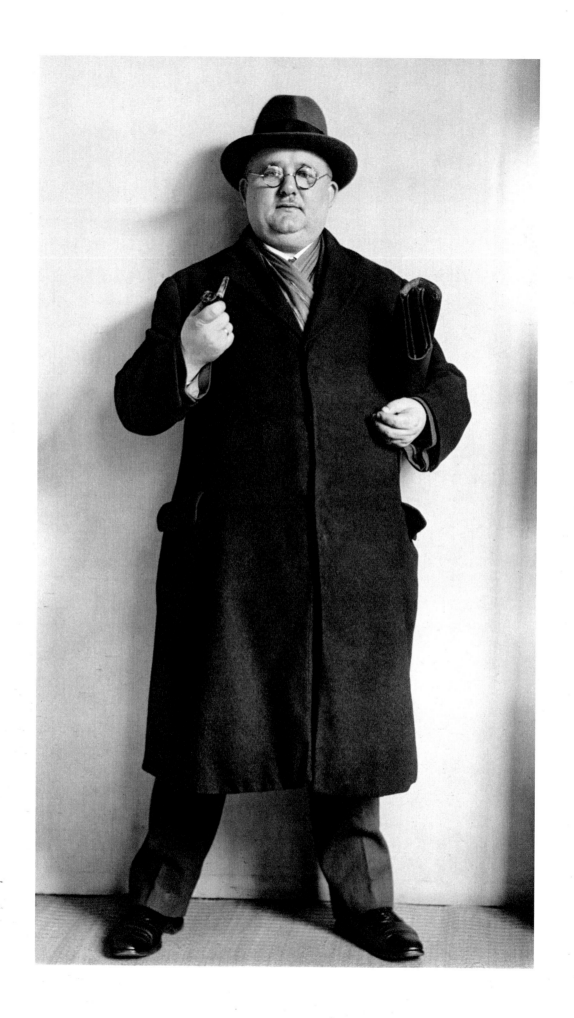

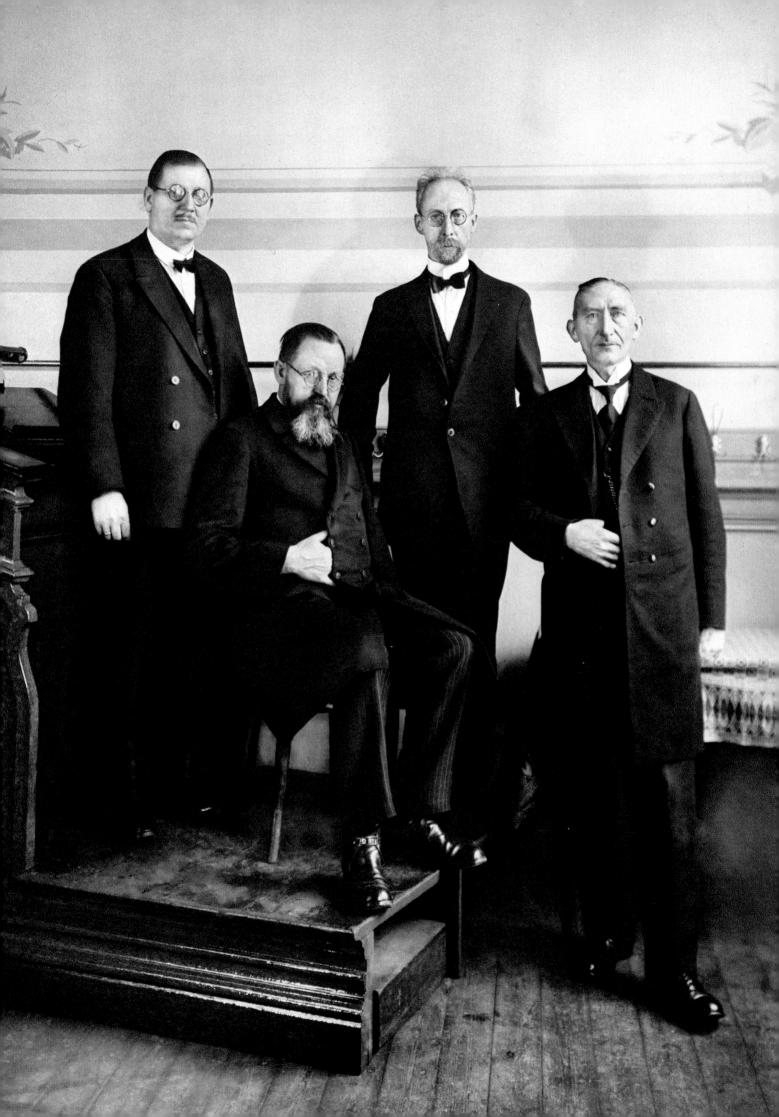

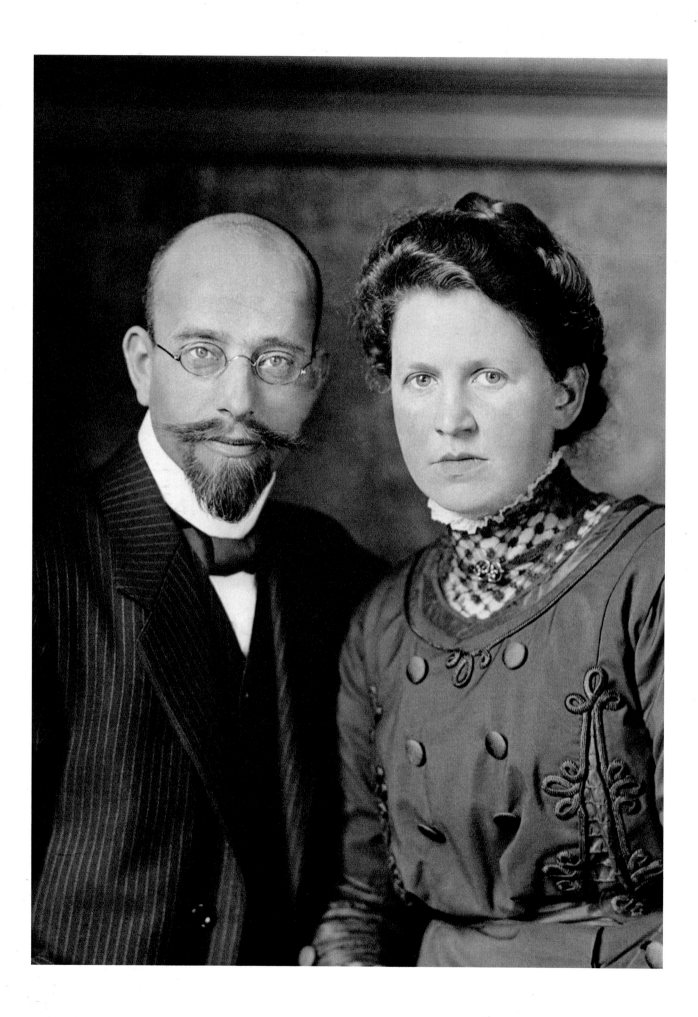

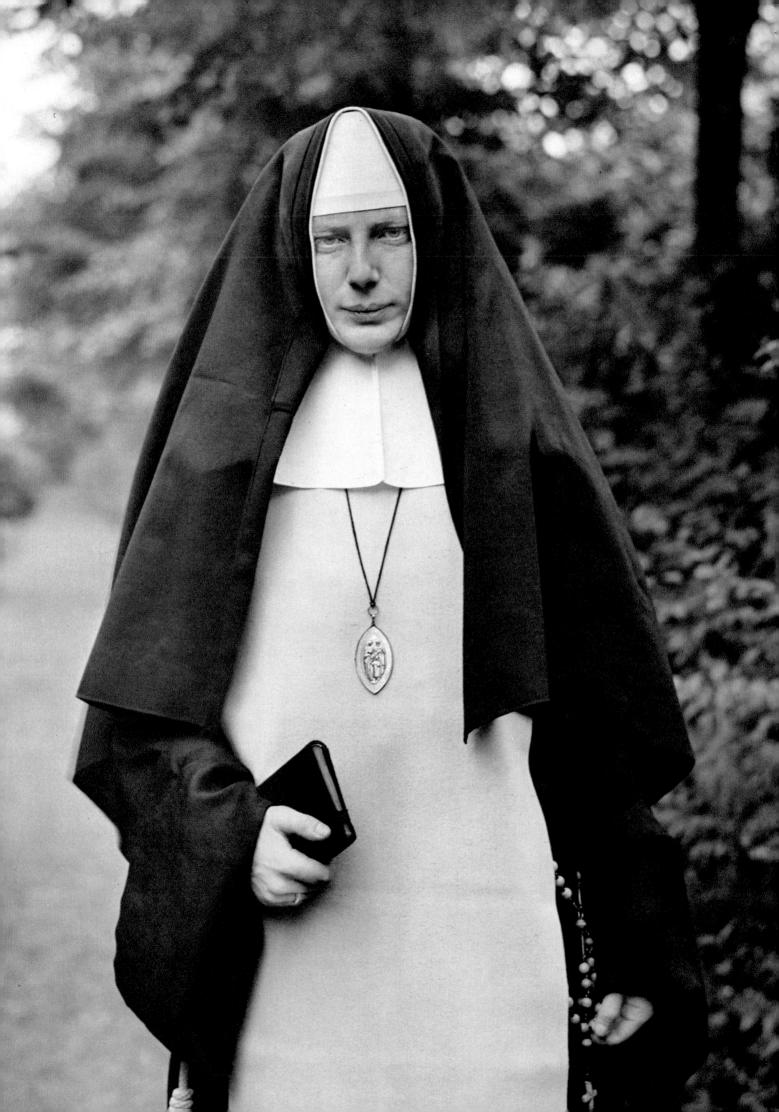

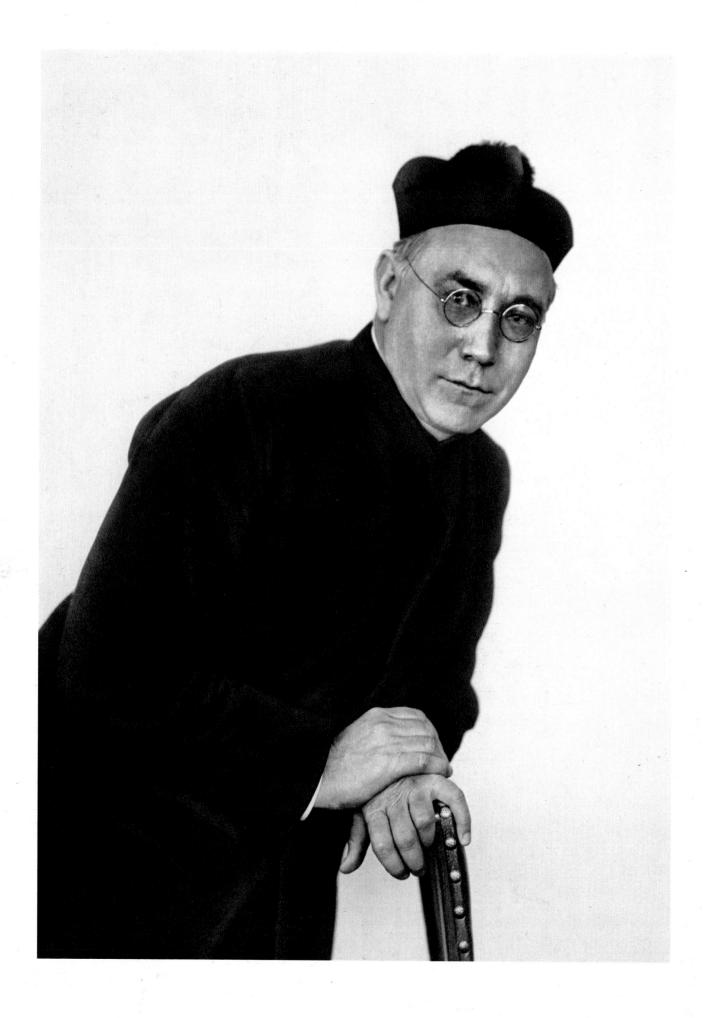

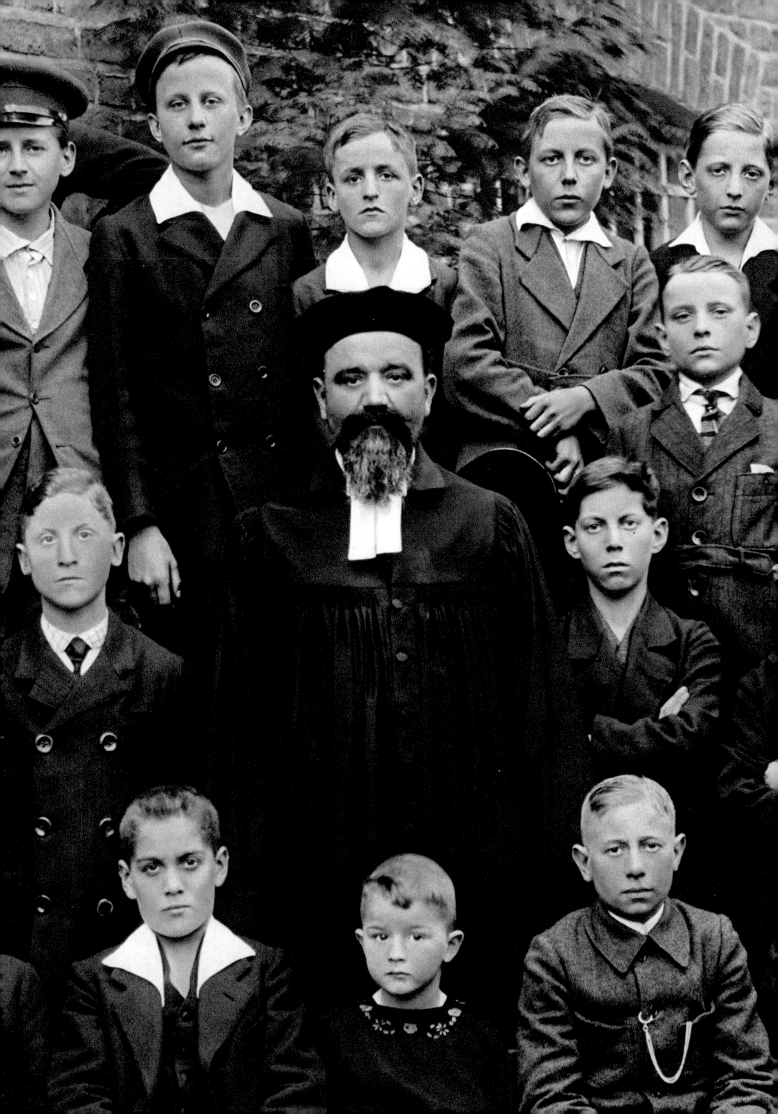

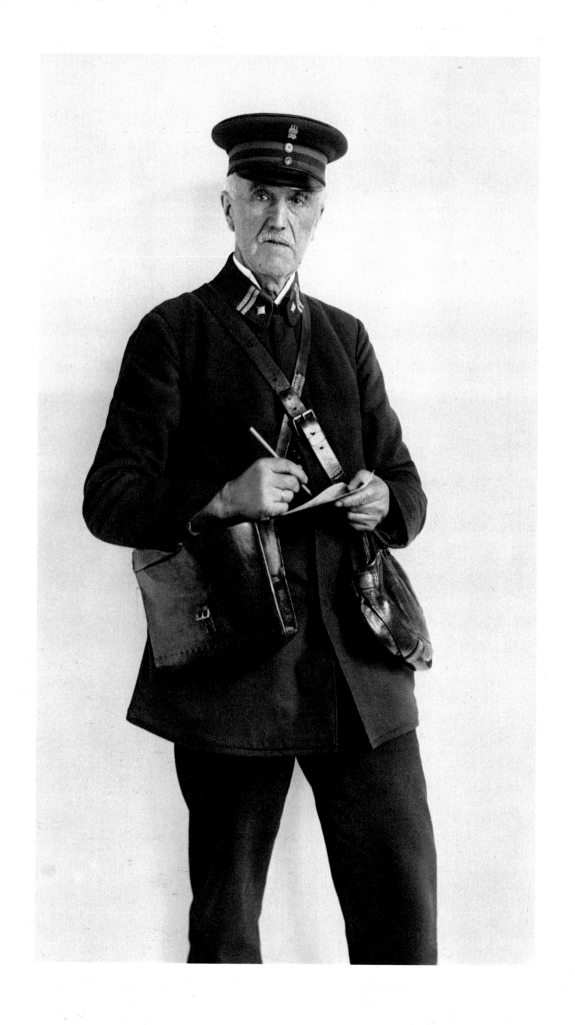

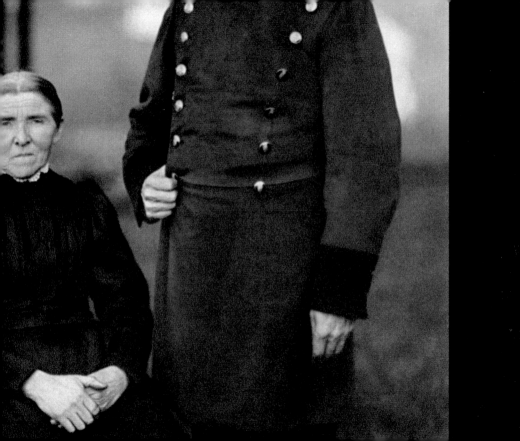

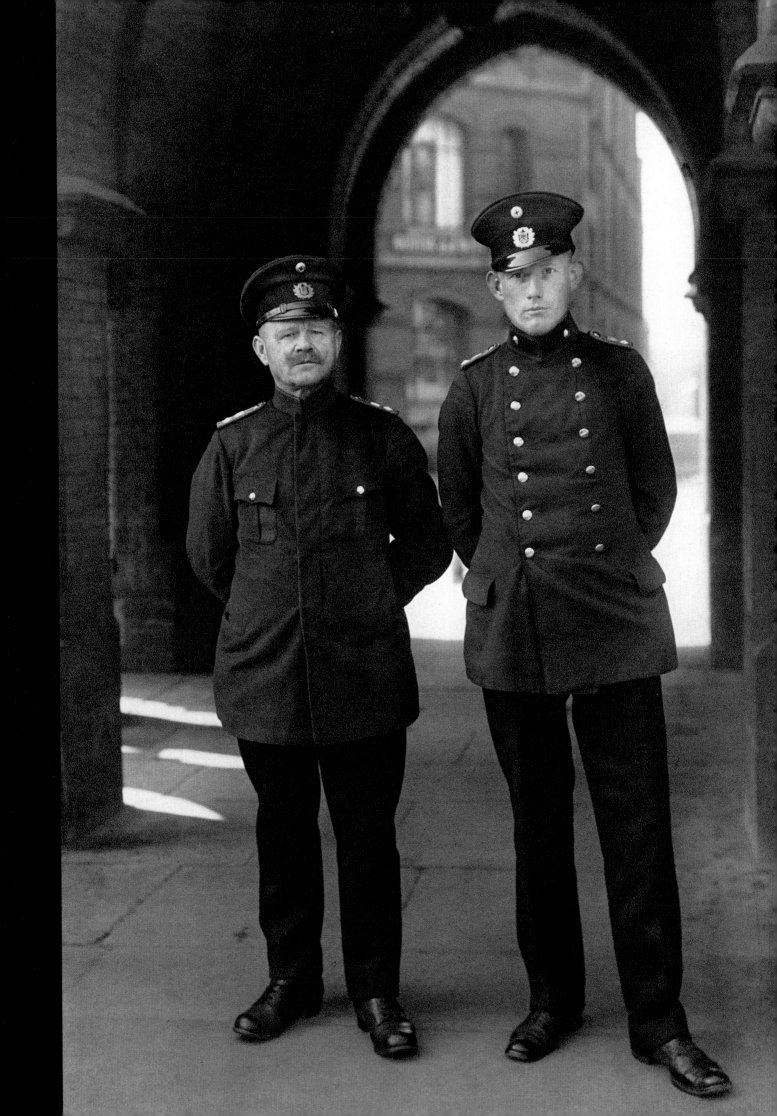

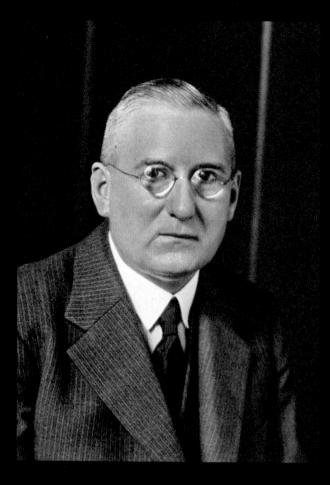

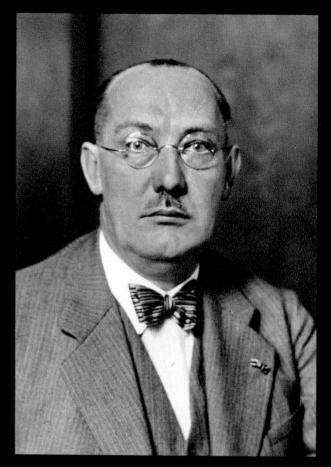

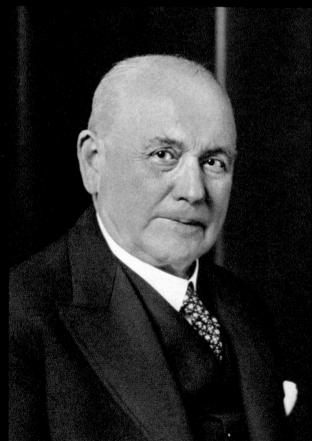

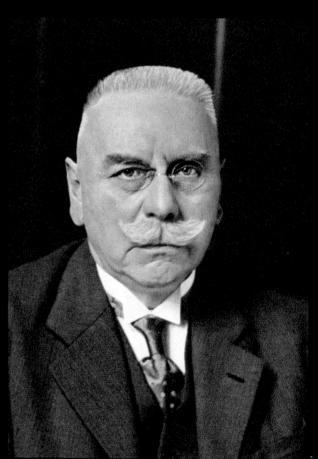

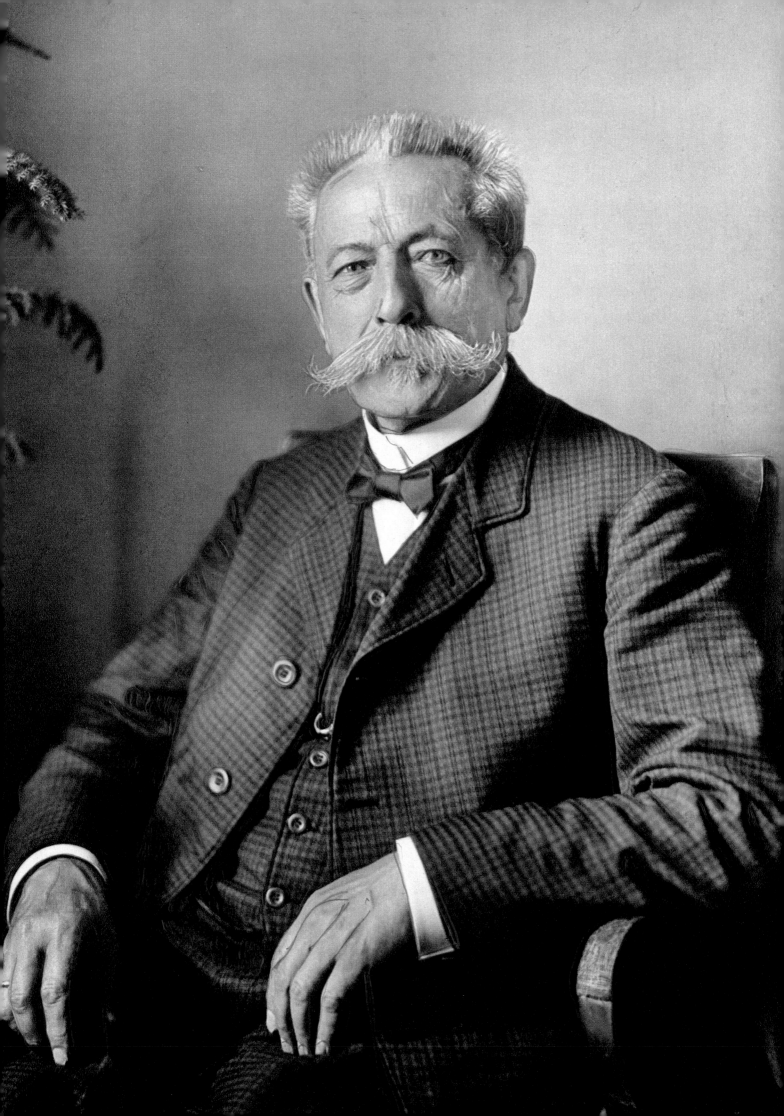

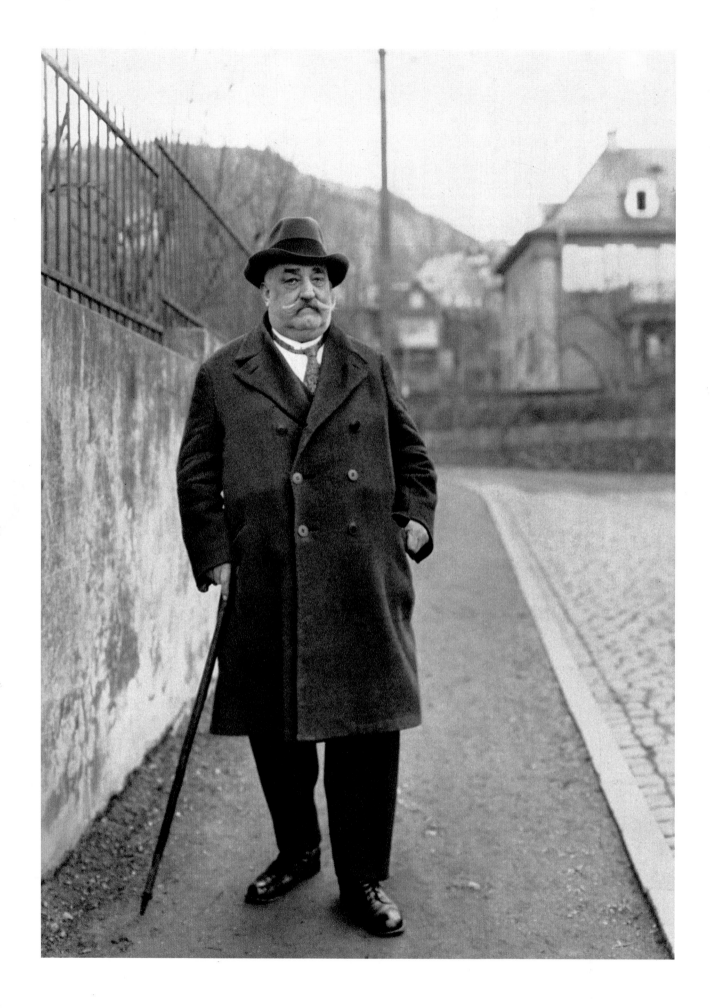

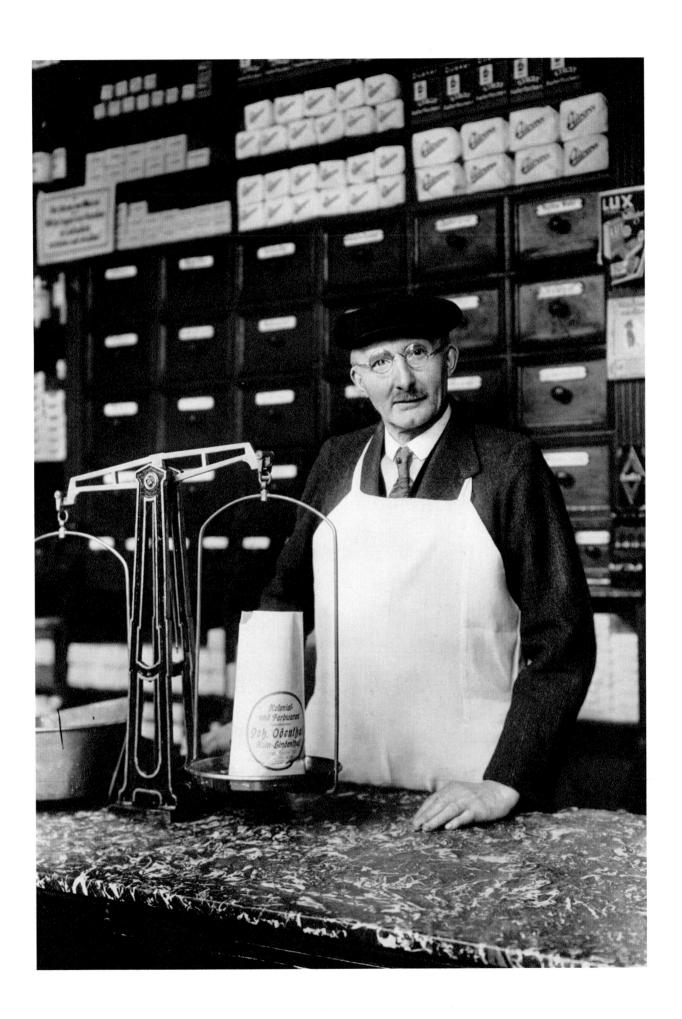

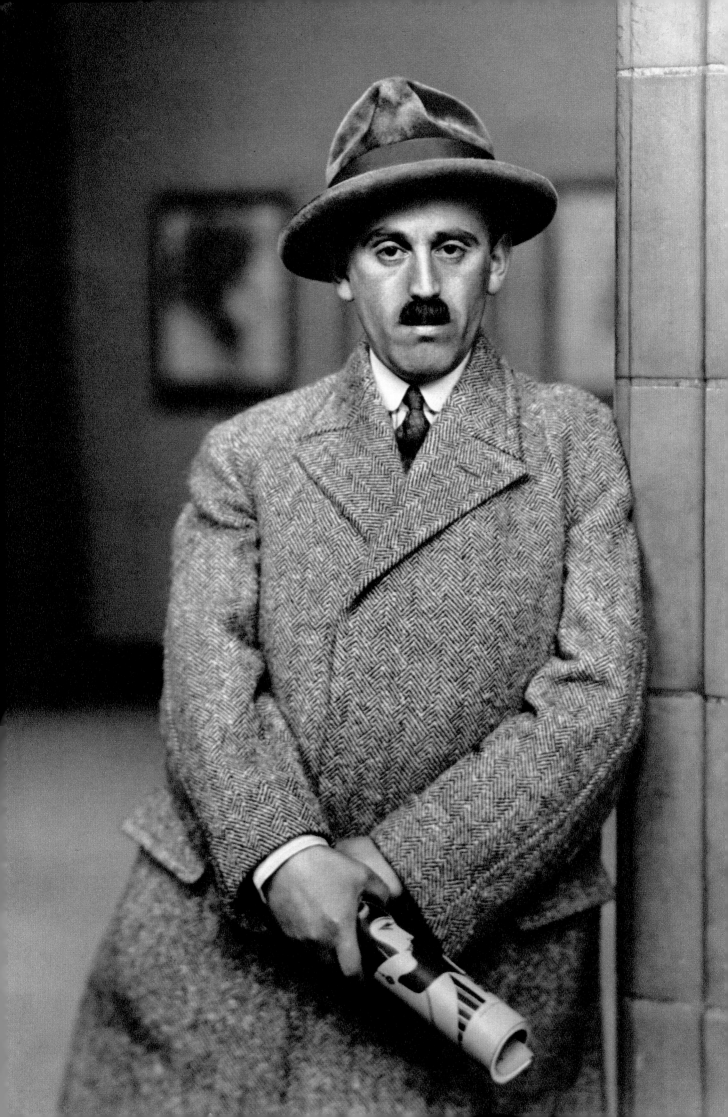

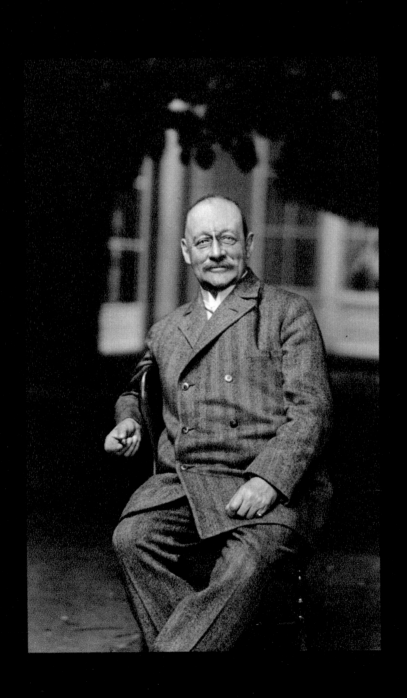

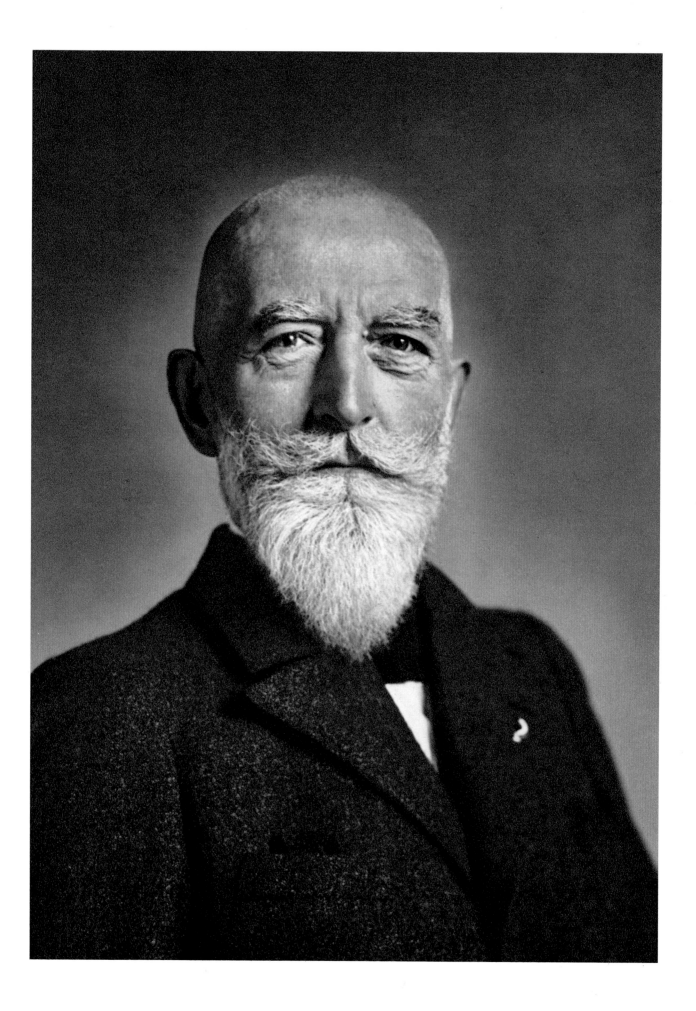

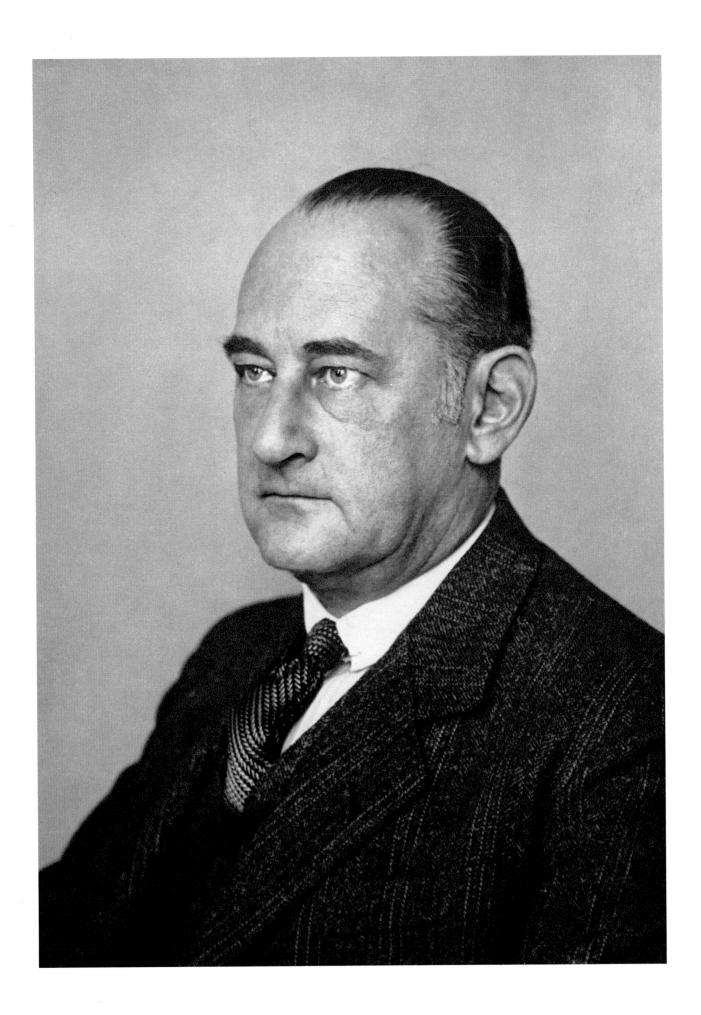

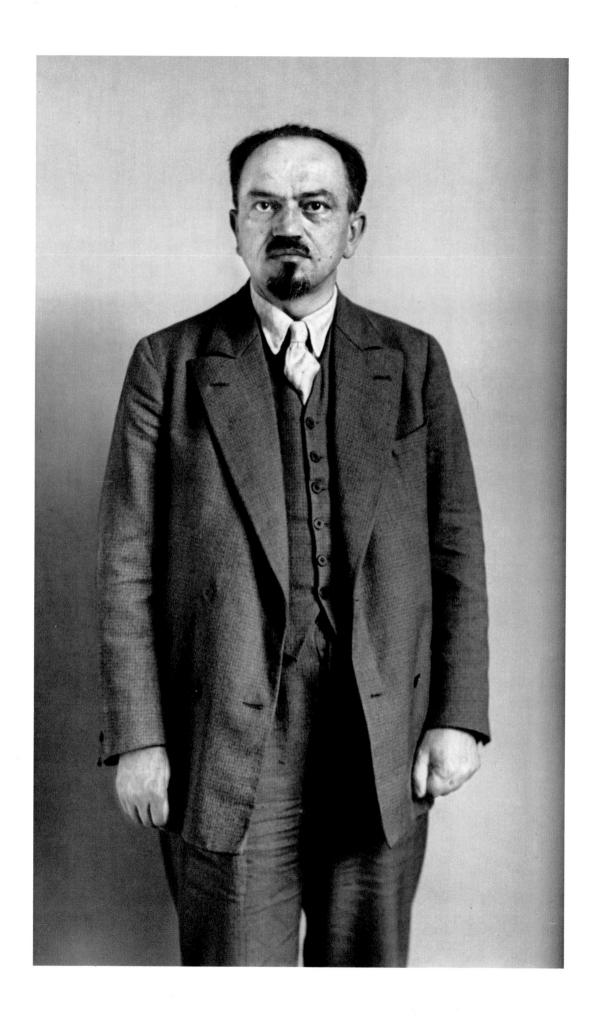

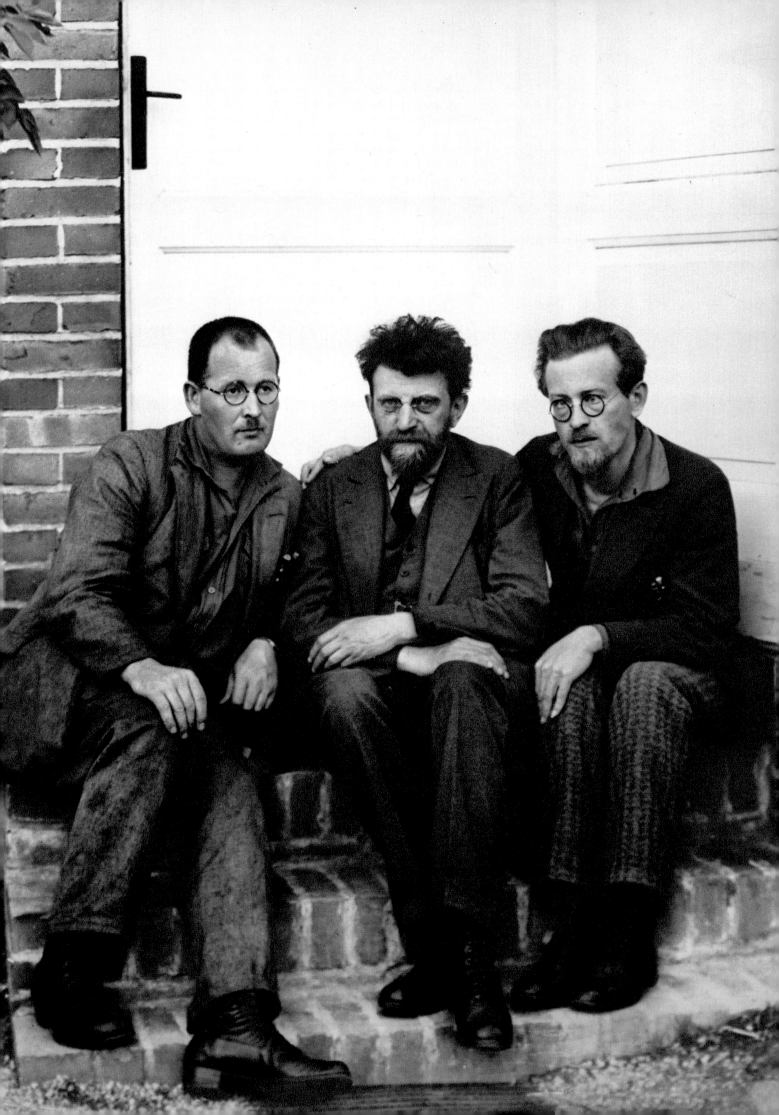

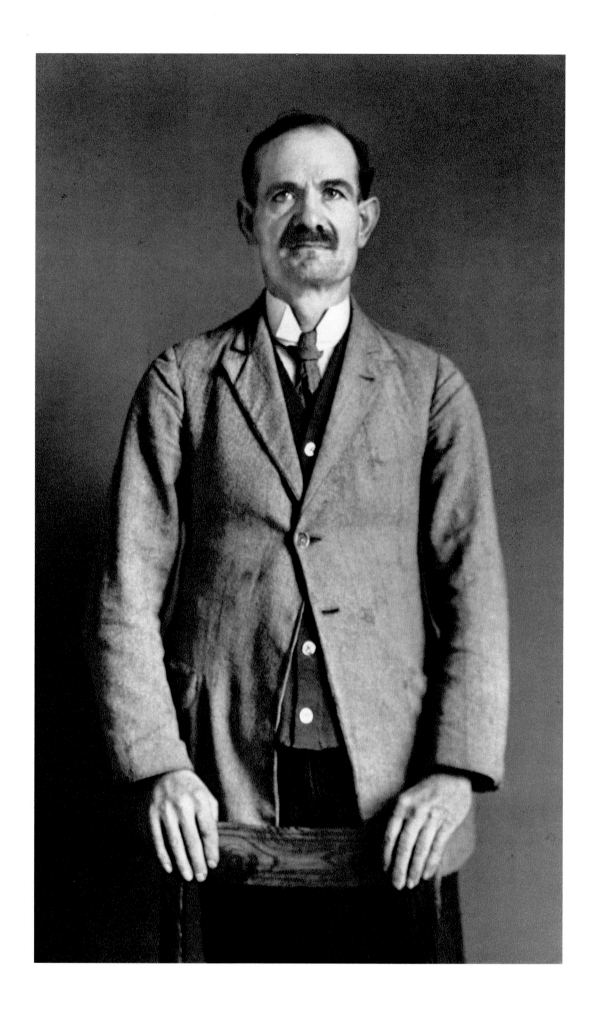

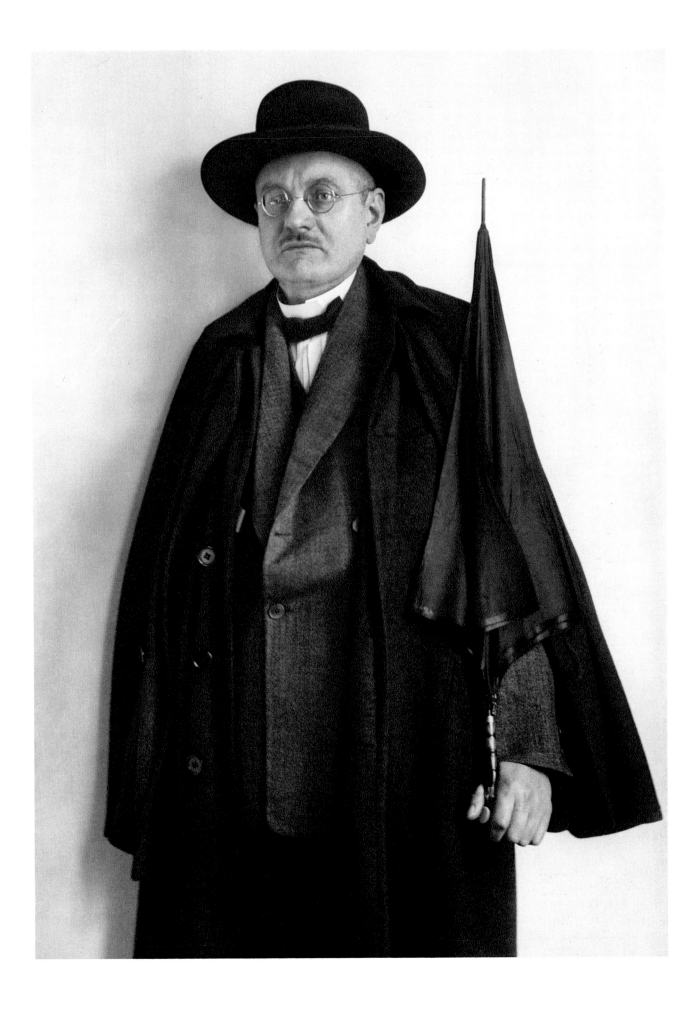

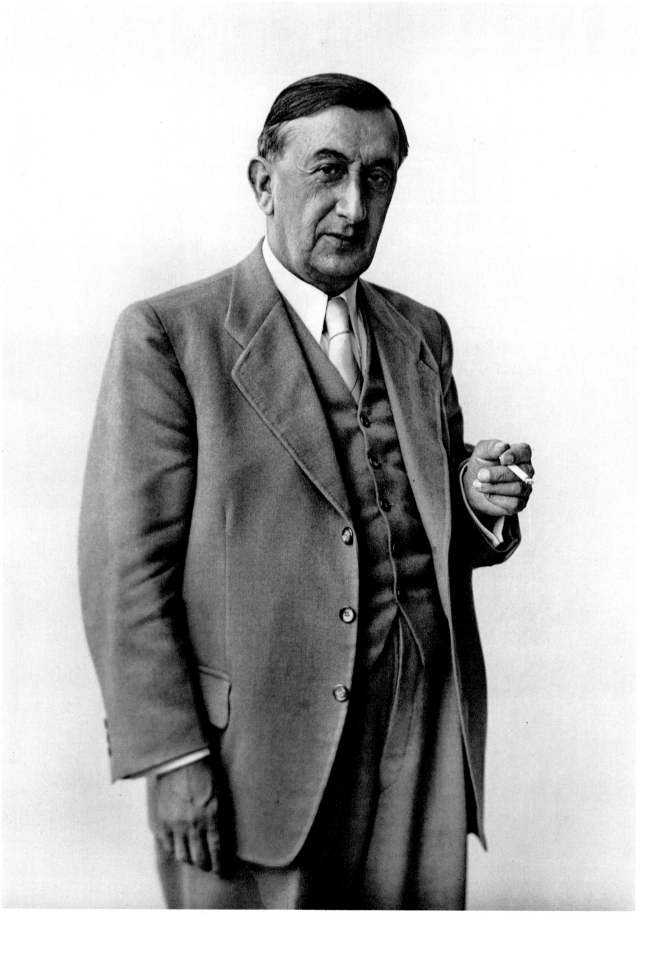

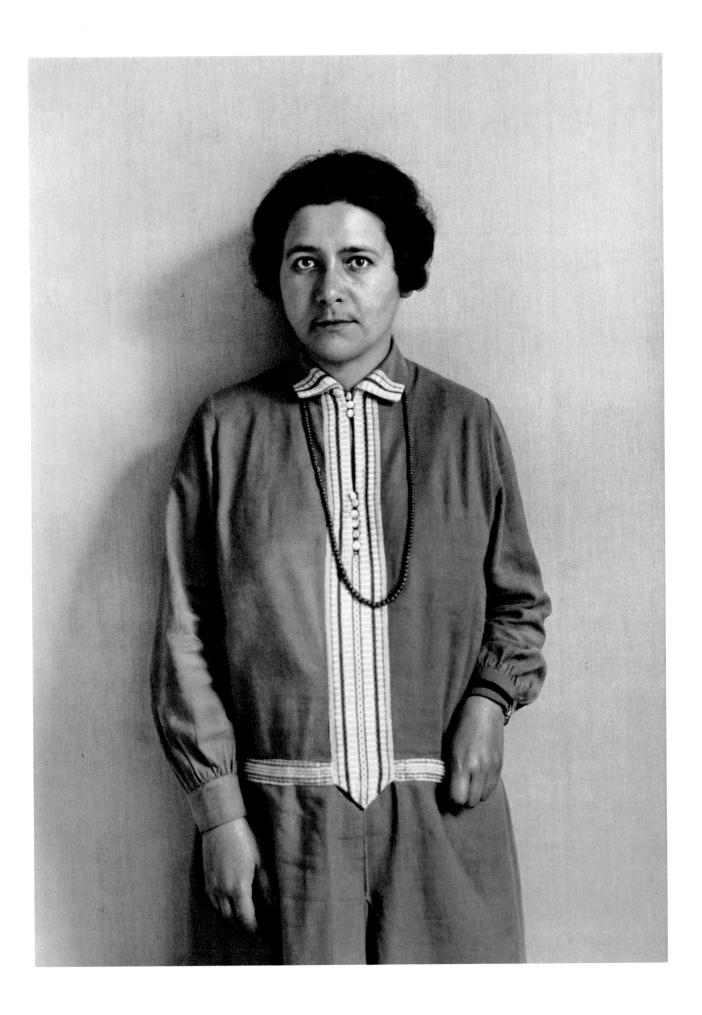

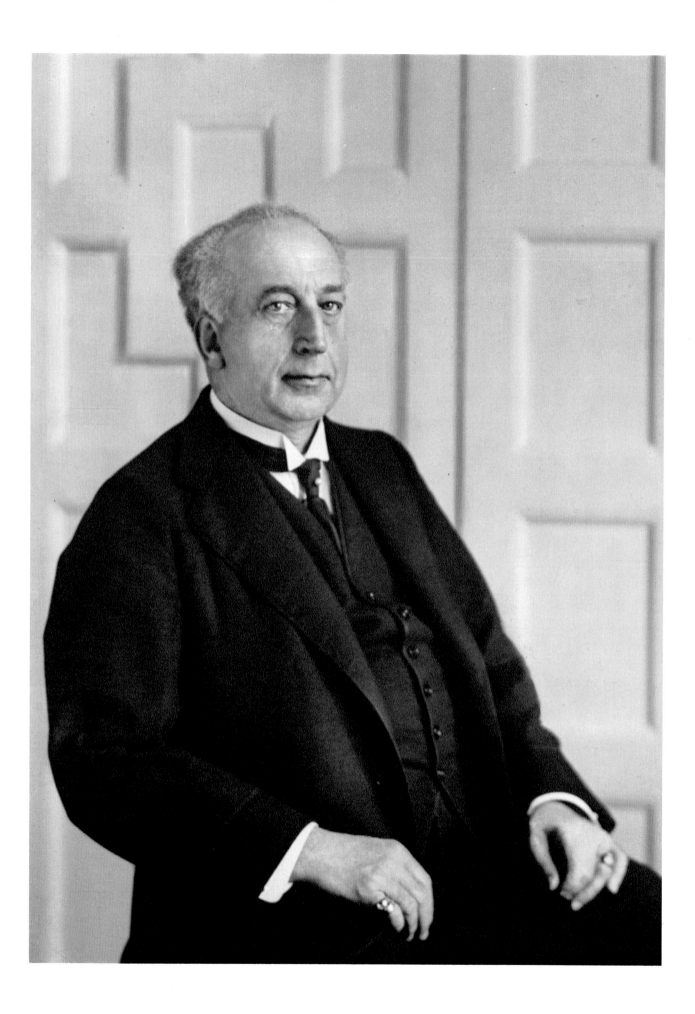

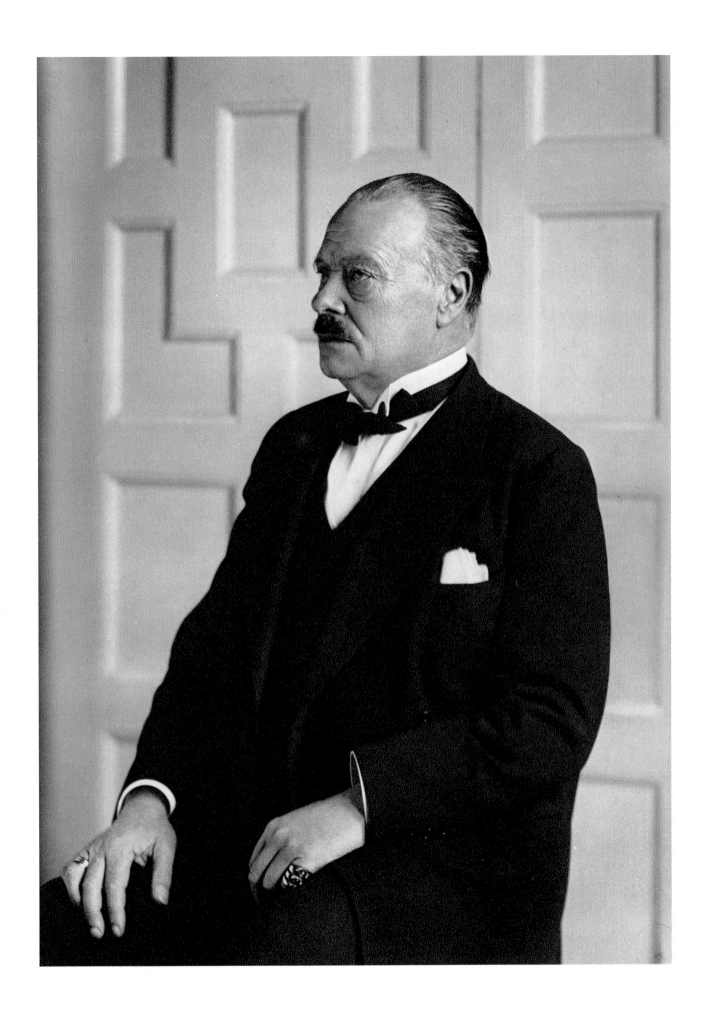

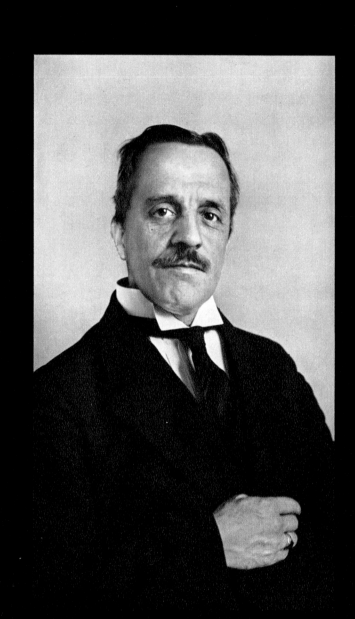

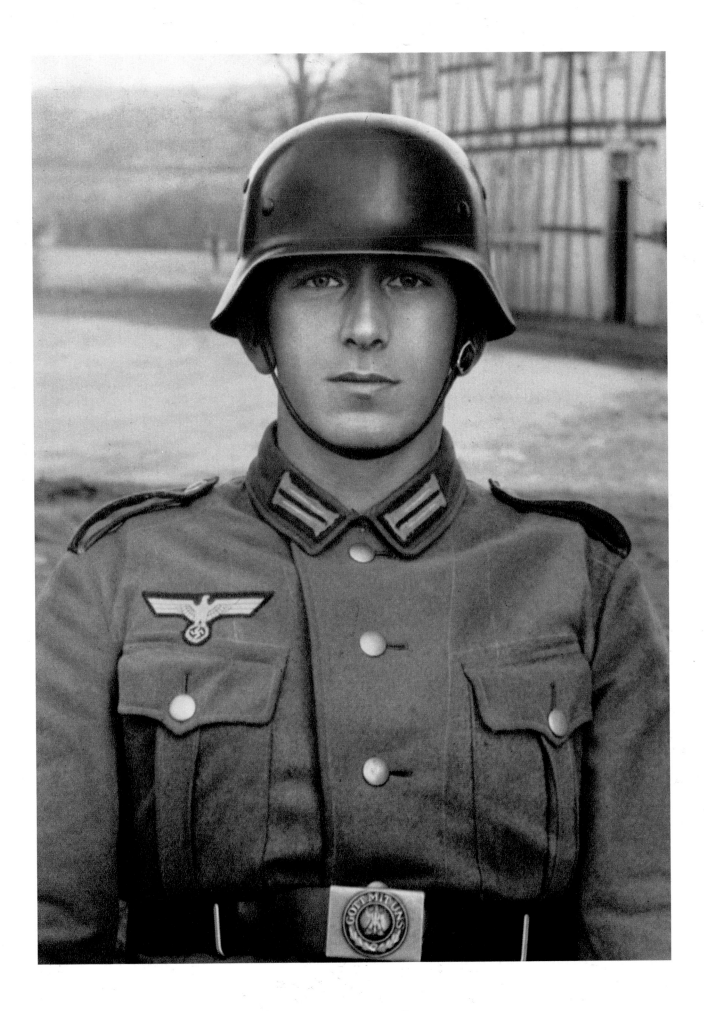

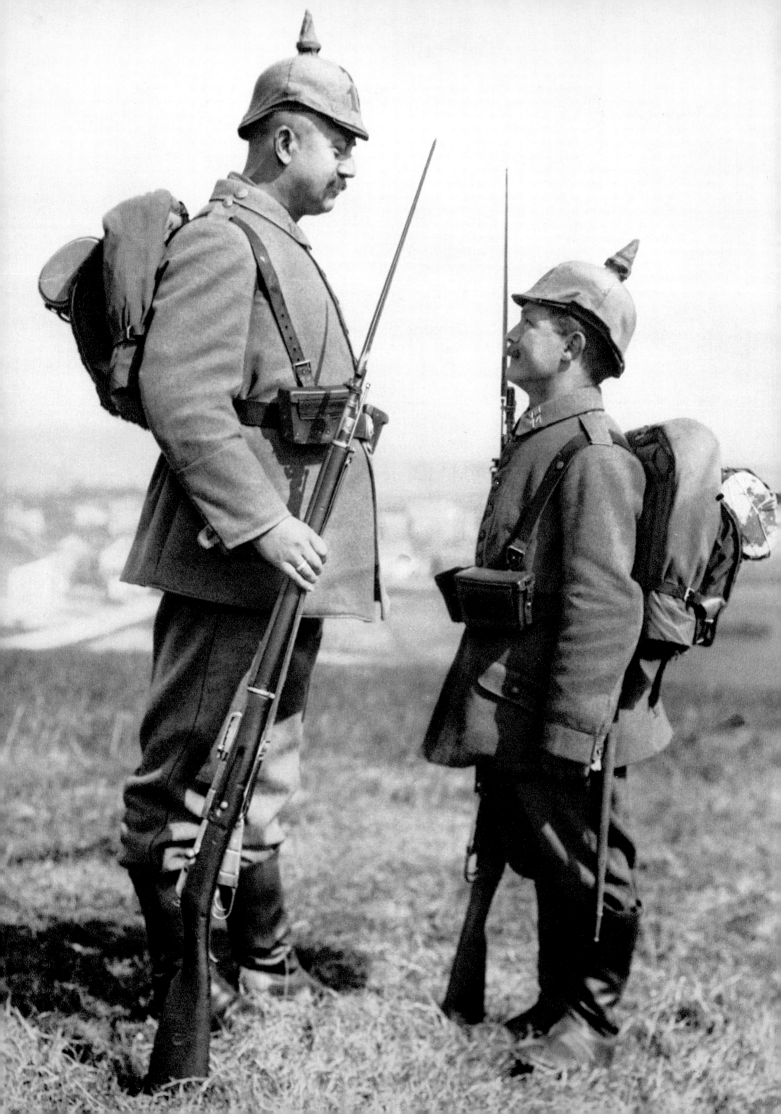

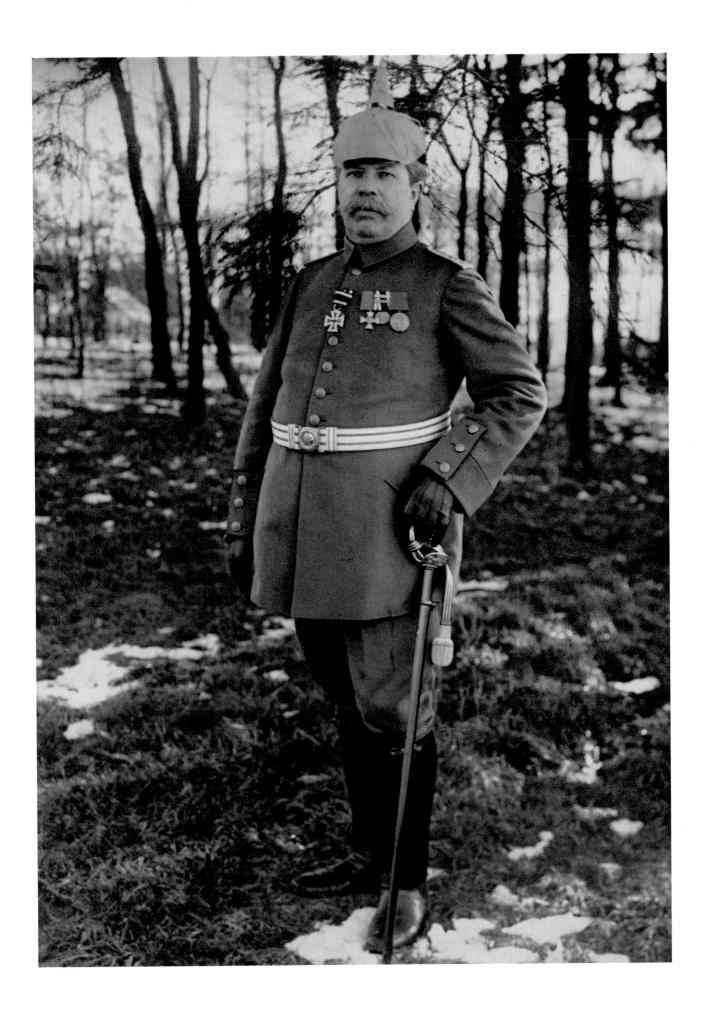

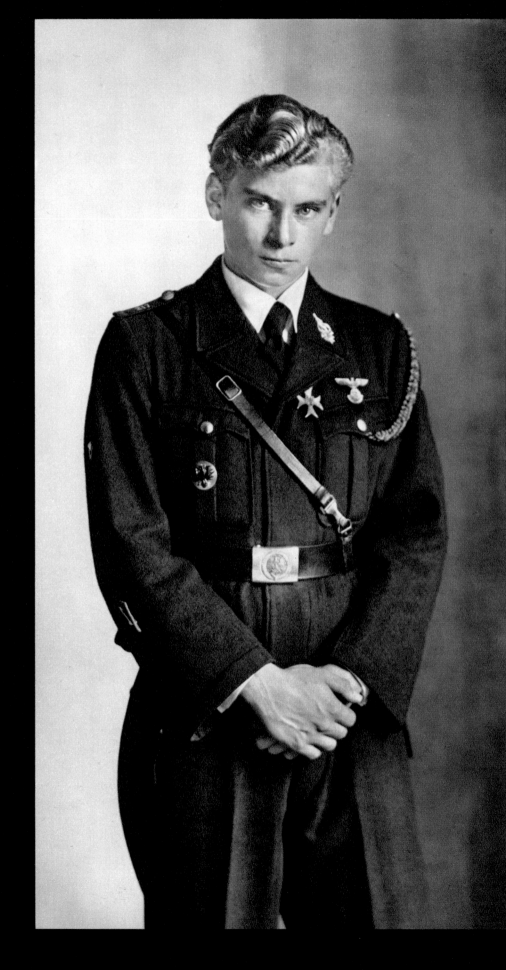

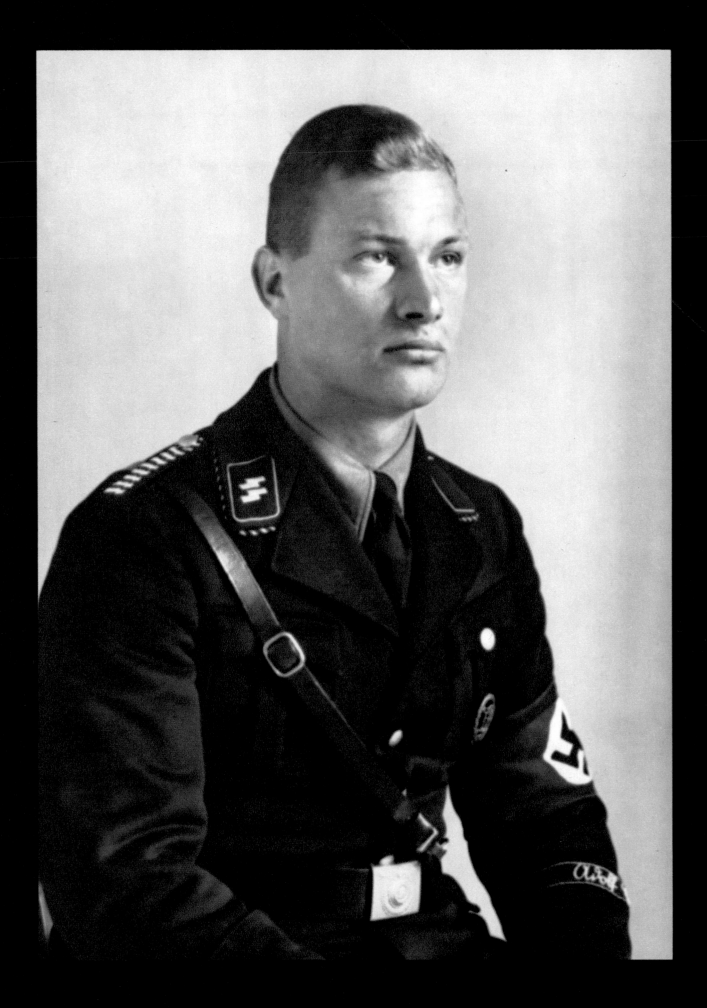

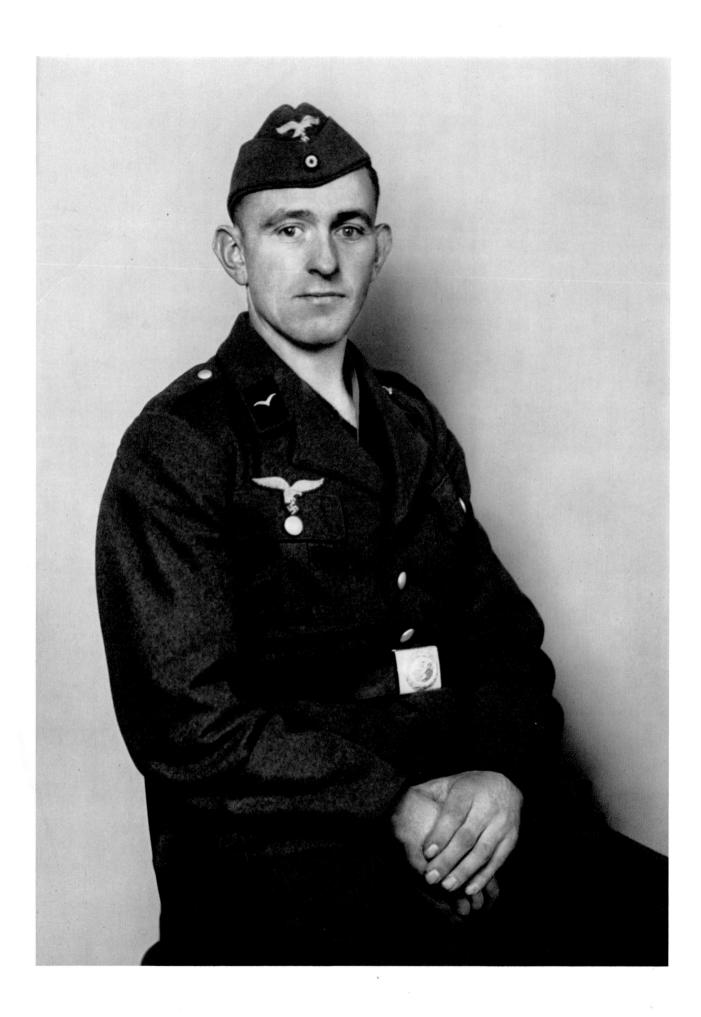

# Trades, Classes and Professions 3

Film actors (Berlin, 1952)

Workman and writer
(Cologne, 1928)

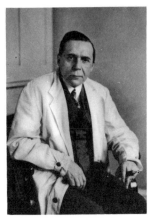

The Cologne architect
Edmund Bolten
(Cologne, 1932)

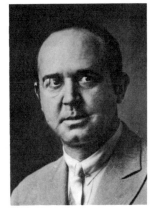

Fritz August Breuhaus
de Groot, Professor
of Architecture
(Düsseldorf, 1930)

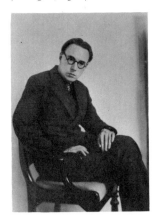

Otto Brües,
writer and editor of the
*Kölner Stadtanzeiger*
(Cologne, 1928)

The writer Karl Wittvogel
(Cologne, 1928)

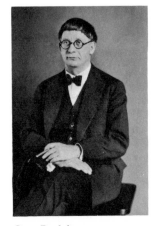

The Düsseldorf architect
Professor Emil Fahrenkamp
(1928)

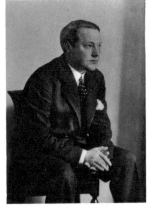

Otto Poelzig,
Professor of Architecture
(Berlin, 1928)

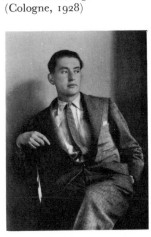

The writer Claus Clausen
(Bonn, 1928)

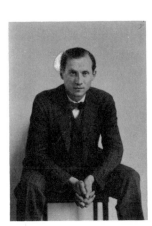

The writer Albert Busche
(Hamburg, 1928)

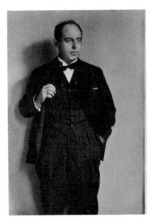

The Cologne architect
Dr Wilhelm Riphahn
(Cologne, 1930)

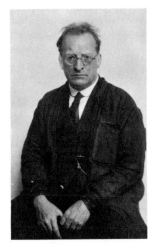

Prof. Wilhelm Riemer-
schmid, Director of the
Cologne Technical Schools
(1928)

Painters

Sculptors

Musicians

Composers

Actors

Writers

Architects

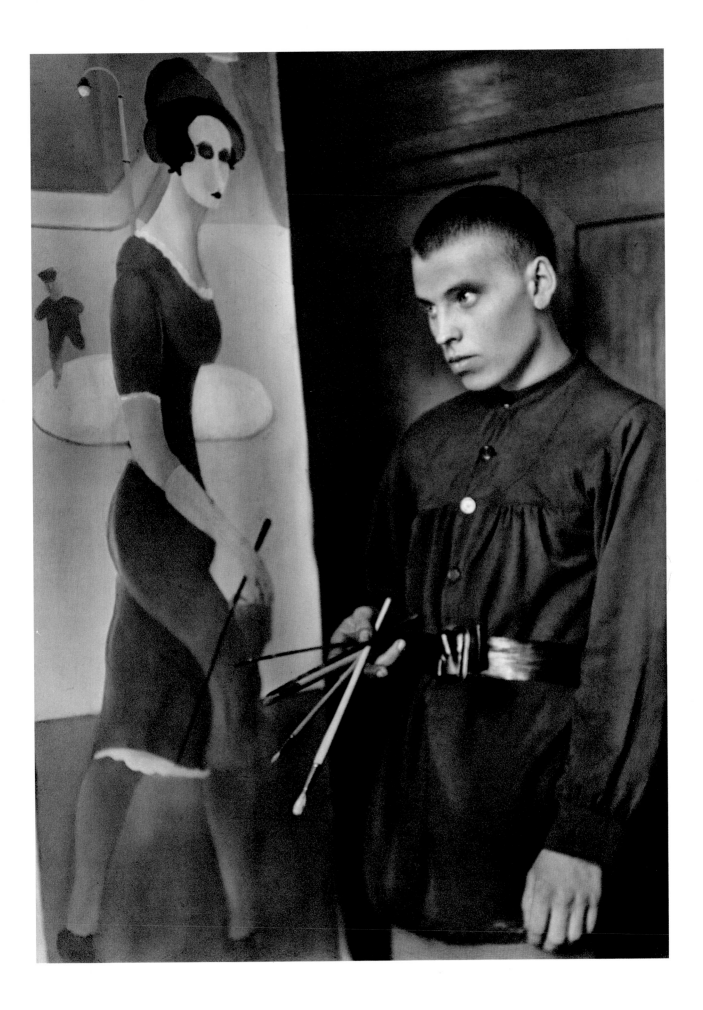

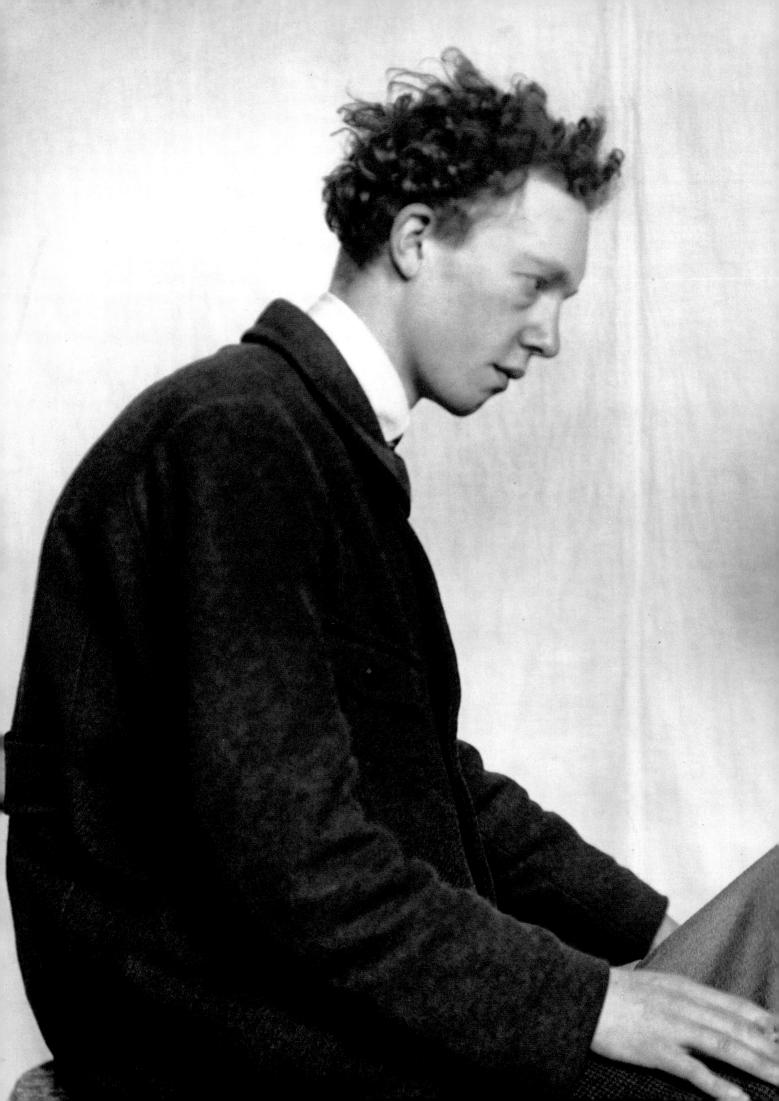

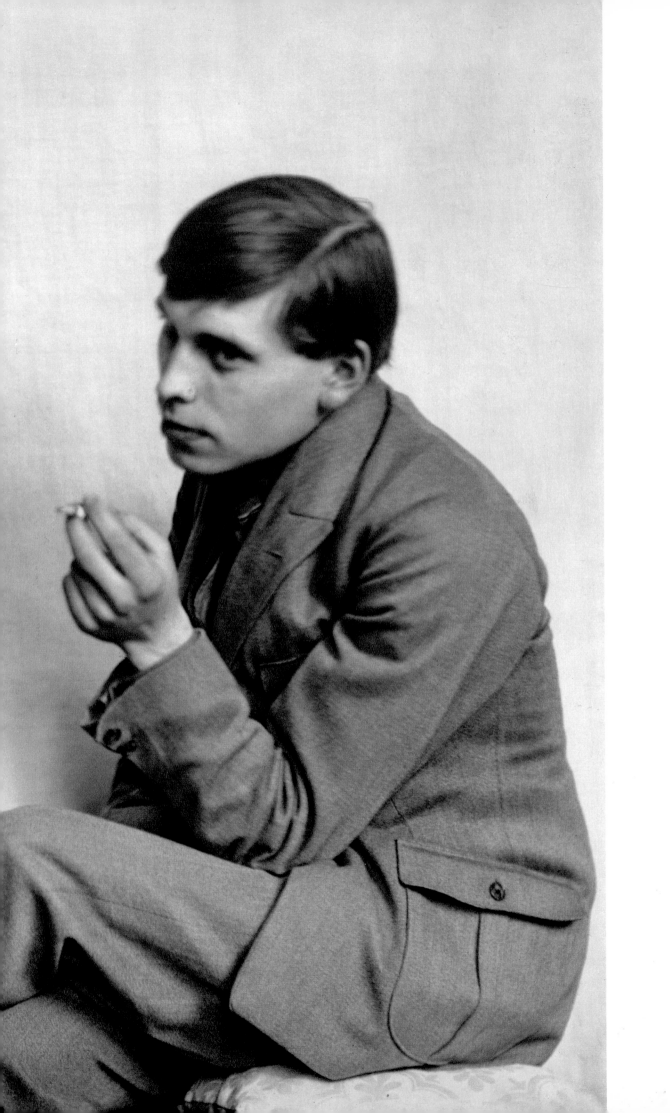

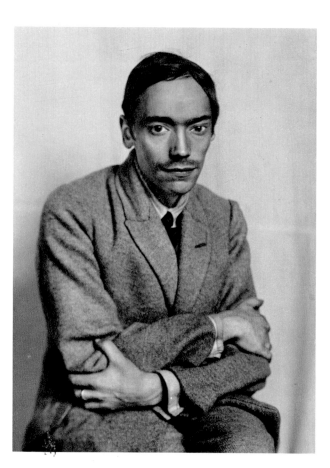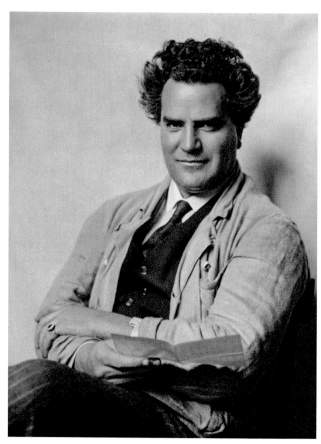

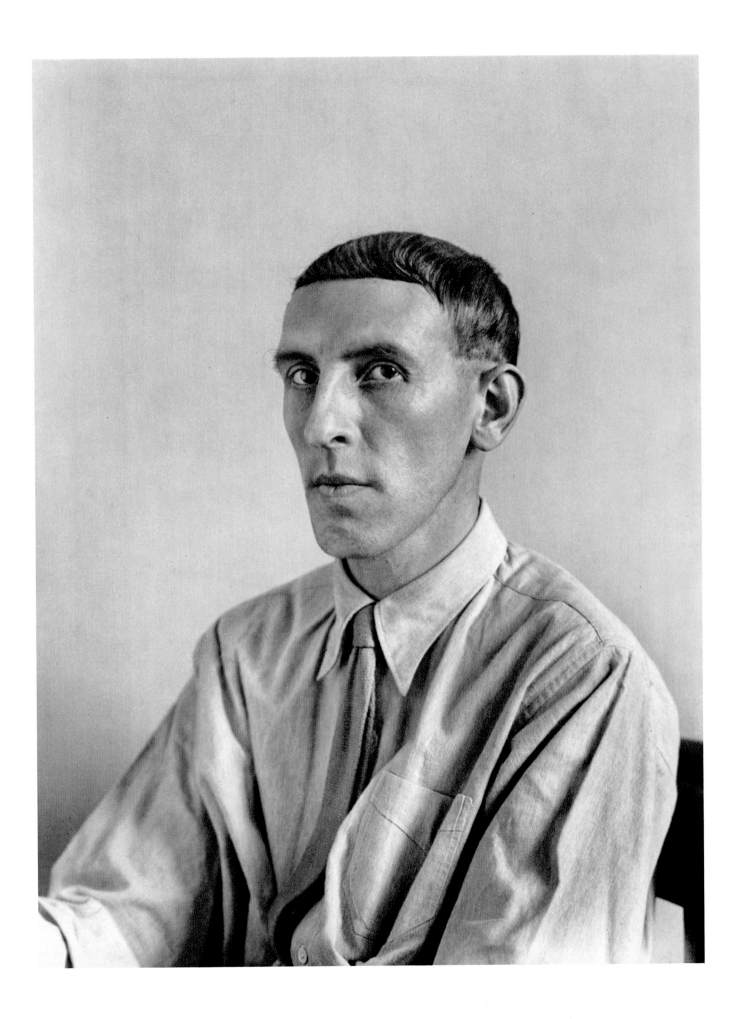

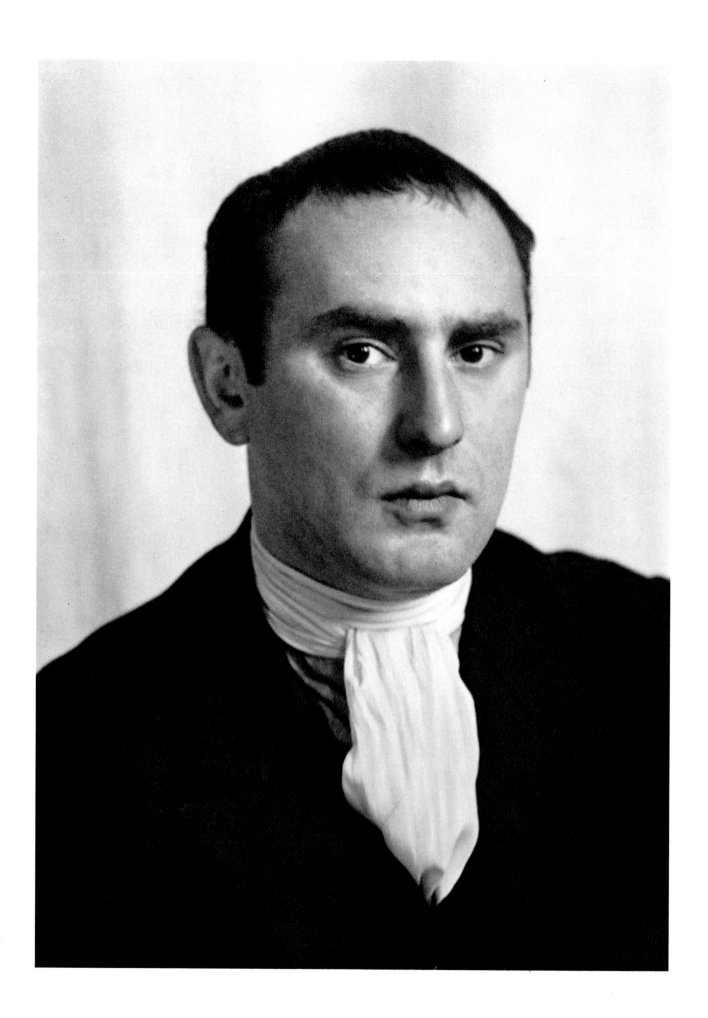

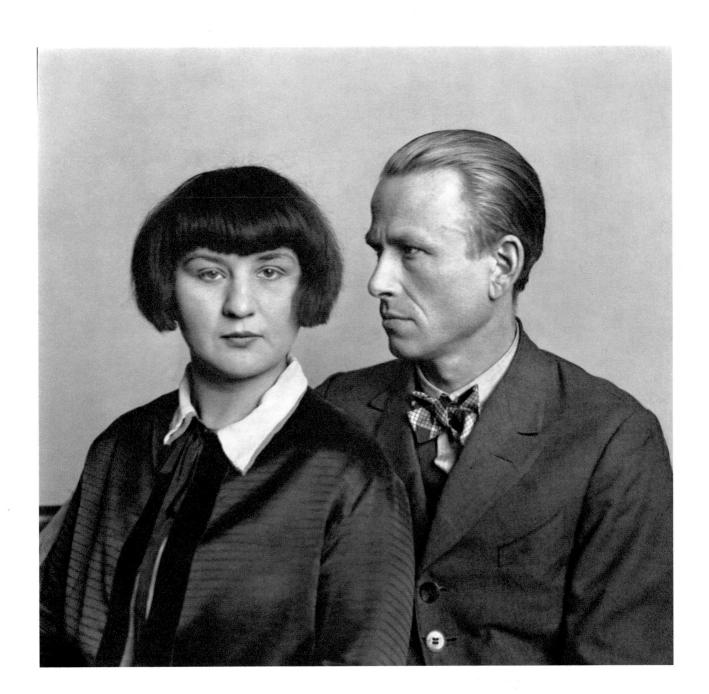

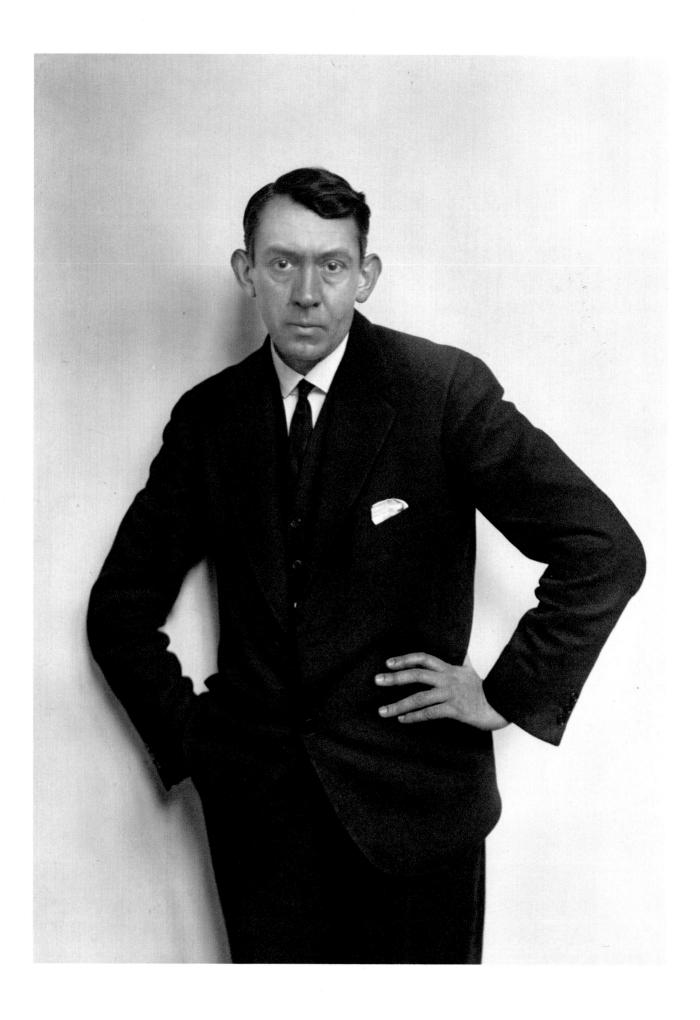

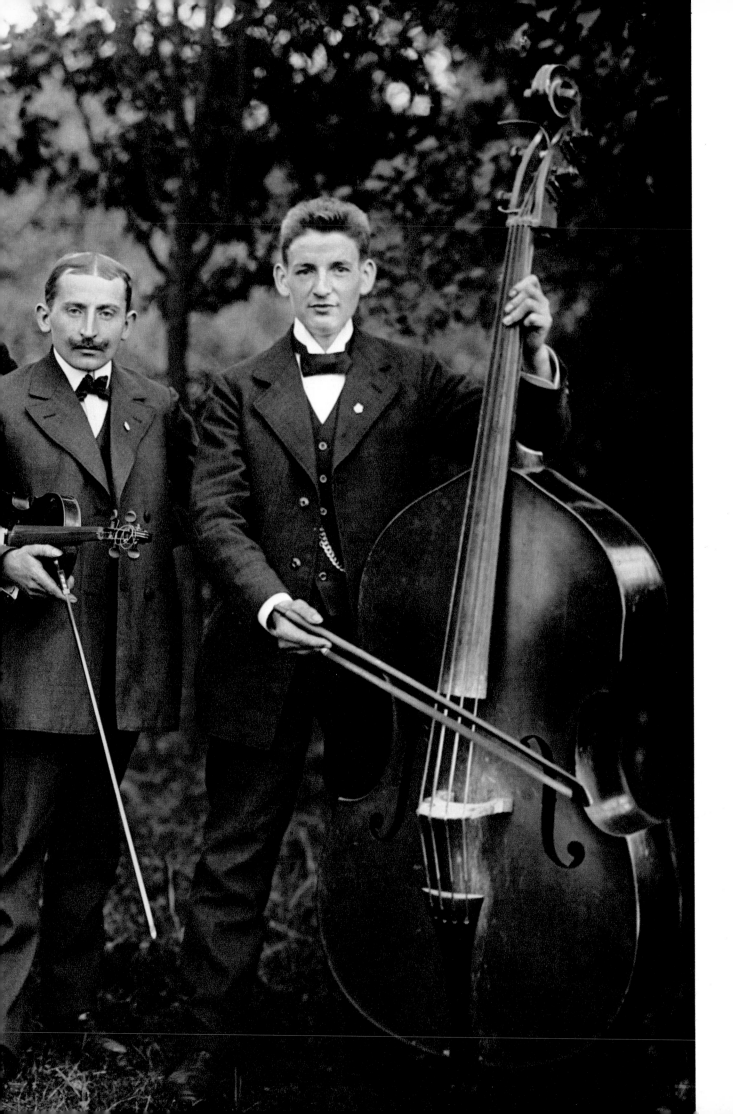

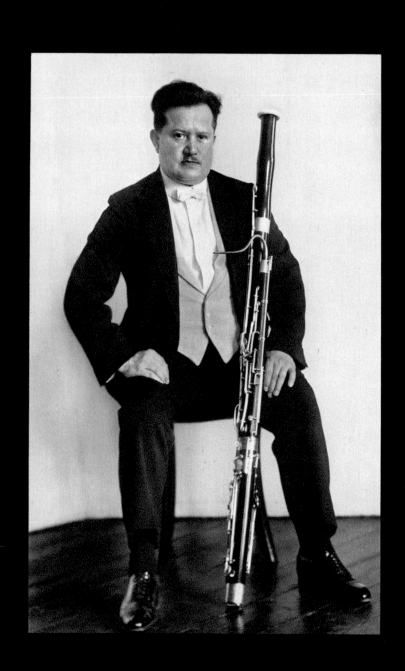

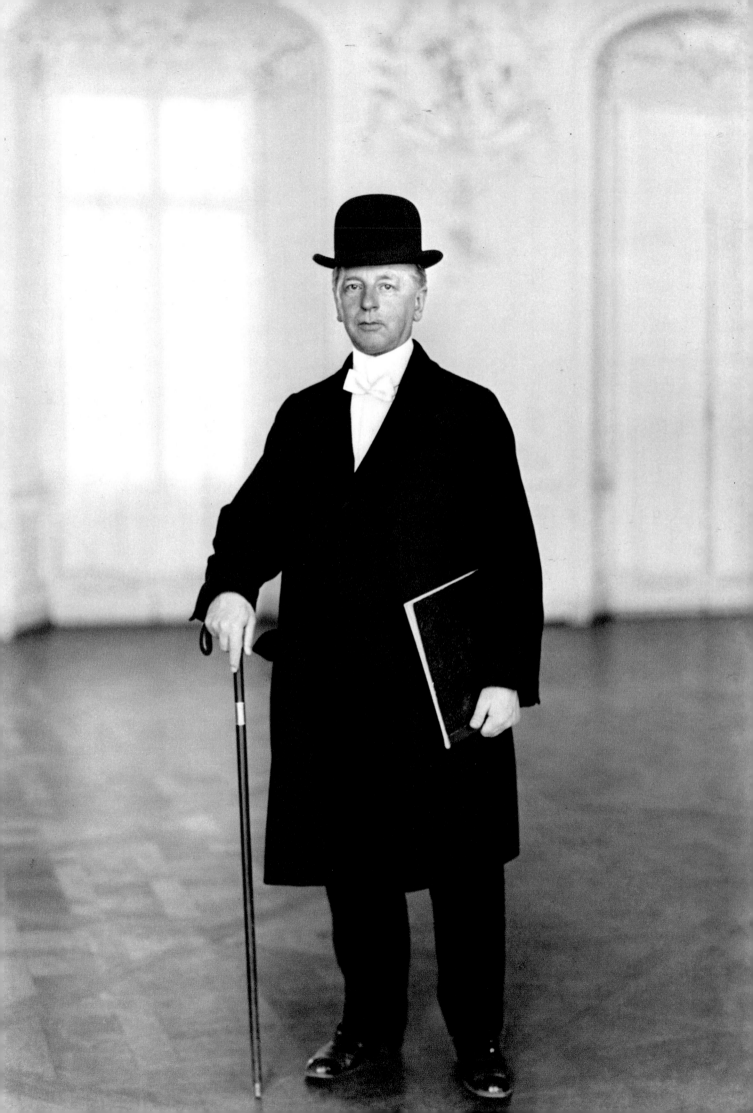

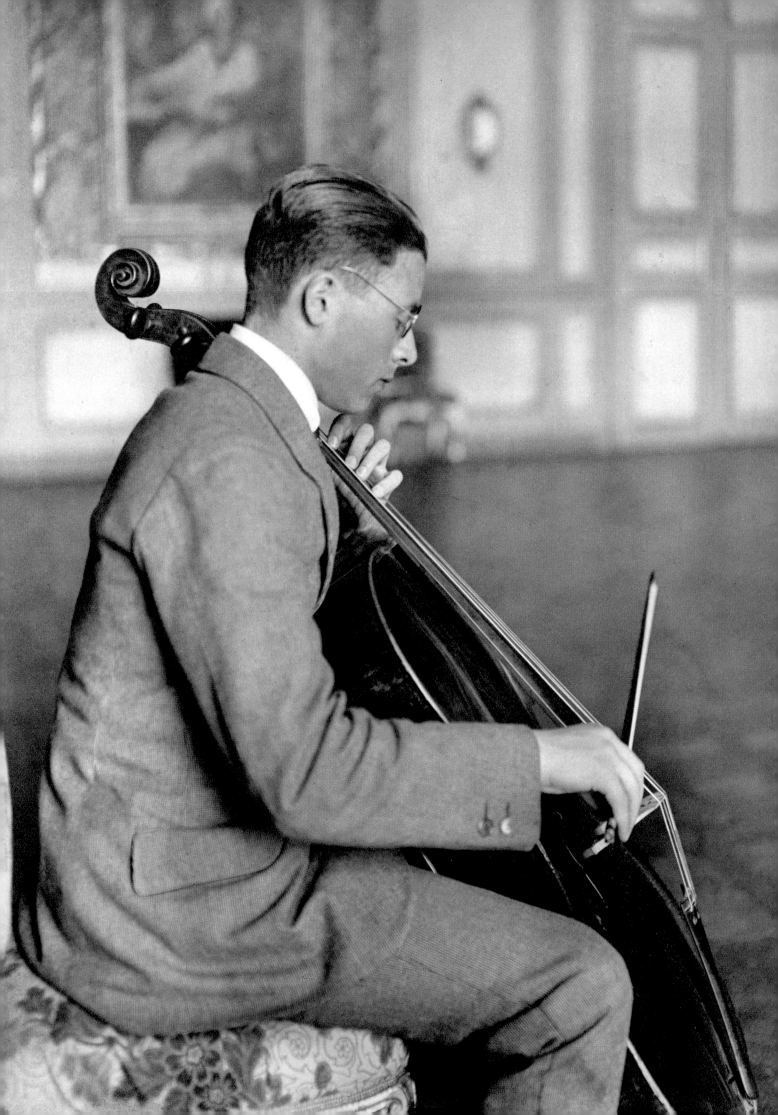

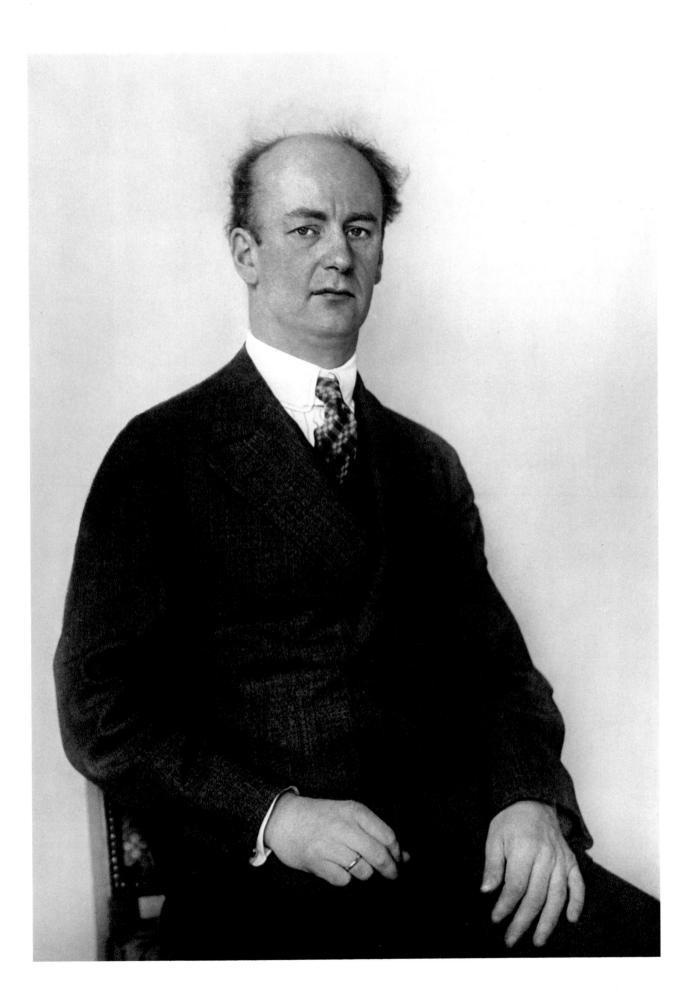

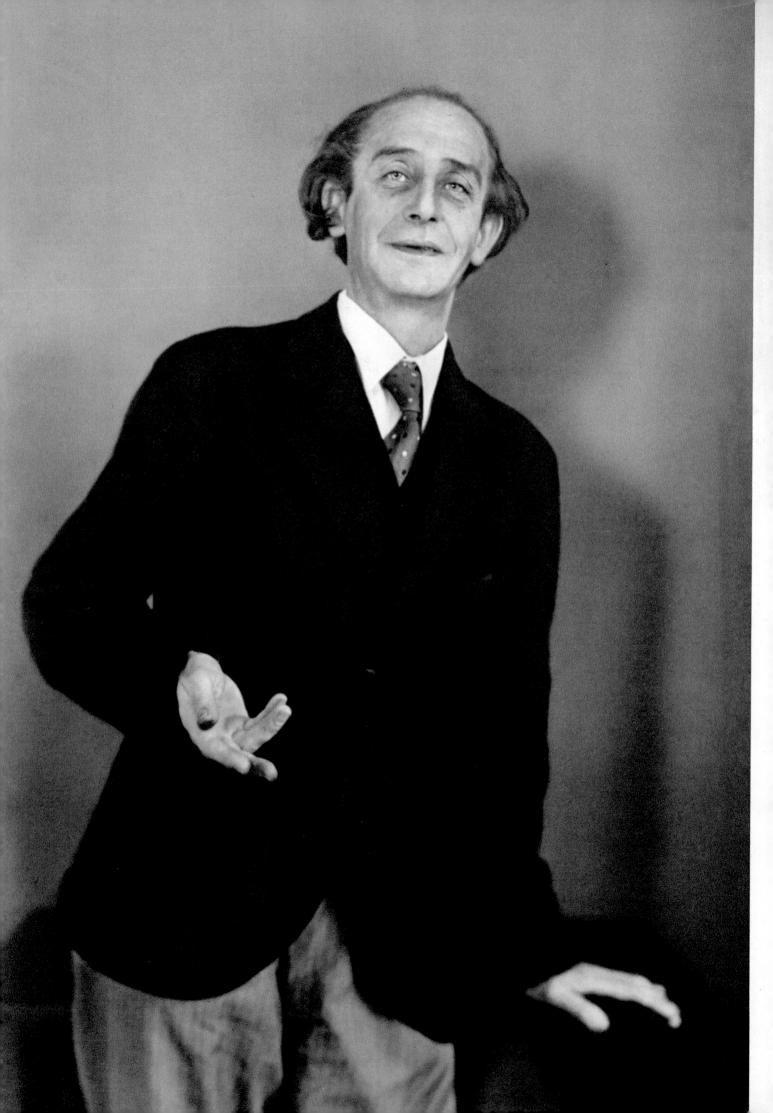

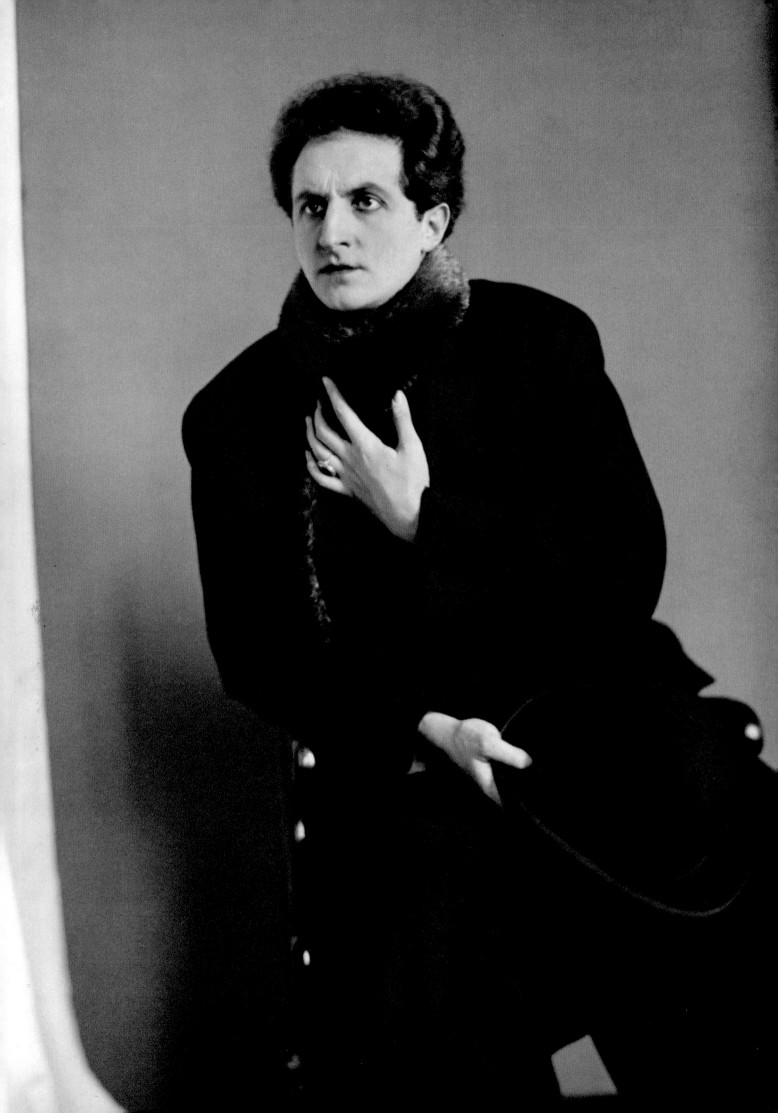

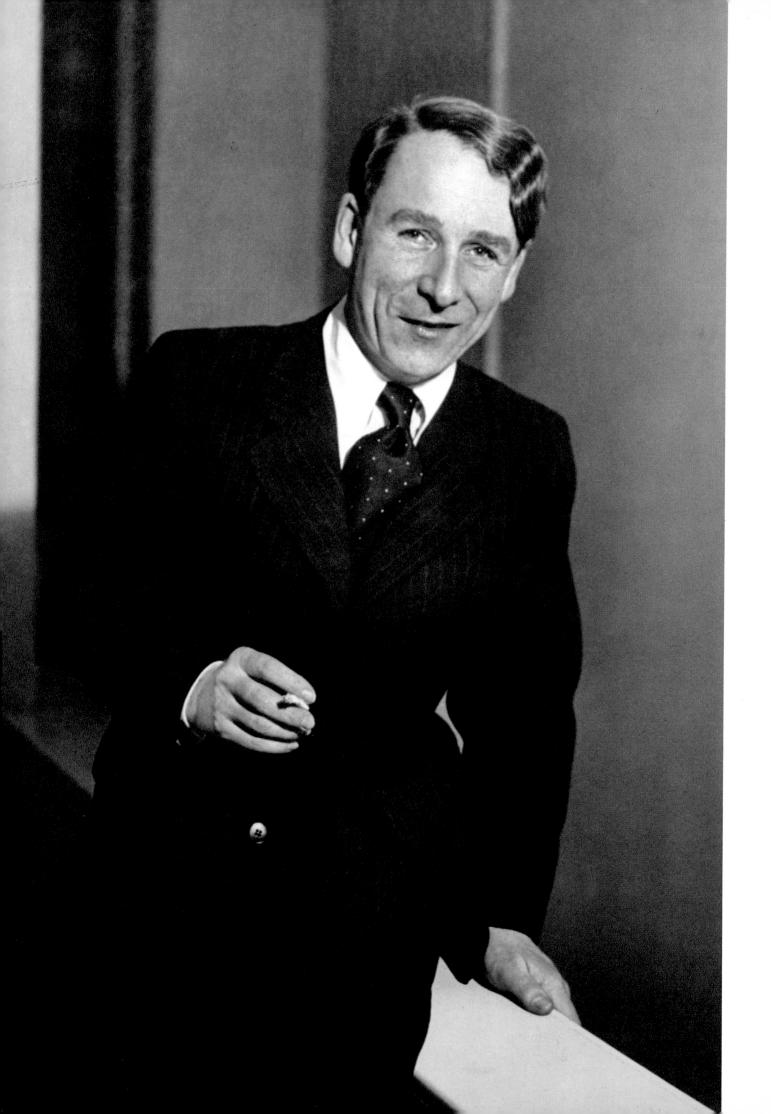

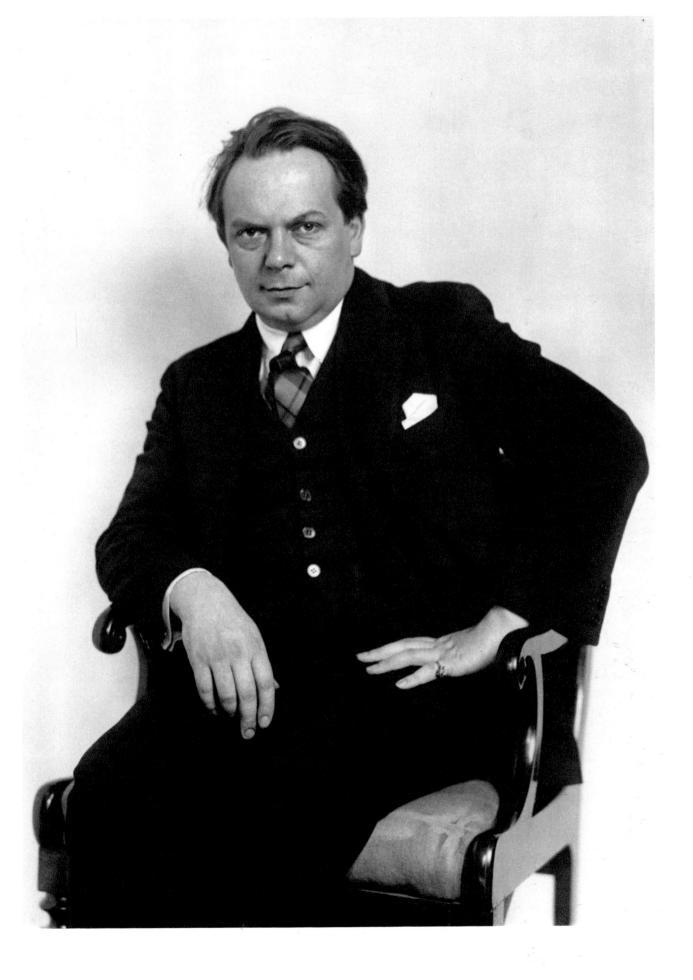

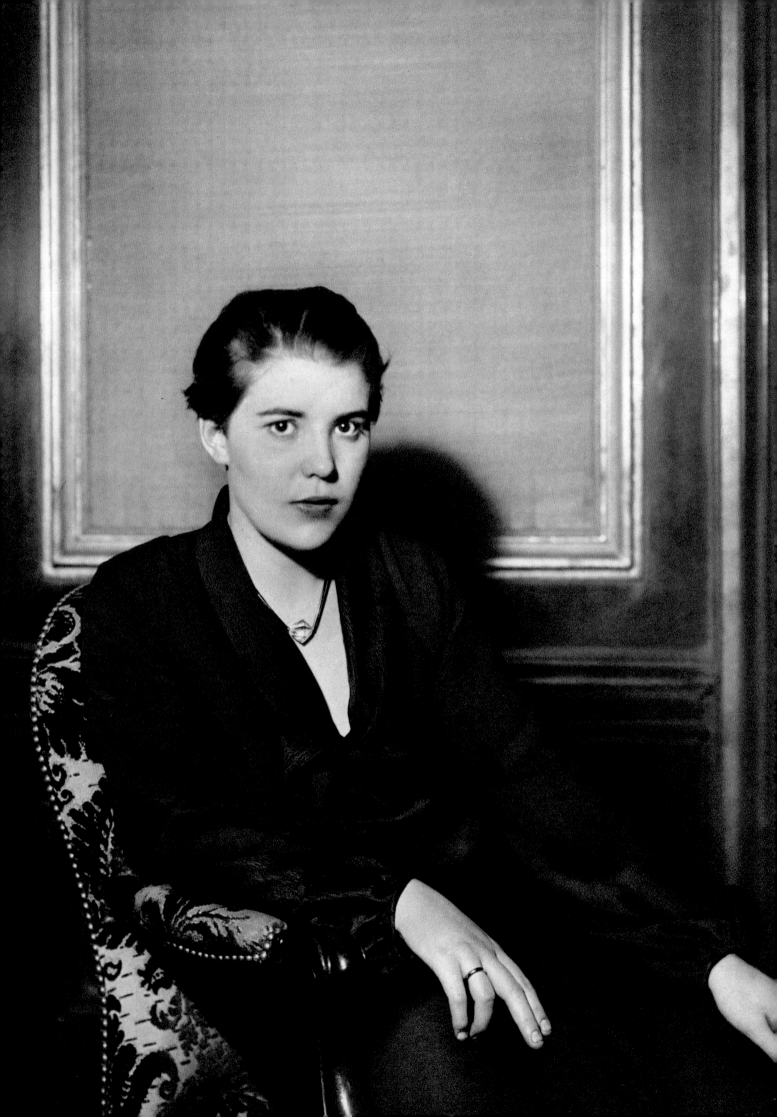

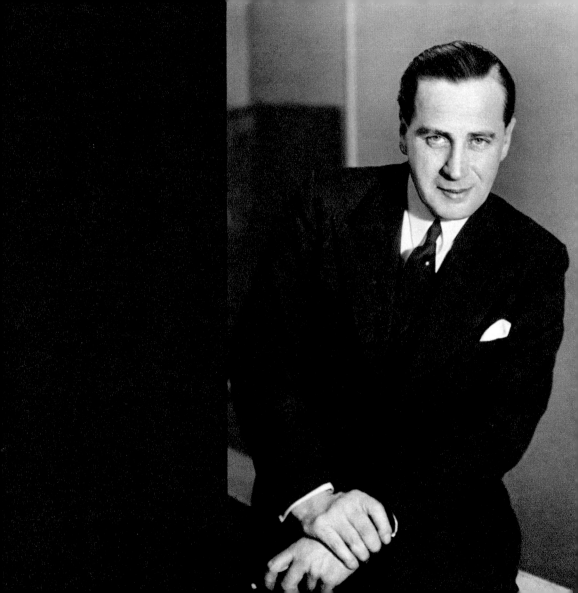

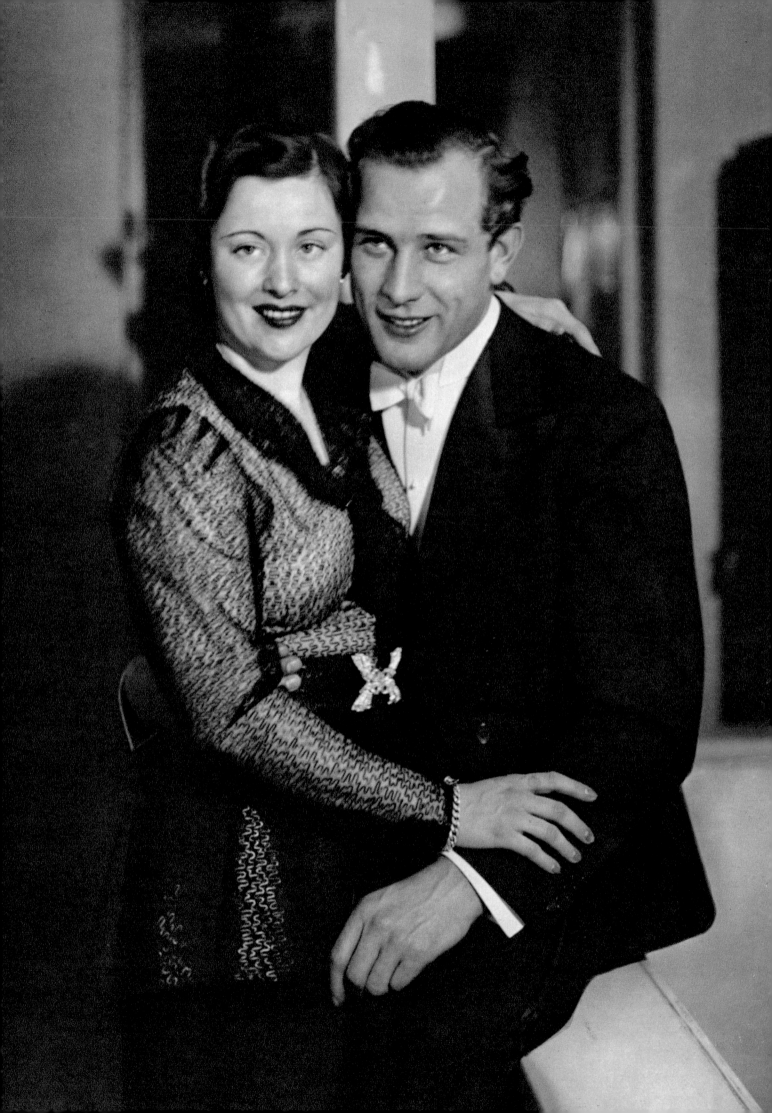

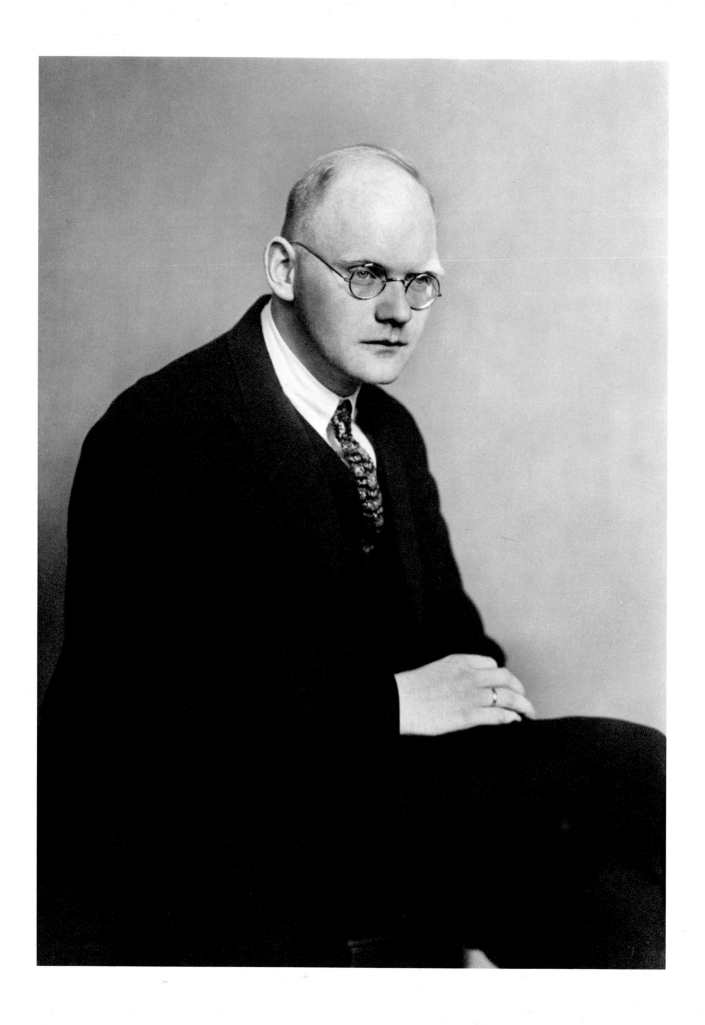

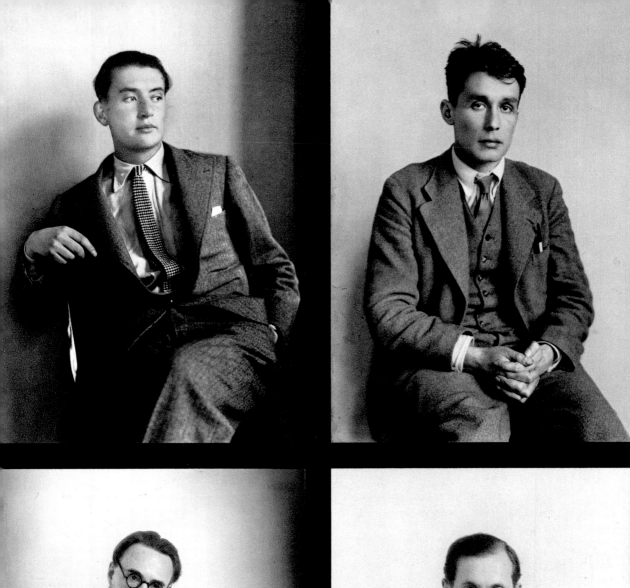
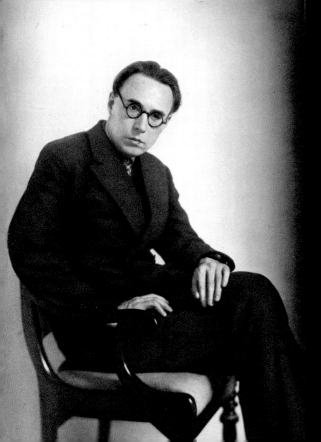

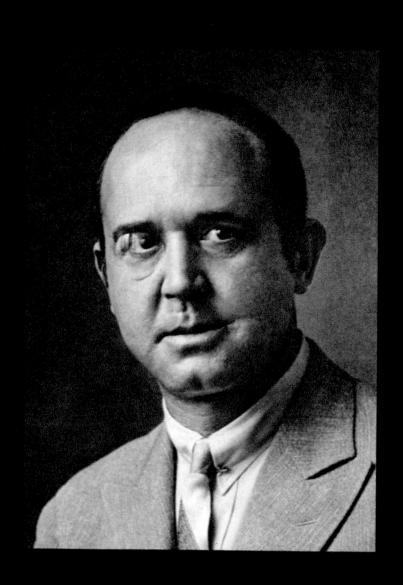

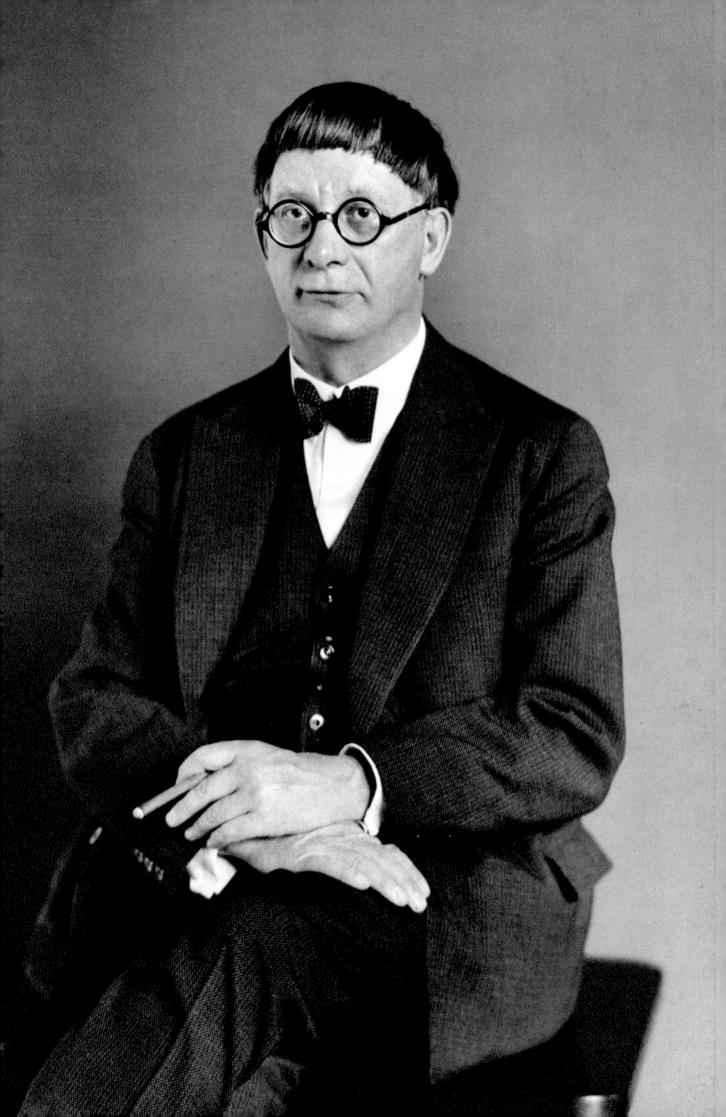

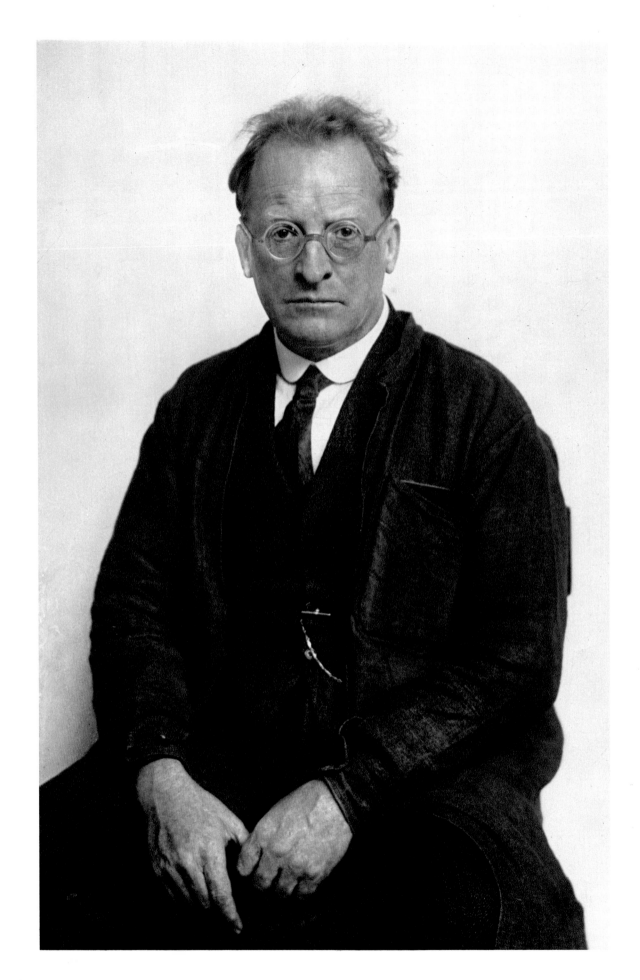

# Life 1

Y

'Hannes', a Lindenthal eccentric who worked as a broker (Cologne, 1928)

Dancing teacher (Cologne, 1932)

Wife of the Cologne architect Wilhelm Riphahn (Cologne, 1931)

Secretary at West German Radio (Cologne, 1931)

Manageress of a dress firm (Trier, 1932)

Society lady (Cologne, 1932)

Wife of the Cologne painter Peter Abelen (Cologne, 1926)

Man and wife

Mother and child

The family

Professional women

Society ladies

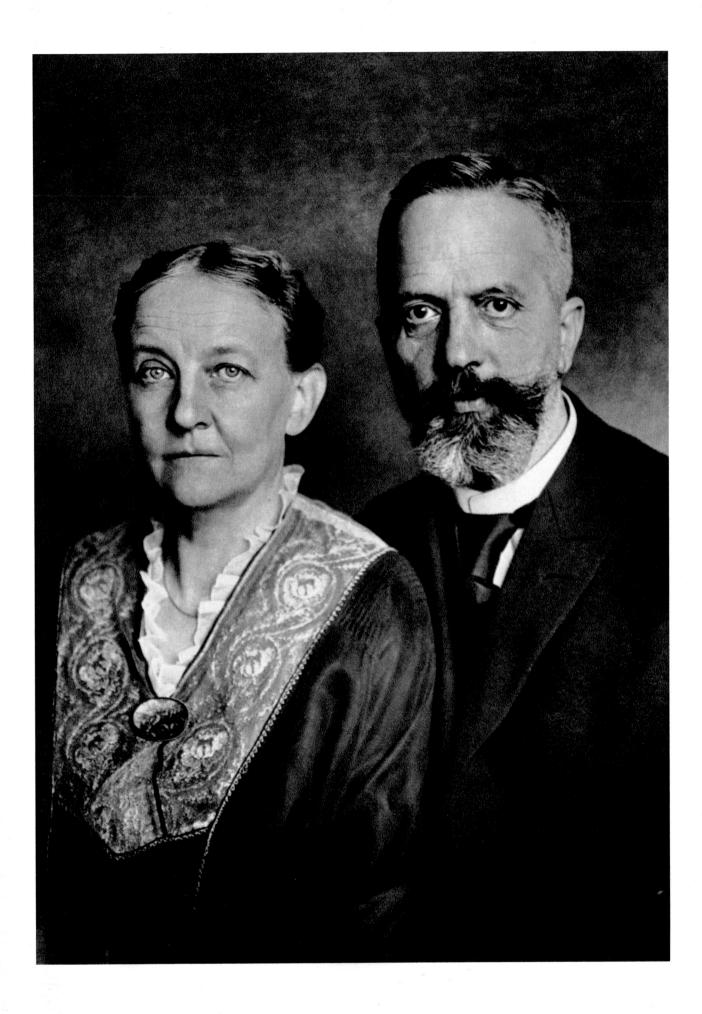

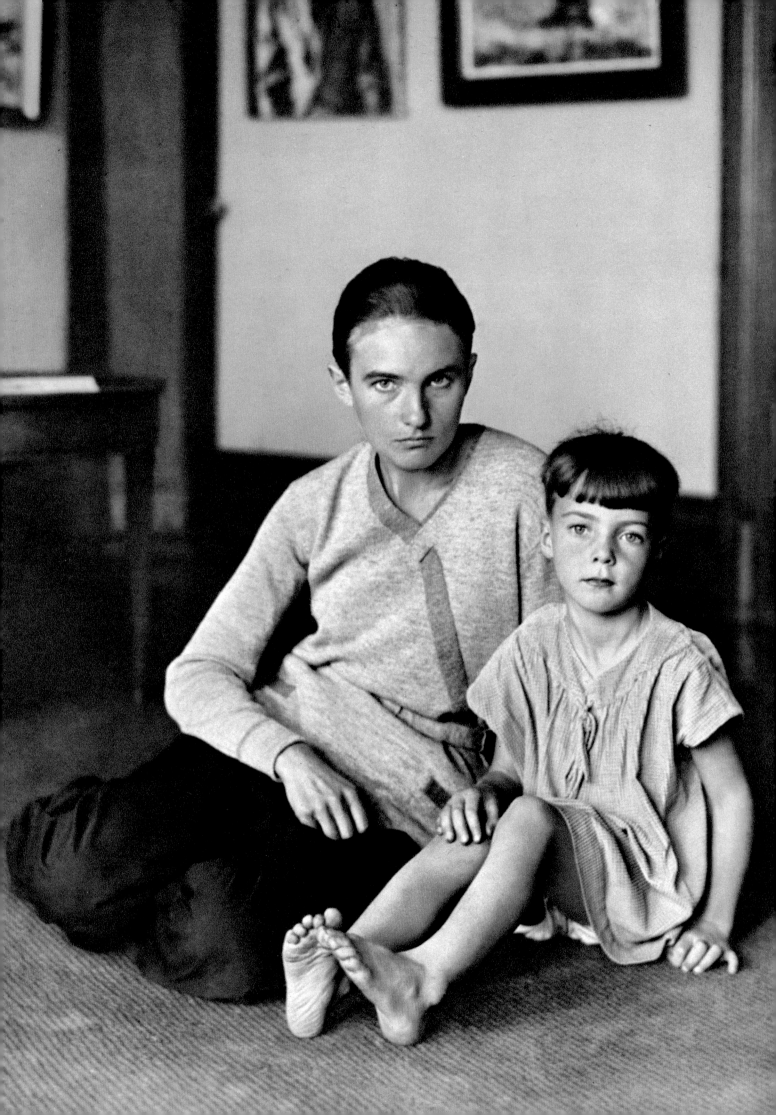

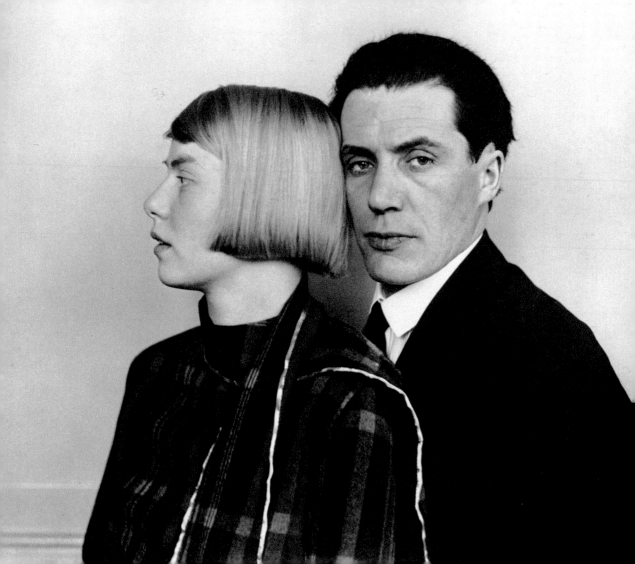

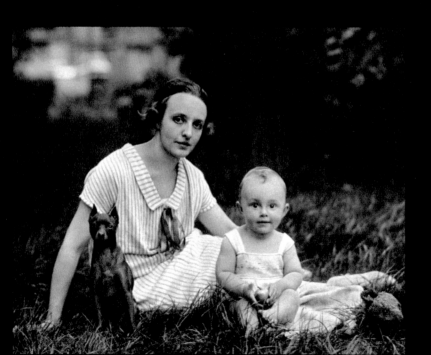
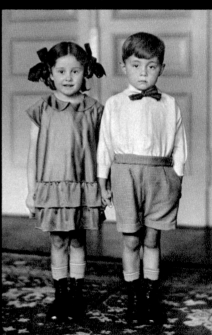

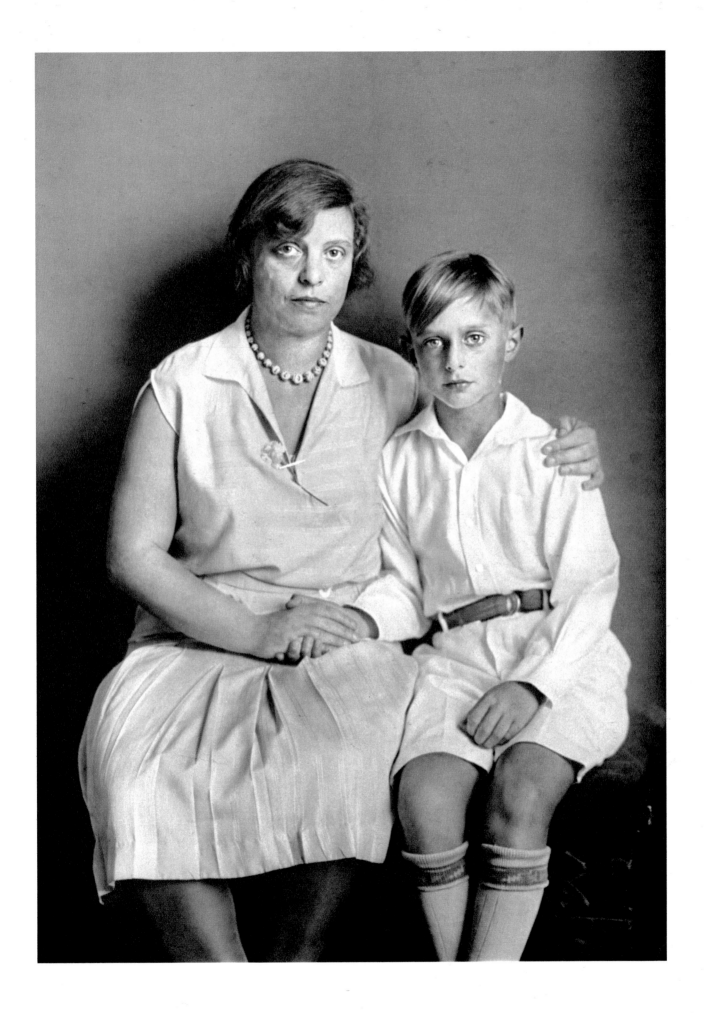

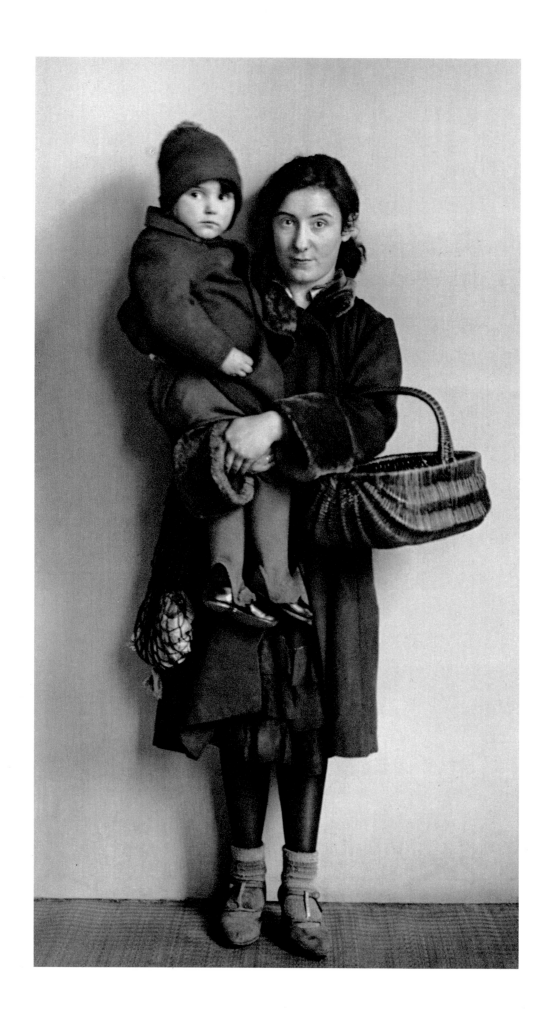

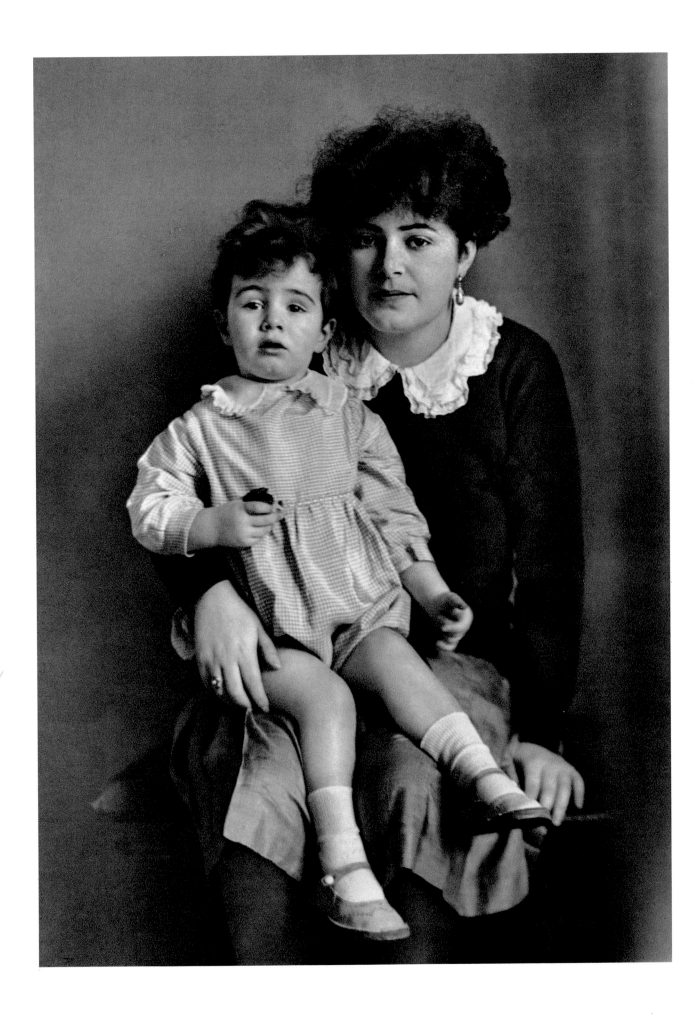

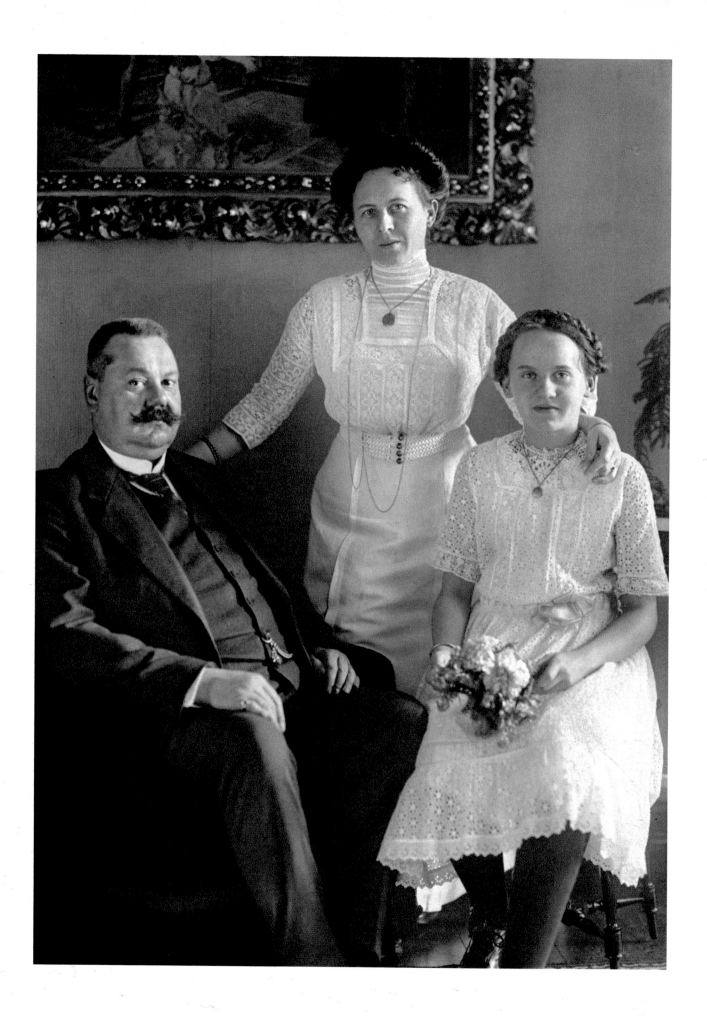

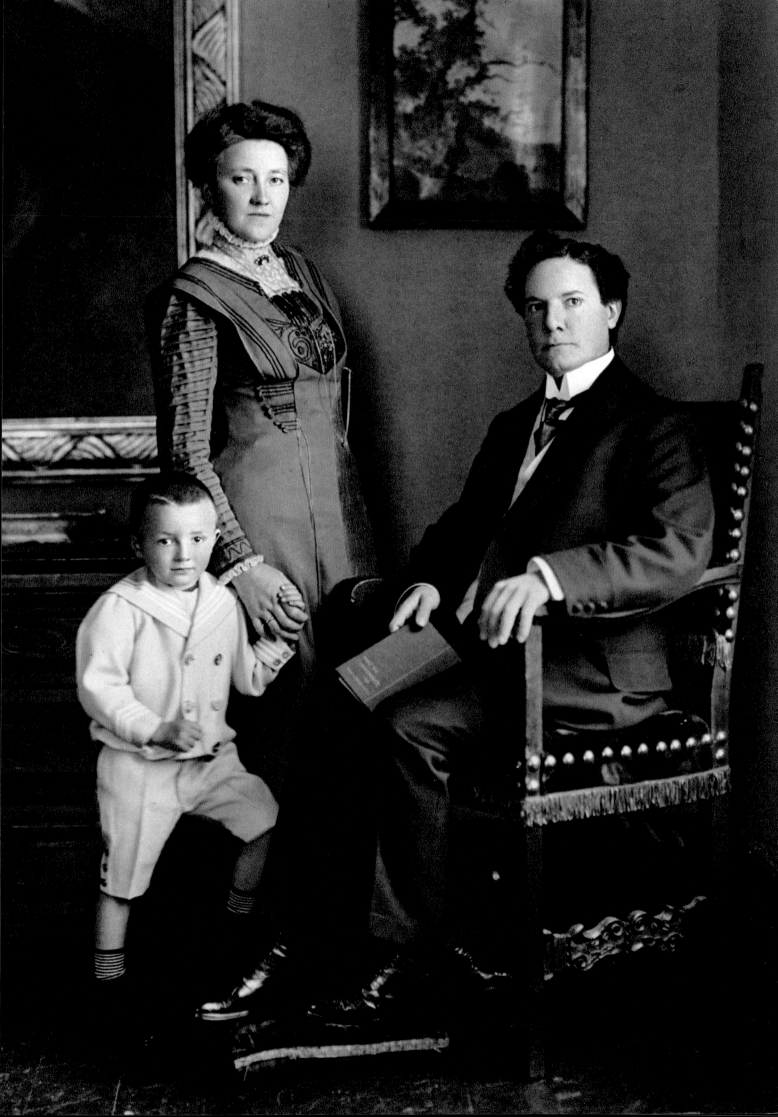

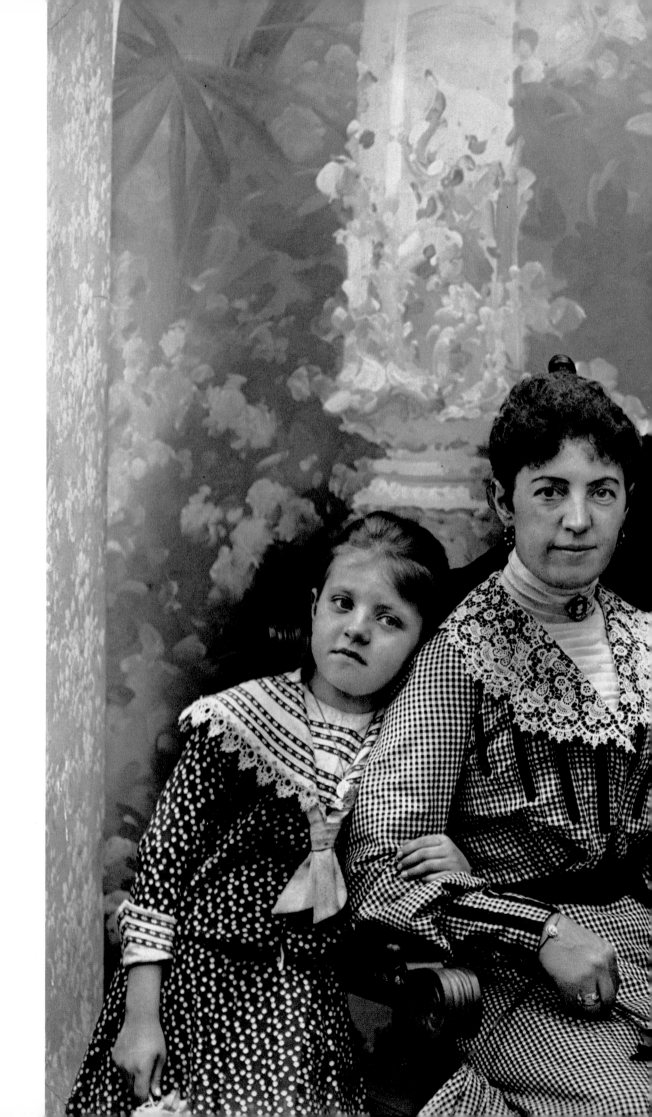

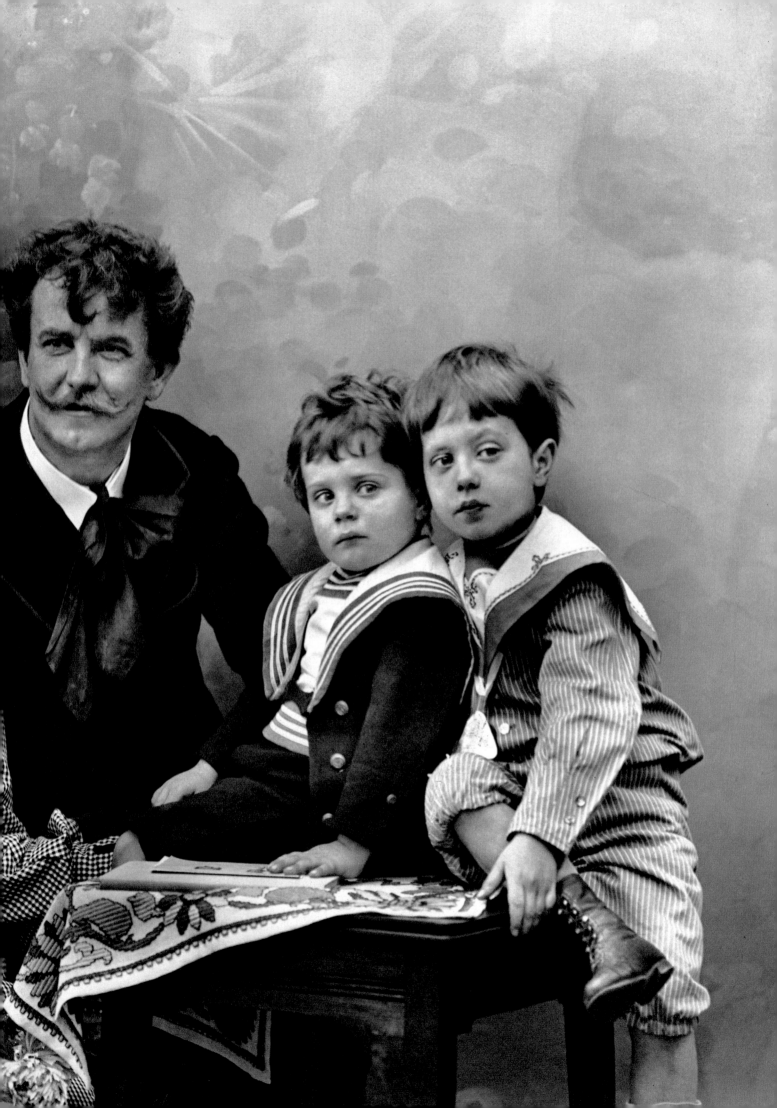

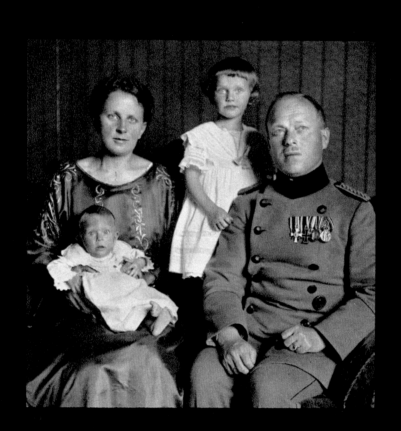

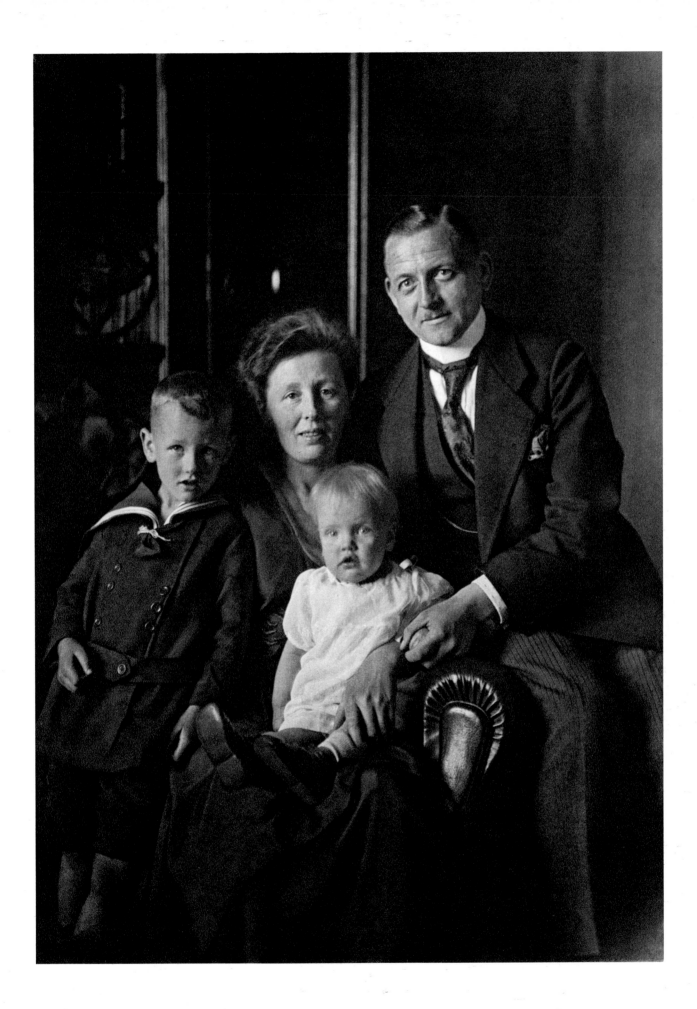

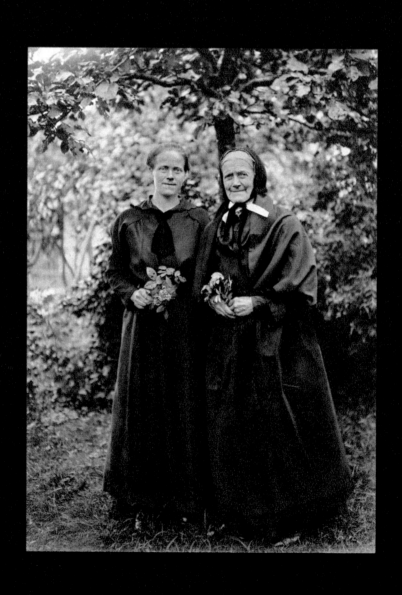

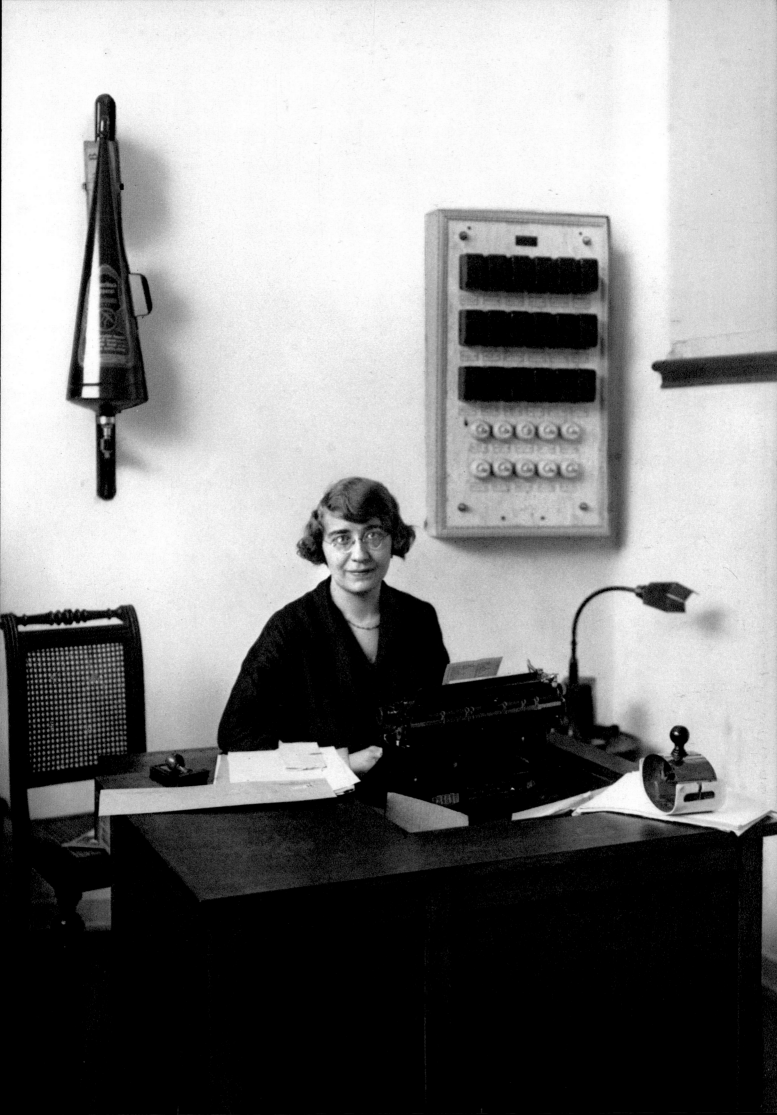

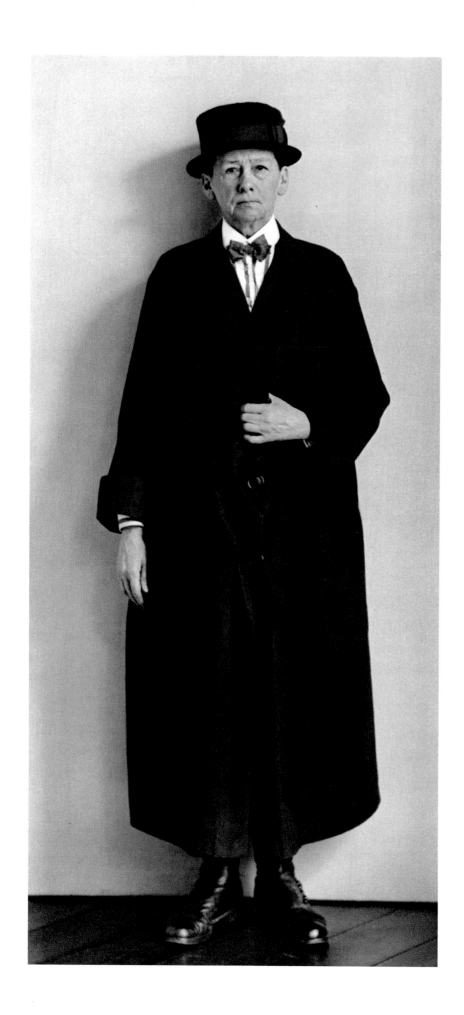

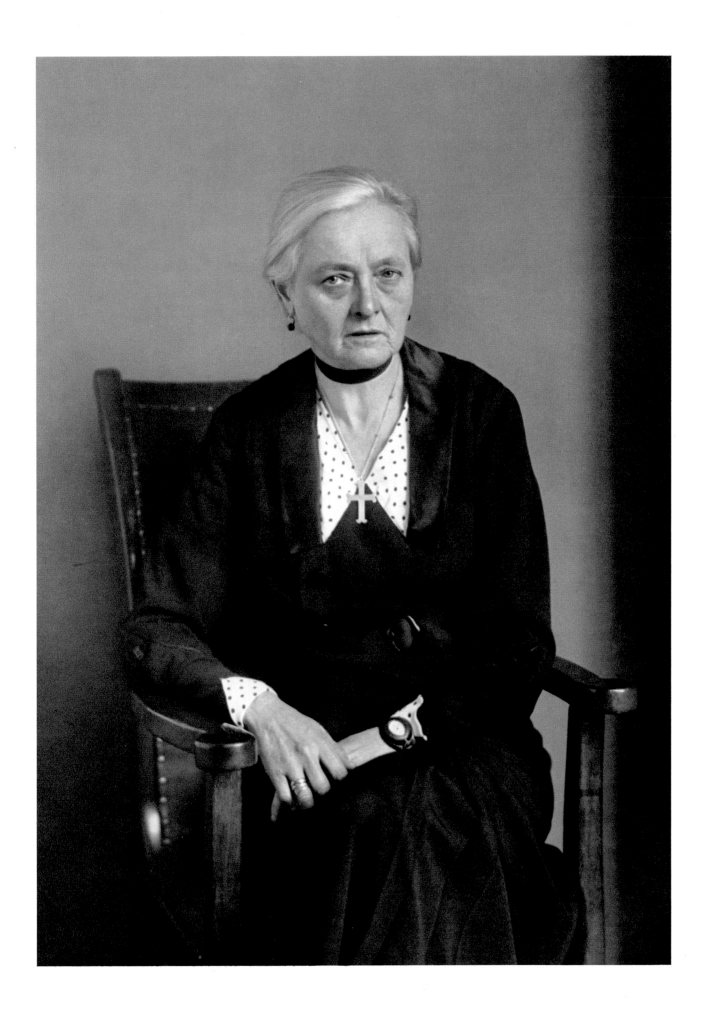

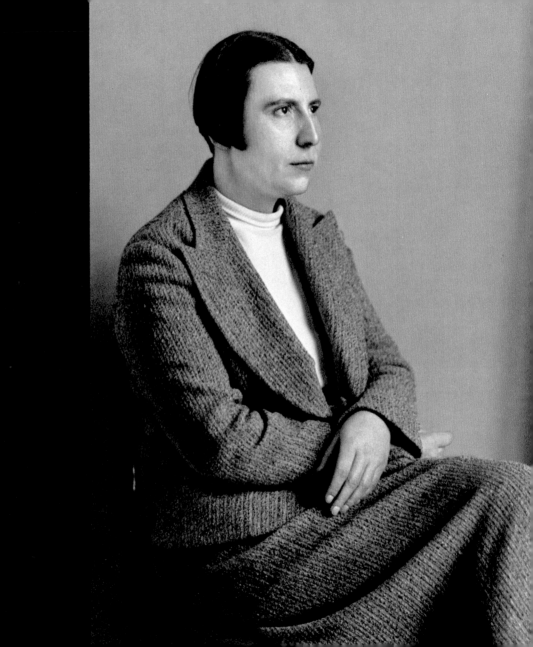

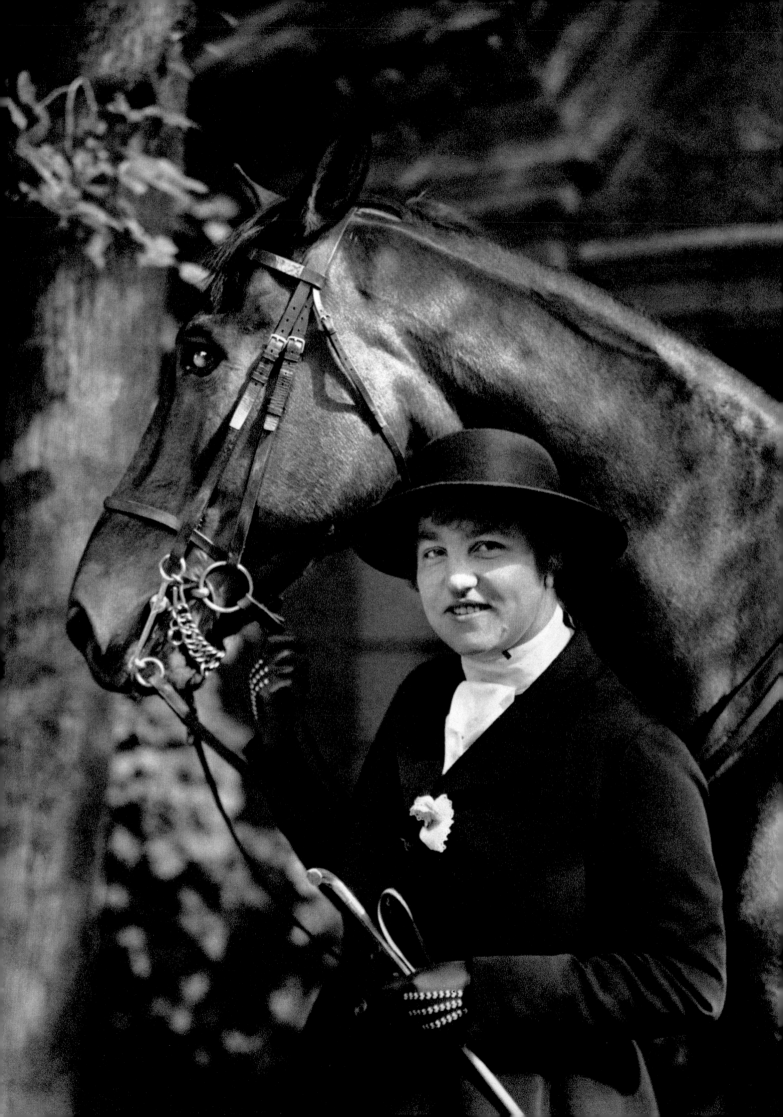

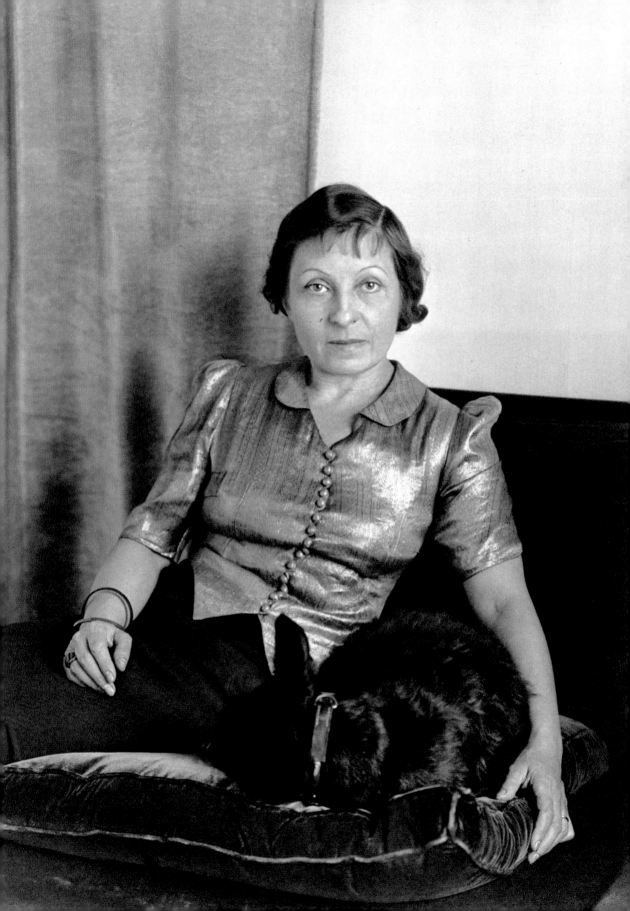

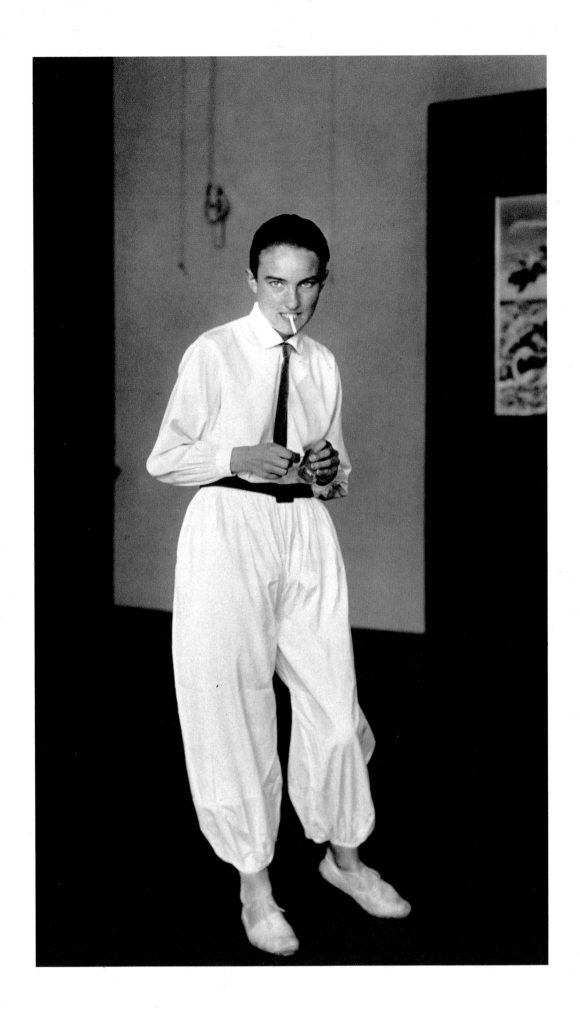

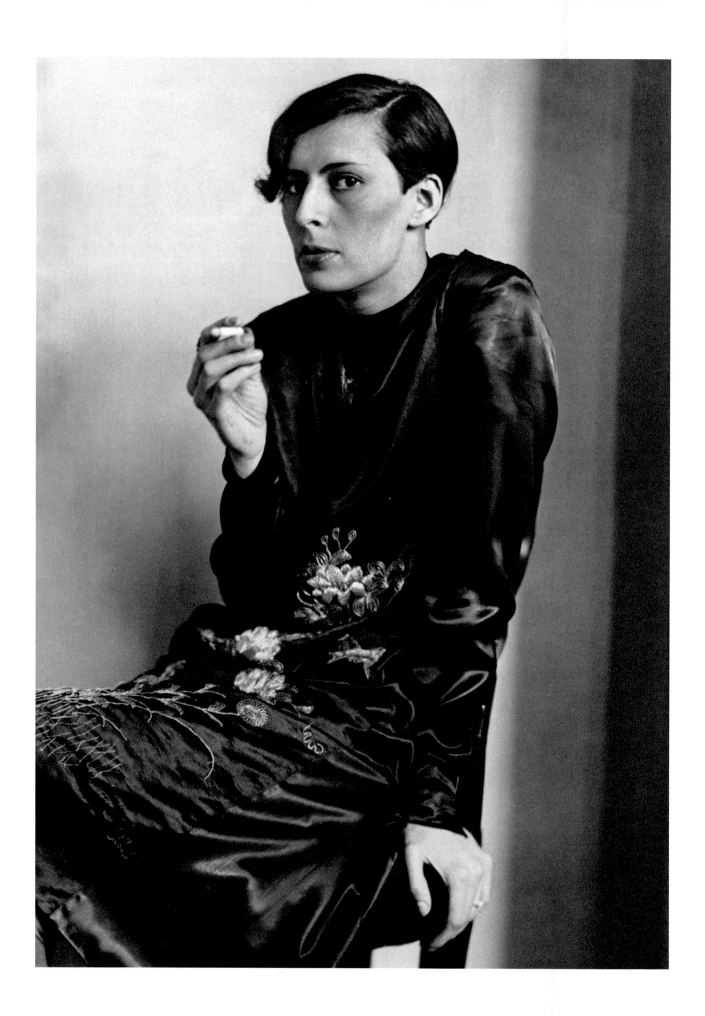

# Life 2

Porter (Munich, 1928)

Basket-makers
(Westerwald, 1931)

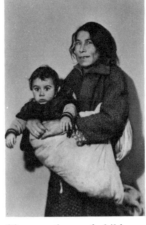

Gipsy mother and child
(Cologne, 1930)

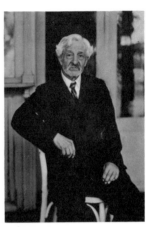

Director of a waxworks
(Vienna, 1931)

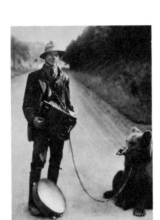

Bear-leader (Cologne, 1929)

Workers in a circus
(Cologne, 1926)

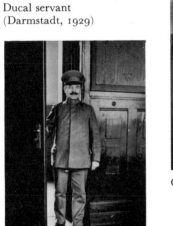

Ducal servant
(Darmstadt, 1929)

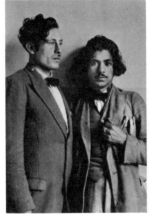

Gipsies (Cologne, 1930)

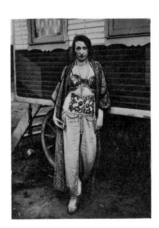

Circus artiste
(Cologne, 1926)

Court usher (Cologne, 1928)

Urban images

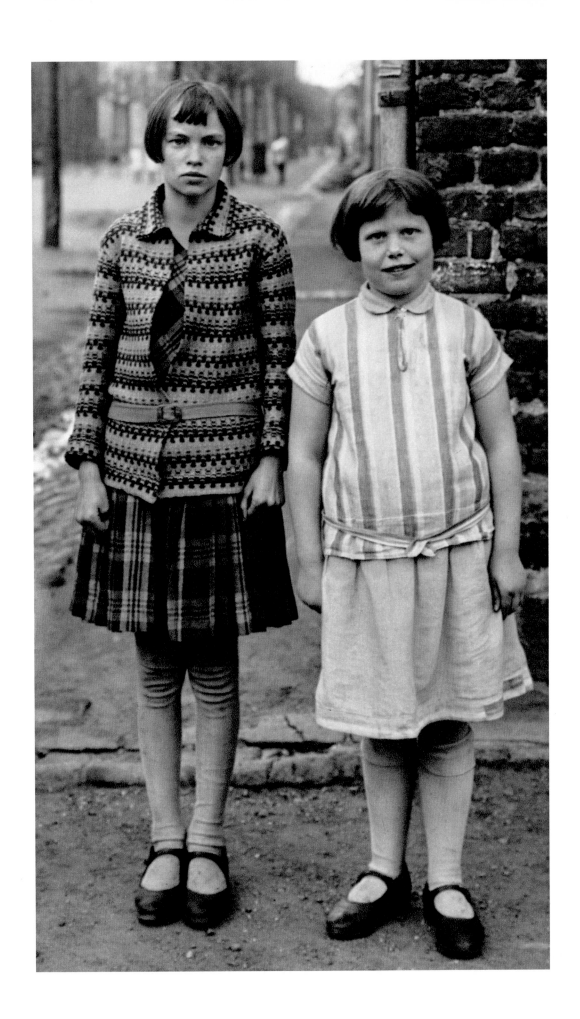

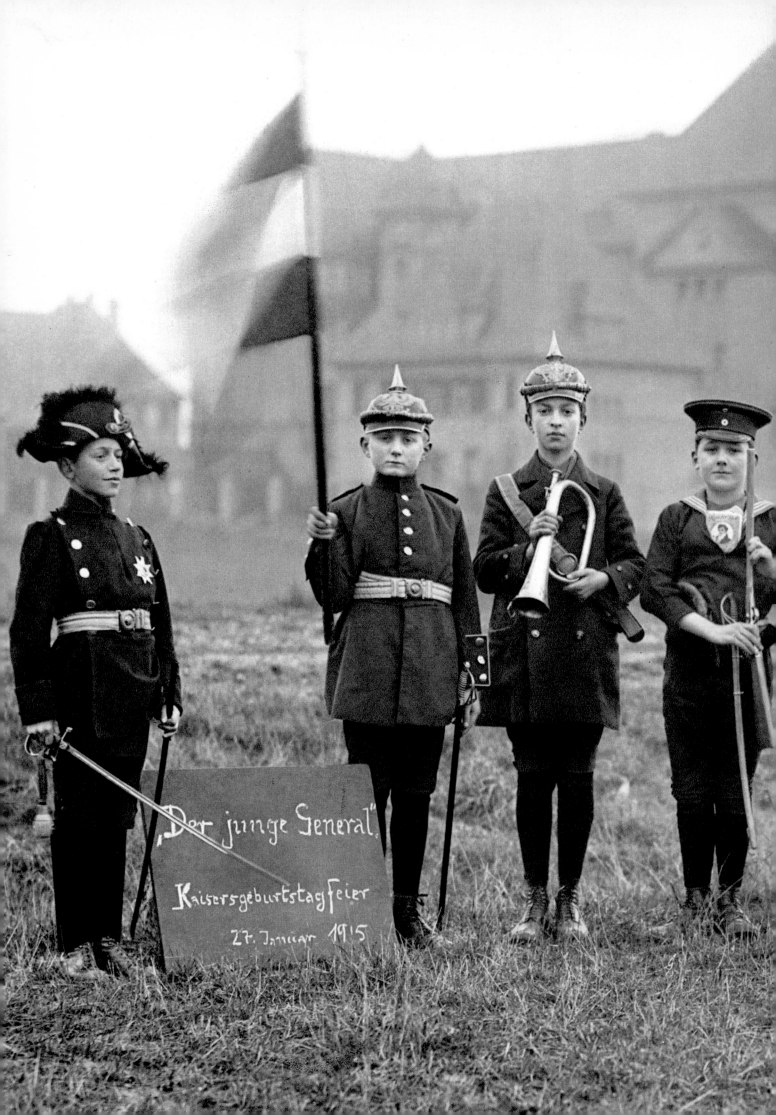

„Der junge General"

Kaisersgeburtstagfeier

27. Januar 1915

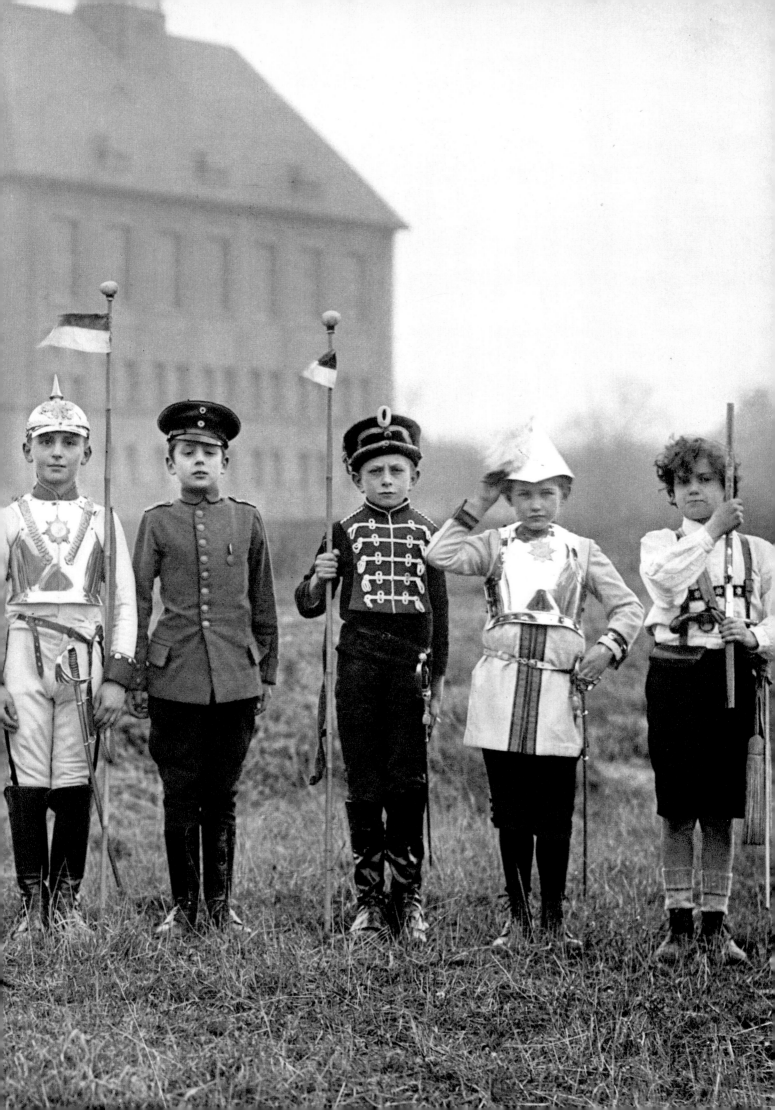

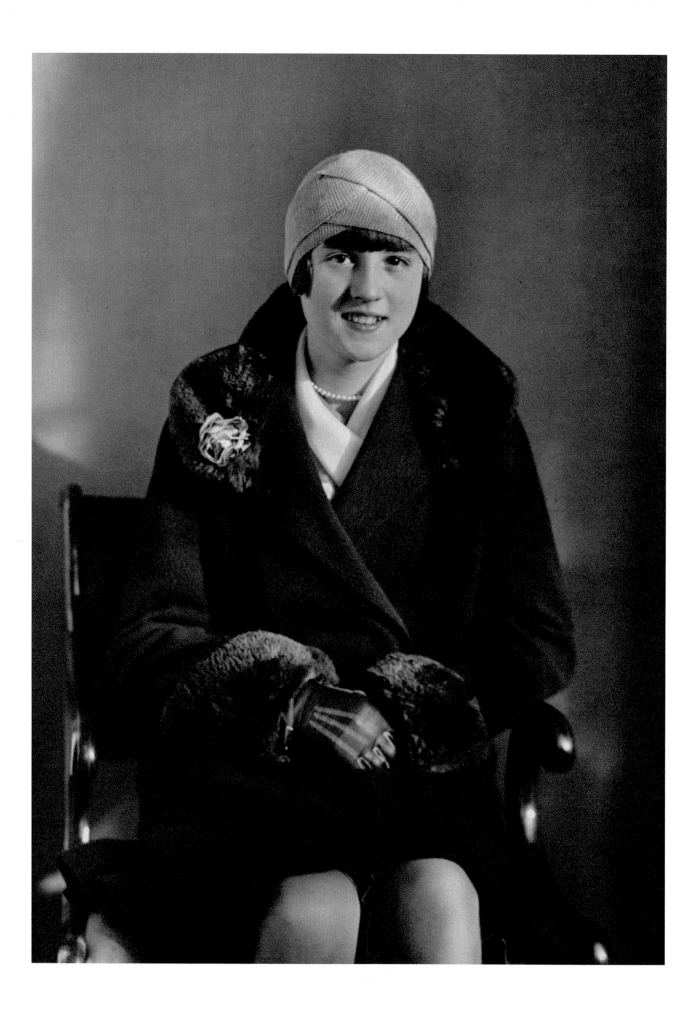

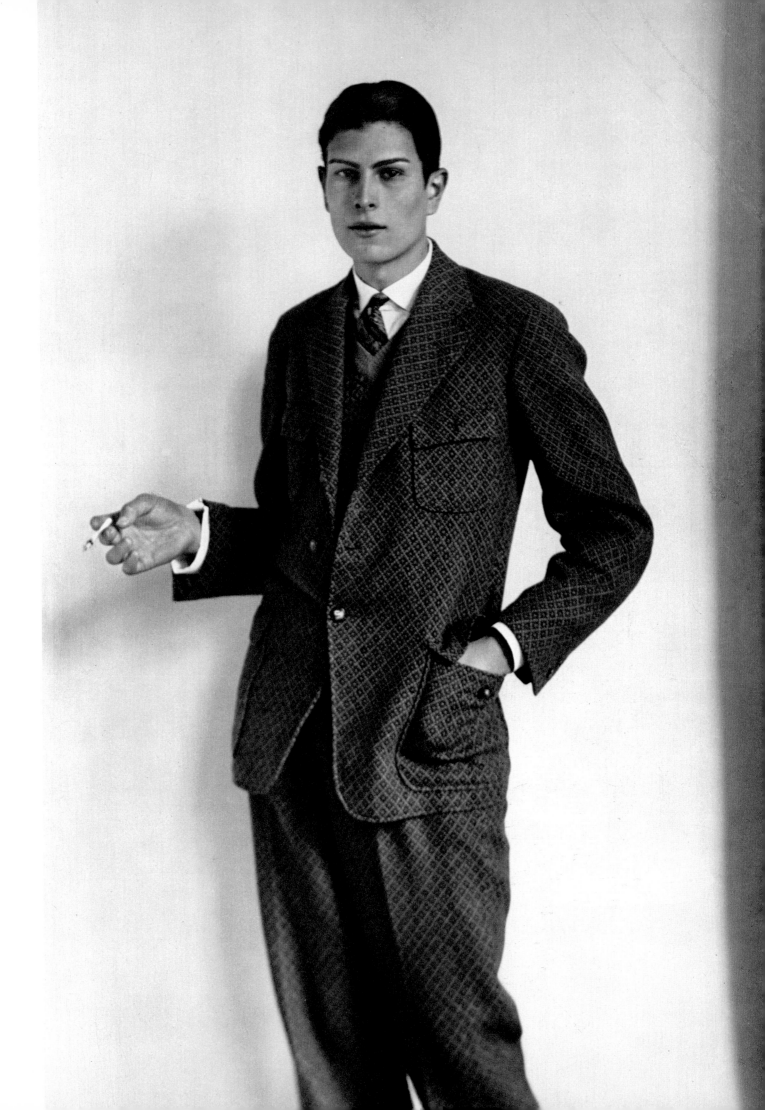

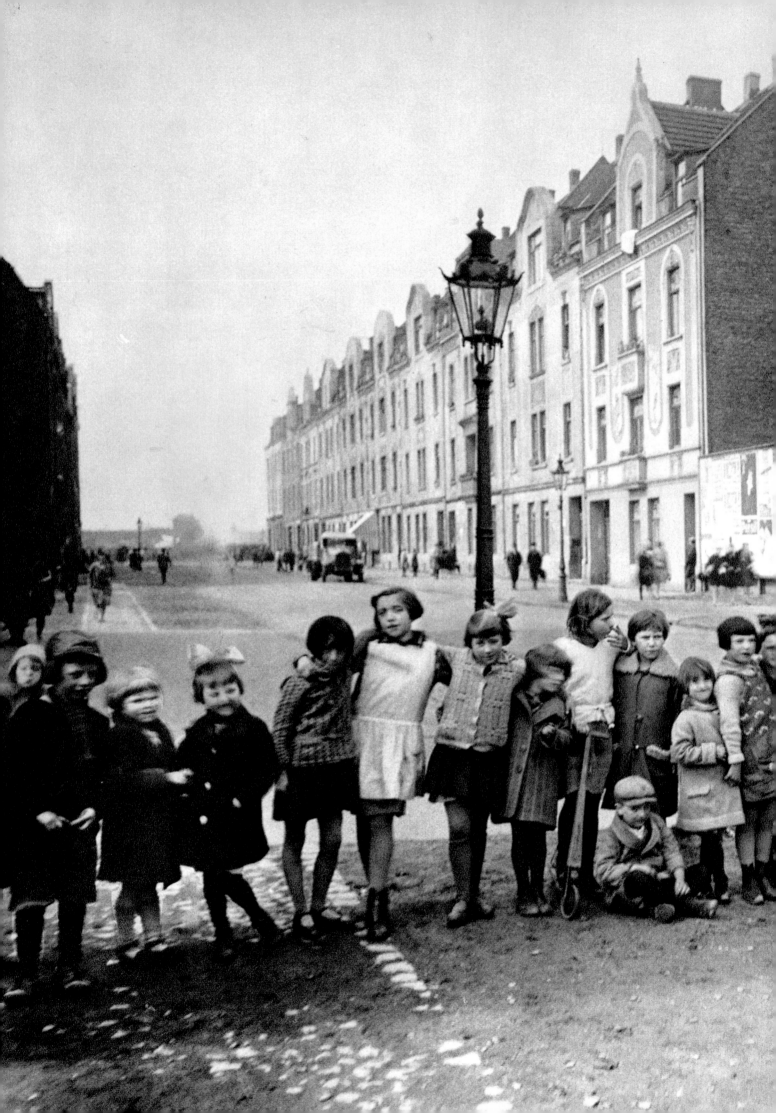

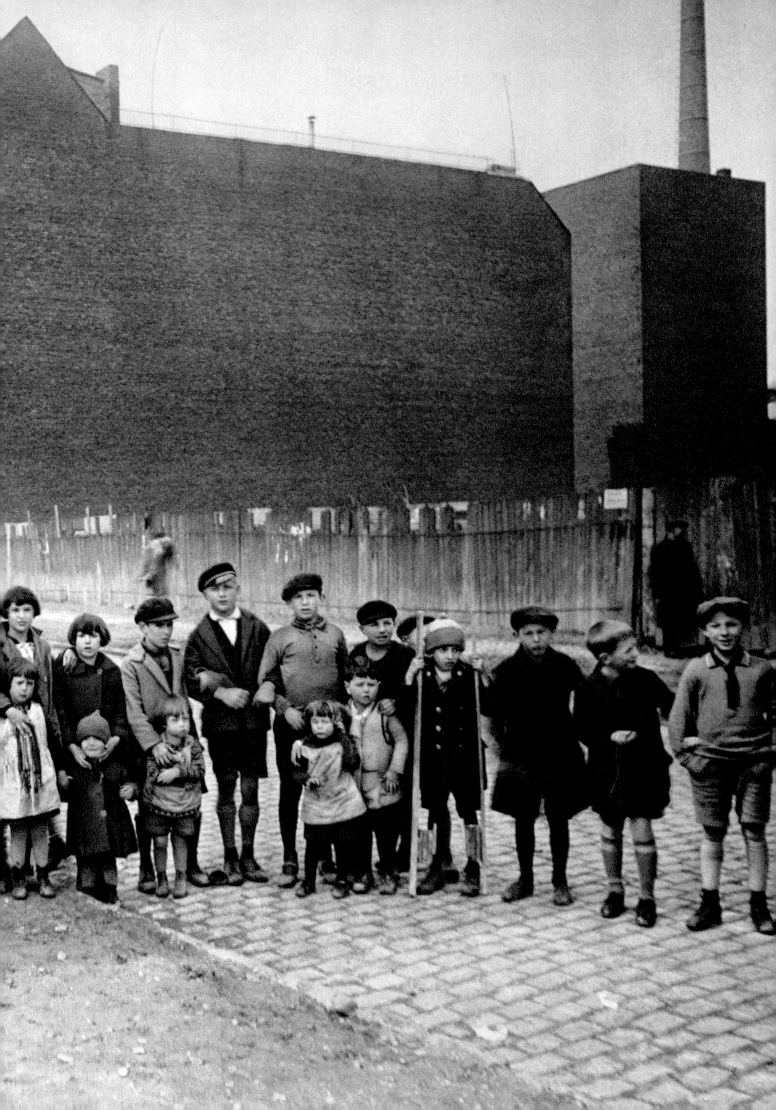

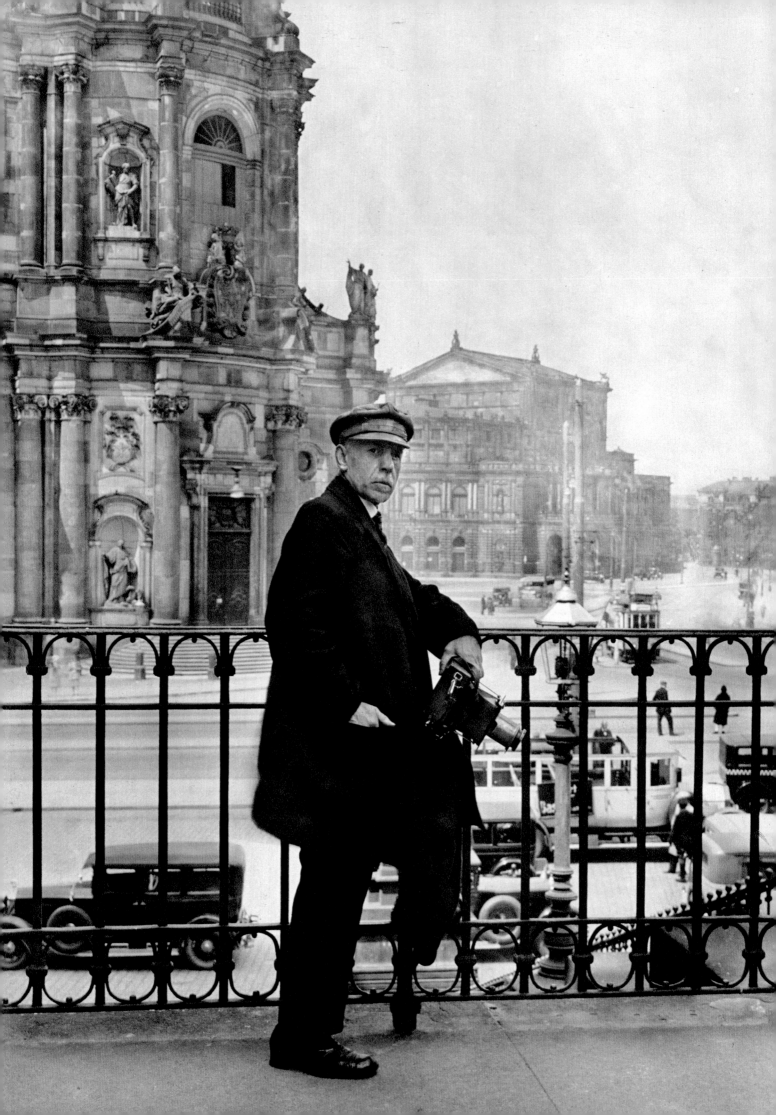

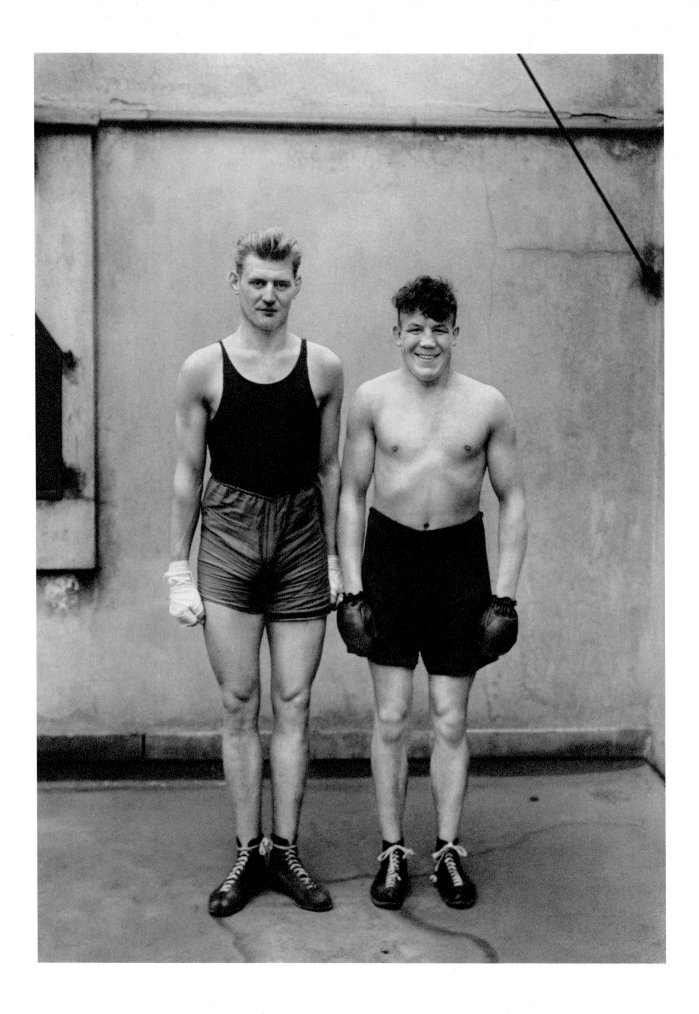

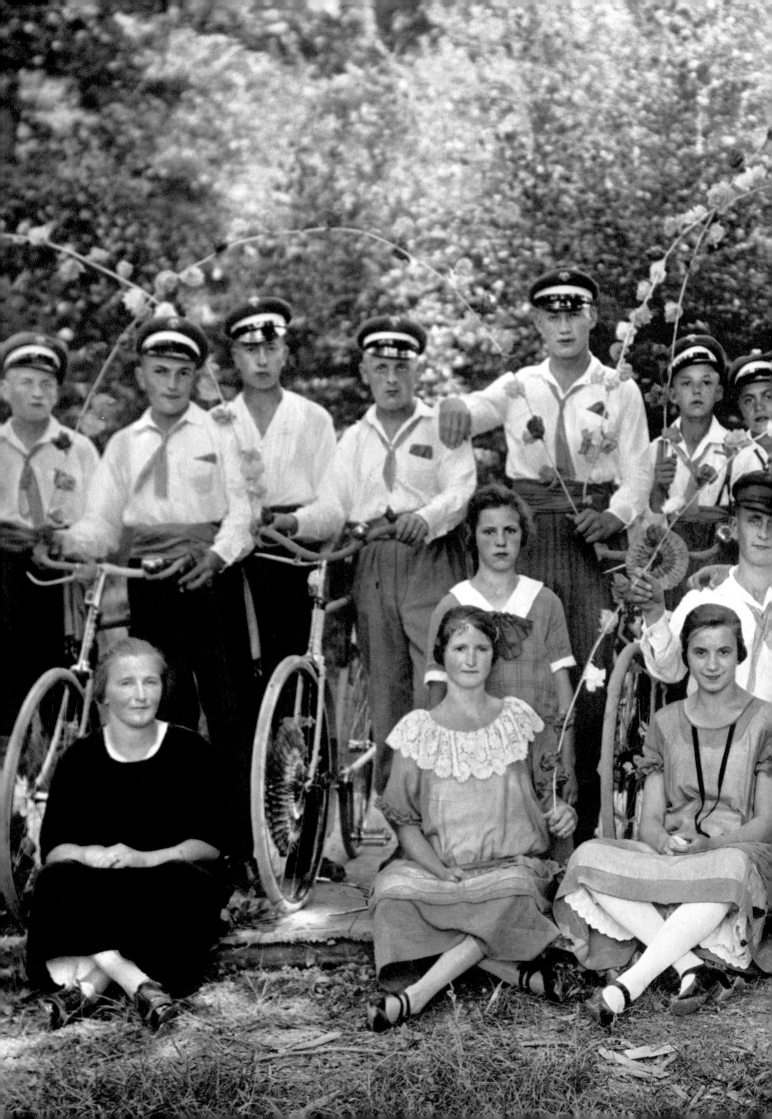

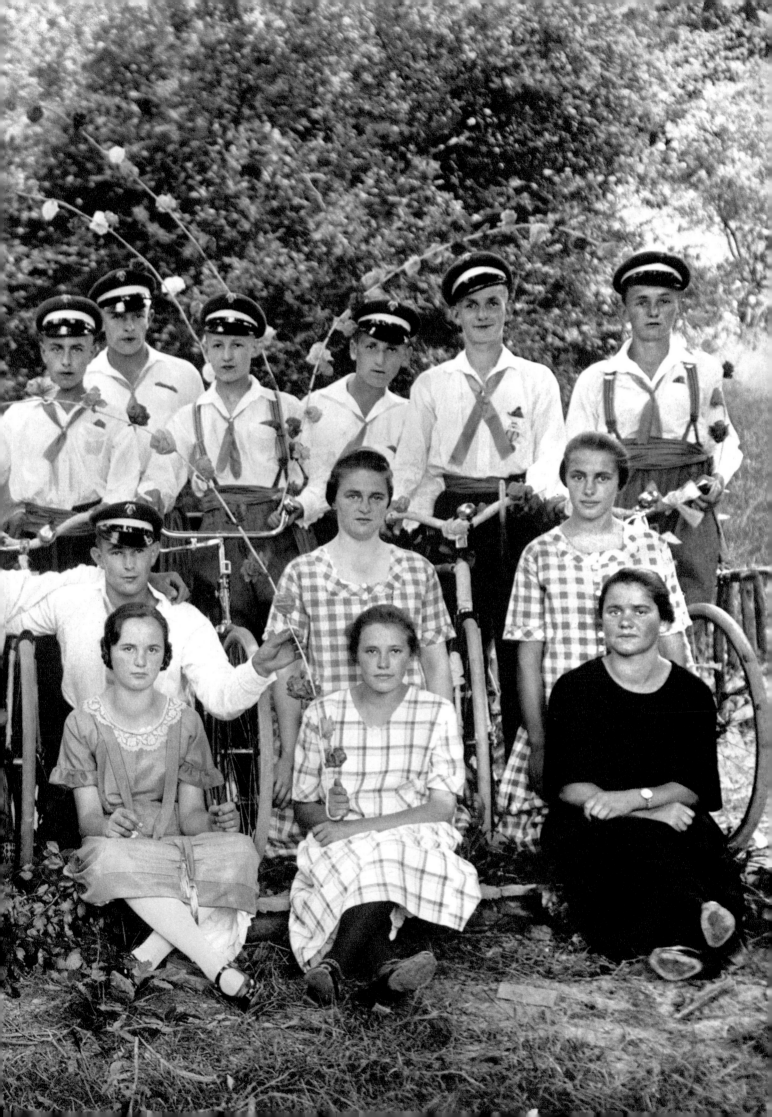

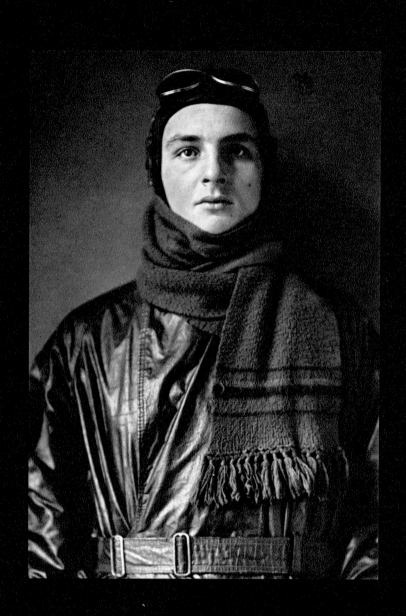

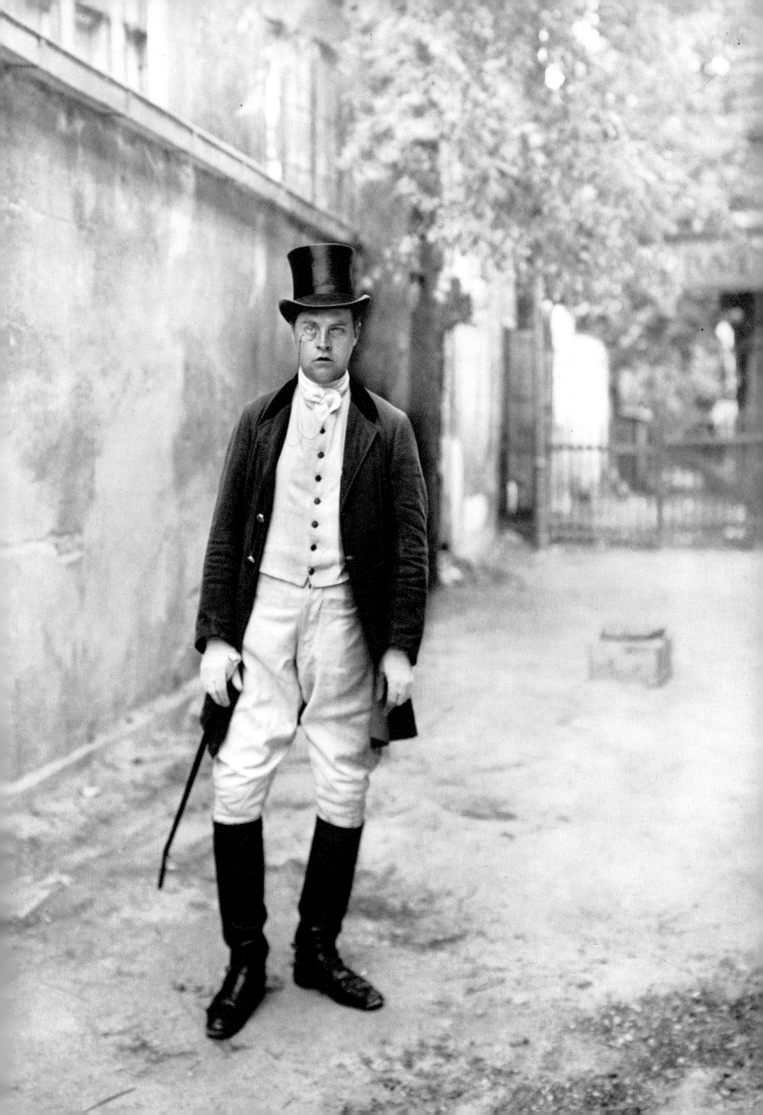

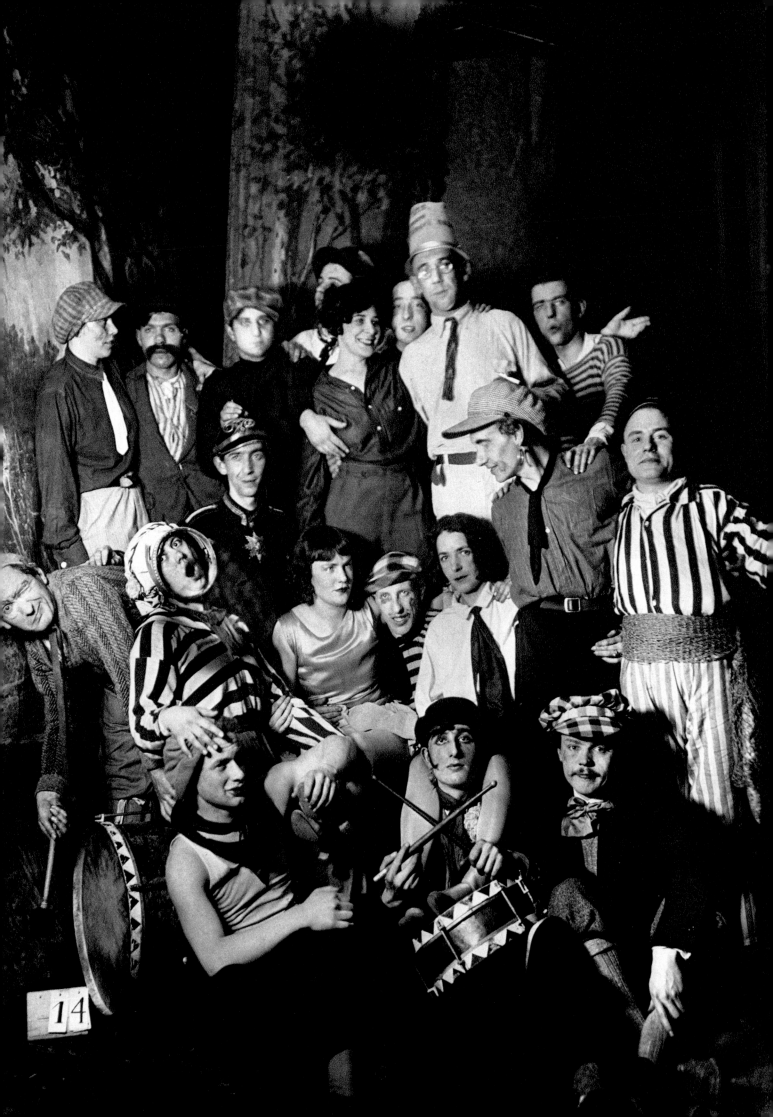

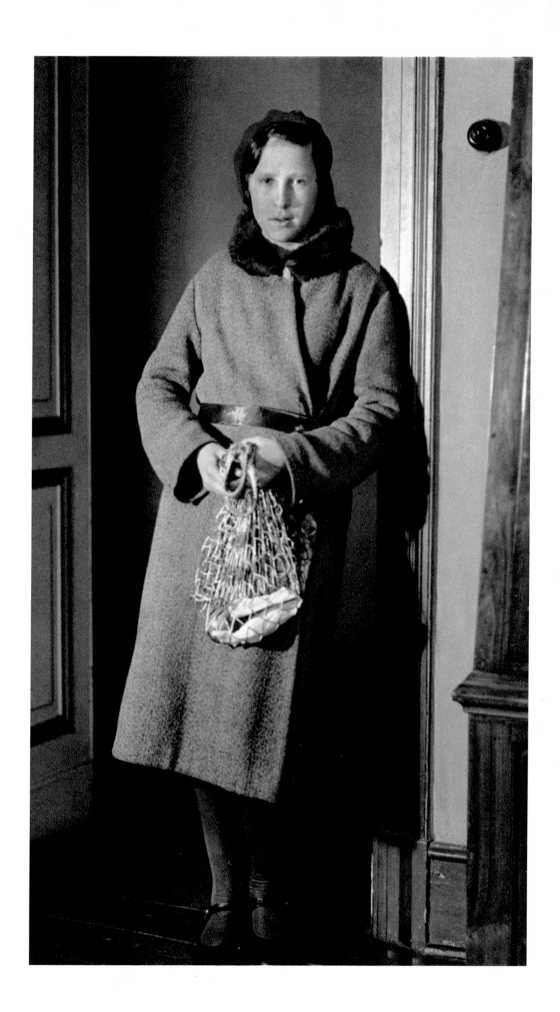

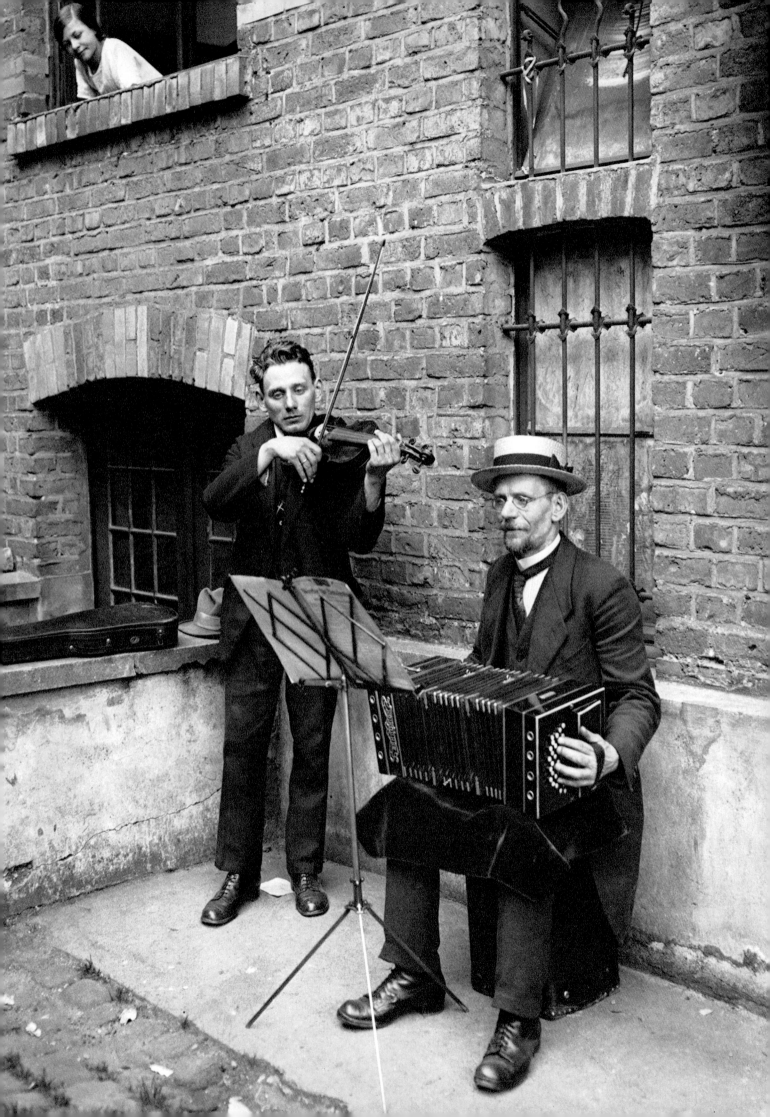

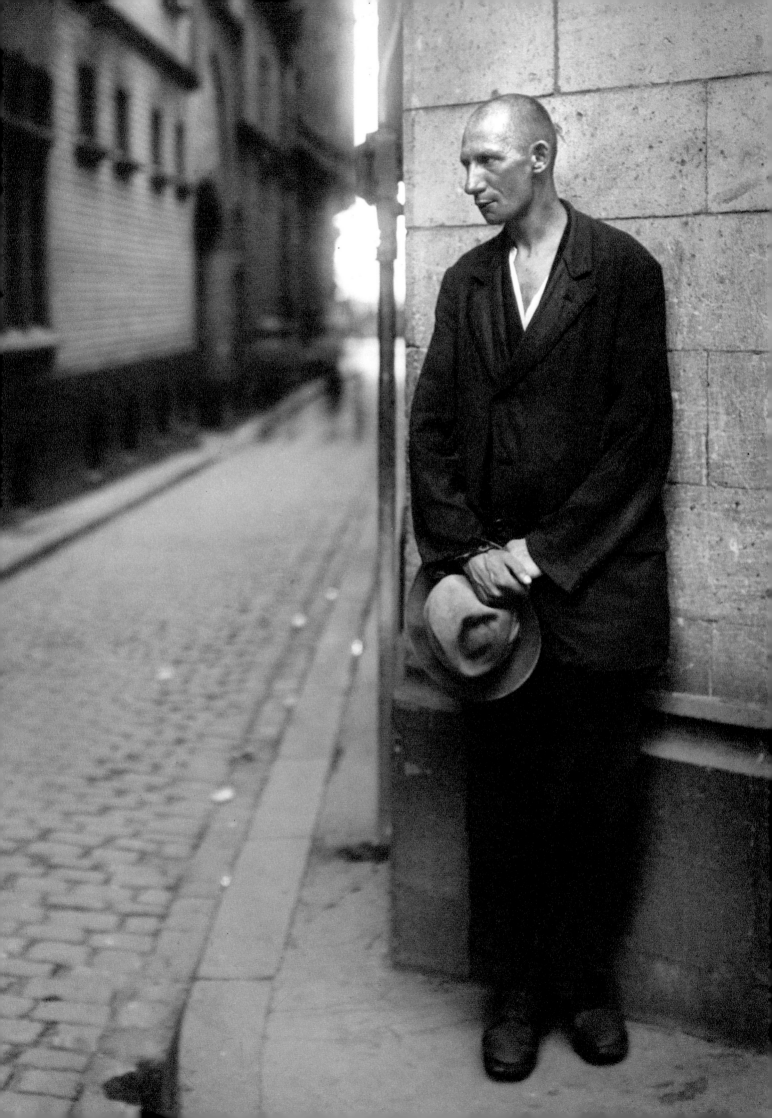

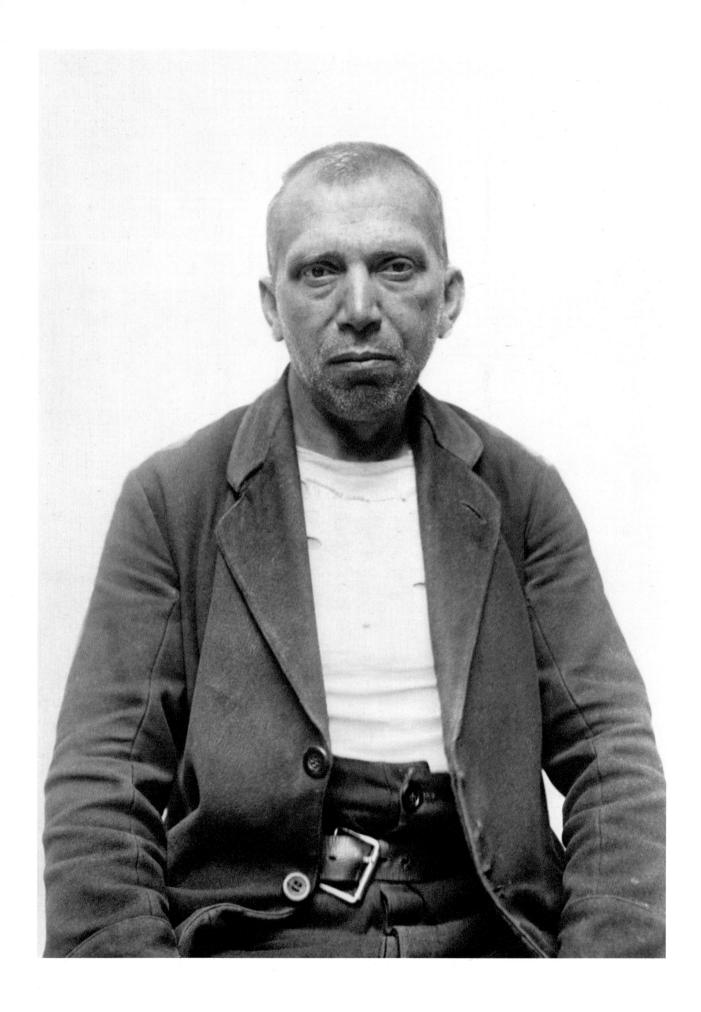

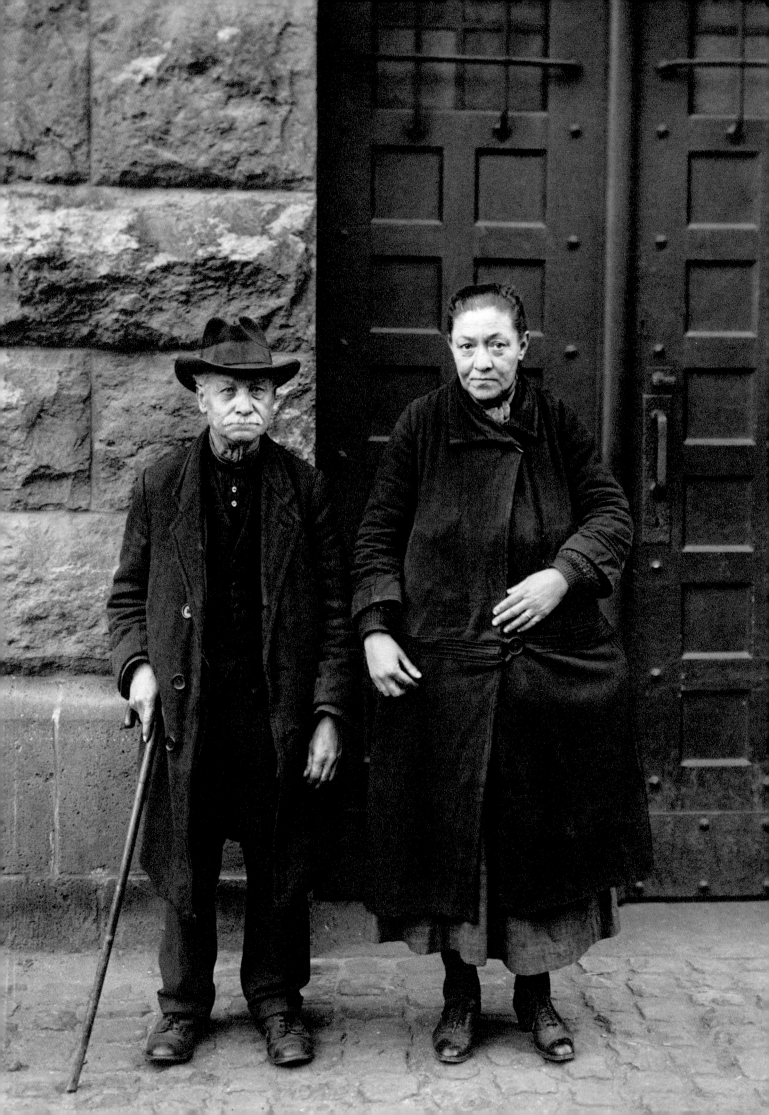

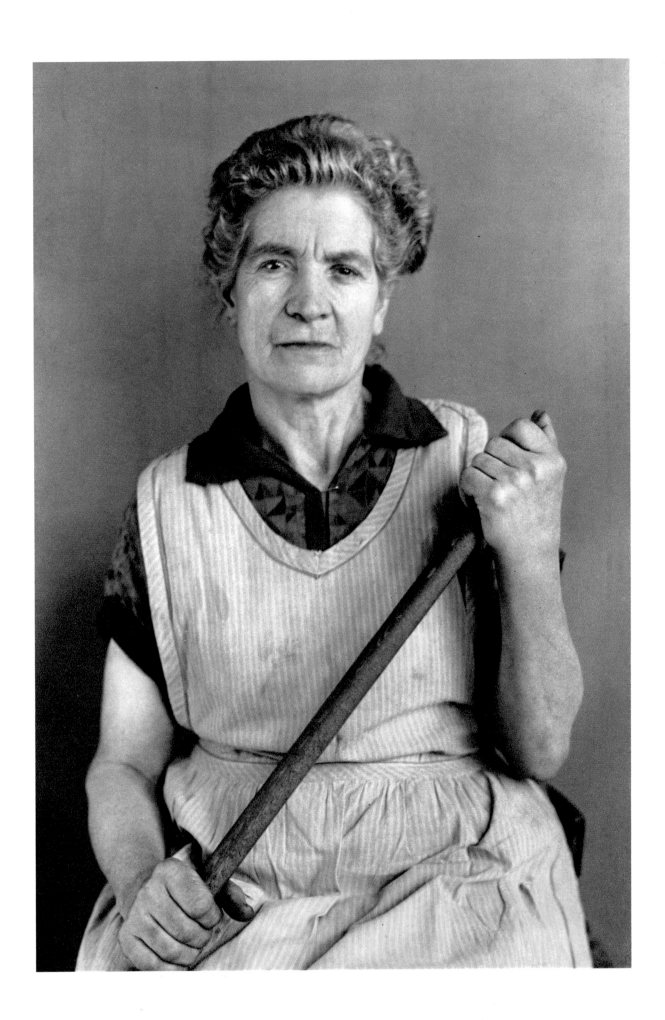

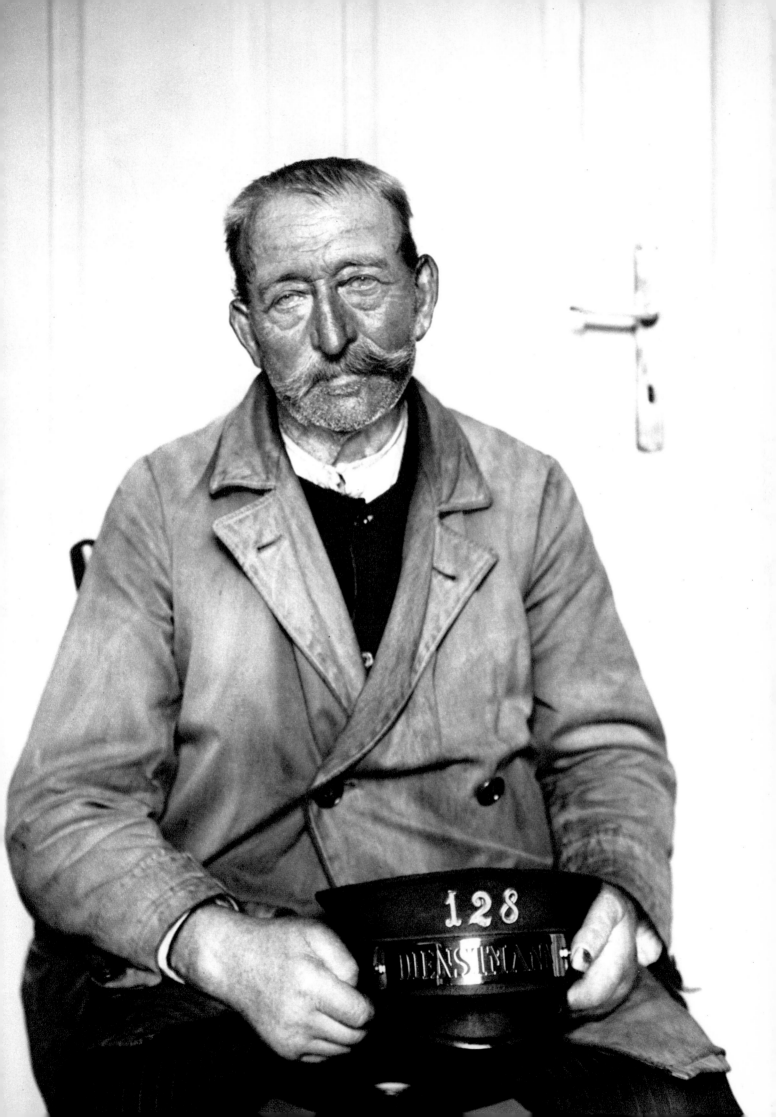

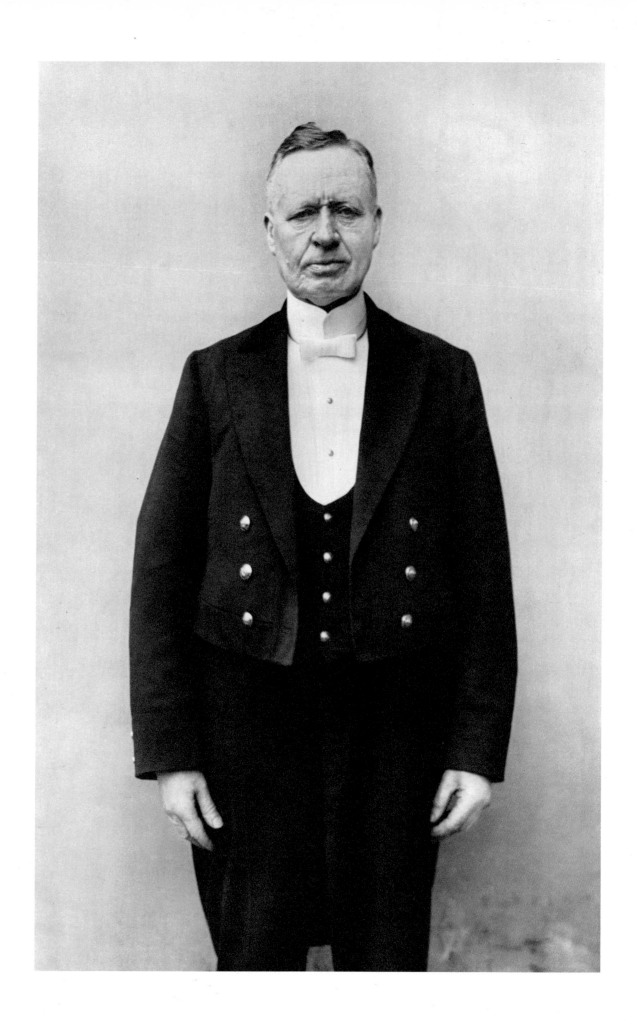

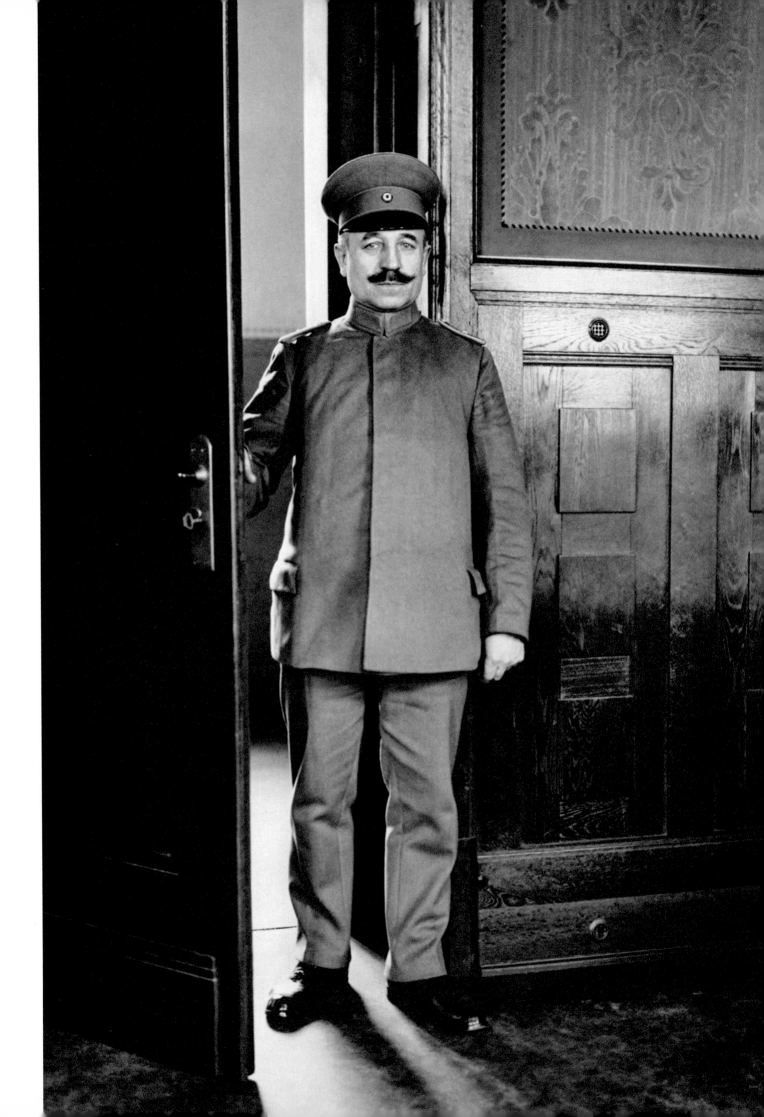

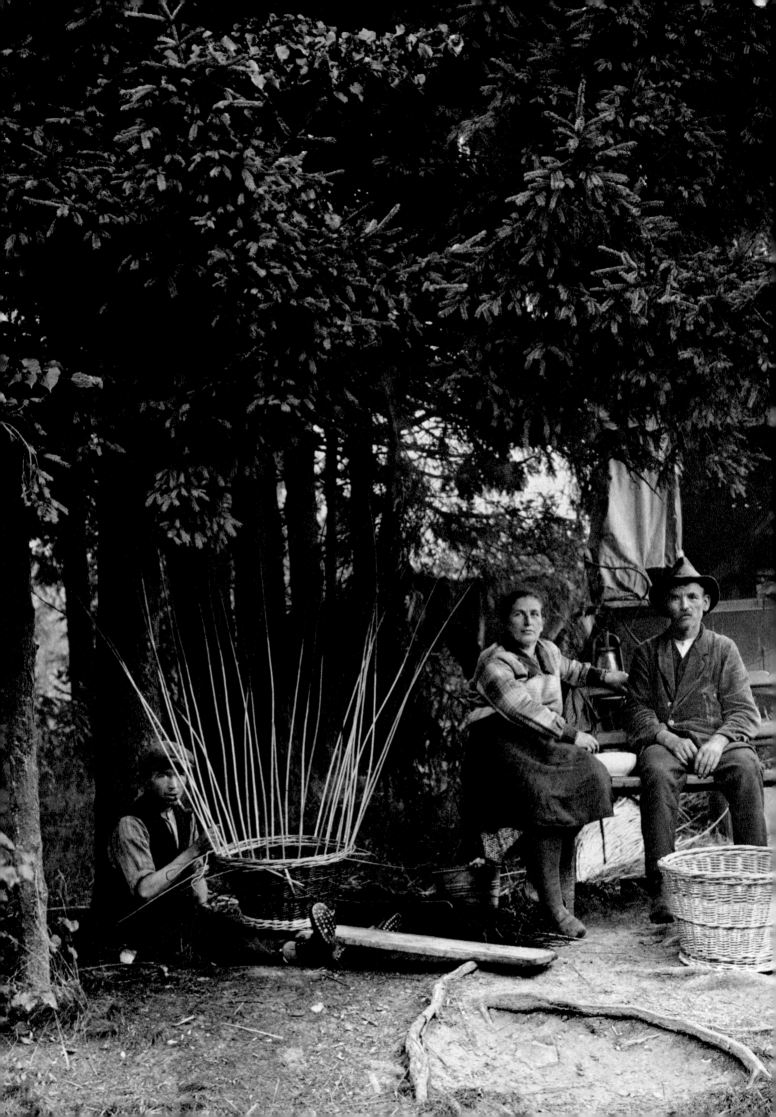

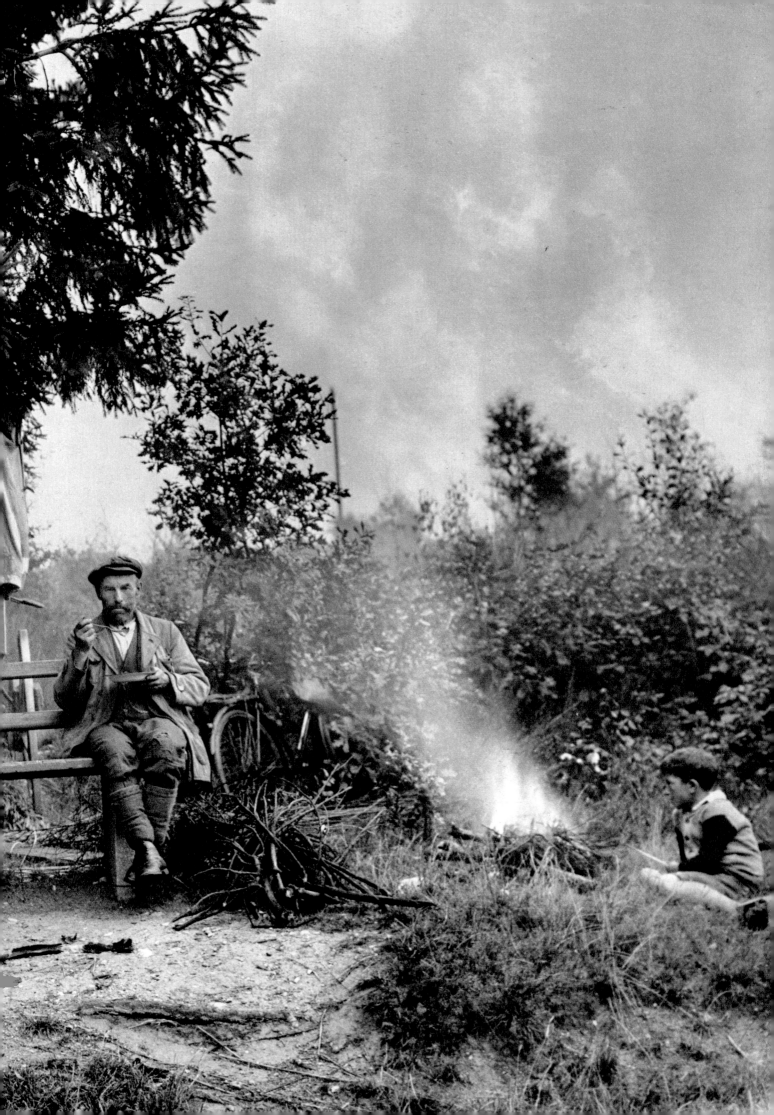

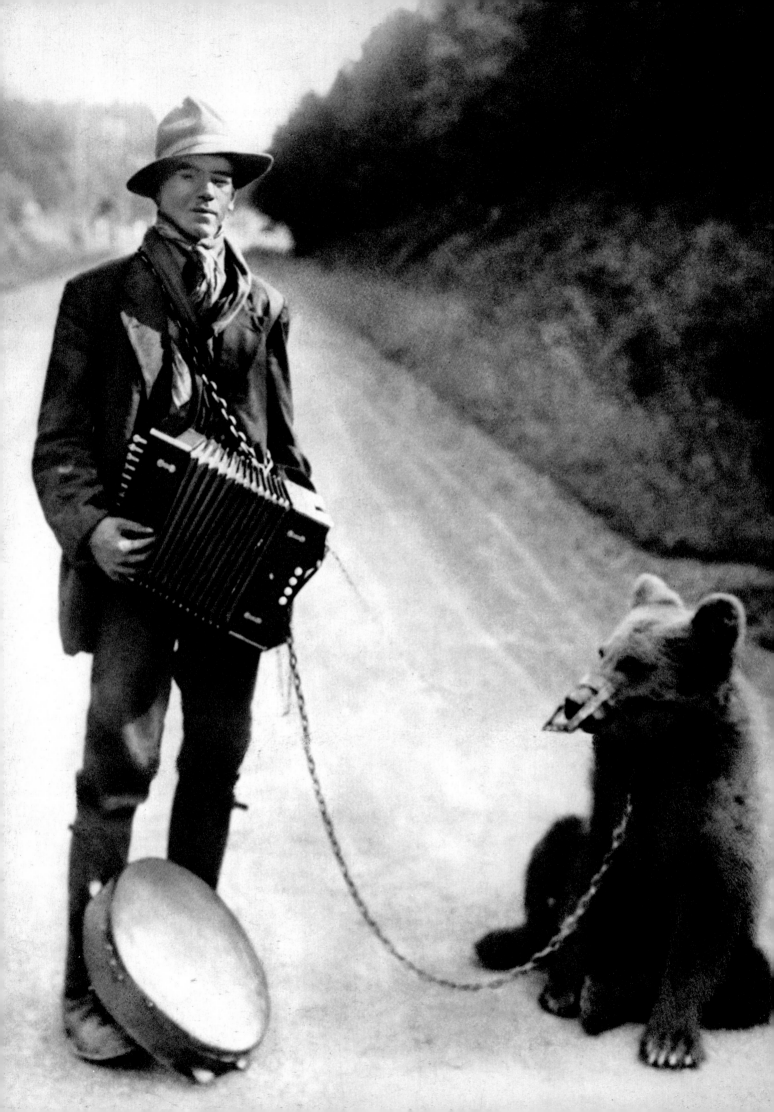

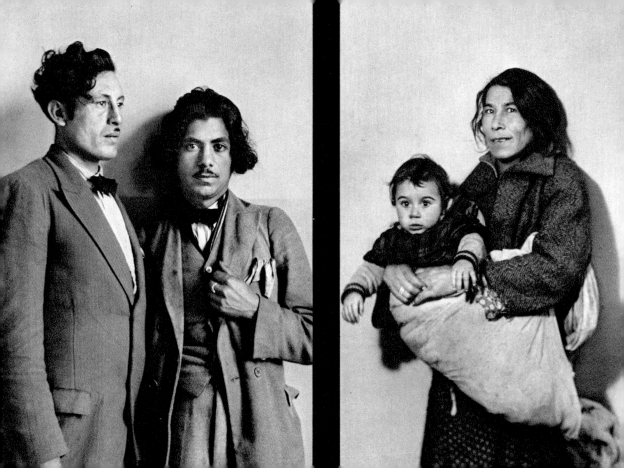

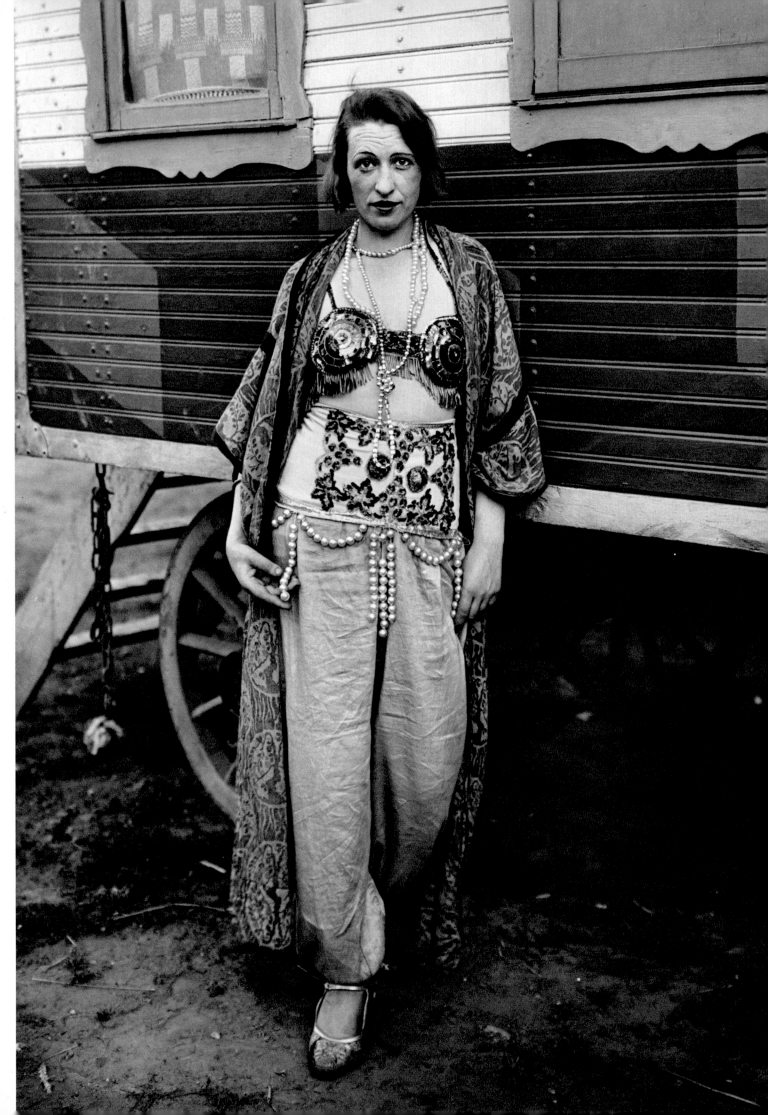

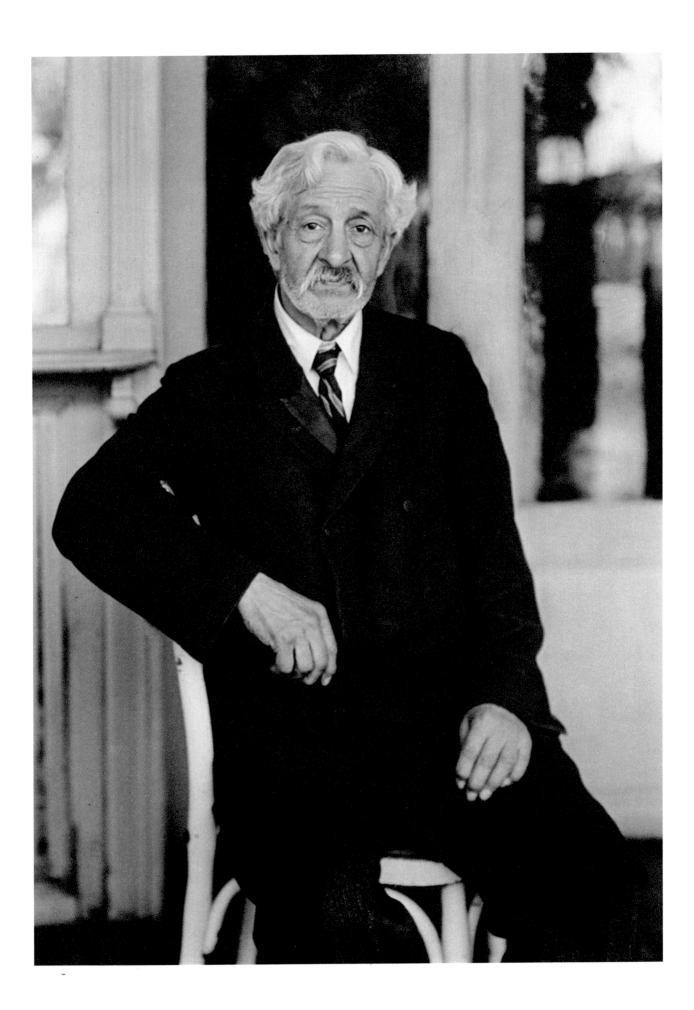

# Transience

Cretin (Westerwald, 1926)

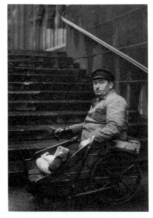

Legless ex-serviceman
(Cologne, 1926)

Children in a home for the
blind (Düren, 1930)

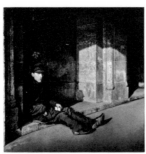

Match-seller
(Cologne, 1926)

Inmates of a home for the
blind (Düren, 1930)

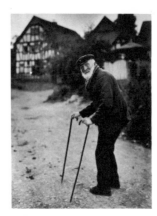

Infirm old man
(Westerwald, 1930)

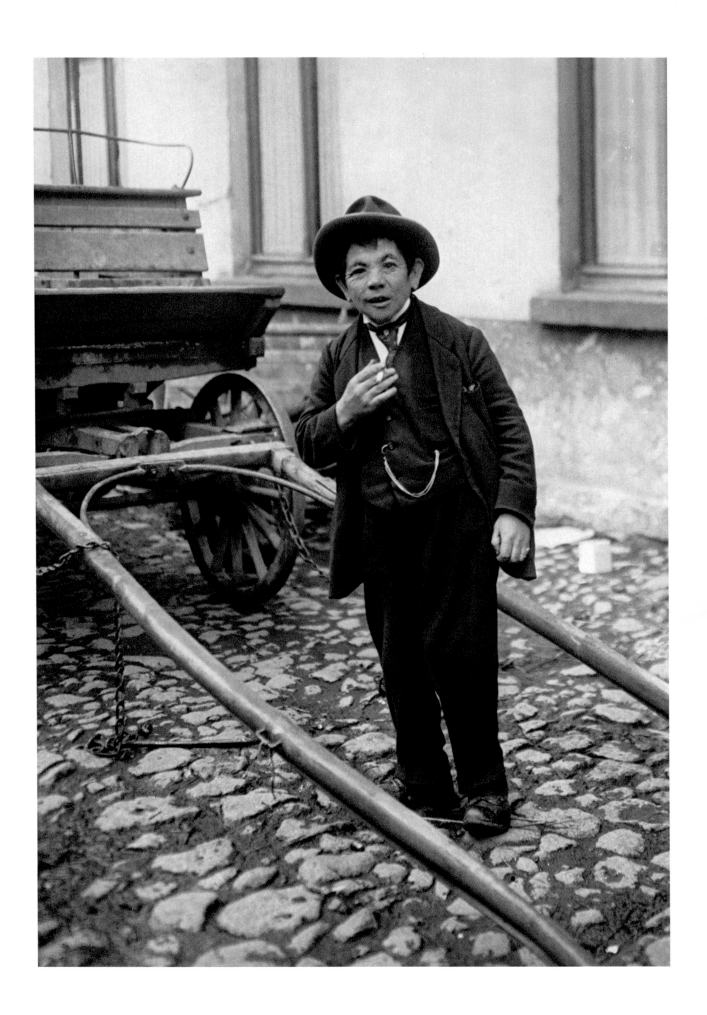

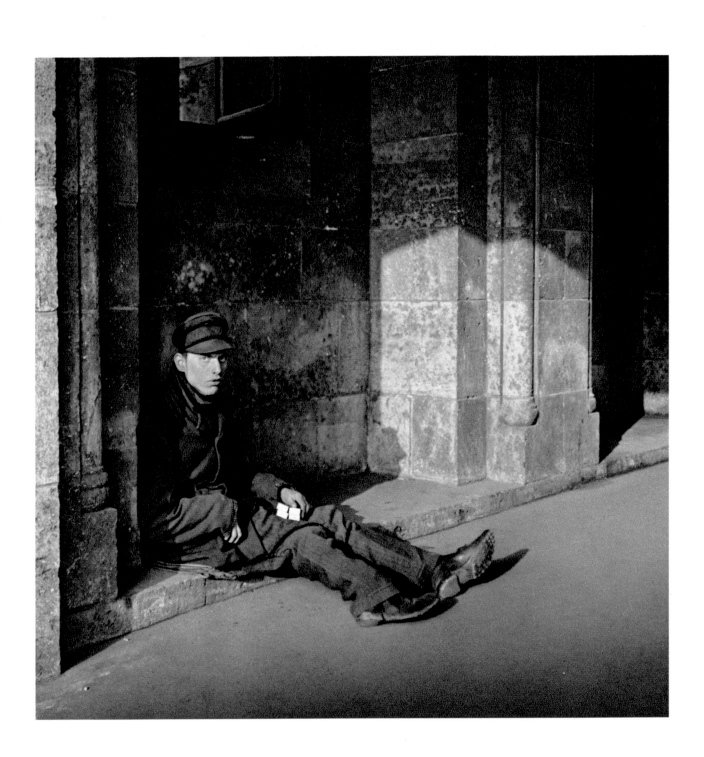

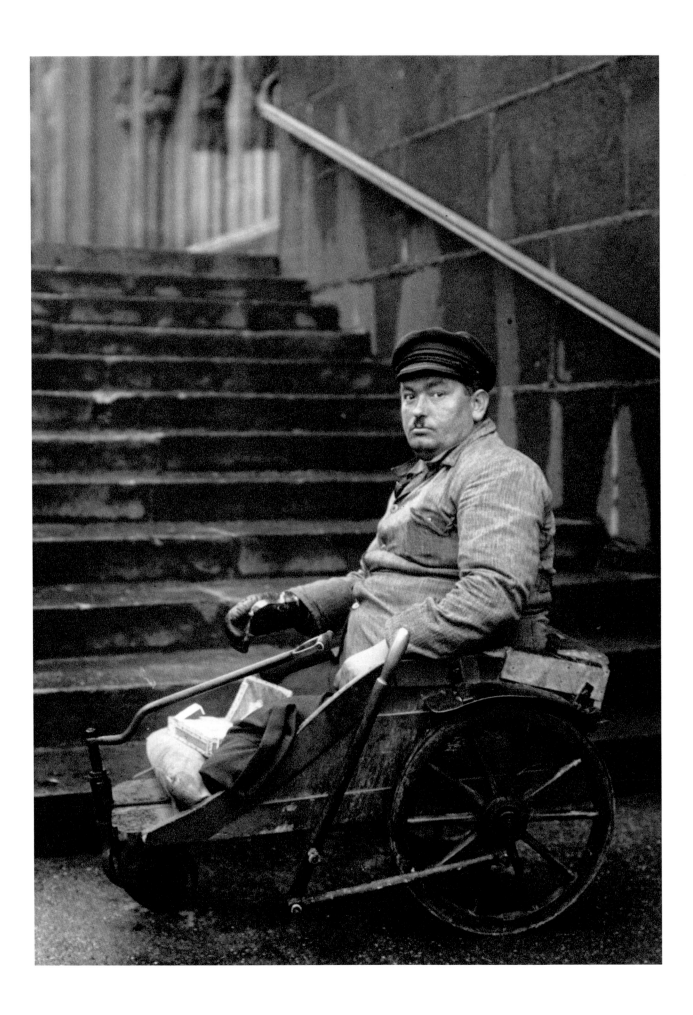

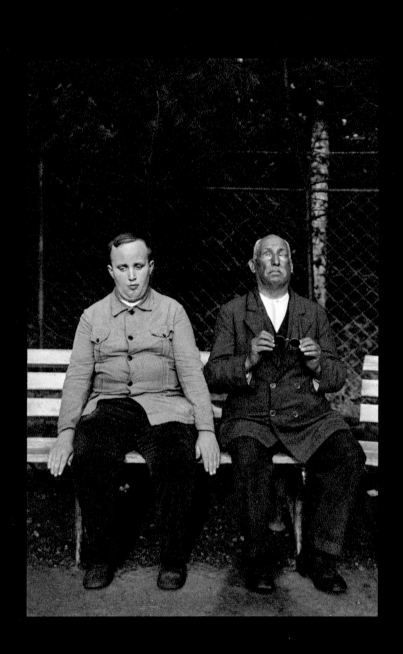

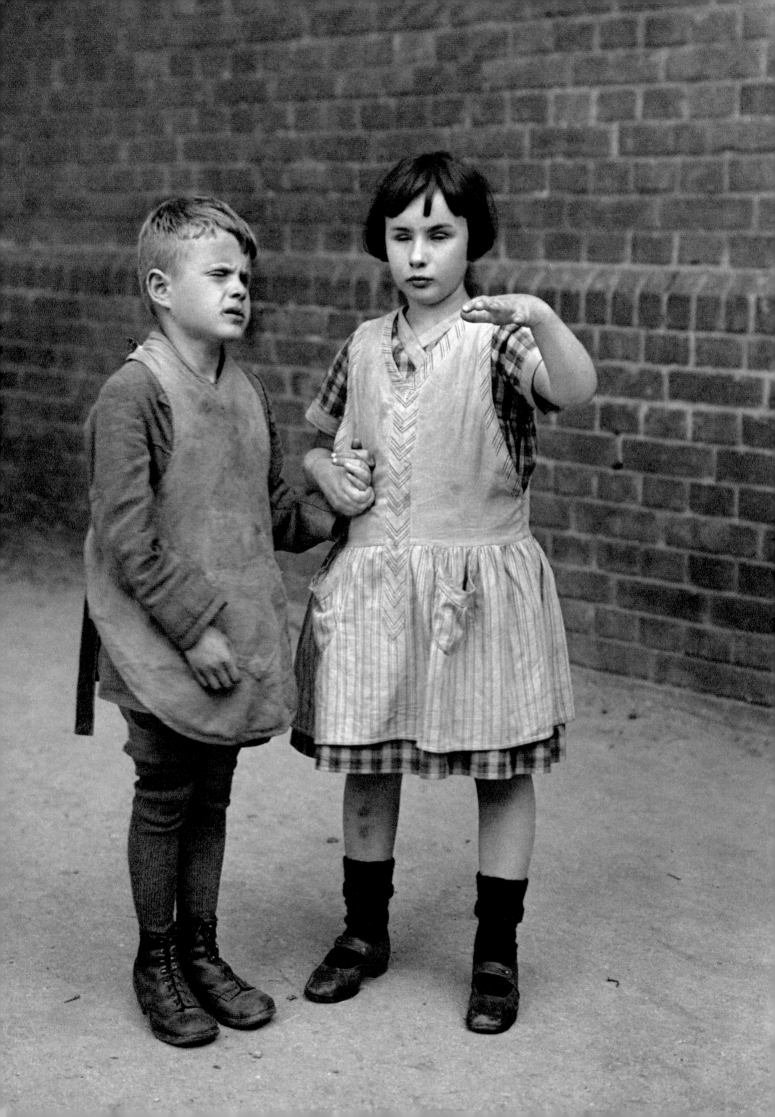

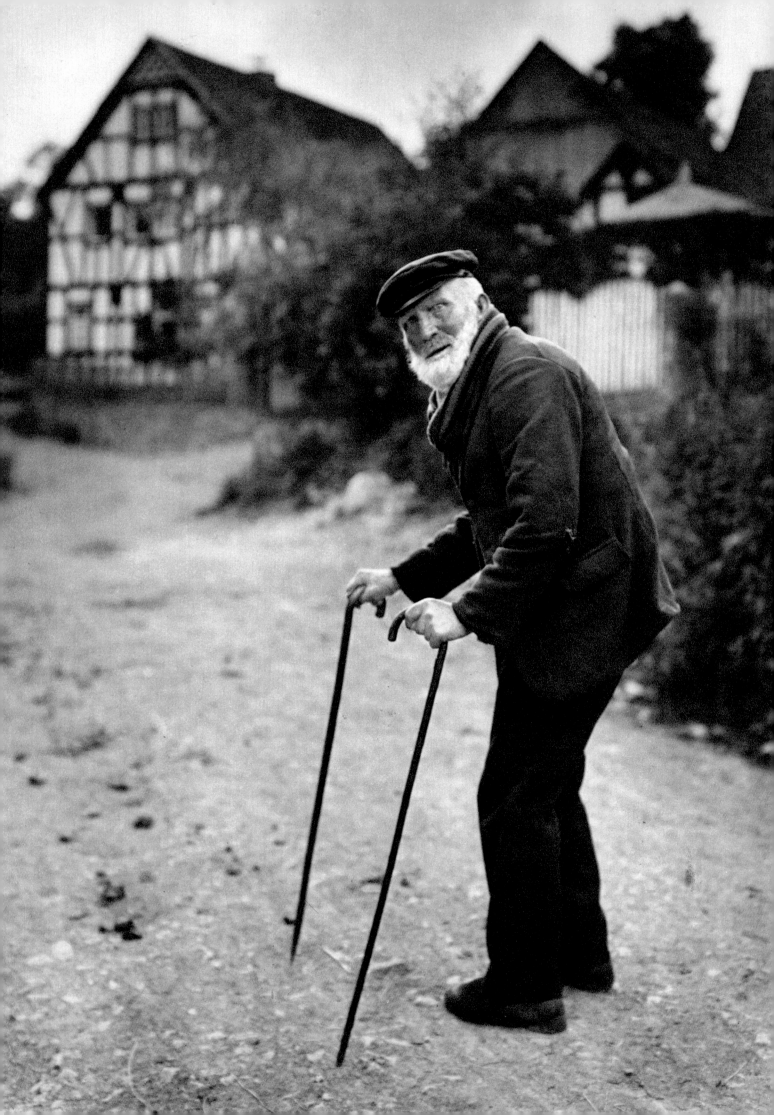

# *Photographer Extraordinary*

GUNTHER SANDER

The attempt to establish a relationship between a man and his work can at times prove valuable, at times futile, and at times positively harmful. Total congruity between the two is rare, although affinities sometimes, and vague parallels almost always, exist. But why in fact should we expect congruity? The result would surely be to put at stake the individual self-will which constitutes – in this case at least – the essence of the man himself. On the other hand, the attempt to write a biography *without* the restrictive desire to explain each event and action does not seem to me to be so futile. The charm of the unknown in a person is too strong to justify too detailed a psychological investigation of his character. What is important is to meet, accept, and perhaps get to know him.

August Sander was born on 17 November 1876, the third son of the mining carpenter August Sander and his wife Rosette, *née* Jung, at Herdorf on the Sieg river. Although his parents were the owners of a farmhouse and a certain amount of land, as well as the proceeds of an iron-ore mine which they had sold for 3000 talers, this was hardly sufficient to give them any degree of prosperity, particularly as they had nine children and did not intend to send them down the mines.

Although he was much smaller than his brothers in stature, my father was by no means inferior to them in strength. On the contrary, I can still hear the tone of satisfaction in his voice when he told us stories of his youthful pranks and scuffles – perhaps not without an element of fantasy at times.

As a young worker on the spoil heaps of the mine (this interim period before starting an apprenticeship was usual because compulsory schooling lasted only six years), my father had an experience which was to have a determining influence on his whole life, and contribute a great name to the history of photography. One day he was ordered to accompany a stranger, heavily laden with luggage, into the country. Among this luggage was a strange three-legged support which, after careful selection of his vantage point, the stranger set up. My father observed every movement with great curiosity and close attention. He watched the man screw a brass tube on to a box which he had fixed to the tripod, cover the back of it with a black cloth, and suddenly stick his head under it. To my father's excited questions as to what he was doing, the stranger replied by allowing him to put his head under the cloth, and for the first time he saw a small, upside-down landscape in miniature which thrilled and enchanted him.

At that time – around 1890 – photography had for ten years been free of the narrow limits imposed upon it by the necessity of producing the sensitive plate immediately before the exposure and developing it in the darkroom immediately afterwards. The new material, the gelatine dry plate, gave the photographer a considerable degree of independence, and it was possible to allow some time to elapse between exposure and development, which made it easier to take landscape pictures. This was the beginning of modern photography. The old alchemy had disappeared, and knowledge gained through experience, experimentation and invention could already be learned from books.

My father's meeting with the photographer Friedrich Schmeck (incidentally an ancestor of the founder of the Meteor photographic equipment factory) left him restless, tense and determined: determined to follow his example, and determined to acquire a camera. Understandably, he met with a degree of opposition from his father; but old

287

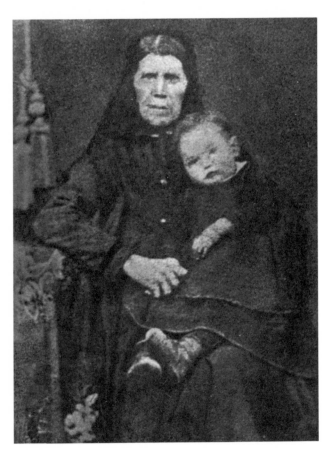

August Sander, at the age of two, with his grandmother

August Sander was nevertheless not unsympathetic to his son's ambitions, for he himself had a talent for drawing, and had found his son an attentive observer and a willing pupil. It was from him that my father learned to observe exactly and to isolate the essential – harmless childhood lessons which were later to develop into a diagnostic skill which enabled him to make his subjects unconsciously interpret their own characters. Perhaps it was the motion studies, in which it was less a question of setting down exactly what he saw than of re-creating an image from the existing possibilities, which formed his intellectual and technical basic model. His father once asked him to pull the cat's tail, as it sat on the mantelpiece, so that he could watch it jump down. My father gained some theoretical knowledge of photography from a book which – as promised – was sent to him by Friedrich Schmeck. The prospects concerning the practical side, however, were grim, and it was not until the family was visited by a prosperous relation, Uncle Daniel, a mine manager, that he came unexpectedly closer to his goal. Uncle Daniel was quickly infected by his nephew's enthusiasm and promised his assistance.

Overjoyed, my father lost no time in ordering a $13 \times 18$ cm camera, the smallest plate size available at the time, with an Aplanat lens, two magazines and a tripod, all of which amounted to 300 marks. Nor had Uncle Daniel forgotten the darkroom equipment and materials, and all that was missing was the darkroom itself. Here, however, his father was able to help, and he and his son collaborated in building a small hut by the side of the barn. There was water nearby, and an oil lamp with a red glass cylinder provided the necessary light for development.

One Sunday morning everything was ready at last, and the family next door turned up in their Sunday best to be photographed. The sun was shining, and one hour later the first picture was taken with all the care and conscientiousness of a dress rehearsal. When my father developed the plates that evening, he obtained negatives (incidentally still in existence) which were good as regards both focal sharpness and contrast. The actual printing brought difficulties, however, for my father was under the illusion that it was necessary to protect the paper from strong light. In actual fact, this applied only to the process of putting it in the printing frame, but my father assumed it to relate to the print itself and was disagreeably surprised when no image appeared on the paper during printing in dimmed daylight. He was on the point of despair when chance came to his rescue and he left the printing frame in bright daylight. When he returned to the laboratory, he was delighted to find a complete picture which needed only to be toned and fixed.

One of August Sander's first photographs (Herdorf, 1892)

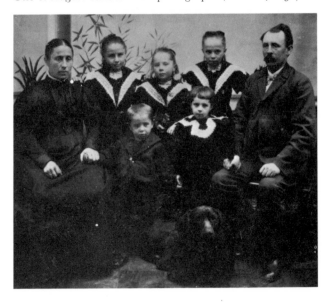

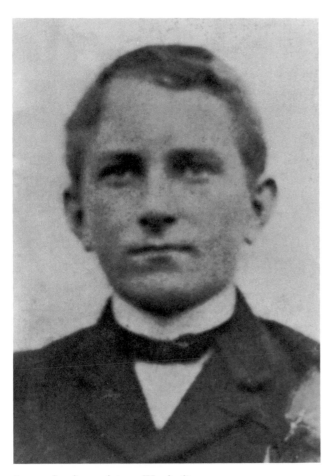

August Sander at sixteen (Herdorf)

In 1896 his photographic activities were interrupted when he was called up into the army and posted to Trier. It was with a heavy heart that he packed up his equipment and gave it to his father to look after. But the two years in the army also showed him new perspectives in his chosen craft, for there were photographers in every garrison town who were occupied almost exclusively with the demand for military souvenir portraits. Once, when one of these photographers took a picture of his section, my father acted as his assistant, to the photographer's complete satisfaction, and he was subsequently able to spend all his free time in the Jung studio. Even after his discharge from the army, he continued to work there in order to extend his knowledge.

But apart from his professional ambitions, there was another reason why August Sander chose to remain in Trier: a girl by the name of Anna whom he had first noticed when taking a picture. He now saw more of her, but only from time to time, as convention and his uncertain future required. He was intensely conscious of the fact that a law-court official with a monthly salary of no more than 120 marks must insist that his daughter's fiancé must be in a position to support a family.

It did not take August Sander long to learn all that was to be learned in a studio devoted to military group portraits, and after a few months he left Trier

A second setback was not long in following; the family he had photographed were not pleased with the result. They were disappointed to see wrinkles, blotchy faces, imperfectly ill-fitting clothes and a generally unflattering result, especially where the children were concerned. The blotches were the result of the non-orthochromatic plates, which darkened all the red tones – the reason, incidentally, why retouching was introduced. But August Sander knew nothing about this; all he knew was that the vanity of his subjects seemed to be infallibly roused every time. He was not yet thinking commercially. He continued taking pictures for nothing until the money from Uncle Daniel had run out, and from then on he took payment for his pictures – the first of which were approximately seventy copies of a photo of his workmates at the mine.

The word soon spread around that August Sander could take photographs, and it was not long before he was sought out by young men who wanted pictures to give to their parents before they emigrated to America. It may be that my father also thought of emigration, but his attachment to his homeland and his photography was too strong.

The Jung studio, Trier, with August Sander in the foreground (1899)

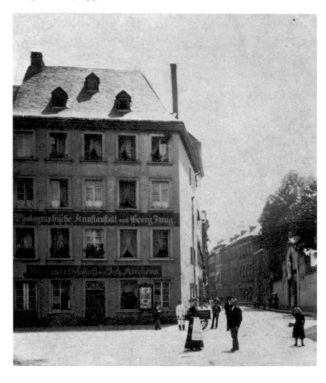

with a good testimonial in his pocket and embarked, like a traditional journeyman, on a period of travel; he worked in Magdeburg, Halle, Leipzig, Dresden and Berlin.

The main demand was for 'carte-de-visite' and 'cabinet' format portraits; amateur photographers were few and far between. Photography had become a profession, and it now became possible for people in all walks of life to have their picture taken; previously it had been the privilege of the well-to-do. Family photo albums became the fashion, and photographic studios multiplied and expanded. Refinements in technique and printing rapidly arrived on the scene. At the same time, architectural and industrial photography began to develop, and my father followed up every opportunity, sought out the best-known and most recommended practitioners, and worked in portrait studios as well as with more technically minded photographers such as the industrial and architectural specialist Kullerich in Berlin. It was probably from Kullerich that August Sander acquired the meticulous sense of order and precision which are an integral part of his work, and with which – indisputably important qualities though they are – I came into contact all too often during my apprenticeship with my father. Every bottle had its appointed place, so that he

could not fail to find the correct one in the dark-room.

The years of travel and apprenticeship had done their work, and all that he now needed to start out on his own was money. He may also have felt a certain element of scepticism about this new profession, and it may have been this, added to the fact that many of the good photographers of the time were also competent portrait painters, which led him to spend some time at the painting academy in Dresden (it was once again Uncle Daniel who helped with the financial side). The acquisition of this additional professional qualification was also bound up with his continued wish to marry Anna; and when he felt he had mastered the technique of portrait painting sufficiently to be able to practise it professionally, he returned to Trier to ask for her hand in marriage – no easy undertaking for a shy farmer's son, especially as he was obliged to confess to the Clerk of the Court and his wife that he had secured the post of first operator (the name given to the right-hand man of the director of a photographic studio) in Linz in Austria, and would therefore wish to carry off his bride to a foreign country. Anna's parents gave their consent – sadly and hesitantly, it is true, but they gave it. On 1 January 1901, when August Sander was twenty-five, he reported for work at the Greif studio in Linz, without Anna – she had yielded to her parents' wish that she should remain at home for the time being – but full of confidence. The work allotted to him lived up to his expectations, and he was delighted with this new-found independence.

The wedding took place one year later in Trier, and this was followed by a reunion with his parents at Herdorf. His wife Anna was greeted by the difficulties which are usual during the first contact between a new wife and her parents-in-law, and he himself was confronted with the lack of understanding of those entrusted with his photographic equipment: his brother-in-law had turned his darkroom into a wash-house, and in his ignorance thrown away all my father's negatives (with the exception of a few which still bear witness to the work of the sixteen-year-old August Sander). The camera, lenses and other equipment, which his father had looked after, subsequently accompanied him to Linz.

A new phase in August Sander's life had now begun, in a country which had always fascinated him, but in which he knew no one and was faced with the necessity of proving himself. His position in the best studio in town automatically gave him an entrée into influential circles, but probably he did not yet know how to move in them. This was much

August Sander at twenty-five (Linz, 1901)

easier for Anna, for as manageress of a well-known Trier ladies' dress salon she had been obliged to acquire the social graces much earlier. Thus she was able discreetly to correct any errors which might arise, and to develop a plan whose consequences she was able to calculate in detail. They applied for membership of a Linz choral society, the Linzer Liedertafel. For, in spite of the fact that many respected citizens had already realized that the first operator in the Greif studio was a good photographer, the accolade of general acceptance and respect was only to be gained by a social gesture of this kind.

How quickly August Sander found his feet can be inferred from the surprising fact that the owner of the studio, one Helmut Gruber, soon offered to sell out to him. The price was 20,000 crowns. How could my father possibly raise such a sum? Wishful thinking and common sense waged a mighty conflict within him, and his wife was intelligent enough to let him have his say while she satisfied herself of the genuineness of the offer by inspecting the accounts. The time at their disposal for thinking the matter over was short, and the decision was urgent. Finally a broker agreed to put up the sum of 10,000 crowns and to persuade Gruber to accept payment of the other half, with interest, within a year. Agreement was reached, since sufficient capital was available to eliminate any real risk, and the contract was duly signed. An important step forward had been taken; but it was a step which necessitated a period of the utmost thrift and hard work.

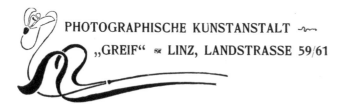

PHOTOGRAPHISCHE KUNSTANSTALT
„GREIF" LINZ, LANDSTRASSE 59/61

For my father this challenge was virtually a liberation. He set out to become one of the best photographers of the day. This was the period of what is known as art photography: a style characterized by its similarity to painting, divorced from precise, purely photographic representation – a continuation of painting with other means. In order to break away from the sober photographic image and the smooth surface of the picture, complicated positive processes were developed which lent the picture the atmosphere of an artist's print, or a monochrome painting, rather than a photograph as such. Pictures produced by these methods were known as *Edeldrucke*. Each print had to be worked

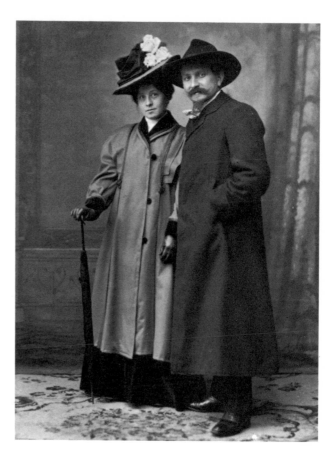

August Sander and his wife (Linz, 1905)

on individually. This called for experience; and experience could only be gained by experimentation, which in its turn required materials, plus the necessary literature on the subject. Thus it was by no means easy to become established as one of the foremost photographers of the day, and Sander's ambition cost him much time – time which, although it may have brought him recognition, did not bring in any money.

Enthusiasm has a tendency to blunt our sensitivity to danger. Perhaps this is what happened in my father's case: in his efforts to overcome the difficulties with which he was faced, he was partly successful in ignoring them, and his will to succeed remained unshaken – for what leads more easily to defeat than exaggerated caution? He worked with a feverish intensity until his work achieved a clear-cut success at an exhibition of arts and crafts in Linz and he received the State Medal for his art photographs – for the most part pigment prints and gum prints. The unprofitable art had ceased to be unprofitable; August Sander had made his name, and Linz was proud of him.

The running expenses were now covered, although the balance of 10,000 crowns for the purchase of the business was still outstanding. Legal

August Sander's first three-colour picture (Linz, 1904)

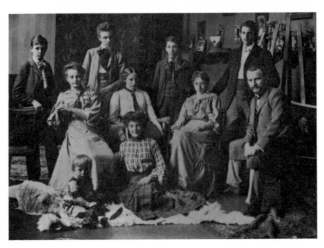

The Sanders (seated, right) with their staff (Linz, 1905)

action could be avoided only by finding a partner prepared to put up this sum. A glance at the photographic press provided the solution – a solution which turned out well, largely because the partner, Herr Franz Stuckenberg, made little use of his partnership. True, the firm became known as Sander & Stuckenberg, but in fact the running of the business lay very largely in my father's hands. The business flourished, and the demand for Sander's work increased as art photographs became more and more popular. There was much talk of photography in natural colours; no one in Austria was studying the problem, but this was just one more reason for my father to do so.

All-important though his work was to him, the event which took place on 22 December 1903 was of momentous significance: the birth of his first son, Erich. The happy father photographed the child through all the phases of his life.

Frequent differences of opinion with Stuckenberg led in 1904 to the dissolution of the partnership. The name of Sander & Stuckenberg disappeared and was replaced by the sign AUGUST SANDER PHOTO-GRAPHIC ART ESTABLISHMENT OF THE 1ST RANK. The business lived up to its name, and in the very first year my father received three distinctions at international exhibitions: a Gold Medal at nearby Wels, the Stifter Prize in Leipzig, and a Gold Medal and Cross of Honour in Paris – notable successes for an impecunious twenty-eight-year-old photographer who had started out as a mine labourer. He had now also begun to make colour prints, and the Leipzig Museum purchased some of these on the advice of the Seemann publishing house. The photographic press not only praised Sander's black and white photography, but mentioned his colour photographs in the same breath as those of Nicola Perscheid,

probably the best-known photographer in Germany at the time.

The question of the photographer's knowledge of himself in relation to his work, and the problem of the relationship between the picture and reality, never ceased to occupy my father. The studio, which provided the background for all his sitters, seemed to him to mask rather than to emphasize the individuality of his subjects. The idea of photographing clients in their homes was not new, but the unknown lighting conditions deterred most photographers. To August Sander, however, this represented a new and fascinating challenge which extended far beyond the purely technical aspect. His work as a whole contained much that transcended formal and aesthetic considerations, and although this was probably not consciously intended – he was not an educated man – he was emotionally fascinated by aspects of art and science which he

August Sander with his father (Linz, 1903)

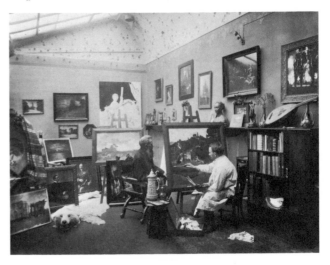

292

instinctively felt had much to offer. His library became more and more extensive, and no doubt my mother's patience was sorely tried by his ever-expanding collection of antiques and books on the history of art.

August Sander the elder had meanwhile paid a visit to Linz and convinced himself as to his son's ability and success; he was therefore all the more disappointed when his youngest son Adolph broke off his apprenticeship with his brother in Linz and emigrated to America. Serious work had never appealed to Adolph, and he probably considered my father's insistence on it as an authoritarian imposition. But although my father was not really as autocratic as Adolph thought him – not yet – an excess of severity coincided with an incident which was planned as a glorious occasion.

It so happened that Emperor Franz Joseph decided to visit the city of Linz, and my father was able to discover from his friend, Professor Leopold Korenski, the exact spot from which the Emperor could best be observed and photographed in the hope that a really good portrait of His Majesty might result in the title of Court Photographer. The designated spot in the garden of the School of Arts and Crafts, a projecting section of wall, was just big enough to accommodate the large-size camera, and was so placed that it would be practically impossible for the Emperor not to see the photographer. Everything was ready hours in advance of His Majesty's arrival, and, as promised, Professor Korenski drew the Emperor's attention to my father at the appointed moment, received his gracious permission to be photographed – and the picture was taken. My father rushed home as quickly as possible, and, still clad in his festive tail coat, developed the precious film with all speed. But the film was empty of any image whatsoever, and as the minutes went by beads of anxious perspiration formed on the brow of the aspirant to the post of Court Photographer. August Sander had forgotten to remove the curtain shutter. No one ever knew of this mishap, but my father reacted as if the whole world knew. Nothing was ever again to be left to chance, and that meant an even more obsessive observance of routine than before. And the same went for his unfortunate employees.

Ambition has its farcical aspects. My father made the acquaintanceship of a famous lutenist and composer, Robert Kothe, at a concert and was promptly promoted to the status of a student of lute-playing. A concert which turned out to be more successful for Herr Kothe than for August Sander fortunately soon scotched this new ambition. It had already taken up too much of the photographer's time, and

Anna Sander (Linz, 1904)

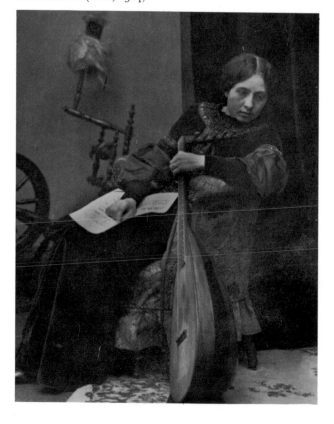

293

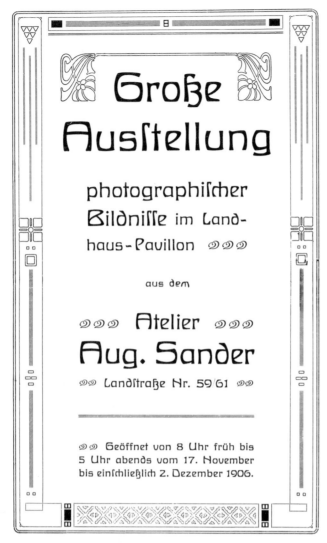

Große

Ausstellung

photographischer
Bildnisse im Land-
haus-Pavillon ✪✪✪

aus dem

✪✪✪ Atelier ✪✪✪
Aug. Sander

✪✪ Landstraße Nr. 59/61 ✪✪

✪✪ Geöffnet von 8 Uhr früh bis
5 Uhr abends vom 17. November
bis einschließlich 2. Dezember 1906.

Exhibition advertisement (Linz, 1906)

the desire to be a master in all fields was finally
sacrificed to common sense. It did in fact recur from
time to time – as was proved by the two large-size
paintings, one of the Sander family and one a copy
of the Rembrandt self-portrait with Saskia, which
decorated the walls of all Sander's future homes –
but the amateur became progressively less anxious
to parade in the feathers of the professional.

In 1906, on his return from the funeral of his
father, August Sander received an invitation from
the publishing house of Knapp in Halle to take part
in an international competition for portrait photog-
raphy. He entered, and was awarded the fourth
of the five prizes – a worthy success in the light
of international competition. In addition, he now
considered that the time had come to show the
people of Linz a cross-section of his work, and on
his thirtieth birthday an exhibition with a hundred
large-format prints was ceremoniously opened

in the Landhauspavillon. (The catalogue of this
exhibition bears witness to the fact that, even in this
early period, August Sander was more interested
in revealing the essence of the human being than in
presenting a flattering exterior.) Both the daily
newspapers and the professional press were generous
in their praise of his work, and Sander's business
received a considerable impetus. Sander himself,
however, was apt to think too little of the financial
side of things, and his fondness for books, paintings
and antiques continued to overshadow his re-
sponsibility to pay his debts.

The birth of his second son, Gunther, on 7 No-
vember 1907 brought trouble to the family. The
child fell ill with double pneumonia at the age of
four weeks, and it was only the advice of a homoeo-
path, who recommended that the child should be
carried from one room to another, in each of which
a bowl of hot salt water was placed, which resulted
in an improvement. I do not know if it was these
anxious hours which made my father aware that
he had in fact devoted too little time and attention
to his family over the years; in any case, this was the
first year in which the family went on holiday
together, and Sander took a series of family photo-
graphs which reveals that the emphasis had shifted
to his private life. Even his participation in exhibi-
tions now took second place, and it was not until
1909 that he exhibited again, in the Arts and Crafts
Exhibition in Linz, where he received the State
Silver Medal.

At the end of 1909 an epidemic of polio broke
out in Linz. August Sander's elder son Erich
contracted the disease, and his parents worried
greatly about both their sons. On the advice of the
family doctor, my father sent his wife and children
to Trier and decided to give up his business in Linz

August and Anna Sander with their two sons (Linz, 1907)

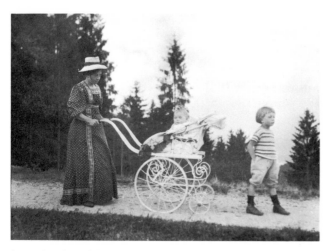

Anna Sander with her sons Gunther and Erich (Linz, 1908)

and follow them two months later. He left Linz, leaving behind him debts to the total of 3,000 crowns. From Trier he secured the post of manager of the Blumberg & Herrmann photographic portrait studio in Cologne. The work of this studio, however, was restricted to conventional rigid portraiture, and August Sander neither would nor could be satisfied with this. A few months later he gave notice and became once again – hard though it was – his own master.

The initial results of the new photographic studio which Sander opened in the Cologne suburb of Lindenthal were by no means encouraging, and the unfriendly attitude of his local professional colleagues did nothing to help the situation. August Sander was once again in search of a clientele. The idea of photographing his subjects in their own surroundings had already occurred to him in Linz, and he now pursued this idea with renewed vigour. Westerwald, his native district, was situated not far from Cologne, and my father knew the people who lived there, spoke their language and knew how to get on with them. Thus it was that one weekend he took his courage in both hands, bought an old bicycle, shouldered a rucksack packed with equipment and a portfolio of his work, and took the first step into a new photographic world. Despite the natural reserve of the Westerwald peasants, my father nevertheless managed to take about twenty pictures. They were developed and printed during the following week, and the following Sunday saw Sander off again in search of new subjects, with the previous weekend's pictures, and the new unexposed plates, in his rucksack. He was lucky – perhaps due to his intuitive sympathetic understanding – in that the peasants were delighted with the portraits of themselves as seen through Sander's

eyes, and this success marked the beginning of a year of weekly excursions into his home district. These excursions gave my father a great deal of pleasure, and they also compensated for the lack of success of the Cologne business, not least because he was able to buy food much cheaper in the country. The ever-expanding bulk of his luggage bore ample witness to the increasing demand for his work. He was obliged to carry with him large, heavy family portraits, framed and under glass, and the bicycle and its rider often seemed to be laden to their utmost capacity.

As the studio in Cologne also began to enjoy a certain measure of success, it was decided to answer an advertisement that had been put in the paper by a young photographer from Reykjavik. Sigga Zoega was an enchanting young girl; she quickly became familiar with the work, and developed a friendship with the Sander family which was to last over many years. Later on she also established valuable contacts for my father's studio. Sigga never thought of the limits of her duties – she simply helped wherever she could in both private and business spheres, and my mother, whose health was considerably undermined by the birth of twins in

August Sander in Westerwald (1911)

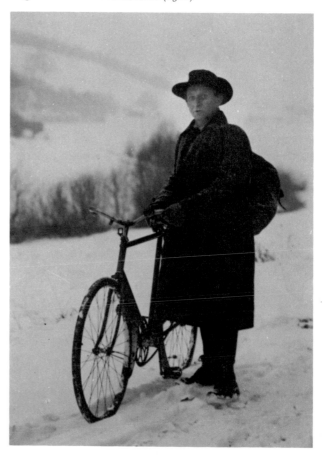

295

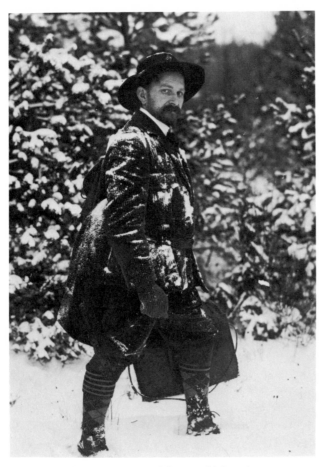

August Sander on his way to Westerwald (1911)

June 1911, was particularly grateful for her constant readiness to help.

Sigga was also a considerable support in my mother's constant battle against my father's endearing but not entirely harmless foible of spending his hard-won earnings on antiques. Money gave him pleasure only after he had spent it. For example: a rich hotel owner from Westerwald ordered two large-format gum-bichromate prints for the hall of his hotel, for which my father charged 400 thalers each. He was so proud and delighted with this sum that he at once felt his home surroundings to be inadequate to his new status, and it took a good deal of diplomatic skill to avoid an immediate move to more prestigious quarters. But necessity is the mother of invention, and his love of antiques now became the basis of a commercial enterprise. One day a dirty, unprepossessing piece of furniture was delivered from the railway station. My father had purchased it from a peasant for five marks, and before the astonished eyes of his family he conjured up a fine dresser out of the ugly grey monstrosity. A cabinet-maker carried out the necessary repairs, and with the help of the influential merchant

Heinrich Erkes (whom we had met through Sigga Zoega in connection with his research in Iceland), the cupboard fetched 700 marks from the Kunstgewerbemuseum (Museum of Arts and Crafts) in Cologne. This sum provided the financial basis for the desired move.

Our new home was situated in the main street of Lindenthal, and new furniture was specially designed and made to set off the antiques. The wide entrance hall was fitted out with showcases which set off my father's best pictures, and his prizes, medals and diplomas, to their best advantage. The new image was not long in making its impact. Although Lindenthal already had two photographic firms, the customers soon realized the difference between them and my father's. But, in spite of the rapidly increasing demand for his work, my father did not forget his old clients in Westerwald: no doubt he would have felt it to be ungrateful simply to exchange them for new customers, and he was also perhaps more at home with their physical presence. Thus it was that he left the business in my mother's hands whenever possible; she had learned enough about photography over the years to deputize for her husband without difficulty. And how necessary her collaboration was, particularly in the Christmas season when everyone was working under high pressure! It was only on Christmas Eve that the tension was relaxed, for my parents from the stress of their work, for us children from the stress of waiting.

The everyday work took up a lot of time, but August Sander never forgot his own creative work. In accordance with the general trend of the day, the Kunstgewerbemuseum in Berlin began to regard photography as a branch of the visual arts, and to include a collection of the best photographs by German and foreign photographers in its collection. My father was among those invited to submit work for the exhibition, which finally comprised 140 pictures, the work of pioneers in pictorial photography, including Edward Steichen from New York, whom my father was to meet forty years later when Steichen was preparing his exhibition 'The Family of Man'.

Another impetus for August Sander's personal work was provided by the preparations for the large-scale Werkbund exhibition planned to take place in 1914 in Cologne. The Werkbund was already proving an active influence in the stimulation of modern creative work in all fields. In addition to this, Professor Emanuel Bachmann, lecturer in architecture at the Cologne Werkschule, arranged for my father to receive the commission to supply

the necessary architectural photographs for the exhibition, and here August Sander was able to make use of the experience he had gained at the Kullerich studio in Berlin.

With the outbreak of World War I, August Sander was called up as a reservist. All he was able to do before mobilization – which he had never really believed would happen – was to make provision for the possibility of bad times to come. He left on 5 August, in my eyes the incarnation of a hero with his black shako and real bayonet. He was detailed – and this must have been a comfort to my mother – for service in the army of occupation. But things were to turn out differently.

Anna Sander ran the business with enormous competence. Financial reserves were meagre, and the greater part of the clientele fell off with the outbreak of war. She was therefore obliged to look for new customers, and found them in the army. There were two barracks in the district, and the request for group photographs was not long in coming. I loved to accompany my mother; the field-kitchen attracted me greatly, and I was often given tit-bits. Even on Sundays, the soldiers crowded into our house to be photographed, and it sometimes seemed that my mother would never be able to keep pace with the work. I was able to help her, but my elder brother was lame and my sister too young (her twin brother had died shortly after birth). The tips and instructions which my father gave us during his first leave made things easier, but it was nevertheless a hard time for us all.

August Sander had taken a camera to the Front, and somehow he had managed to set up a darkroom as well. He realized that it was asking too much of my mother to expect her to deal with his developing and printing.

August Sander's makeshift studio in World War I

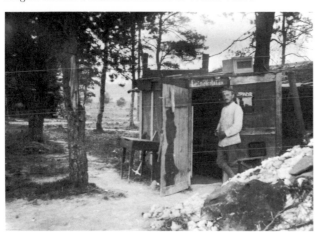

The first years of the war passed, and no end came in view. In spite of the supply situation, which drove many people almost to despair, we somehow managed not to starve. Of course, luxury products were out of the question, but we always seemed to have an adequate supply of natural produce. My father sent us parcels of food and clothing which he bought out of his army pay (the parcels sometimes contained photographs of a devastated Belgium). My mother maintained the particularly valuable connections with the peasants in Westerwald. Cologne was bombed, and the rumours that Germany had lost the war increased. In 1917 my father did not receive Christmas leave, and my mother reacted against the general state of passivity by arranging for alterations to the house and by looking around for new work. At the beginning of 1918 she installed electric light in the whole house, which greatly facilitated the processing work. She now began to make reproductions of old photographs, which she then enlarged; an increasing amount of work came in from the relatives of fallen soldiers.

In October 1918 August Sander was posted to Cologne. He surprised us with a visit and a huge crate containing thirty young rabbits. He had previously proved his talent for organization by securing a quarter of a horse which – with a lightning reaction – he had immediately dissected on the spot where it had fallen. Even so, the thirty young rabbits seemed to us to be almost an unbelievable piece of luck. It was planned that his leave should last for eight days, but the political situation had changed so greatly that the local headquarters office advised my father not to report back for the time being. He was only too glad to get out of uniform. Hopeless confusion reigned everywhere. The flood of returning soldiers led to obligatory billeting, and our house was no exception. Food supplies for the civil population failed entirely, and those who did not find their own ways and means of survival were soon in a desperate plight.

The occupation brought new opportunities for my father. He filled his showcases with pictures calculated to appeal to a new clientele, both officers and other ranks. He rapidly established a good relationship with the occupying troops, most of whom were from either Canada or New Zealand. Payment took the form of food, and especially the much-missed luxuries such as tea, coffee and cocoa. The situation gradually improved, the ban on travel which had existed at the beginning of the occupation was lifted, and my father was able to visit Westerwald for the first time since the outbreak of

war. His old customers were delighted to see him, and he received a good deal of work, above all enlargements of pictures of relatives who had been killed in the war – often a far from easy task.

A practically impossible situation arose from the fact that every citizen was obliged to acquire an identity-card photograph within the shortest possible time. His customers stood in queues before my father's door, and he worked far into the night in order to keep up. The pressure was so great that August Sander was obliged to devise a more rational way of working than photographing each individual separately, and he hit upon the idea of photographing them in groups on an 18 × 24 cm plate from which he then cut out the single passport photos. And the rationalization process was further helped by the fact that we children helped him with the cutting.

Prominent people began coming to August Sander's studio, among them the composer and conductor Heinrich Wetzlar and the cello virtuoso Professor Willi Lamping. The latter was so delighted with his portrait that he wished to express his gratitude in some form. What could be more natural than the exchange of professional skills? My father had provided him with an excellent gum-bichromate print, and Professor Lamping now took the musical education of his son Gunther in hand. This came as a heaven-sent excuse for my bad school reports. One could not, I argued, be a master in all fields. This attitude was not, perhaps, so very different from my father's – but it was probably rather early for me to come to this conclusion.

His many friends and acquaintances in artistic circles soon brought August Sander into contact with modern painting. Even before the war, the tendency had been towards Expressionism, but now, thanks to the impact of the experience of war, this became the dominating element. Franz Wilhelm Seiwert (whom we met through Professor Lamping) was a modern painter, and, in discussions about the new stylistic trends in painting, Lamping found parallels in music. Seiwert sought new forms of expression and the stimulus of an openness which forced the viewer out of the inertia and passivity which was the natural result of faithful, true-to-life portraiture. Art as mere *mimesis* did nothing to stimulate creative thinking, and photography had long since become a branch of art. These discussions with Seiwert had a deep influence on my father.

Thus it came about that one day he made an enlargement of the portrait of a peasant on a type of paper which was normally used only for technical photographs – a smooth paper with a glossy surface

August Sander at forty-five (Cologne)

which emphasized every detail and concealed nothing. When August Sander compared this picture with a gum-bichromate print of the same portrait, he was delighted with the result, and his enthusiasm was shared by Seiwert. The 'pictorial' effect was entirely lacking. It was hardly to be expected that his customers would appreciate this type of portraiture, and my father had no illusions about this; nor did his clients' vanity bother him. He was not interested in making hasty and flattering portraits, which was what most of his customers wanted, but in reproducing exactly what he had observed through the camera lens. These experiments produced a whole series of enlargements of his best photographs. The previous retouching was removed from the negative – I remember noticing this at the time. Pictorial photography, to which August Sander had contributed so much, was finished for him. And he had plenty of time on his hands to weigh up the pros and cons of the consequences of his firm resolution to devote himself solely to objective, unfeigned photography. During the period of inflation, when no one had the money to spend on photographs, August Sander gathered together an archive of all the pictures which seemed to him to reflect this objectivity.

There was another painter who was a regular guest in August Sander's house: Friedrich Brock-

298

mann. Lively discussions sprang up between him, Seiwert and my father, and by this time I was old enough to play the part of a silent listener. I remember one evening when my father showed his friends a portfolio of portraits of Westerwald peasants, all of them startlingly true to life and photographically accurate, printed on glossy paper. In reply to the question as to the purpose of this series, he answered that they represented the beginning of a photographic work on 'People of the Twentieth Century', and that he planned to start the work with portraits of farming people because he recognized in them an archetypal element, an unmistakable human essence. His intention was to follow these farmers' portraits with people from all walks of life and professions. Seiwert and Brockmann were enthusiastic about the concept, and I can still hear the excitement in their voices when discussing the details of the project. My father refused to be influenced as to the arrangement of the work, however, and he only accepted concrete suggestions concerning possible subjects on the condition that the persons in question should appear without name or title. He wanted the photographs themselves to express what was missing in verbal descriptions and details.

This enterprise brought us into contact with a number of important people. As the cultural life of Cologne slowly began to come to life again, my father had plenty of opportunities to find the subjects he wanted. He photographed well-known conductors, composers and interpretative musicians in their own environment, and I often saw him comparing his pictures with work by other photographers. At that time I was unable to understand why he thought highly of the work of Hugo Erfurth, for example, when I considered it to be no more than competent. My admiration for my father knew no bounds, without, however, my making the concessions which are necessary when one takes into account the origins of another individual's ideas.

Additional material for 'People of the Twentieth Century' came from an unexpected and previously untapped source. As a convinced Social Democrat who held the opinion that the world revolution of Communism could only lead to anarchy, August Sander had frequent and heated discussions with my brother Erich, who was studying philosophy in Berlin and who was a member of the German Communist Party. My brother's request for permission to bring a friend, the Party secretary, to stay at our house was met with a definite No. But in spite of Communism and the red Soviet star on his lapel,

the friend was able to pay in dollars, and that was by no means unimportant in the existing financial situation which followed the devaluation of German currency. And since as a result of this acquaintanceship my father's work became known to a wide circle of socially active and appreciative persons, he was reconciled.

Urkunde

über die Befugnis zur Anleitung von Lehrlingen.

Dem Herrn August Sander in Köln-Lindenthal, Dürenerstraße Nr. 201, geboren im Jahre 1876, wird auf seinen Antrag gemäß § 129 der Gewerbeordnung in Verbindung mit Artikel II des Gesetzes vom 30. Mai 1908 die Befugnis zur Anleitung von Lehrlingen in seinem Handwerk

—— Photograph ——

verliehen.

Köln, den 27. Mai 1926.

Der Oberbürgermeister.
J. V.

Licence to engage apprentices (Cologne, 1926)

The domestic political situation gradually improved, and my father began to go to Westerwald increasingly often, leaving the Cologne business in my mother's hands. My parents' chief worry at this time was myself, for my attitude to school had not altered, and what had started as a childish weakness now took on a more serious aspect due to the necessity of deciding between a grammar-school education and a photographic apprenticeship. I decided on the latter; and my father was pleased at the thought of being able to hand on his knowledge. At first I was allowed only to help with the simple

retouching and just watch the rest of the work. At the time I considered this restriction to be irksome, boring and unjust. Later, however, I realized the value of this method of learning, and after a year's apprenticeship I started making my own enlargements – although not before I had presented my instructor with a test strip for exposure.

The circle of painters who met at my father's house had gradually widened. August Sander made reproductions of their pictures, and such men as Otto Dix, Jankel Adler and Wassily Kandinsky were among his customers. But there were few among them who were in position to pay cash for the reproductions, and payment took the form of drawings, paintings and prints. And even this did not always happen, since my father often recognized the artists' financial difficulties or forgot to remind them of their debts.

In 1926 August Sander made the acquaintance of the writer Ludwig Mathar, who had published a number of novels and stories, as well as a book on Italy with illustrations by the painter Ludwig E. Ronig. Mathar was enthusiastic about my father's work, and suggested that they should work together on a book on Sardinia, in which the accent

in the illustrations was to fall on the Sardinian people. This was enough to arouse my father's interest, a contract was signed, and a three-month journey arranged. My father packed a 13 × 18 cm camera, various photographic equipment, and a supply of plates and cut film.

With my father's departure, a period of trial began for me since the main burden of the work was to fall to me during the next three months. I did my best, and the reports which my mother sent to Sardinia confirmed that I was doing well. A flash exposure very nearly cost me my sight, though. My father had always had a weakness for improvisation, and our equipment for the ignition of the flash powder consisted of the bottom of a box, impaled on the end of a walking-stick. The flash powder was ignited by a fuse which was nothing more than a strip of newspaper. One evening I had to take a flash picture of a wedding group; everything was ready, but the flash failed. I was just going to investigate the cause of the failure when the box fell from the walking stick, and the powder exploded in my face. Completely stunned, I fell to the floor beside the camera, and it was the merest stroke of luck that, although my cornea was injured, my

Peasant girl (Sardinia, 1927)

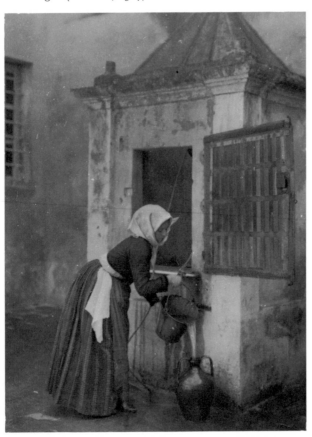

Sardinian peasant (Sardinia, 1927)

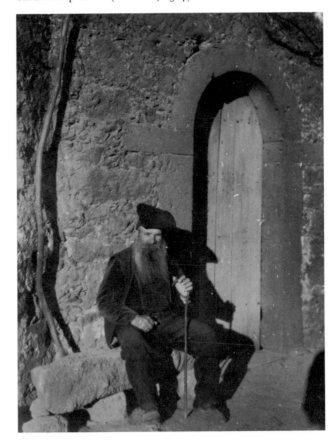

sight was unimpaired. A few days later I was back at work, but I never again cared much for improvised equipment. After my father's return the dangerous contraption was replaced by a safe flashlight unit.

August Sander brought hundreds of pictures back from Sardinia, and the two of us began to work on developing the films. Not all the photographs were successful, however, for my father had exposed the cut films according to his experience with plates, and a flawless development was not always possible. He was very annoyed, but reluctant to admit that he had made a mistake. We tried everything we could think of to achieve serviceable negatives from these films, and we finally managed it with the help of a special developer combination. I made the enlargements, and Mathar was thoroughly satisfied with the results, including the colour pictures. For the time being, however, publication was out of the question: Mathar and the publisher were unable to come to an agreement, and my father was forced to find another market for his Sardinian pictures. By chance, a Cologne architect was planning an exhibition of modern painting for the Cologne Art Association, and my father participated with a large number of photographs. The notices in the press were detailed and enthusiastic, both as regards the exact portrayal of the subjects and the formal design. But no matter how often his work was greeted with approval and appreciation, my father never seemed to be able to achieve the corresponding financial rewards, and this is strange when one thinks of the talent for organization he had shown in the war years. But perhaps it was less a question of organization than of the simple fact that the prices he asked were too high – an attempt on his part to achieve recognition for photography as an art in its own right by pricing it at the same level as painting and drawing.

A new and amusing source of income was provided by the Cologne Carnival, and although my father was not altogether enthusiastic about the project at first, he installed small photographic studios in the corners of the halls given over to balls and other festivities. His doubts were allayed by the success of the venture; photos were supplied only in return for immediate cash payment.

In 1928 the financial situation of our business became more stable. The international 'Pressa' exhibition in Cologne brought in some good work and plenty of success. The publisher Kurt Wolff became acquainted with my father's work on this occasion, visited his studio shortly afterwards, and quickly decided to publish August Sander's work.

Wolff was one of the first to recognize the possibilities of modern photography in book form. Shortly before he met my father he had published the volume entitled *Die Welt ist schön* ('The World is Beautiful'), with photographs by Alfons Renger-Patzsch. A book dealing with the expressive possibilities of the human physiognomy seemed to him to be even more interesting. Since my father's work was by no means completed, and was extremely ambitious in scale, Wolff wanted to publish an introductory volume to serve as an invitation to subscribe to the completed work. This first volume was entitled *Antlitz der Zeit* ('Face of Our Time'). The selection of the pictures took half a year, and – at the suggestion of the publishers – the accompanying text was by the novelist Alfred Döblin, a former doctor who had written the famous novel *Berlin Alexanderplatz*. Sander did not know him, but at the first meeting he was conscious of the writer's perception of an entirely new objective and psychological realism in his photographs. Döblin, the poetic spokesman of the victims of society's brutal neglect, immediately recognized that August Sander's work was, as he put it, comparative photography in the same sense as we speak of comparative history or anatomy. He was at once aware of its sociological importance, which extended far beyond mere photographic detail. Like painters, photographers can teach us to see certain things and to see them in a certain way. He speaks of 'a select group of photographers – but group is perhaps too grand a word, for there are certainly very few, and the only one I know in Germany is August Sander – this group consciously belongs to the disciples of realism; they regard the great universal truths as real and efficacious, and when they photograph they produce pictures in which it is no simple matter to recognize with certainty Mr X or Mrs Y'. In these faces – retouched, perhaps, but not by the photographer – individuality is no longer present, for they have been rendered anonymous by death or by human society. 'Seen from a certain distance, the differences vanish, the individual ceases to exist, and universality is all that remains. The individual and the collective are... no more than matters of a difference in distance.'

From the financial point of view, *Antlitz der Zeit* (published by Transmare-Verlag, Munich, in 1929) did not come up to expectations. It did, however, bring business connections of all kinds, among them orders from architects for architectural photographs, including one from the famous Fritz August Breuhaus de Groot. After the success of the test shots, he commissioned us to take some of the interior photo-

graphs of the liner *Bremen* which he had designed (the rest were taken by the well-known Cologne photographer Hugo Schmölz).

One day August Sander received a request to give a series of six talks on the origins of photography for West German Radio. My father was undecided and slightly irritated: he had never had anything to do with writing or lecturing, but the subject interested him intensely. After repeated assurances that the best possible assistance would be put at his disposal, my father agreed to the proposition. Each talk was to be restricted to a definite theme and last for twenty minutes; the first was to be broadcast in six weeks. The radio station agreed to the fee and the title, 'The Nature and Development of Photography', suggested by my father. August Sander buried himself in his books, and a few days later he began to dictate the text of the first talk. My brother Erich – with the best of intentions – corrected his somewhat clumsy style, but this annoyed my father, and he dismissed his well-meaning editor. My mother and I then stepped into the breach, confidently enough at first, only to learn that our task was to be by no means easy: when we read back the dictated text – and in our opinion some corrections were essential – my father denied ever having said anything like our version. He forgot that his thoughts were constantly in advance of his words, and that we had not the slightest interest in changing the substance of his lecture. Under the pressure of the deadline, we became accustomed to this tug-of-war. The microphone test brought further difficulties; it was not a success, and August Sander was by no means prepared to have his scripts read for him by a trained radio speaker. So my father gave his talk himself; and during the actual broadcast, in spite of a dose of tranquillizers, he lost track of time to such a degree that the planned twenty minutes shrank to thirteen. The end of the talk was followed by a short pause, and then my father's voice rang out loud and clear through the ether: 'Well, what happens now?' The microphone was quickly disconnected; and the whole episode remained a family joke for ages. It was the first time that an important photographer had ever broadcast a talk on photography, and said exactly what he wanted to say.

Carnival time came by once more. At the fancy-dress balls organized by progressive artists, everyone was present from the most simple, unknown painter to the most famous composers of the day. Tirelessly and persistently my father moved among the crowd, making new contacts and renewing old acquaintanceships (the actual photography was left to me).

Once, when he was standing on the stage, someone rushed up to him and brusquely demanded a photograph of himself. August Sander, to whom servility was entirely unknown, answered back in no uncertain terms, the man became angry, and my father picked him up by the scruff of the neck and the seat of his pants and removed him from the stage. His quick reactions and his ready wit (in this case the unconcern and openness with which he made his views clear) is also illustrated by a meeting with Paul Hindemith. My father: 'There's Hindemith, what a pleasure to see him again!' One of Hindemith's companions, very quietly: 'Please call him *Herr Professor*.' But my father was having none of this; he answered that the composer was more than a mere professor as far as he was concerned, and Hindemith replied with a loud 'Bravo'.

The difficulties in the domestic political situation led to family tensions. Unemployment was constantly on the increase, emergency decrees put a stop to building projects, and this meant a stoppage of work in the field of architectural photography. My father tried to improve this precarious situation by raising his prices, but this did not help. I had for some time been toying with the idea of striking out on my own – my father had two assistants and did not need me. I quietly raised the matter with him, but his reaction was far from calm. At first I thought it was selfishness which made him want to keep me against my will, but it is more likely to have been the wish to retain me as his successor. At times like this, parental affection is apt to become somewhat schizophrenic. It was a pity that his reactions, although not his reason, were so often governed by his hasty and obdurate temper; fellow human beings found it hard to realize that his outbursts should not be taken too seriously. Finally, on the advice of his friends, he agreed to my project, and armed with an old wooden camera and two lenses (I had constructed the rest of my equipment myself), I moved into a flat with a studio in the centre of Cologne. My father never visited me. Occasionally I went to help him, but when I saw that he was concentrating intensively on colour photography, my pride forbade me to return to his studio.

The domestic political situation soon put an end to his experimentation in any case. The new methods which he had sought in the beginnings of photography (daguerreotype, the first photographic process, and the making of sensitive paper, had absorbed his interest for a long time), had to be abandoned. The German people were seduced into a bout of unbridled wishful thinking. Communism, the arch-enemy of the Nazi party, was persecuted

relentlessly. Arrests became everyday occurrences, and my brother Erich fled from one hiding-place to another. After spending some time in Paris, he returned to Cologne despite warnings from all sides. And although my parents were in despair over his credulous belief that the horror would soon pass, they helped him produce his leaflets by photographic methods (the party printing presses had long since been seized). As my father did not possess a drying machine, the prints were dried outdoors on the roof. A gust of wind must have blown some of them down into the courtyard below, and my brother was arrested the next day by the Gestapo. His library was confiscated, and my father's archives were virtually turned inside out. All our complaints were to no avail – on the contrary: our connection with Erich had labelled us as anti-social parasites. And, understandably, customers were afraid to come to us.

Around the middle of 1934 we received the news from the Transmare publishers that August Sander's *Antlitz der Zeit* had been withdrawn and all stocks confiscated. Even the printing-blocks had been destroyed. My father was furious, and his anger only abated during an excursion into the Siebengebirge district, where he went to take landscape pictures. This inner emigration did him good. Since there was no chance of his pursuing his own line of work, he was obliged to look around for new possibilities. Up in the Siebengebirge he found an enchanting stretch of completely unspoiled land.

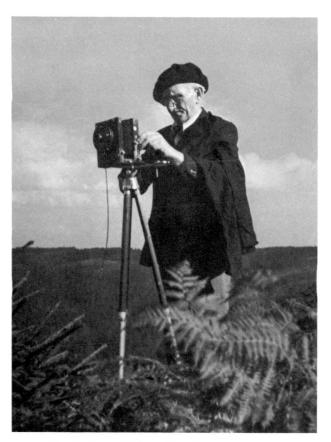

August Sander in the Siebengebirge (1941)

At night he slept in a sheltered spot in a sleeping-bag, in the daytime he read or went out looking for new subjects. The rest and relaxation which he found in this lonely spot even gave him a degree of confidence when he thought about the approaching trial of his son. The verdict, however, brutally proved him wrong: Erich Sander was sentenced to ten years' imprisonment and an equal period of loss of civil rights, as well as to pay costs.

August Sander's new interest in landscape photography had at least the advantage that it was totally apolitical. In addition, pictures of the German countryside were much in demand for magazines and books. A well-known Rhineland publishing firm suggested that he should provide the illustrations for a series of small booklets on the German countryside. The German Chamber of Literature was in agreement, and even requested the continuation of the series. But later, when August Sander was busy with the preparation of a volume on Cologne, the Gestapo came back to ransack his archives. They confiscated some particularly valuable negatives on the pretext that they represented important war objectives. Luckily, however, my father still retained positives, of which he later had copy prints made.

August Sander's country refuge (Siebengebirge, 1940)

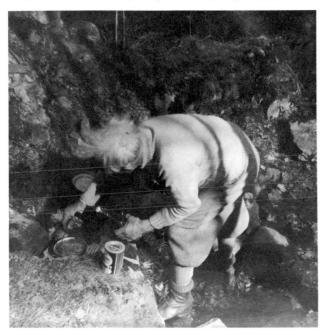

# *Landscape*

Landscapes do not reveal themselves spontaneously, and August Sander must have felt this when he withdrew to the Siebengebirge, the hills south-east of Cologne and Bonn, in 1934, after the Nazis had confiscated his work *Antlitz der Zeit*. It is from this period that the following pictures originated.

Between 1920 and 1940 August Sander took two hundred landscape photos of the Siebengebirge. It may have been an enforced exile at the time; in retrospect, it proves to have been of incalculable value.

*G. S.*

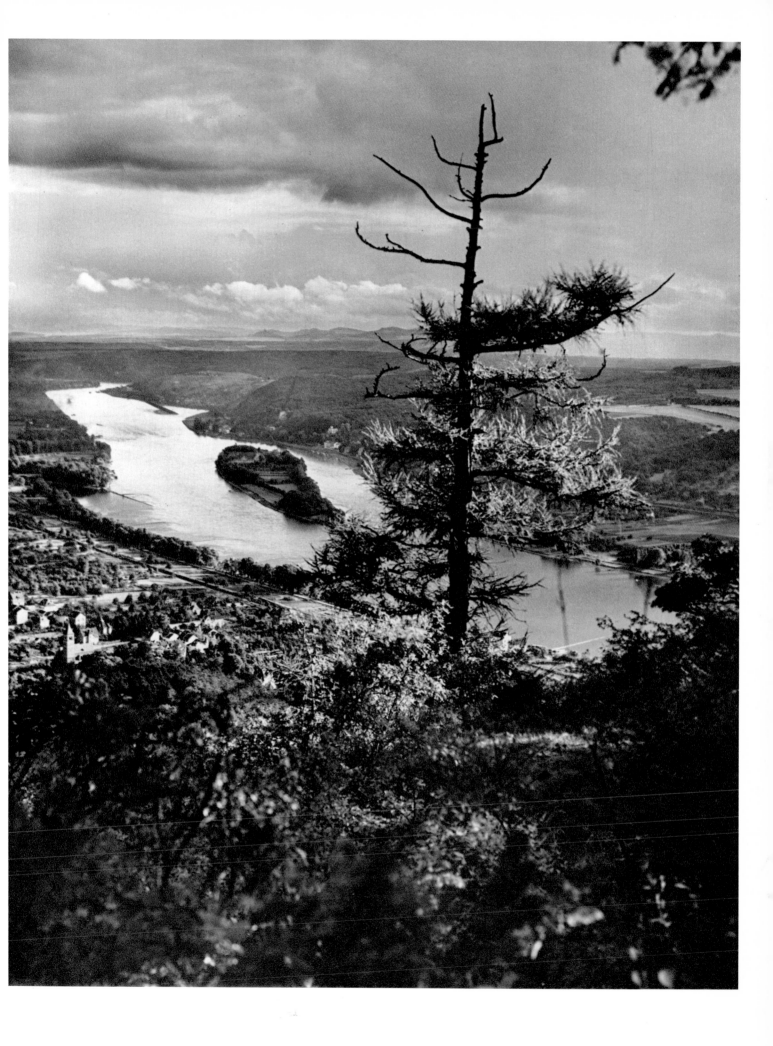

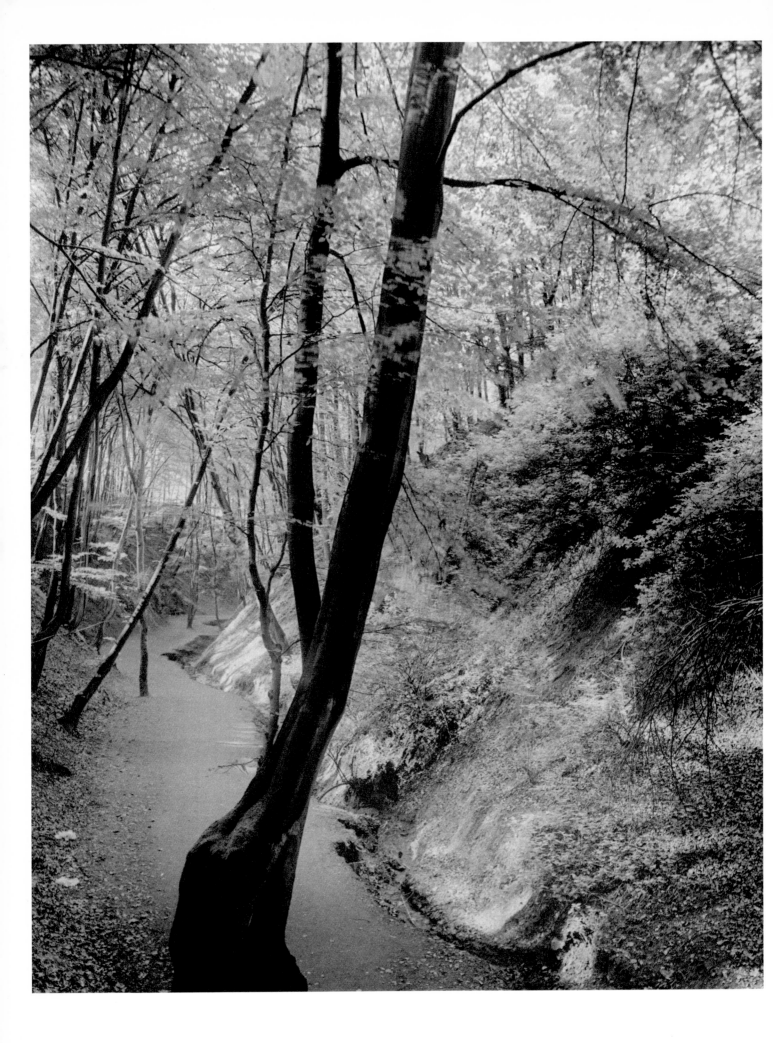

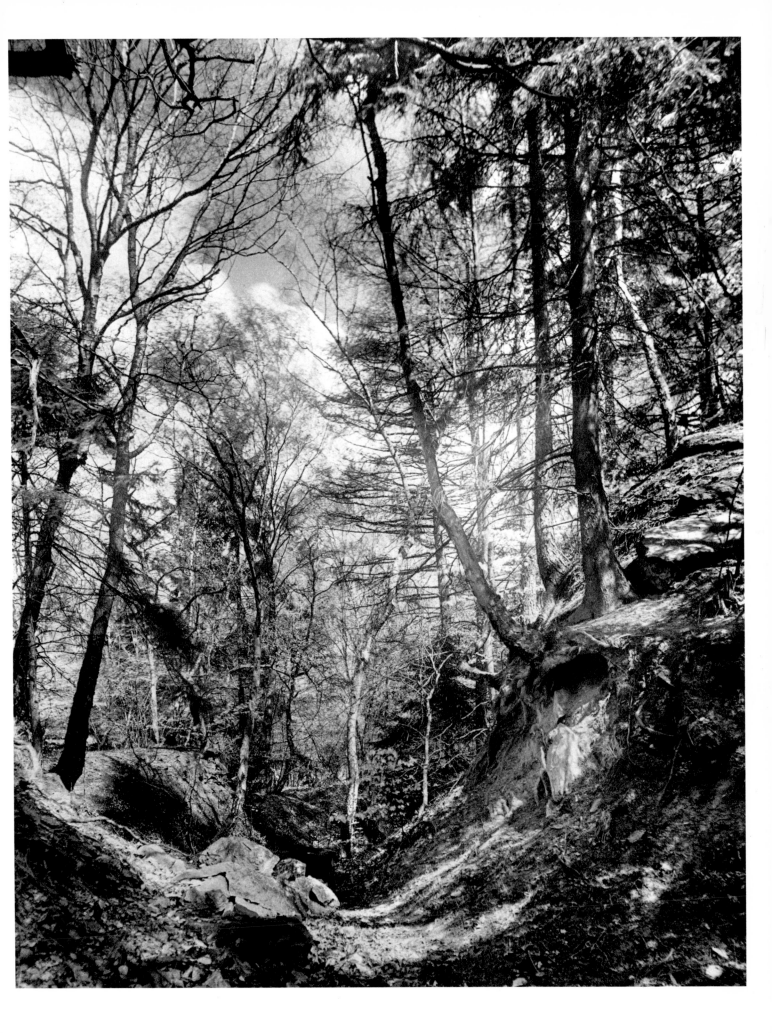

At the end of 1936 my brother was sent to Siegburg prison, and, for the first time since his arrest, my parents received permission to visit him. Up till then their only contact had been sporadic letters which were heavily censored. The confrontation with his son shook my father to such an extent that he now concentrated his entire energy and hopes on a plea for clemency, which he presented with the help of the Cologne law professor Martin Spahn. The petition was granted, but with conditions attached; and it was impossible for my brother to guarantee that he would abstain entirely from all political activities. His life in prison became harder, but his consistency also won him a degree of sympathy. An evangelical pastor brought us regular news of Erich, and eventually managed to arrange for him to take over the management of the photographic department in the prison. It thus became possible for August Sander to give work to his son which he would otherwise have had to get done elsewhere. And when he formed a project to produce a volume on the flora of the Siebengebirge, my brother was responsible for collecting the necessary information from the available botanical literature. The volume was also to include extinct plants, and somehow or other my father managed to get hold of seeds of plants apparently impossible to find, which he sowed near his old camping ground; he watched their growth with great interest and took pictures of the mature plants.

The annexation of Austria, the invasion of Czechoslovakia, and finally the attack on Poland on 1 September 1939, led Erich Sander to beg his parents in his letters to look for a refuge in the Westerwald. My father had packing-cases made for his negatives and stored them in the cellar. Air raids became a daily occurrence, and my father finally found a place to live at Kuchhausen, a small village between Honnef and Altenkirchen. The first three removal vans were packed (and it had been difficult enough to get hold of them), but furniture from eleven rooms and an archive of over a hundred thousand negatives would have required many more journeys; the rooms in Kuchhausen were small and primitive, and it was necessary for my parents to restrict themselves to the bare necessities. But what were the bare necessities? The bombardments became more and more frequent, and our house was finally hit. Seeing the framework of the roof in flames, my father hastily cut away the burning beams with an axe and let them fall onto the street below. This time he was successful in saving his property. Later, during a

heavy bombing raid on Cologne, the entire house was destroyed.

Erich Sander died as a result of the arrogance and stupidity of the SS officers who accused him of shamming as he lay doubled up with stomach pains and explained away the consequences with the words 'cause of death unknown'. There was nothing to keep my parents in Cologne (I myself was on the Eastern Front). At Kuchhausen they set to work with a will to improve their living conditions, to find out what had been preserved, and perhaps to deaden their unhappy memories and their worry about my safe return.

After my release from captivity as a prisoner of war, Kuchhausen was the scene of the reunion between my parents and myself. My father fetched the last bottle of his pre-war rhubarb wine from the cellar. He had waited long enough for this moment, and also to show me proudly all that he had been able to save from destruction. His darkroom was already more or less adequately equipped, and although it was far too small and much in it was makeshift and temporary, it was nevertheless a new beginning. There was still no proper enlarger, for the daylight enlarger which he had constructed from an old camera was not only tricky to handle but also made our work largely dependent on the weather.

August Sander's joy in his work was unimpaired despite his age (he was nearing seventy). His archive of negatives was excellently arranged, and he was never at a loss for new projects – in this case his landscape pictures. A good deal of his time was taken up by the repairs to the house and laboratory and by a small garden behind the house. In September 1946 I approached West German Radio to inform them of my father's coming seventieth birthday and to arrange an official recognition of the occasion. It was decided to interview August Sander on 17 November at Kuchhausen. My mother was told in advance, but my father was not; the surprise proved successful, and my father was most communicative – until his old fear of the microphone caught up with him and he was overcome with a shyness normally entirely foreign to his nature.

A great many friends and acquaintances from earlier times reappeared during these years, and his work was repeatedly requested by various magazines. At first August Sander refused because his archive of finished pictures was not yet complete. His aim was to achieve portfolios of good enlargements of all his pictures, and he worked towards this goal with an intensity which was on the borderline of his physical capacity. It was only after the cur-

August Sander working in an air raid shelter (Cologne, 1943)

August Sander in his darkroom (Cologne, 1936)

rency reform, when he received compensation for my brother's arrest amounting to 18,000 marks, plus a monthly pension of 150 marks, that it was possible to think of acquiring new equipment. August Sander bought a good enlarger – not a modern one, but one for which he would not have to learn a new technique. He laid in a stock of paper and film, and the portfolios were gradually filled.

On a visit to the Cologne Fair we made the acquaintance of L. Fritz Gruber. The first 'Photokina' exhibition was already planned, and Gruber was one of its most active initiators; he was also responsible for the direction and administration. On his recommendation August Sander exhibited his best pictures at the opening of the exhibition in 1950. They were met with great enthusiasm. This mecca of photography helped my father to regain his old reputation and – in a considerably extended professional circle – to gain new recognition and appreciation of his work. The former Mayor of Cologne, Robert Görlinger, was particularly active in his promotion of my father's work, and as president of the German Photographic Society which

was founded in 1951 he was responsible for his election as a full member; seven years later he was made an honorary member. Görlinger's intense interest in my father's pictures, and his far-reaching agreement with his political attitude, resulted in his becoming one of August Sander's closest friends. It was largely due to his influence that the city of Cologne later purchased his work entitled *Köln, wie es war* ('Cologne as it was'). The destruction brought about by World War II had endowed his pictures with a particular documentary value.

It was some time before the transaction with Cologne was finally completed, and the fault was certainly not all on the side of the City! A miscalculation regarding a loan was followed by a bitter disappointment: August Sander was thinking seriously of returning to Cologne, and, inspired by the prospect of once again owning a business of a respectable size, he prematurely purchased a piece of land. Although he still had a small amount of the compensation money left, it was nothing like enough for a piece of land, not to speak of building a new house on the site. He was obliged to sell the land at a loss, and if he had not finally – and unwillingly –

agreed to settle for a fee of 25,000 marks for *Köln, wie es war,* his debts would have swamped him. With this not inconsiderable sum, however, he was able to settle his accounts, and he never again spoke of building a house.

As always, August Sander's tendency to make hasty decisions was compensated for by the ability to recover quickly from a disappointment and look forward to the next project. His darkroom was on the small side, and it was hard for him to carry out work which demanded absolute precision. In spite of this, orders poured in, and he now invested the funds with which he had hoped to return to Cologne in creating better conditions at Kuchhausen. August Sander tended his flower garden behind the house with unbelievable devotion and patience; herbs, and nine-foot sunflowers, grew in profusion, and the mascot of this charming patch of land was a crow by the name of Köbes which my father had found with a broken wing and tended and healed. The crow never learned to fly again, but its ability to caw was unimpaired, to put it mildly.

August Sander at sixty-five (Cologne)

In 1954 the Director of the Photographic Department at the Museum of Modern Art in New York, Edward Steichen, was busy preparing his famous exhibition 'The Family of Man'. In this connection he visited Europe to acquire pictures by important photographers, among them my father. Work by the two photographers had already appeared together in various exhibitions, the first time in 1909. Since then much had changed in photography, but both these great men had pursued their own directions, and both of them had contributed much to the development of modern photography. Edward Steichen particularly admired the absence of artificiality in my father's pictures, and in addition to the photographs which he selected for the exhibition, he also bought a considerable number for the Museum of Modern Art.

Although August Sander may have thought himself forgotten, this was not the case. An increasing number of people remembered his pre-war work, but although the new success of his previous work gave him a measure of confidence, the events of 1954 made it hard for him to believe in his future prospects. Throughout the decades his wife had stood by him through all the difficulties which life had brought, and although she did not always accept his unruly and obstinate outbursts, she was nevertheless aware that his momentary anger hurt him as well as her. And this woman, in whom August Sander had placed his entire trust, who had always stood behind him in sorrow and in joy, and who had constantly helped him with the work of 'seeing, observing and perceiving', now left him alone. Anna Sander died of a heart attack.

The Mayor of Herdorf had long since planned to confer a special honour upon August Sander, and Herdorf now made him a freeman of the town and named a street after him. My father was more moved and delighted by this honour than by all the collective recognition of the professional world, or the respect of anonymous admirers; it represented a personal gesture to August Sander himself, and perhaps also an indication that Herdorf accepted his pitiless eye not as a threat but as a distinction. Apart from occasional visits from old friends, August Sander was now prey to a loneliness against which he felt powerless. The decision whether to succumb to this loneliness or to fight it is probably one of the most tiring struggles of old age – if indeed the tiredness is not the primary cause of the loneliness. It was no longer possible to contemplate completing his life's work, the book *Antlitz der Zeit,* of which only sixty plates had ever appeared. Two

thousand subscriptions had originally come in for 'People of the Twentieth Century', which it was planned to publish in seven groups divided into trade, classes and professions and distribute in forty-five portfolios – but this was before the Nazi Party had condemned the work as anti-social. At certain times it is precisely the quality of honesty that is unacceptable. How was it possible now for August Sander to find and photograph the people who were missing for the completion of his work? He was unhappily aware that it was no longer possible to take pictures good enough to find a place in the work. He often searched in his archives for prints which could fill the gaps, and my protest that the essential physiognomy of modern man had altered was met with scepticism. Perhaps he regarded my remarks as an attack on his concept of the recurrence, not of the superficial image, but of the basic essence; to him, each subject in fact represented a prototype although each one believed himself to be unique. I should have had the sense to drop the word 'essential': we might then have agreed that there had been changes on a more superficial level. His difficulty in accepting the existence of change might have been solved by a slight change of approach. But even then only a new hand could once more present the human being as a prototype without his being aware of it.

It was hard for August Sander to lay aside his camera and rummage through his archives in search of what he could no longer produce; and this enforced frustration often resulted in feelings of apathy and futility which he found it hard to overcome. But at the very moment when he was slowly taking leave of life, the world seemed to try to hold him back and disperse the old man's resentment about its previous lack of understanding. Much was made good which had previously been neglected, and my father received the Cultural Award of the German Photographic Society. August Sander also received the Federal Order of Merit, interest on the part of the radio, publishers and press increased, and numerous exhibitions of his work were organized.

In December 1963 I took my father to hospital following a stroke, and four months later, on 20 April 1964, he died.

August Sander at eighty-two
(The portraits of August Sander on the title page and the cover were taken in 1959 and 1961)

August Sander – was he a great name in the history of photography, a legendary figure? Documented greatness does not exempt him from his question; for attention to detail, precision and aesthetic effect still represent more than just the bogey of formalism. Thematic completeness and consistency of execution to the extent which August Sander achieved, can easily be interpreted as an intention to mislead; whereas in fact the last thing August Sander ever meant to do was to lie. The determination and tenacity to carry out an idea must necessarily result in a coldness which, if not exactly suspect, is nevertheless worth questioning. But perhaps an exclusive concentration on a particular direction always brings with it the risk represented by the borderline between obsession and perfection.